> MONEY_VALUE_ ART_

STATE FUNDING FREE MARKETS BIG PICTURES
> EDITED BY SALLY McKAY AND ANDREW J.PATERSON

D1445827

Chris Lloyd
2003

YYZBOOKS

DESIGN AND PRODUCTION:
Jay Wilson @ WALNUT

YYZ DIRECTOR FOR OPERATIONS AND PUBLISHING:
Dionne McAffee

YYZ Books is an alternative press dedicated to publishing critical writings on Canadian art and culture. YYZ Books is associated with YYZ Artists' Outlet, an artist-run centre that presents challenging programs of visual art, film, video, performance, lectures and publications.

YYZ Artists' Outlet is supported by its members, the Canada Council for the Arts, the Ontario Arts Council and the city of Toronto through the Toronto Arts Council.

YYZ Artists' Outlet gratefully acknowledges the support of the Canada Council for the Arts for our publishing program.

THE CANADA COUNCIL
FOR THE ARTS
SINCE 1957

LE CONSEIL DES ARTS
DU CANADA
DEPUIS 1957

PUBLISHED BY
YYZ Books
401 Richmond Street W. Suite 140, Toronto, ON M5V 3A8

PRINTED IN CANADA BY
Kromar Printing Ltd.

CANADIAN CATALOGUING IN PUBLICATION DATA
Main entry under title: Money value art : state funding, free markets, big pictures

ISBN 0-920397-76-X

1. Government aid to the arts—Canada.

2. Art and state—Canada. I. McKay, Sally. II. Paterson, Andrew J. (Andrew James), 1952- . III. YYZ (Gallery).

N8846.C2M66 2000 700'.971 C00-931528-4

> CONTENTS_

Acknowledgements

The authors would like to thank all the contributing artists and writers; Susan Kealey for advice, encouragement, and example; Melony Ward, Dionne McAffee, Lorissa Sengara, Joanna Fine, and the Publishing Committee of YYZ Books; Kim Tomczak, Wanda Vanderstoop, and Chris Kennedy at V Tape; Ana Silva and the Community Arts Biennale 2000; Beth Reynolds at the Toronto Arts Council; Isabel Fryszberg of Creative Works Studio, Toronto; Ellen Anderson of Creative Spirit Art Centre, Toronto; Jonathan Culp and Satan MacNuggit; pickAxe Productions; James MacSwain, Rosemary Donegan, Petra Chevrier, Milada Kovacova, Sandy Plotnikoff, Catherine Osborne, Victoria Stanton, Vincent Tinguely; Ben and Nancy Smith Lea; *FUSE* magazine; the Laidlaw Foundation; George Wharton at Metro Toronto Archives; Darren Wershler-Henry at Coach House Books; Hank Bull; Nick Gamble; and the Ontario Arts Council Writers' Reserve Program.

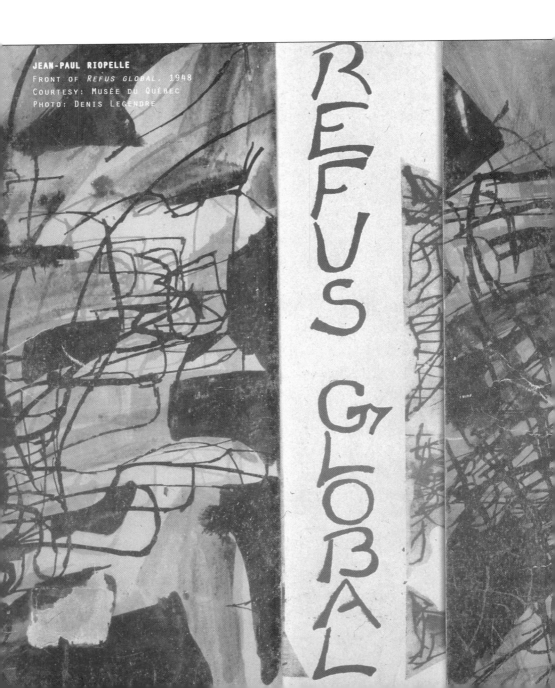

JEAN-PAUL RIOPELLE
FRONT OF *REFUS GLOBAL*, 1948
COURTESY: MUSÉE DU QUÉBEC
PHOTO: DENIS LEGENDRE

> SALLY McKAY AND ANDREW J.PATERSON

Introduction

Now, at the beginning of the twenty-first century, it seems important to take stock of our systems—philosophical, political, cultural, economic, and social. In Canada, ideologies and perspectives on money, value, and art are shifting into new, and sometimes disturbing, configurations. Recent government cuts to arts funding have been heavy and demoralizing, and they have been escalating at a frightening rate. But there have also been many plucky responses to these cuts: in-your-face, do-it-yourself responses and initiatives that mix and match government funding, commercial sales, scrimping, and fund-raising into a confusing but energetic combination of fiscal strategies. Impatience with both government red tape and corporate benevolence has motivated artists of all ages to open their own storefront galleries, to launch their own electronic and other communication networks, and to collapse the historically revered distinction between profitable and non-profit art activity.

This burst of activity in the face of adversity is both exciting and inspirational, but there are several questions that must be asked. Are Canadian artists and art workers actually making enough money to sustain themselves and their practices? What kinds of energies are being created by new free market approaches? What freedoms and explorations are disappearing as government funding is cut?

The call for submissions for *Money Value Art* was sent out widely, and the response was varied and eclectic. Most submissions, however, assumed government funding to be a necessary component of Canada's contemporary art systems and practices. Why this relative lack of discourse on the advantages of the free market as a cultural support system? Perhaps there is a generalized fear of jinxing already vulnerable support systems. Possibly this reticence results from an internalized historical feeling that to openly discuss the practicalities of money and art is both crass and threatening to higher, non-material values of art practice. The clandestine nature of Canadian art

markets may also be a factor, and it just might be that artistic transactions within market economies do not interest those who, for various reasons, concern themselves with the politics and morals of the public realm.

That said, the artists and writers contributing to this anthology represent their concerns from many different perspectives and with stylistic diversity. Artists' projects from Jill Henderson and John Marriott posit humorous fictional scenarios. Henderson's architectural blueprints play with the not merely hypothetical notions of galleries as public venues for lowbrow fun and games. Marriott's "Children's Letters to Charles Saatchi" innocently posits the concept of a Canadian foothold in the international art market from the position of a curious child. In contrast, Luis Jacob's project presents a serious look at artists' living and working spaces and their symbiotic relationships to development, economy, and status. Scott McLeod's project "Security" takes a deadpan approach, reclaiming the grids deployed by financial institutions to simultaneously protect and enforce privacy. Michael Balser and Andy Fabo contribute an artist's board game that mocks the snakes and ladders of art careers, with their successes and failures ultimately measured in monetary terms.

Several writers use case studies as a catalyst for investigation. Kevin Dowler details the nationalist and vanguardist root of governmental and other public arts-funding policies while focusing on a specific case scenario involving Toronto Metro Council's refusal to ratify recommended grants to two queer organizational clients. Josephine Mills focuses on criticisms of commissioned public art in Vancouver, with an eye to evaluating criteria for specific commissioned works. Mills argues that classic arm's length arguments based on artistic autonomy fall short when required to defend projects that are economically and socially accountable to both public and private interests. Andrew Johnson reports on the trials and tribulations of the Art Gallery of Windsor and its relocation in proximity to a casino and a major suburban mall. This not-so-comical farce illustrates the pitfalls of literal-minded attempts at "becoming more accessible" and "going public."

Defenders of arm's length government funding systems, as well as believers in the free market as a level playing ground, like to consider their preferences fair, inclusive, and accessible. But many artists and arts organizations have consistently felt themselves positioned outside of the various funding systems and markets. Jan Swinburne's "Merging" is a heartfelt response to issues around equitable access from the perspectives of those who are, in many ways, living and working with disabilities. Swinburne calls for intelligent lobbying strategies to make arts funding and evaluation more accessible to a wider spectrum of artists, while making conscious efforts to move beyond condescension and ghettoization. Rinaldo Walcott's "Blue Print for Resistance" looks at the very

complex problems of setting criteria for funding based on representational issues involving racial minorities. Walcott critiques institutional tendencies to deny vitality to minority artists by regarding their work as "heritage" and he ponders the future for "ethnic" artists as art world economies and exchange systems become even more corporate and remote.

Cliff Eyland and Pierre Beaudoin each present their personal strategies for negotiating money, value, and art. Eyland posits exchange systems as a structural component of his personal art practice, making an individual attempt to collapse the value and the values of his work into a systematically coherent on-going project. Beaudoin offers a bittersweet yet wickedly humorous overview of the very low-income opportunities for individuals attempting to pursue distinctive art and art-administrative careers in Québec.

Robin C. Pacific, Jan Allen, and Barbara Godard each contribute an in-depth analysis of a particular institution or terrain. Pacific's essay, originally presented as an address to the Laidlaw Foundation, itemizes the variety of community art discourses, models, and practices in the United Kingdom, Australia, and the United States, as well as in Canada. Allen presents a history of the Canada Council Art Bank and its on-going attempts to bring contemporary Canadian artworks into private sector workplaces. Godard places former Ontario Arts Council (OAC) chairperson Hal Jackman's uniquely distorted equation of public interest with private sector under the microscope. Godard marks the origins of the OAC, and indeed of subsistence models for the arts, in relation to conflicting definitions of that loaded word "culture."

Globalization and the history and future of our economic, arts, and cultural systems have captivated Bernie Miller, David McIntosh, and the collaborative team of Krys Verrall and Bill Burns. In "Red Goods, White Goods," Miller highlights the histories of bohemia and looks at practicality and consumption in light of the limited scale of actual art markets. McIntosh, with a focus on protectionist agreements masquerading as free-market initiatives, tracks national and international exchange treatises and practices from Adam Smith's *The Wealth of Nations* through the repeal of Great Britain's Corn Laws in 1846 to the Canada-U.S. Free Trade Agreement of 1989 and the subsequent North American Free Trade Agreement, and right into our current cyber-economies and radical redefinitions of body, mind, and nation-state. Verrall and Burns' departure point is that lingering question of how one can be simultaneously of the state and against it. Verrall and Burns look at the symbiotic relations and differences between museums and international art fairs, as well as individualist, nationalist, and internationalist perspectives on art practice and markets—all within the shifting contexts of governments, governmentality, and arm's length funding policies administered in a spiralling global economy.

Artists have learned to negotiate these contradictory non-profitable and potentially profitable systems. But the world is in fluctuation and therefore so are the art worlds. We are now officially living in the twenty-first century. So why does the 1950s continue to resonate, with its fear of aliens, its moralistic binaries, and its obsession with viruses? This anthology probes the present state of contemporary art and culture in Canada, unravelling some of the ideologies, picking out some of the political pitfalls, and noting the various gains and losses that are accumulating all around us. *Money Value Art* is intended as a signpost, marking a moment in time when Canada's and the world's cultural systems are in flux, and our economic and technological futures are barrelling toward a superficially undifferentiated global culture of capitalism. There is a new technological utopianism that proclaims leftover Cold War paranoia and binarisms to be obsolete in lieu of the hegemonic realities of our New World Order. But such harmonious systems, whatever the pseudo-unifying brand name, beg questions of fiscal, informational, and ideological downloading and even annihilation. Who is out and who stays in? Who is in position to define the terms?

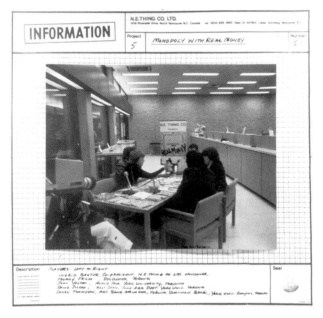

N.E. THING CO., *MONOPOLY WITH REAL MONEY*, 1973
PERFORMANCE AT TORONTO DOMINION BANK, YORK UNIVERSITY, TORONTO
IAIN BAXTER, PRESIDENT OF N.E. THING CO., PRODUCER
PHOTO: IAIN BAXTER

> ANDREW J. PATERSON

Preface

By the end of the Second World War in 1945, Canada had metamorphosed from an underdeveloped former British colony into an emerging nation-state. The United States of America, situated immediately to the south, had become Canada's principal trading partner. The Great Depression of the 1930s had been eradicated by the war effort and the economy was now healthy enough to encourage surplus. In this brave new world there were fresh technologies, as well as exciting modern and modernist exchanges. The centre of the modern international art world had effectively shifted from Paris to New York. Therefore, the post-war period was also characterized by defensive nationalist anxieties regarding Canadian dependence upon American currencies and about concurrent American industrial, technological, and cultural imports with their various accompanying values.

If economic dependency on the United States was already a foregone conclusion by the beginning of the 1950s, then Canadian distinction from the expanding American empire had to be asserted in a different domain. The cultural realm provided an excellent opportunity. Beginning with the 1941 Artists' Conference in Kingston, Ontario, the Federation of Canadian Artists and other arts-funding advocates "invoked the national interest as the best strategy for defending and advancing the boundaries of what they understood as culture,"[1] perhaps with a utopian fervour and perhaps strategically. Indeed, coalitions of visual and performing artists of the time tended not to position themselves as autonomous modernist artists. Instead, they engaged in discourses concerning democracy, culture, nation building, and public space. They worked alongside agrarian and labour activists, proto-feminists, and even popular entertainers. It is worth noting that the Brief Concerning the Cultural Aspects of Canadian Reconstruction, presented to the 1944 federal Turgeon Special Committee on Reconstruction and Re-establishment,

resolved that Canada's National Gallery should be radically decentralized and reconstituted as a network of location-based centres and practices.

It is also notable that emerging nation-states, especially those tentatively linked across vast landscaped space by means of recently constructed highways, railways, and communications systems, tend to be highly conflicted as to how to construct essential or official identities. Assertive nationalism, not unlike other identity movements, often demands that those asserting their identity must see themselves realistically depicted in the pictures they claim as their own. The primal modernism of the Group of Seven did not initially impress many Canadians and Canadian critics who failed to recognize their own landscapes accurately portrayed in the Group's radical subjectivism. The Group of Seven was designated an exemplary and commodifiable example of idiosyncratic Canadian culture only after they were legitimized by British and European art critics. Québec, too, was isolated from the rest of the Canadian nation by its antipathy to supplying troops for a war that Canada was fighting in on behalf of the British, and by its immersion in the bleakly introverted, religious, and philistine Duplessis regime. But Québecois artists such as the Automatiste abstractionist painters were aggressively declaring autonomy from church, state, submissive social responsibilities, and literal-minded representationism. The 1948 document Refus Global,[2] authored by Paul-Emile Borduas and signed by fifteen associate Automatistes, was a landmark of modernist defiance. This artist's manifesto was an assertion, not a defence, and it played a pivotal role in Québec's subsequent Quiet Revolution.

The report of the Royal Commission on Arts, Letters, and Sciences, published in 1951 and known as the Massey Report, was strongly motivated by defensive, nationalist concerns.[3] The commission recommended the establishment of a centralized or federal arts-funding agency to develop, nurture, and sustain a high culture distinct from the crassly material popular culture that was now flooding into Canada from (predominantly) American dissemination systems. Thus, plans for Canada's future as a committed player on the world stage and in the world economy were paradoxically tied to colonial heritage and an idealized past. Aggressive modernist artists' initiatives toward progress at the expense of conservationist parameters were structurally contradicted by the commission's insistence on protecting Canadian arts or cultural sectors from the lowest common denominator values of uncontrollable free market capitalist economies. The Massey Report reiterated the (Matthew) Arnoldian belief that culture is fixed, permanent, and ordered rather than fluid or historical. The report's "opposition to the vulgar materialism of American consumerism and its promotion of high art over mass culture shaped the parameters of future debates over national culture."[4]

It wasn't until 1957, six full years after the recommendations of the Massey Report, that the Canada Council Act was passed by the Liberal St. Laurent federal government. A generous endowment funding source conveniently presented itself, and the money was strategically divided between cultural funding and higher education. Grants to individual artists as well as to arts organizations were awarded on the basis of merit by a system of peer assessment or evaluation, at arm's length from the government and its employees. If the fine arts and their refined performing cousins were to remain autonomous from the pressures of the market place, then they, at least in theory, had to be safeguarded from any possibility of state coercion or invective.

Artists, as well as arts administrators, and even occasionally dealers, have frequently telegraphed mixed and confusing messages with respect to money. Bohemianism has recurrently confounded (and sometimes reinforced) rigid class definitions and expectations, and the myth of the starving artist has too customarily been advantageous for cynical politicians as well as for artists themselves. However, the liberal humanism of the Massey Report ignores the fact that many practising Canadian artists, while maintaining a dignified indifference to all but "pure" values of appraisal, were quite effectively declaring their presence in the international art market. Protectionist measures and trade barriers have as often as not been perceived as anathema to artistic enterprise and even free expression.[5] The conflicting signals of the late 1950s were echoed in the discourses generated by the 1988 federal election that was fought over the impending Canada-U.S. Free Trade Agreement. Many stalwarts of the artist-managed and non-profit cultural sectors were startled to read a petition signed by prominent art dealers and even artists who declared protectionism to be in opposition to artistic practices and sensibilities. However, artists and dealers preferring neo-liberal trading agreements and a relaxation of rigid geographically demarcated borders indeed had their quietly distinguished precedents.

As the federal council became entrenched, provincial and even municipal arts councils (some pre-dating the Canada Council and some founded far too long after the fact) formed and declared their mandates. Various Canadian artists and activists set about constructing alternative systems to existing commercial and even community galleries and exhibition forums. These fresh arts and cultural initiatives were enthusiastically encouraged by the Pearson and Trudeau federal governments of the mid-1960s through the early 1970s. Pierre Trudeau and his Minister of Cultural Affairs, Gerard Pelletier, envisioned and set about constructing a strong centralized Canadian culture intended to provide a unifying bulwark against threats to national unity, particularly those of Québec separatism or sovereignty. Communications systems

linking various centres throughout the nation-state (but heavily concentrated in the major cities) lent themselves to exploratory networking by different non-profit or "parallel" galleries and to the eventual establishment of the Association of National Non-Profit Artists' Centres (ANNPAC) in 1976. Participating galleries and centres provided exhibition forums for artworks and practices that seemed outside of, and even antagonistic to, traditional commodity values. Thus, installation art, performance, and video were more likely to be presented among the parallel or artist-run centres (ARCs). But, toward the end of the 1970s, many contradictions began to surface within the parameters of autonomous artistic production, funded at arm's length from the state and at safe distance from art markets, leading to serious differences and even ruptures within the parallel or non-profit networks.

Krys Verrall, in her collaboration with Bill Burns in this anthology, refers to a December 1999 panel at which an artist/audience member skeptically inquired how one can be against the state and also of the state.[6] This question might presume that all artists are in fact against the state, but I would argue that many are not. It has been suggested, and not only by curious visiting Americans, that the Canadian mentality is essentially bureaucratic, and thus suspicious of individualism and individual enterprise.[7] Perhaps many Canadian artists are fascinated by systems, with their checkpoints and negotiable contradictions, and are also quite willing to exchange risks for securities. They might even tolerate a particular degree of surveillance as long as the apparatus is positioned safely at a distance.

However, bureaucracies also create hierarchies and even class-systems. Many artists, politicians, and taxpayer spokespersons have perceived the publicly funded arts and artists' support systems as hermetic, inaccessible, and inflexible. What supports and assists some individuals and organizations also denies resources and benefits to others. The Canada Council, its provincial and municipal cousins, and the systems of artist-run exhibition and distribution have often been accused of deploying classically aesthetic and apolitical alibis in lieu of charges of exclusion on the basis of race, gender, age, sexual orientation, language facility, and class.[8] During the recession of the late 1980s and early 1990s (soon after the passing of the 1988 Free Trade Agreement), enraged taxpayers and various conflicting interest groups lashed out at perceived gratuitous rewards and purchases. The fact that arts and cultural funding by governments is dependent upon both direct and indirect taxation of citizens motivates demands for accessibility and appropriate response. Class-fuelled resentment is never far below the surface with regards to politicians' and citizens' outrage at perceived wasteful expenditures and violations of community standards. And, when confronted by angry demands for accountability and stared down

by moral panic, artists and arts-advocates have traditionally fallen back upon modernist or vanguard defences that fail to persuade those with serious contrary agendas (and who all too frequently have money, family values, and governments lined up behind them). The security of an imperfectly-defined arm's length distance from political interference inevitably collapses when confronted by political protests and moralist anxieties.

The twenty-first century commences at a time when global and local concerns are, paradoxically, a click of the mouse away and light years apart. Binarisms such as nationalism vs. internationalism, non-profit vs. for profit, or communitarian vs. individualist have already long been problematized if not completely obliterated. What do distinctions such as individual and group (or society or nation) mean in a technocratic or even cybernetic universe? Values such as originality, purity or clarity of vision, and authorship have been problematized by discourses of post-modernism, by the mechanics of reproductive-image technologies, and by the quasi-anarchic, but overwhelmingly corporate, universe of cybernetics.

Yet issues concerning the status of artists within the global economy are mirrored by issues concerning the roles of artists within society. At local (referring not necessarily to communities but to neighbourhoods or locations— places in which different people live or share space) levels, issues around artists' accommodation and exhibition persist. The truism that artistic presence increases property values and thus that artists function as vanguard agents for developers is not entirely inaccurate. It is paradoxical that artists, who have traditionally justified their lives and lifestyles by claiming that their processes and products should be evaluated by alternate values to the purely material or economic, have themselves served as agents of gentrification, a process which displaces affordable housing or accommodation for various low-income citizens. So then, how do artists counter this and other similar paradoxes? By inhabiting a social milieu as citizens and then artists, or by living and practising as artist-citizens? This may not be the situation in the twenty-first century for those artisans who can afford to bypass social issues, but this is a hopefully not irresolvable problem for citizens who insist on their rights to self-definition and self-sustenance, whether or not the actual word *artist* is part and parcel of that self-definition.

At the top of the millennium, many economists and other pundits are warning of an impending recession. Although nobody is worried about anything as severe as the recession of the late 1980s, let alone the American stock market crash of 1929, it is not only the ideologically and fiscally conservative governments that are bracing for a stricter austerity. The arts and cultural sectors have so often attempted to justify themselves with economics-based

arguments, but cost-cutting governments and their free market supporters are securely positioned to reject such arguments. If art indeed has values other than of a strictly economic character, then now is as crucial a time as any for artists and art supporters to articulate and act upon those values.

NOTES

1 Jody Berland, "Nationalism and the Modernist Legacy: Dialogues with Innis," in *Capital Culture: A Reader on Modern Legacies, State Institutions, and the Value(s) of Art*, Jody Berland and Shelley Hornstein, eds. (Montreal and Kingston: McGill-Queen's University Press, 2000), 27.

2 Paul-Emile Borduas, "Refus Global," in *Documents in Canadian Art*, Douglas Fetherling, ed. (Peterborough: Broadview Press, 1987), 112–25.

3 Kevin Dowler, "The Cultural Industries Policy Apparatus," in *The Cultural Industries of Canada*, Michael Dorland, ed. (Toronto: James Lorimer & Co., 1996), 328–46.

4 Dot Tuer, "The Art of Nation Building," *Parallélogramme* 17:4 (1992).

5 "We Are Not Fragile: Artists and Writers for Free Trade," *Border/lines* 14:9 (1988–89). Originally published in the *Globe and Mail*, November 19, 1988 (paid for by the Canadian Alliance for Trade and Job Opportunities, in association with the Business Council on National Issues).

6 "'slash-and-burn' funding cuts impact arts communities," a forum to examine survival strategies organized and presented by *FUSE* magazine at Rivoli Café, 334 Queen St. W., December 4, 1999.

7 A.A. Bronson, introduction to *Media Works*, by N.E. Thing Co. Ltd. Co-Presidents Iain and Ingrid Baxter (Toronto: Art Metropole, 1992).

8 Monika Kin Gagnon, "Building Blocks: Anti-Racism Initiatives in the Arts," and "How to Banish Fear: Letters from Calgary," in *Other Conundrums: race, culture, and canadian art* (Vancouver: Arsenal Pulp Press, 2000), 51–72, 73–85.

> MONEY_VALUE_
ART_

1941 - Kingston Artists Conference at Kingston, Ontario. The foundations of national cultural policy and growth laid at this conference included: *public support, as the cornerstone of arts and culture policy in Canada; the arm's length principle; the central role of the artists in the development and implementation of policy; commitment to the cultural integrity of the regions.*

Formation of the Federation of Canadian Artists; headed by sculptor Elizabeth Wyn Wood, painter Lawren Harris, and conductor Sir Ernest MacMillan (from Declaration of the Halifax Conference: A National Forum on Canadian Cultural Policy, 1985, in Harry Bruce, ed. *You've got ten minutes to get that flag down: Proceedings of the Halifax Conference,* 51).

CLIFF EYLAND

Mixed Funding, Mixed Markets, Little Pictures

My art is worth money, but how much? Since 1981, with a few exceptions, I have made only 3" x 5" (7.6 x 12.7 cm) paintings, drawings, and sculptural works, very small things. If everything is the same size, should all the things be worth the same amount?

In fact, all of the paintings, collages, and photographs that I mount on board do have the same retail price, but, to complicate matters, all of my file card drawings on paper are, at least for now, free (price-less?). If you approach Leo Kamen Gallery in Toronto, or the James Baird Gallery in St. John's, Newfoundland, or Site Gallery in Winnipeg, a single Cliff Eyland work retails for $300. That price seems fair, not too high or low, maybe the price of two or so big glossy art books, a couple of nights in a hotel, or maybe, for some people, the cost of a single night out. Art dealers get 50%. Not bad? Reasonable, I think, at least for now.

Three hundred dollars may be too little or too much for a tiny painting, but who's to say? I set the price, and I reserve the right to change it. The rule about pricing is, as I understand it, that anything goes, as long as the price isn't lowered for a fire sale—deep discounting doesn't work with commodities such as high art. I'd prefer to set a reasonable standard, and then run with it, see how it goes, and adjust prices upward only after some careful thinking. The Federal Cultural Property Review Board has had my paintings evaluated by approved agents for donation to public institutions: their evaluation? Three hundred dollars each. That's because the Board depends on a circular method, accepting the current market value instead of leading the market by making their own judgments. Similarly, the public art galleries use commercially

1944 – MEMBERS OF THE FEDERATION OF CANADIAN ARTISTS WERE THE PRIMARY ORGANIZERS BEHIND THE DRAFTING OF A "BRIEF CONCERNING THE CULTURAL ASPECTS OF CANADIAN RECONSTRUCTION" PRESENTED TO THE FEDERAL TURGEON SPECIAL COMMITTEE ON RECONSTRUCTION AND RE-ESTABLISHMENT. THIS BRIEF RECOMMENDED BOTH THE ESTABLISHMENT OF A FEDERAL ARTS FUNDING AGENCY AND A SYSTEM OF COMMUNITY ART CENTRES THROUGHOUT THE NATION'S REGIONS.

set prices as a benchmark for donation values and purchases, when they too could instead lead the way and assert a high dollar value on works that they judge important.

By the late 1960s, conceptual artists realized that it was futile to deny the exchange value of art unless the point of the work is to challenge exchange values. Collectors, they discovered, will buy anything—photocopies, video tapes, dirt, you name it. Artists shouldn't pretend that they think their works are not valuable, nor should they imagine that they make things that operate outside our systems of exchange, even if in day-to-day life some art can actually lower the value of the materials used to make it. Today's auction market proffers lots of trivial non-art objects for large amounts of cash; the playing field has never been so bizarre (take a look at eBay) so why deny that one's own art, however ephemeral, has monetary value? Many Canadian artists of my generation (I was born in 1954) act as if their work is at once of great value and worthless. Their ambivalence about public and private funding, about selling and buying, is never resolved.

Like all artists, I reserve the right to give away or to trade away a small number of my paintings. I give my art to family, to close friends and to support charitable causes. My drawings, however, unlike my paintings, are simply not for sale—so far at least—but are only available as give-aways, mostly to library patrons in various countries who stumble across them as they are reading a book. So how much are the drawings worth? I have hidden drawings at the Raymond Fogelman Library at the New School University in New York City, where I am doing a long-term installation; at the Muttart Gallery and Library in Calgary, where I did a work in the fall of 1999; and at the Art Gallery of Ontario (December 1999–February 2000) and in unpublicized installations since 1981.

I insist that these drawings, even if they are given away, are also worth money, but exactly how much has never been established. I know from my friends in the archives business that a document is worth at least what it costs to reproduce it, so my drawings are worth at least the cost of photocopying them. The drawings will find their own level of monetary worth. (I'm hoping that someday they may reach the value of some Pokémon trading cards.) In the meantime they occupy, like so much art that attempts to challenge art's price and place, a monetary limbo.

These "free" projects, like all art making, cost money to produce. Funding comes from arts agencies that support the installations, from my own financial contributions, and from sales of my paintings. I could attempt to sell one of my public library installations, even if the collector might not be able to obtain the work, or I could contract someone to buy and resell drawings discovered by library patrons: stranger deals have been made. If some of my work is in a financial limbo now, that may not always be the case. ▪

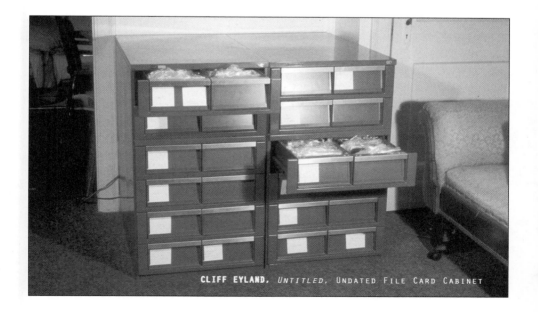

CLIFF EYLAND, *UNTITLED,* UNDATED FILE CARD CABINET

1946 – Establishment of the Cultural Development Branch by Alberta's Social Credit Government. This agency later became Alberta Culture, characterized by a program that encourages more support to the arts from the private sector by matching, in various ratios, all individual and corporate contributions (Woodcock, 86).

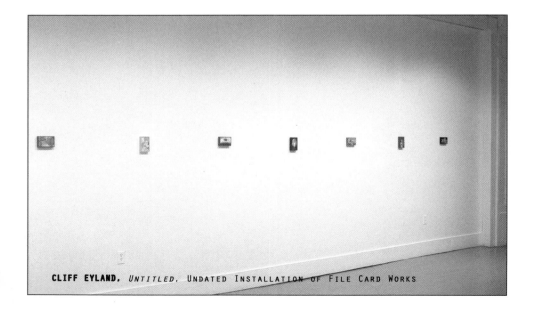

CLIFF EYLAND, *Untitled,* Undated Installation of File Card Works

CLIFF EYLAND, *Untitled*, Undated Installation of File Card Works

1948 - Publication of *Refus Global* by Automatistes, led by renowned and influential painter Paul-Émile Borduas. This manifesto denounced the repressive power of the Catholic Church, of the Duplessis government in Québec, and indeed all artistic, intellectual, and political restraints on free expression. The fifteen artists signing the manifesto were censured and Borduas was fired from his teaching position at l'École du Meuble.

CLIFF EYLAND, *Untitled*, Undated File Card Works

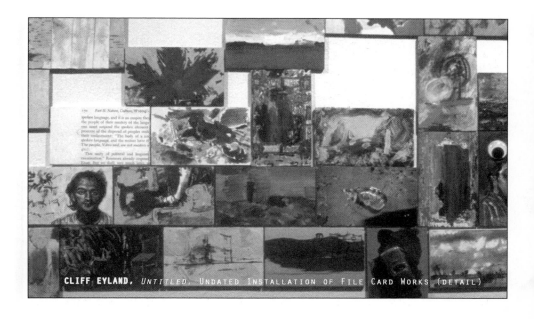

CLIFF EYLAND, *Untitled*, Undated Installation of File Card Works (detail)

1949 - FORMATION OF CANADIAN ARTS COUNCIL, A COTERIE OF ARTISTS' ORGANIZATIONS (NOT TO BE CONFUSED WITH THE CANADA COUNCIL FOR THE ARTS). THE CANADIAN ARTS COUNCIL LATER BECAME KNOWN AS THE CANADIAN CONFERENCE OF THE ARTS.

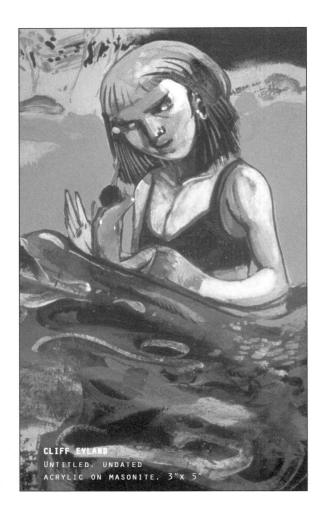

CLIFF EYLAND
UNTITLED, UNDATED
ACRYLIC ON MASONITE, 3"x 5"

> KEVIN DOWLER

In the Bedrooms of the Nation
State Scrutiny and the Funding of Dirty Art

We do not belong in the bedrooms of the nation, but when
people start asking for public money, they have invited us in.
—*Metro Toronto Councillor Brian Ashton*

Recent political attacks on the cultural funding policies and agencies in Canada (and elsewhere) have taken place within a shifting context marked not only by transformations in the economic realm, but also by the recent emergence of a plurality of forms of aesthetic practices. Some contemporary artwork, particularly that with explicit political or sexual contents, has gained a controversial status that has precipitated government intervention into the cultural funding process. These interventions have been based on moral and economic appeals for government action brought forward by private individuals or groups, as well as coming from within governments themselves. Many artists and cultural groups feel besieged by both private interests and governments determined to ensure that public monies are not spent on certain kinds of art and cultural production. This has been especially so in the case of artworks with religious or homosexual and/or homoerotic contents and themes, where issues of the autonomy of aesthetic practices have collided with questions of the public good.

From the beginnings of modernity, the aesthetic and the moral have developed along different paths. As characterized by the slogan "l'art pour l'art," the aesthetic realm has come to be regarded as a more or less fully autonomous realm of experience—a realm removed from, and therefore of little consequence to, the quotidian.. This has also meant that discourses of art and aesthetics have developed independently of the other domains of knowledge—the moral/practical and scientific—with which they had been previously intertwined. However, as many artists have begun to explore a critical politics of representation, and in particular the politics of identity, the occasional blurring of the

1949 - SASKATCHEWAN'S CCF GOVERNMENT ESTABLISHES THE SASKATCHEWAN ARTS BOARD, WHICH MAKES A POINT OF SUPPORTING CRAFTS AS WELL AS "THE CONVENTIONALLY CONCEIVED ARTS" (WOODCOCK, 86).

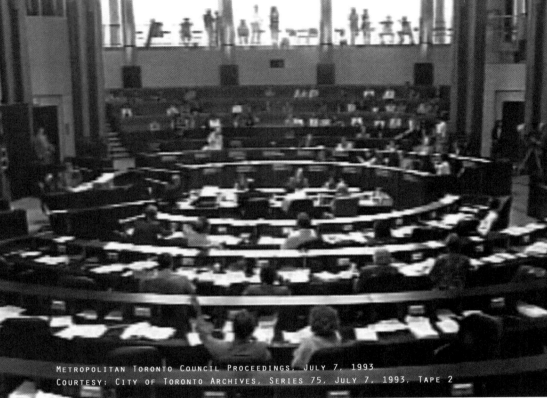

METROPOLITAN TORONTO COUNCIL PROCEEDINGS, JULY 7, 1993
COURTESY: CITY OF TORONTO ARCHIVES, SERIES 75, JULY 7, 1993, TAPE 2

distinction between the aesthetic realm and everyday life—as signalled by the recent controversies over art—has led to friction and contestation between the sphere of art and society as a whole. This has in turn exposed some works to political and moral criticism. Unfortunately, this has often been met by art professionals either with shock that the autonomy of aesthetic practices should ever be questioned, or by a retreat into aesthetic jargon and a defence based on the thinly disguised paternalism of an expert culture which insists on reaffirming the autonomy of art. Difficulties arise when aesthetic discourses are faced with the exigencies of specific political situations in which the various participants are not concerned with the aesthetic merits of individual works or practices, but rather their social and moral implications for the polity as a whole.

Of course, the problems are not all on one side. Political representatives in their turn must exercise judgments when confronted with the same sets of exigencies. Assuming often that they represent a consensual majority, in these situations politicians are confronted instead with a fragmented lifeworld in

which a shared set of aesthetic and moral standards appears to no longer exist. Here again, the autonomy of the spheres militates against the transfer of criteria for judgment from one realm to the other; in this case, the authority of politicians to make what appear to be aesthetic judgments comes under scrutiny. Judgments, it seems, must be made between competing versions of the good, but where the rationales for those versions are incommensurable.

In what follows, I want to address some of the issues raised by this collision of interests as it impinges on the production of art in Canada. I begin with a brief historical sketch which argues that the making of art in Canada is primarily a "statist" enterprise, which is consistent with the predominant role of the state in Canadian life in general. I further suggest that attempts to dismantle or reconstruct the structure of public sponsorship of the arts is a radical manoeuvre, given this tradition of state support both in the arts and elsewhere. This is followed by a discussion of a 1993 meeting of the Council of the Municipality of Metropolitan Toronto, in which two grants approved by the municipality's Cultural Affairs Division were singled out for debate. The grants were to be awarded to two organizations involved in the exhibition of gay and lesbian artwork. An examination of this case provides a means of observing how, in the political sphere, positions are articulated around issues of aesthetics and sexual representation and the authority of governmental structures to manage and steer their production in the aesthetic realm. The debate raises (although does not necessarily answer) critical questions concerning the relationship between a liberal discourse of rights of individual freedom of expression and notions of collective value and the public good. Finally, my discussion turns to general questions concerning the problems that ensue from an encounter between aesthetic discourses and political exigencies. Ultimately, my argument suggests that if art is to break out of its status of relative autonomy (and, therefore, relative lack of utility), it can no longer be defended in terms of art *qua* art; controversies over the social effects of art cannot be avoided by asserting a privileged status for art that claims immunity from social sanctions.

A Tradition of State Sponsorship

To invoke the term *culture* in a discussion relating to Canada is to simultaneously invoke a discussion of the state. Indeed, to think of the two separately is to confront what Michael Dorland has called "the particularly blurry nature of the interaction between the two."[1] This is so since, according to Dorland, "the problematic of the Canadian state is the politicization of cultural discourse

that simultaneously collapses the possibility of distinguishing the political from the cultural and at the same time widens it by the mediating creation of a *statist* culture."[2]

It is precisely this condition as a "statist culture" that has come to characterize culture in Canada; not, however, as a form of culture imposed by the state, but as the product of a demand from below, so to speak, for state intervention in the form of various kinds of investments, both of capital and rhetoric. This statist approach would differentiate Canadian culture from that of other nations—particularly that of the United States:

> state intervention, direction, and even ownership must be seen as fundamental to the whole process of differentiating Canada from the United States. It is not merely that the state alone has the resources necessary to finance cultural survival . . . it is also that a statist . . . approach to culture would in itself be evidence that Canadian culture is different. . . .[3]

In the absence of private interests in Canada, or at least their reticence to finance national development, successive Canadian governments have established a tradition of ownership and sponsorship in both the economic and cultural spheres extending from pre-Confederation times up until today. Harold Innis was one of the first to recognize the central role of government capital in the formation of the Canadian nation and the extent to which Canadian governments have been willing to make political decisions ahead of economic ones for the sake of the perceived interests of the nation, and to step in where private interests refused to go.[4] A willingness on the part of government to support ventures that served national interests, and the acceptance of, and indeed demand for, such a government role by Canadian citizens, typifies historical development in Canada.

These national interests emerge in relation not only to the transportation and economic infrastructures of the nation, as Innis notes, but also in relation to culture. The Massey Commission's findings are in particular a fine example of how persisting historical concerns about nationhood manifest themselves in regard to culture, notably in the inclusion of a chapter on geography which shifts the discourse of the economic domination of space onto the cultural terrain. This is symptomatic of a persistent preoccupation with space and nation; here, however, rather than through the more conventional means of road and rail, it is the binding together of the nation through "ideas." The explicit linking of the material and cultural realms is central to the report:

"Physical links are essential to the unifying process, but true unity belongs to the realm of ideas."[5] There is thus clearly an ideational space to be occupied by government ownership along with geographical space, and the cultural policy and funding apparatus that grew out of the report was devised to do so.

At the core of the thinking which led to the Massey Report, however—and subsequent reports on culture in Canada—lay troubling tensions over the relationship between parochialism and cosmopolitanism, terms that are clear expressions of the spatial concerns that dominate Canadian discourses of development. Concerns were expressed that emphasis on nationalism might lead to an inferior culture: as a part of what Paul Litt has called a "venerable feature of Canadian cultural history," the leaders of the cultural lobby "feared that emphasizing nationalism over cultural excellence would breed an inferior and parochial culture in Canada."[6] Thus, although government was being asked to sponsor the development of Canadian culture, a certain amount of autonomy was required to ensure a balance between the interests of the state and those involved in cultural production. As Jody Berland has written:

> the delicate independence of the "quasi-autonomous non-governmental organization" (which describes most government cultural agencies) in the liberal capitalist state depends on a successful mediation between state policy directive, and the specific aspirations of individuals and groups active in the areas with which such policy is concerned.[7]

The attempt to reduce the risks of parochialism resulted in the adoption of the "arm's length" doctrine as a solution (on the model of the British Council), and this was enshrined in the act creating the Canada Council.[8] This has allowed the government-created body to function autonomously in terms of its dispensation of monies.[9] Soon after the Canada Council was established in 1957, it created a peer review process, since it was felt that artists were the best judges of artistic merit. This process (although not necessarily accompanied by the arm's length principle) has been subsequently adopted by the provincial, regional, and municipal arts agencies that developed in the period subsequent to the creation of a federal arts funding policy and practice.

An examination of the discussion preceding the creation of the Canada Council indicates that the principle of government sponsorship of the arts and sciences was never considered problematic.[10] Canadian culture would not be left to the dictates of the market; the Canada Council was a direct manifestation of the demand for a government policy and role in the formation and stimulation of Canadian culture. In that respect, the development of a policy of cultural sponsorship was a direct analogue to, and product of, the tradition of

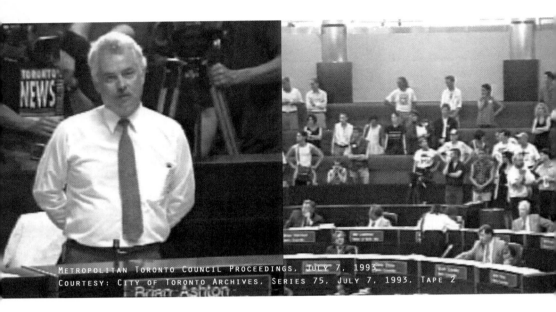

METROPOLITAN TORONTO COUNCIL PROCEEDINGS, JULY 7, 1993.
COURTESY: CITY OF TORONTO ARCHIVES, SERIES 75, JULY 7, 1993, TAPE 2

government capitalization of economic infrastructures that preceded it.

It is this very tradition, however, that is being undermined by the conflation of what is perceived as public antipathy toward art, along with current attempts to control government spending. Governments at all levels have begun to reconsider the quasi-autonomy established in the arts funding domain in an attempt to weaken the arm's length relationship and ostensibly to obtain more control over the adjudication processes. It appears that governments are determined to dismantle the very agencies they created, or, at minimum, to reconfigure the grant approval process. Under the guise of fiscal restraint, governments (as the case presented below demonstrates) are apparently willing to micro-manage the awarding of grants in order to determine how monies allocated for cultural activities are spent. The legacy of government sponsorship of the arts has therefore taken an ominous twist and raised once again the spectre of political control of culture which the original system was devised to prevent. The same demand appears to exist—that is, that government exercise a role in culture—but in a curiously inverted form. What is new is not state intervention into the cultural domain—an accepted practice in Canada—but rather the form it has recently taken: governments attacking their own self-created cultural policies and institutions, backed ostensibly by the demands of an electorate that would see governments either withdraw support for certain activities or withdraw cultural sponsorship altogether.

Laissez-faire Versus Enlightened Despotism

In 1993, the Council of the Municipality of Metropolitan Toronto attempted to reverse the decision of its Cultural Affairs Division and withdraw its approval of grants for two organizations involved in the exhibition of gay and lesbian artworks, the Inside/Out Collective and the Buddies in Bad Times Theatre. This particular case provides an opportunity to observe the determination of certain public and private interests to punish those practising or promoting sexually explicit art and, if the chair of the Metropolitan Council is to be believed, also provides an example of what is in store for these groups in the future. It also points to the difficulties faced by artists and aestheticians when confronted by either citizens or government representatives hostile to certain cultural activities and unwilling to countenance defences from a purely aesthetic perspective, as well as highlighting the relatively ineffectual arguments raised by liberals promoting a laissez-faire position with respect to cultural activities.

The Inside/Out Collective organizes and administrates an annual exhibition of gay and lesbian film and video. Their grant, along with one for the Buddies in Bad Times Theatre, was singled out as an object of debate by the Council from a total of 236 other grants approved by the Cultural Affairs Division of Metropolitan Toronto. In the case of Buddies, the theatre was not attacked directly concerning its own presentations, but rather for exercising bad judgment by allowing the Queer Culture Festival of Toronto to rent their space to hold two seminars on bondage and "female ejaculation." In regard to the Inside/Out Collective, debate focused on the use of sexually explicit language in the catalogue from the previous year's program. It is perhaps important to note that the issues upon which the debate rested did not concern any artworks in particular, but rather their description.

According to customary procedure, at a meeting on June 29, 1993, the Management Committee of Metro Council approved the recommended cultural grants in the report of the Chief Administrative Officer (C.A.O.)—with the exception of the grants for Buddies in Bad Times Theatre and the Inside/Out Collective. The Committee recommended to the Metropolitan Council that the Buddies grant be subject to review and discussion with the cultural grants staff, and that no funding at all be given to Inside/Out. Not surprisingly, the concern of many individuals and groups in the cultural community was that out of the total number of grant applications subject to recommendation, the only two singled out for scrutiny should be from the two groups dealing with explicitly homosexual materials.

The Management Committee members' attention was presumably drawn to these particular grants due to a sustained campaign against Buddies by columnist

1951 - THE MASSEY-LEVESQUE COMMISSION ISSUES ITS REPORT (A.K.A. THE MASSEY REPORT). AMONG ITS MANY RECOMMENDATIONS IS THE ESTABLISHMENT OF AN AGENCY INTENDED TO NURTURE AND DEVELOP THE ARTS AND CULTURE IN CANADA. "THE MASSEY REPORT STANDS AS AN ACT OF DIVINE SUBMISSION: ITS OPPOSITION TO THE VULGAR MATERIALISM OF AMERICAN CONSUMERISM AND ITS PROMOTION OF HIGH ART OVER MASS CULTURE SHAPED THE PARAMETERS OF FUTURE DEBATES OVER NATIONAL CULTURE." THE 1944 FEDERATION OF CANADIAN ARTISTS' RECOMMENDATION OF A COMMUNITY ART CENTRE NETWORK IS NOTABLY ABSENT FROM THE MASSEY REPORT (TUER, 1992: 28–30, 32).

Christina Blizzard of the *Toronto Sun*, and as a result of written submissions from individuals opposed to funding for both groups. After hearing oral depositions from both sides, the Committee moved to recommend that Metro Council adopt the report of the C.A.O. with the exception of these two grants, and the report, along with the recommendation, was then forwarded to Metro Council.

A reading of the depositions provides a foretaste of the acrimonious quality of the debate as it would unfold during the next Council meeting. Submissions to the Management Committee opposing the funding manifested both intolerance toward homosexuality and class resentment simultaneously. As a not atypical deputant wrote:

> I am fed up with my tax dollars being spent on trash like this. I am opposed to all cultural grants, because my husband and I cannot afford a night at the ballet, yet we are expected to subsidize the habits and hobbies of the rich. I live in Scarborough, a place called the Galloway Road area, a.k.a. Scumville. The problems we live with on a daily basis are: prostitution; drugs; guns; muggings; and now because groups like Buddies promote "coming out of the closet," with my tax dollars, we now have to deal with perverts and exhibitionists in Morningside Park."

A number of different forms of resentment have been condensed in these comments. There is an explicit connection made between an elite culture and decadence, and the suggestion that participation in cultural activities is restricted to an elite few. More important—and ominous—however, is the suggestion that the public subsidy for cultural activities is responsible for the deterioration of the public space: the erosion of services as a result of the inappropriate allocation of tax dollars is blamed for the invasion of "perverts" into public space. Also implied is that the levels of taxation required for subsidization of cultural activities have deprived individuals of the resources necessary to participate in those activities (i.e., "my husband and I cannot afford a night at the ballet, yet we are expected to subsidize the habits and hobbies of the rich"). This text makes clear the case for the re-privatization of

cultural activity: if everyone would simply stay in the closet, as it were, public space would be free from the risks of exposure to both crime and decadent behaviour.

The kinds of resentments displayed in this submission more or less typify the attitudes of the various deputants at the Management Committee meeting. The anger displayed in the various interventions was not, however, limited to this type of symbolic violence alone, and came close to becoming actual violence; according to some present in the chamber, death threats were uttered by members of the gallery at gays and lesbians making oral presentations defending the activities of the two groups under scrutiny. The amount of hostility directed against cultural funding for gay and lesbian groups in the written and oral submissions can perhaps be gauged by the potential for actual violence as it appeared on that particular day. Whether homophobia distilled itself into hostility toward cultural funding or vice-versa is difficult to determine.

In the opinion of the *Toronto Star*, "after a barrage of insults from people who denounced gays and lesbians as 'unscrupulous, sodomizing pigs,' the politicians caved in" at the Management Committee meeting and denied funding to Buddies and Inside/Out.[12] This statement set the tone for subsequent debate at the Metro Council meeting on July 7, 1993. The violence, symbolic if not actual, manifested by those opposed to funding was, after the Committee made its recommendation, met in turn by the increasingly strident rhetoric of individuals and groups supporting the activities of Buddies and Inside/Out. Accusing those opposed to the grants of exhibiting narrow-mindedness and parochialism (thus raising the fears expressed originally by the Massey Commission), supporters unleashed a barrage of invective aimed at undermining the credibility of their opponents:

> **The campaign to discontinue funding for this fledgling and very respected film and video festival [Inside/Out] is prejudicial, ill-informed, and unwarranted. The masquerade of "taxpayers up in arms" must be seen for what it is: merely the latest ruse through which reactionary and mean-spirited "normal" people influence and strong arm the decisions of a democratic and diverse society. . . . [C]ouncil has aqcuiesced [sic] and buckled under to the hysterical paranoia of these self-appointed "guardians of our moral fabric."[13]**

Obviously, those supporting the grants agreed with the *Star* that the Management Committee had succumbed to pressure from the interests of a (homophobic) minority. The stage was thus set for a confrontation between the opposing camps at the upcoming Council meeting, in which politicians supporting one or the other position would have to make their case.

1957 - CANADA COUNCIL ACT. THE CANADA COUNCIL INITIATED WITH ENDOWMENT FUND INCOME FROM ATLANTIC CANADIAN ENTREPRENEURS SIR JAMES DUNN AND ISAAC WALTON KILLAM'S ESTATES ($53 MILLION, 50% OF WHICH IS CAPITAL MONIES FOR UNIVERSITIES), SIX YEARS AFTER MASSEY REPORT RECOMMENDATION. THE ACT STATES THAT THE CANADA COUNCIL IS NOT AN AGENCY OF THE FEDERAL GOVERNMENT AND ITS STAFF MEMBERS ARE NOT PART OF THE FEDERAL CIVIL SERVICE (WOODCOCK, 100).

The issues of the debate that occurred at the Metro Council meeting of July 7 can be summed up by examining the first two speakers: Councillor Joe Pantalone, who supported the funding, and Metro Council Chair Alan Tonks, who opposed it. Pantalone, who spoke first, started his speech by suggesting that Council played a progressive role in the city, in effect leading its constituency: "Metropolitan Council has always been at the vanguard—of being a progressive level of government which recognizes that the arts and culture are an essential element of the quality of life."[14] Particularly interesting is the rhetorical identification of the Council as a "vanguard" group with that of an artistic vanguard, implying that Council plays a progressive political role similar to that played by the aesthetic avant-garde. By identifying the Metropolitan Council with the avant-garde, Pantalone cleared the way to make the claim that in opposing these grants "what has been happening here, in terms of certain sections of our community, [is that they] want us to become the censors of groups . . . to cut cultural grants altogether," and that in so doing, he suggested there were certain segments of the community—i.e., those opposed to cultural grants—who desired to return to a Toronto which was "provincial."

The "progressive" group—those in favour of the grants—argued that to oppose the funding of the organizations in question was to risk yet again the possibility of parochialism that had so concerned the original founders of Canadian cultural funding policy. Here, the term often used to describe Toronto—a "world-class" city—was implicitly invoked in relation to a conception of cosmopolitanism against which was counterpoised the potential slippage toward, or return to, provincialism. Furthermore, in Pantalone's chain of reasoning, the possibility of regression was also linked to the problem of censorship. Indeed, the danger that censorship apparently posed was so great as to require that it be placed beyond the power of the Council, in order to diffuse its threatening potential: "Ultimately, Metropolitan Council does not have anywhere . . . in its constitutional mandate [the power] to be the guardians of morality."

It was this very issue—the moral responsibility of the Council—that Alan Tonks took up in opposition to Pantalone's remarks. Expressing indignation at the aforementioned *Star* editorial, Tonks took "umbrage with the fact that it is an editorial writer that would characterize the actions of the Management Committee in those terms," that is, as caving in to homophobic pressure

groups. The remainder of his speech would, as a result, be devoted to a defence of the decision made by the Management Committee. Unlike Pantalone, who argued that questions of moral and aesthetic value are beyond the scope of the Council's mandate, Tonks argued (in regard to Inside/Out) that:

> The concern was generally felt that in taking public funds there has to be some degree of taste, if you will, some degree of value judgement, if you will, some sense of value as it relates to integrity, if you will, of advertising and, in fact, what public funding is used for.

For the Management Committee, this logic led to the "conclusion that that was not the kind of publication that in fact the Committee supported public funds being contributed to."[15]

For Tonks, this was not a question of censorship, but rather a matter of "taste" with regard to the provision of public monies. To a degree, this coincides with the privatization argument put forward in the deputation cited above. Indeed a number of councillors opposed to these specific grants, or to all cultural grants, argued that the withdrawal of public funds did not in fact constitute censorship, since it did not, in their reasoning, inhibit cultural groups from pursuing their interests; as Councillor Scott Cavalier succinctly put it: "We all have basic human rights, but one of those basic human rights that does not exist is the right to public funds."[16]

Tonks went on to distinguish between what he described as "narrow" interests versus "general" interests. The Management Committee, according to Tonks, was attempting to "separate the issues out," that is, to differentiate between "what constituted a general group with universal access that people of all walks of life can go and enjoy," and those "smaller groups that are of a specific self-interest." Unfortunately, Tonks did not indicate why this criterion should be applied only to the two grants under scrutiny, rather than being applied to all grants subject to approval by Council. Even if we leave that aside, the question still remains as to whether the distinction between narrow and general interests holds: that one or another group may not be to a given individual's "taste" does not imply that they are inaccessible.

One of the most ominous claims made by Tonks had to do with what he described as the inevitability of bringing all grants of this type under scrutiny; referring to the Management Committee's actions, he stated that "that is the leading edge of questions that are going to have to be made by this Council as we become more constricted in the level of funding that we can provide." Again, what is unclear is whether he was referring to all organizations receiving grants or specifically to the type represented by the two groups under review.

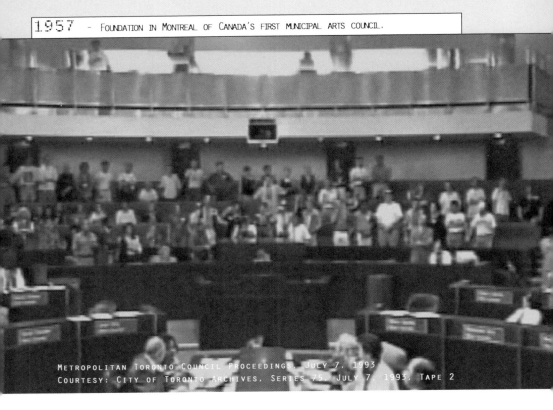

METROPOLITAN TORONTO COUNCIL PROCEEDINGS, JULY 7, 1993
COURTESY: CITY OF TORONTO ARCHIVES, SERIES 75, JULY 7, 1993, TAPE 2

What is abundantly clear is the fact that politicians such as Tonks appear to have no compunction regarding direct intervention into the cultural funding process. When asked whether the funding policies of the Ontario Arts Council, the Toronto Arts Council, and the Ontario Film Development Corporation (since they have all supported Inside/Out and Buddies) were questionable, Tonks suggested that these institutions had yet to "come to grips" with the issues that the Management Committee had already begun to address—i.e., the de-funding of certain cultural activities. In a way, Tonks appropriated Pantalone's notion of the Council as a vanguard body, only to invert the sense in which a future orientation might be understood: Tonks certainly claims an enlightened leadership role for the Metropolitan Council, but one which looked toward the dismantling of the cultural funding apparatus, rather than the more commonly understood notion of progressive vanguardism employed by Pantalone.

Perhaps the only councillor actually willing to come to grips with the political dimensions of these issues was Raymond Cho. In what counts in the context of the debate as an extraordinary statement of virtue, Cho pointed out that:

> you have to make a judgment in . . . terms of how we allocate taxpayers' money—
> that's our responsibility, that's why people elected us. So we have to become prudent
> about which area we spend taxpayers' money. . . . [I] think we have to make a *political*
> decision, whether it is censorship or not, as elected representatives.

Unlike either Alan Tonks, who sought to justify the Management Committee's
decision with a questionable rationale based on a differentiation between nar-
row and general interests and the exercise of judgments of taste on the com-
munity's behalf, or Joe Pantalone, who refused to claim responsibility for any
decision at all, Cho appeared to be willing to invoke the necessity of acting
with prudence as the objective of the exercise of political power. Instead of
inventing rationales to substantiate a position taken *a priori* (that is, either the
moral condemnation underlying Tonks' position, or the liberal laissez-faire
attitude represented by Pantalone), Cho opted to weigh arguments presented
by the public and to make a judgment on the basis of the deputations and a
viewing of the print materials presented as "evidence."[17] This stands in direct
contrast to rationalizations for the employment of power on the one hand,
and the unwillingness to exercise power responsibly on the other, the two
positions which characterized the largest part of the debate.

The most interesting (and bizarre) comments of all, however, were
undoubtedly those uttered by Councillor Brian Ashton near the end of the
four-hour debate. In a fascinating twist on a statement made in the late sixties
by then Justice Minister Pierre Trudeau, Ashton claimed that "We do not
belong in the bedrooms of the nation, but when people start asking for
public money, they have invited us in." Once the invitation has supposedly
been made, Ashton then presumes that a test of community standards is
attached to any public monies being offered: "Once we were invited in, once
we were asked for a grant, certain standards of this Council and of this
community that is providing the money had to be, or should be, applied."

The major—and most questionable—presumption is that in asking for fund-
ing, cultural groups have implicitly invited the state to scrutinize their activi-
ties and to pass judgment on them. Ashton seems to suggest that there is some
sort of unwritten contract between the state and those seeking funds. This is
arguably even more problematic than the conditions briefly imposed on grant
recipients in the United States. Under the National Endowment for the Arts
regulations subsequent to the Helms Amendment of 1989, artists receiving
funds were obliged to sign an undertaking that they would not use the funds
to produce art that was obscene or denigrating to religious and other groups
or individuals.[18] Unlike that agreement, however, Ashton's contract would
come into effect the moment a group or individual applied for funding; the

1957—58 - NEW PROGRESSIVE CONSERVATIVE FEDERAL GOVERNMENT OF JOHN DIEFENBAKER FORMS CANADIAN RADIO-TELEVISION AND TELECOMMUNICATIONS COMMISSION (CRTC) IN ORDER TO REGULATE THE MOVEMENTS OF THE PRIVATE BROADCASTING SECTOR IN CANADA. THE MASSEY REPORT HAD RECOMMENDED THAT CANADIAN BROADCASTING BE PREDOMINANTLY PRODUCED AND OVERSEEN BY THE CANADIAN BROADCASTING CORPORATION (CBC) AS A NECESSARY FORUM FOR THE PRODUCTION AND DISSEMINATION OF DISTINCTLY CANADIAN JOURNALISM, LITERATURE, AND PERFORMING ARTS FREE FROM COMPETITIVE COMMERCIAL ANXIETIES. THE ESTABLISHMENT OF THE CRTC IN EFFECT PLACED THE CBC IN COMPETITION WITH PRIVATE OR COMMERCIAL BROADCASTERS (BERLAND, 21).

act of requesting funds would be sufficient to invoke state scrutiny. Also implied is the idea that there is a coherent set of community "standards" which are assumed to be embodied in the Council itself as a reflection of the community it represents. Under the sign of community, Ashton attempts to arrogate to Council the power to determine how these standards, if they indeed exist, are to be applied.

On the basis of a split motion to consider the two grants separately, the funds requested by the Buddies in Bad Times Theatre were approved, and the grant for the Inside/Out Collective was denied on the basis of a tie vote.[19] This marks the reversal of a cultural policy that has functioned relatively undisturbed at all levels of government in Canada for over thirty years. In part, this was due to the fact that although Metropolitan Toronto had a structure of advisory juries that was identical to those in virtually all other cultural grant agencies in Canada, it did not have a version of the "arm's length" principle—the Cultural Affairs Division was merely a bureaucratic extension of the Metropolitan Council itself.[20] The absence of this crucial status allowed the Council the opportunity to intervene in the fashion that it did. This particular instance of intervention may seem relatively minor (although it certainly was not for the groups concerned), but it indicates the relative fragility of cultural funding policy, and takes on even more significance when seen alongside attacks on the National Gallery of Canada in 1990, 1991, and 1993, the laying of child pornography charges in 1993 against a Toronto artist, and the continual seizure of sexually "explicit" materials by Canada Customs.

Larger Questions

As a result of a concatenation of different factors—the intervention of governments in the name of the public good, the controversial status of recent works, and the failure of aesthetic arguments to legitimate recent art practices—there emerges from these confrontations between competing groups the possibility for the transformation of symbolic violence into real violence:

> The erosion of the boundary between public and private art is accompanied by a
> collapsing of the distinction between symbolic and actual violence, whether the
> "official" violence of police, juridical, or legislative power, or "unofficial" violence
> in the responses of private individuals. . . .[21]

It is at this point that we observe a breakdown in the communicative structures
that mediate between the spheres of both public and private and aesthetic and
political. Indeed, reasonable debate is only possible when consensus is maintained
over the structures and contents of aesthetic practices. Once there is a divergence
of opinion with regard to what constitutes appropriate art, however, the
potential for violence arises.

Although there have been continual attempts to denigrate modernist aesthetic
production of various kinds, a degree of consensus surrounding that production,
in addition to a relative lack of utility inherent in modernist works, appears to
have provided a buffer against attempts to dismantle its institutional foundations
until quite recently.[22] The absence of explicit signification characteristic of
abstract works in particular could lead either to dismissal on the basis of an
apparent absence of meaning, or such works could be conveniently imbued
with meaning as the situation called for.[23]

Although modernist artworks have certainly not been immune to controversy,
more recent work, engaged with direct political or sexual contents, has
gained a controversial status considerably greater than that of its post-war
modernist predecessors:

> If modernist public art aroused controversy over its abstract, non-referential nature,
> recent public art has tended to arouse reactions by means of specific political references
> and direct affronts to standards of decency and taste. These controversies have clear
> ideological implications involving national and racial pride, and homophobia.[24]

It is these "direct affronts" which have precipitated recent government
interventions. The ideological implications are, unfortunately, difficult to
discern. Crucial here is not so much what might be ideological, however, but
what counts as aesthetic. To hide behind "art" as a defence is simply not adequate
any longer as a rhetorical move:

> The recent response[s] . . . indicate the presence of an American [and Canadian]
> public, or at least of some well-entrenched political interests, that is fed up with
> tolerating symbolic violence against religious and sexual taboos under the covers
> of "art," "privacy," and "free speech," and is determined to fight back with the very
> real power of financial sanctions.[25]

1961 - FORMATION OF QUÉBEC DEPARTMENT OF CULTURAL AFFAIRS. THIS AGENCY, IN ADDITION TO BEING RESPONSIBLE FOR THE ARTS, WAS ALSO IN CHARGE OF MUSEUMS, CENTRAL LIBRARIES, AND THE PRESERVATION OF THE PROVINCE'S HERITAGE BUILDINGS.

The inability to substantiate claims for certain types of expression from an aesthetic perspective is the product of the failure of aesthetic approaches to either address or explicate the social functions of art. Given this, the strategies adopted by those supporting the grants are doomed, since they rely on an appeal to art as the *sine qua non* that legitimates the practices under scrutiny, without regard for the social conditions that allow for the emergence and sanction of such practices. As Rosalyn Deutsche points out, "even when they [aesthetic approaches] comprehend some of the problems of the public sphere or entail sophisticated materialist critiques of aesthetic perception, they are generally formulated with an inadequate knowledge of urban politics."[26] What this suggests is that the encounters between artists and politicians are further problematized by an aesthetics that is unable to thematize the relation between the social subsystem of art and the rest of the lifeworld. Indeed, as Deutsche goes on to state, current aesthetics work potentially to obscure the social relations that lie under the surface of, and provide the context for, the production of artworks:

> . . . traditional art-historical paradigms cannot explicate the social functions of public art—past or present—since they remain committed to idealist assumptions that work to obscure those functions. Maintaining that art is defined by an independent aesthetic essence, prevailing doctrines hold that, while art inevitably "reflects" social reality, its purpose is, by definition, the transcendence of spatiotemporal contingencies in the universal, timeless work of art.[27]

In other words, art practice is still defended in terms of its autonomy from the rest of the social sphere. We must remind ourselves, however, that the price of that autonomy has been an absolute lack of utility for art—its "abstract, non-referential nature," as Barbara Hoffman put it—which was its guarantee of freedom. That freedom was bought at the cost of having no effect whatsoever on the lifeworld from which art had retreated in modernism. However, as Deutsche tries to explain, and as the case described here demonstrates, there is clearly a disjunction between the discursive apparatus within which artistic production occurs and that of politics. Furthermore, I would add that this disjunction holds also between newer practices and art-historical and theoretical paradigms. Thus, when artists and art institutions are confronted with opposition to their practices from the political sphere, they are woefully unprepared to defend themselves, and in the end, out of frustration, resort to the same tactics as those used to attack them.

In this context, the state has a particularly onerous burden. It is asked to arbitrate between values represented by different constituencies that it is in turn presumed to represent. Thus, "government sponsorship or ownership of art in the public context must reconcile, through state institutions and law, this tension between art's subjectivity with its potential for controversy, and the government's need to promote the public good."[28] In order to avoid such conflicts in the past, a system was devised that was thought to be value-free; by leaving the decision-making process in the hands of "experts," the state could encourage the growth of cultural activity without the risk of being seen to control its direction. Under the regime of fiscal restraint and deficit reduction, the state has discovered the means through which to introduce selective cuts, touched off by a complex intersection of moral panic and economic conservatism. Either on its own initiative, or at the behest of individuals or interest groups, the state has seen fit to intervene in the mechanisms of cultural funding. By doing so, however, the state appears to be upsetting the balance by imposing its "will" upon culture through policy directives. It also places both itself and cultural activity in jeopardy:

> If the state seeks to impose its own apparatus too strongly on the constellation of forces active within cultural life, it will deny both the forces of culture and its own apparatus the legitimacy necessary to conduct their respective tasks.[29]

This legitimacy is placed at risk at both ends of the spectrum: either through the erosion of credibility through intervention, or, conversely, in the absence of intervention.

Controversy over these initiatives arises in part due to the state being seen by civil libertarians to enter into areas in which it has no business. The notion of decency in particular has been, strictly speaking, determined by definitions produced in the judicial sphere, and has not properly been the subject of the legislative branch. For politicians to attempt to make judgments of taste is, to borrow a legal phrase from the United States, to impose a form of "prior restraint," according to views that hold freedom of speech and expression as paramount rights. The norm has been to test the standards of decency on the basis of forensic arguments in the courts. It is precisely this norm which is currently undergoing revision.[30]

Changes in aesthetic practices, as well as contestation over social values and forms of governance, have precipitated the demand to restructure norms, from both artists and non-artists. It is within this context that conventional arguments defending aesthetic practices have failed. In addition to the failure of art historical discourses to address the socio-structural underpinnings for

1962 - Opening of co-operative Region Gallery in London, Ontario, in tandem with the 1961 founding of *Region* magazine by Greg Curnoe. This gallery, which continued until 1966, was a forerunner of the subsequent 20.20 Gallery in London, one of Canada's prototype artist-run centres.

the production of art, conventional cultural distinctions, such as that between provincialism and cosmopolitanism, have also failed to have any effect. Like their art historical counterparts, such distinctions are based on the notion of a universal consensus which is no longer intact; the specificity of recent art, particularly in relation to identity, prevents struggles being waged in those terms. Art no longer functions (if it ever did) in the redemptive terms of the neo-Platonic mode implicit in modernist paradigms rightfully criticized by Deutsche.

It is not sufficient to assume that some sort of communicative rationality will prevail; the discursive disjunction between the spheres of aesthetics and of social value has so far prevented any communication at all. Indeed, the case described here underscores the dysfunctional character of the debate and the communicative distortions that emerge from it. Symptomatic is the actual effectivity of the works of art: unlike their modernist predecessors, "bereft of meaning," as Albrecht Wellmer has put it, these works suffer, if you will, from an excess of meaning. Mere description of some works was enough to send a tremor through the apparatus. This is probably good, since it speaks to the effectiveness that art can, and does, possess, but it is also accompanied by a host of difficulties—products of the persistent difficulty in effecting a transformation of aesthetics into politics.

That the state has failed overall in restructuring its participation in the arts does not necessarily mean that the current strategies used to defend cultural subsidy can be considered effective. The case described here indicates both the failure of these strategies and the potential determination of the state to continue to whittle away at the funding structure. In Canada, the absence of private interests has compelled the state in the past to intervene in the interests of the nation; indeed, the emergence of Canadian culture is predicated on state structures organized to support the development and maintenance of culture. The erosion of the cultural funding and policy apparatus—which is symptomatic of the potential devolution of state participation in all areas of Canadian life—would precipitate a fundamental and profoundly alien reorganization of the relations between the Canadian state and its citizens.[31] If, as Innis suggests, Canada is a product of state-created infrastructures, the withering away of those infrastructures in the cultural sphere would on that basis imply the withering away of Canadian culture as well.

It also implies that the deep entwinement of politics and culture in Canada requires an equally politicized aesthetics, in which the loss of autonomy of the aesthetic realm is the price that must be paid for the creation of a discourse of

art and culture that, rather than committed to a set of weak idealist presumptions, is responsive to the exigencies of political and social situations. It is at that point that a possible reconciliation might be glimpsed, where the impure discourse of politics might be met with an equally impure aesthetic disposition. If the art is "dirty," so too must its accompanying aesthetic discourse be dirty in order to accomplish in the political realm what it presumes to effect through aesthetic reflection upon these works of art.

NOTES

1 Michael Dorland, "The Discursive Economy of the Emergence of the Canadian Feature Film: Discourses of Dependency and the Governmentalization of a Displaced National Cinema, 1957–1968," unpublished doctoral thesis, Concordia University, 1991, 35.

2 Ibid.

3 Ramsey Cook, "Cultural Nationalism in Canada: An Historical Perspective," 1977. Quoted in Dorland, 35.

4 See, for example, Harold Innis, "Government Ownership in Canada," in *Problems of Staple Production in Canada* (Toronto: Ryerson Press, 1933), 31–2. On the absence of private capital, see "Transportation as a Factor in Canadian Economic History," in *Offprint from the Papers and Proceedings of the Canadian Political Science Association* (n.p., n.d.), 173.

5 *Report of the Royal Commission on National Development in the Arts, Letters, and Sciences, 1949–1951* (Ottawa: Edmond Cloutier, Printer to the King's Most Excellent Majesty, 1951), 4–5.

6 Paul Litt, *The Muses, the Masses, and the Massey Commission* (Toronto: University of Toronto, 1992), 110.

7 Jody Berland, "Canadian Culture and the Discourse of Cultural Policy, 1951/1981," Working Paper, Centre for Research in Culture and Society (Ottawa: Carleton University, 1986), 8.

8 The Canada Council Act states in section 10 that "The Council may make by-laws regulating its proceedings and generally for the conduct and management of its activities," and in section 13 that "The Council is not an agent of Her Majesty . . ." For a discussion of the special status of the Council, see Frank Milligan, "The Canada Council as a Public Body," in Canadian Public Administration, 22 (Summer 1979), 270.

9 As Milligan points out, this autonomy began to erode in the late seventies with the introduction of "thrust funds" in which "the method of applying the new money was to be proposed by the Council, but the objectives were defined by the government" (277). The Secretary of State also began at this time to exert more control over which Council projects would be recommended for Treasury Board approval.

10 See Litt, op. cit., on the debates leading to the Massey Commission.

11 Mrs. Debbie Wall, written submission to the meeting of the Management Committee of the Council of the Municipality of Metropolitan Toronto, June 29, 1993. Morningside

1963 – ESTABLISHMENT OF PROVINCE OF ONTARIO ARTS COUNCIL. IN 1973 THIS BECAME THE ONTARIO ARTS COUNCIL, STILL AN ARM'S LENGTH AGENCY ACCOUNTABLE TO THE PROVINCIAL MINISTRY OF CULTURE AND RECREATION.

Park had developed a reputation as a meeting site for male homosexuals, and had been subject to police sweeps and arrests during the course of the preceding months.

12 "Restore Funding," *Toronto Star*, July 6, 1993, n.p.

13 *Public Access Collective*, letter to the Municipality of Metropolitan Toronto Clerk's Office, June 30, 1993. This was one of over ninety letters and petitions submitted to the council opposing the Management Committee decision.

14 Joe Pantalone, oral presentation, the Council of the Municipality of Metropolitan Toronto meeting, July 7, 1993. (Metro Council does not keep detailed minutes; comments cited here were obtained from videotapes of the Council meeting, and have been edited for grammar.)

15 The "publication" Tonks is referring to is the catalogue for the 1993 Inside/Out Film and Video Festival, which was the focus of much of the debate.

16 Of course, this only applies globally; denying funding to two grants out of the aggregate created the perception of a punitive measure aimed at a specific type of cultural practice.

17 Interestingly, Cho, reasoning negatively, found no compelling reasons to deny funding to either group, and therefore supported the decisions made by Cultural Affairs.

18 See "Debate in Senate over Helms amendment," in *Culture Wars: Documents from the Recent Controversies in the Arts*, Richard Bolton, ed. (New York: New Press, 1992), 73–4. In the end, the specific grant restrictions were rejected on the basis of recommendations made by an independent legal commission appointed by congress to review the NEA's grant procedures. See "The Independent Commission," in op. cit., 261–265.

19 Under Council rules, a vote ending in a tie results in the defeat of the motion.

20 Similar meddling by the aldermen of the City of Toronto led the Toronto Arts Council and its supporters to demand an arm's length status, which was finally granted in early 1994.

21 W.T.J. Mitchell, "The Violence of Public Art: *Do the Right Thing*," in *Art and the Public Sphere*, W.T.J. Mitchell, ed. (Chicago: University of Chicago Press, 1990), 32.

22 As Jody Berland has astutely pointed out, the relative stability accorded to modernist production may in part be the product of the stability and legitimacy prevailing in the political and governmental realm. Thus the attacks on recent works can also be read symptomatically as attacks on government itself, and as part of an erosion of political legitimacy. As Berland suggests, there may be a mutual dependence between these forms of legitimacy, i.e., political and aesthetic.

23 For further discussion of these points see my "In Defence of the Realm: Public Controversy and the Apologetics of Art," in *Theory Rules: Art as Theory/Theory and Art*, Jody Berland, et al, eds. (Toronto: YYZ Books and University of Toronto Press, 1996).

24 Barbara Hoffman, "Law for Art's Sake in the Public Realm," in *Art and the Public Sphere*, 119.

25 Ibid.

26 Rosalyn Deutsche, "Public Art and its Uses," in *Critical Issues in Public Art: Content, Context, and Controversy*, Harriet Senie and Sally Webster, eds. (New York: HarperCollins Publishers, 1992), 158.

27 Ibid.

28 Hoffman, 113.

29 Berland, 9.

30 An interesting case was the recent seizure of paintings by Eli Langer under the new child pornography statutes. The Crown had offered to drop charges against Langer, and the director of the gallery where the painting were shown, in exchange for the destruction of the paintings.

31 See Greg Albo and Jane Jenson, "Remapping Canada: The State in the Era of Globalization," in *Understanding Canada: Building on the New Canadian Political Economy*, Wallace Clement, ed. (Montreal: McGill-Queen's, 1997), 215–39.

1963 — 64 - Reorganization of Secretary of State to include cultural industries such as the Canada Council.

Collage by Jan Allen

ART BANK: Is Investment More Than A Word?

LES CRITIQUES SUR LA BANQUE D'OEUVRES D'ART

Residents sign up for sculpture war

An erotic error that titillates

THE POLITICS OF THE ART BANK CUT.

These foreigners ought to thank us for helping them suffer for their art

Undaunted by petitions

LA BANQUE D'OEUVRES D'ART DEVRAIT-ELLE S'ADRESSER DIRECTEMENT OU ARTISTES OU AUX MARCHANDS DE TABLEAUX?

Who's who in judging art grants

The Canada Council shuts the door to foreigners

Borowski agents will scrutinize art bank show

CAN ART BANK BE SELF-SUPPORTING? ROBERTS CLAIMS IT MUST.

THE BUY-BACK POLICY PROS AND CONS.

ART BANK: A HIT OR A MYTH?

Workable Art Bank is breeding imitators

> JAN ALLEN

The Realpolitik of the Canada Council Art Bank

The Canada Council Art Bank was formed in 1972 amid the heady idealism of Secretary of State Gérard Pelletier's policy advocating the "democracy and decentralization" of culture.[1] In an imaginative and opportunistic response to abundant tax dollars and a burgeoning federal bureaucracy, Visual Arts Officer Suzanne Rivard-Lemoyne proposed the creation of a reservoir of art to be leased to government offices. By 1995, almost 18,000 works had been collected, and 60% of these were placed in federal government offices throughout Canada.

Although the successes and supporters of the Art Bank are legion, a persistent trickle of criticism has emanated from both within and outside the art community. This essay takes the Art Bank as a case study of the administrative mechanisms and political dynamics of federal funding programs for visual art in Canada, focusing on a series of controversies that erupted through the first decade of its operation. The institution showed resilience in deflecting, managing—and even changing in response to—complaints from virulent nationalists, anti-smut crusaders, dirt-digging journalists, disaffected artists, indignant regional advocates, resistant audiences, outspoken dealers, and, in 1979, a point-blank parliamentary breech of arm's length principles. These challenges expose tensions within the Bank's mandate while throwing into relief changes in the visual arts and the political climate for arts funding through the period.

In 1972, Rivard-Lemoyne described the Art Bank's goals:

> ... to supplement the income of artists whose works are purchased and to bring large numbers of Canadians in direct contact with contemporary Canadian art. It is also intended to provide stimulus to the commercial galleries which have long made an important contribution to Canadian art.[2]

1963 — 64 - REDEFINITION OF FEDERAL SECRETARY OF STATE DEPARTMENT TO INCLUDE JURISDICTION OVER CULTURAL AGENCIES, INCLUDING THE CANADA COUNCIL, THE CANADIAN BROADCASTING CORPORATION, THE NATIONAL FILM BOARD, THE BOARD OF BROADCAST GOVERNORS (LATER THE CANADIAN RADIO-TELEVISION COMMISSION), THE NATIONAL GALLERY, THE NATIONAL MUSEUM, THE PUBLIC ARCHIVES, AND THE CENTENNIAL COMMISSION.

The Liberal government of the day was immediately receptive to her proposal and allocated generous funds to get the Art Bank started. Al Johnson, Secretary of Treasury Board and an enthusiastic collector of Canadian art, was optimistic that, properly started, the Art Bank would become self-sustaining through lease revenues.[3]

The Bank enjoyed a honeymoon period relatively free of criticism under its first director Luke Rombout from 1972 to 1975, an era when new money was flowing to a small pool of visual artists and the venture was permeated by an infectious aura of confidence. After 1975, the mood changed as artists emerging from new education programs and the artist-run centres demanded access to resources that were shrinking rapidly in real-dollar terms. And, despite continuing prosperity in the country, political support for federal arts programs evaporated as the Trudeau Liberals came under a barrage of criticism for lavish spending at the end of the decade. Controversies that arose under the directorship of Chris Youngs (1976–1980) and in the early years of William Kirby's tenure (1981–1995), reflect a struggle for access to and control of resources in the Canadian polity while pointing to internal contradictions within the Art Bank's role and administrative devices.

Public Perceptions

Although the legitimacy of stated goals is seldom questioned, government subsidy of art is subject to recurring challenges in Canada. A 1975 statement by Malcolm Rowan, then deputy minister of Culture and Recreation in Ontario, offers a typical expression of this point of view: "The marketplace is the best and most objective technique yet devised to priorize values. [It is] the key test of artistic worth." Likewise, art critic and publisher Guy Robert considered the government granting system artificial, and dismissed the art thus supported as official art that was not "purified" by the marketplace.[4]

Another sort of purity was invoked by the Canada Council, which argued that excellence is perpetually "ahead" of the commercial art market:

> **Excellence does not guarantee commercial success since the best artists are usually (but not always) well ahead of popular tastes. It would be slow cultural strangulation for this country to encourage only artists who achieve instant commercial success.[5]**

This argument presumes that the best art is unencumbered by commercial necessity and further implies that, in the absence of enlightened—i.e., state—support, Canadian culture would die. This position, much stated and debated over the intervening years, identifies Canadian culture with federally supported culture. Doubtless there would be some sort of culture in the country if Canada's arts support system were dismantled. But the project of nurturing a distinct national culture, begun in the 1950s following the Massey Commission, remains reliant on government financial and regulatory support: federally supported culture *would* disappear without federal support. To date, the best mechanisms at hand (modelled after the British Council) for achieving an "independent" national culture are arm's length, government-funded agencies and the peer adjudication system.

Public suspicion of the moral worth and intrinsic value of art, what writer Réshard Gool calls "the dead hand of puritanism," has been identified by many as a regrettably ingrained facet of Canadian cultural heritage.[6] Even within the consultative fold of the Canada Council, concern is occasionally expressed regarding potential grant dependency of artists. It is unclear whether this reluctance to fully support artists is based on fear of undermining the individualism thought to be central to art making or if it is prompted by an instinct for self-preservation sensitive to political necessity. Chris Youngs (the Art Bank's second director) blamed the 1978 Art Bank funding cut, when the Liberal government of the day deleted funding for Art Bank acquisitions from the Council's 1979–80 budget, on politicians' perceptions—derived from the "cocktail party circuit"—that the public considered the Art Bank a frivolous expenditure.[7]

Another, more inflammatory, issue was public suspicion regarding the value of the art accumulating in the Art Bank. A 1982 article published in the *Vancouver Sun* quoted unnamed experts to the effect that the collection has "little or no value outside Canada."[8] The assumption that Art Bank acquisitions are an investment that should be recuperable is a test not brought to bear on other programs deemed to be socially worthy. The second dubious assumption underlying such criticism is that the extra-national market is a more valid register of values for a national collection than the Canadian market. Where art education is limited and cultural activities generally undervalued, anxiety about the value of art is readily cultivated when those qualified to assess the system of arts support are seen to be a part of that system.

Tied to this concern was the notion that government funding of culture, and of the Art Bank in particular, was in the hands of a self-serving elite. From the beginning, jury members were described as "a small hierarchy." The media played on—or ignited—public fears of a conspiracy of artists and bureaucratic experts indifferent to the public good. Sol Littman's accusations in the

1965 — FORMATION OF MANITOBA ARTS COUNCIL, WHICH HAS MODEST PROGRAMS FOR ASSISTING INDIVIDUAL ARTISTS.

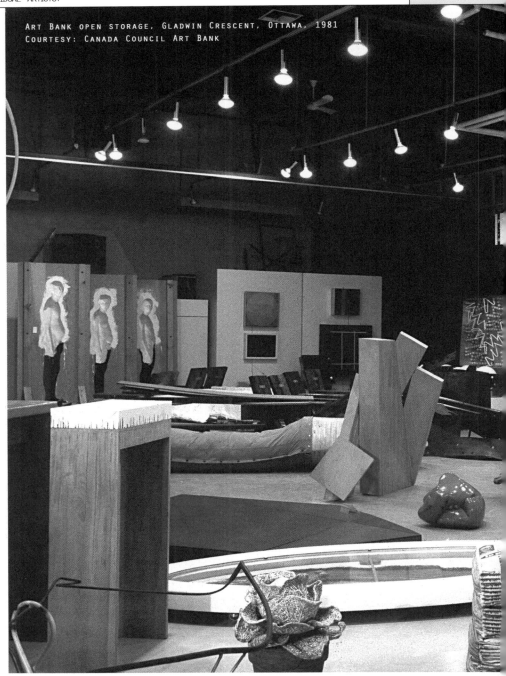

ART BANK OPEN STORAGE, GLADWIN CRESCENT, OTTAWA, 1981
COURTESY: CANADA COUNCIL ART BANK

1965 – LIBERAL PRIME MINISTER LESTER PEARSON ESTABLISHES THE HOUSE STANDING COMMITTEE ON BROADCASTING, FILM AND ASSISTANCE TO THE ARTS. THIS COMMITTEE IS CURRENTLY KNOWN AS THE STANDING COMMITTEE ON CULTURE AND COMMUNICATIONS.

Toronto media that the Art Bank was infected by a "cronyism" in which large purchases were made among a small circle of artists who recommended one another's work were particularly damaging to Art Bank credibility. Littman described Canadian art as "the product of an ingrown, mutually supportive group of people who serve repeatedly on all-important Canada Council grant committees and Art Bank juries."[9] The perceived concentration of purchases was questioned and treated as a matter of resource distribution without reference to the virtues of the art or artists under discussion.

In an attempt to clear the air, the Canada Council commissioned Dr. Davidson Dunton to report on the Art Bank in 1979. This bland report confirmed that the Art Bank was fulfilling its mandate, and suggested changes to more clearly delineate the costs of various programs. Dunton also urged expanded promotion in the form of rental exhibitions to increase the collection's exposure to the public and potential clients.[10] This response was typical in that controversy was treated as a problem of information control and the need for a positive public profile.

Two specific incidents of focussed outrage arose in June 1980.[11] When *Of Intimate Silence*, Ottawa photographer Richard Nigro's series of thirty cibachrome photographs of a couple in a variety of embraces, was presented in an Art Bank rental exhibition in Winnipeg, it attracted the attention of the morality squad. Local authorities took no action, so Joe Borowski, a self-described anti-abortion and anti-smut crusader, filed obscenity charges against exhibition organizer Thérèse Dion. Borowski declared, "Public money shouldn't be wasted buying this kind of peekaboo trash." The case was dismissed due to inaccurate terminology for oral sex in the charge, and rising legal costs dissuaded Borowski from pursuing it further. The sniggering tenor of press reports on this issue suggest little sympathy with Borowski's concerns.[12] But the suitability of *Of Intimate Silence* to the workplace remains a question. It is hard to imagine it at Statistics Canada or the Defence Department, though it hangs today in the offices of the Canada Council.[13]

In another incident, residents of Rockcliffe Park, Ottawa's bastion of the political elite, objected to a proposed sculpture park when eleven pieces from the Art Bank collection were installed on the Rockcliffe Parkway. Protestors complained of a lack of consultation and declared that the abstract works "disrupt the natural beauty of the site." When petitions for the removal of the works were not effective, the "Committee for the Removal of Artistic Pollution" (CRAP) took action under the cover of

night. Robert Murray's *Sitka* was thrown into the Ottawa River, another work was inverted and a third was covered with toilet paper. In the face of sustained opposition, the sculpture park was abandoned and more receptive venues for the works were found in public art galleries in Saskatoon, Regina, and Edmonton.[14]

Rental clients' responses to art installed in the workplace were not always enthusiastic. In the summer of 1979, Statistics Canada employees objected to the installation of an abstract mural by Walter Redinger, which was variously described as a gigantic planet, genitals, and a bowl of pudding. Despite the efforts of Art Bank officers to educate the workers, they were not persuaded and the Redinger piece was replaced by a Claude Tousignant mural.[15]

This incident demonstrated that some workers wanted a sense of control over their environment, and the power to affirm selected works. Initially, as part of the Malraux-inspired program of "decentralization and democratization," the Art Bank intended to offer lunch-hour lectures and workshops about contemporary art to workers, but funding for this aspect of the Art Bank never materialized. There remained an on-going "taste gap" between the public and art purchased through the Art Bank program.[16]

In addition to public resistance to the aesthetic of works, there was the question of the suitability of purchased works to the working environment in public and semi-public office spaces. As early as the Canada Council's 1973–74 annual report, Geoffrey James, Visual Arts Officer from 1975 to 1982, questioned whether an "uncompromising" collection of Canadian art would be rentable. The numerous prints, drawings, and photography in the collection are by and large well-suited to the enhancement of offices, but works in multiple parts and unconventional materials became increasingly the norm through the 1970s. By 1980, video and large-scale installations with light and sound components were being purchased by the Art Bank.[17] These works have been used for international exhibitions and, according to William Kirby, large installations have been useful for the interest they generate among clients at the Art Bank offices. Performance and conceptual art have not been acquired.[18] Large-scale and very small sculpture have been difficult to rent despite low fees and the institution of a sculpture "bonus" program.[19] The extent to which contemporary art is appropriate for the animation of government offices remains a central dilemma of the Art Bank's mixed mandate as an agency of both support and dissemination. It is also, of course, the area in which it can make an enormous contribution as an effective and sanctioned interface between producers and audience.

```
1966  -  FOUNDING OF INTERMEDIA IN VANCOUVER, FORMED BY A THINK-TANK OF INTERDISCIPLINARY
ARTISTS. A LETTER FROM THE COLLECTIVE REQUESTING FUNDING FOR A GALLERY SPACE AND EQUIPMENT WAS
SENT TO PETER DWYER OF THE CANADA COUNCIL, AND $40,000 WAS RECEIVED IN KIND. INTERMEDIA WAS
ARGUABLY THE FIRST TRULY INTERDISCIPLINARY ARTIST-RUN CENTRE (OR ARC) IN CANADA.
```

Concerns and Controversies in the Arts Community

The Art Bank was intended to support commercial art galleries and although the rhetoric has waxed and waned in this regard, the institution has steadily purchased art through them. The proportion of works acquired through galleries varied from 85% in the initial years to approximately 50% by 1992.[20] Art Bank purchase files reveal that in the early years a series of disputes erupted between artists and dealers, and the Art Bank was at times caught in the cross-fire. The newly enlivened institutional market put pressure on artist-dealer relationships as the stakes rose, emphasizing the need for clear contracts. The reliance of commercial galleries on government purchases was expressed by dealer Mira Godard: "There is the official market—the government—and that's it. There's no private market." Indeed, Robert Fulford estimated that Art Bank purchases represented one quarter of the entire market for contemporary art in Canada in 1975.[21]

Although art dealers welcomed the government as a customer, they jealously guarded the corporate market from government competition. When Chris Youngs proposed to rent Art Bank works to private corporations, professional art dealers objected and the idea was dropped.[22] The 1979 Dunton report recommended that rental be extended to public institutions, such as hospitals and schools, but not to the private sector.

In the late 1970s, charges of favouritism in Art Bank juries gained momentum when *Toronto Star* journalist Sol Littman claimed that the arts support system in Canada was in the hands of a narrow clique.[23] A similar scandal arose in Québec when two well-known artists serving on alternate juries made heavy purchases of one another's work, resulting in public protest in Montreal.[24] Printmaker Jo Manning criticized the practices of the Canada Council Visual Arts section, after discerning a "grant-funded clique" in a study of repeat grant recipients.[25] These analyses of Art Bank purchases heated suspicions to the flash point. Examination of Art Bank purchase patterns suggests that perceptions of close identification between jurors and heavily purchased artists were founded on substance, particularly in 1977–78.[26]

A new generation of artists was lobbying for institutional recognition and access to the arts support system, while downplaying the practical realities of the Art Bank as a vehicle of dissemination to government offices. A 1979 article by Clive Robertson charged that Art Bank juries represented a narrow aesthetic, one that ignored art emerging from artist-run centres. Robertson pointed out that certain genres were excluded from Art Bank purchase; he

wrote, "These 'others,' photographers, video artists, performance artists, etc., have not been well-served by Art Bank or for that matter have not been served at all."[27] The article ends with a list of forty-two "major" artists whose work had not been purchased by the Art Bank.

Such implicit resistance to the practical requirements of the intended rental destination as a criteria for acquisition followed the rhetorical lead of Art Bank directors, who objected to suggestions that the Bank was in the business of interior decoration.[28] As an agency of the Canada Council, the Art Bank acknowledged excellence or artistic merit as the sole criterion for acquisitions, an approach that suppressed the specificity of its function.

Administrative tools were used to forestall charges of excess or unfairly concentrated support. An annual maximum purchase limit per artist was set at the equivalent of the largest visual arts grant available at the time. However, these ceilings were regularly surpassed: Art Bank purchase file documents confirm that, if a work was priced over the ceiling, the balance would be paid in the subsequent year.[29] In response to criticism of the jury pool, William Kirby set a goal of 50% new jurors each year, that is, 50% of jurors would have no previous experience serving on Art Bank juries. This more lively rotation of participation, combined with a policy shift away from a strategy known as "depth of purchase," produced much more diffuse purchase patterns such that a broader range of practices entered the collection after 1981.[30] Sustained and substantial support of specific individual artists, seen as a virtue in the early years of the Art Bank, was no longer tenable. This, combined with the shifting aesthetic framework of the period, meant that few artists whose work was purchased steadily through the 1970s sold work to the Art Bank after 1980.

The introduction of more consistent and equitable administrative practices after 1981 by William Kirby, which addressed some of the systemic favouritism in the Art Bank acquisition process, prompted complaints from artists who lost the privilege of an automatic jury visit. One such artist felt that the requirement for slide submissions would change adjudication from a professional process to "aesthetics and ideological judgements, subjected to the whims of passing fads."[31]

The Art Bank files reveal that many artists were unhappy with the haste of the jury process, feeling that inadequate consideration was given to their work. Under Chris Youngs, the juries followed a demanding schedule of up to eight studio visits in one day.[32] Such a pace forced purchase decisions to be made on the basis of immediate response rather than the deliberation more customary in public institutions.

The perils of speedy adjudication were compounded if there was little conceptual common ground between the artist and jurors, a possibility that

1967 – ESTABLISHMENT OF CHALLENGE FOR CHANGE AT THE NATIONAL FILM BOARD (NFB). "INITIATED WITH SUBSIDIES FROM SEVEN GOVERNMENT DEPARTMENTS, THE PROGRAMME GAINED ALMOST INSTANT INTERNATIONAL RECOGNITION"; IT "REINFORCED THE IMAGE OF CANADA AS AN ADVANCED DEMOCRATIC NATION" (MARCHESSAULT, "AMATEUR VIDEO AND THE CHALLENGE FOR CHANGE," 13.)

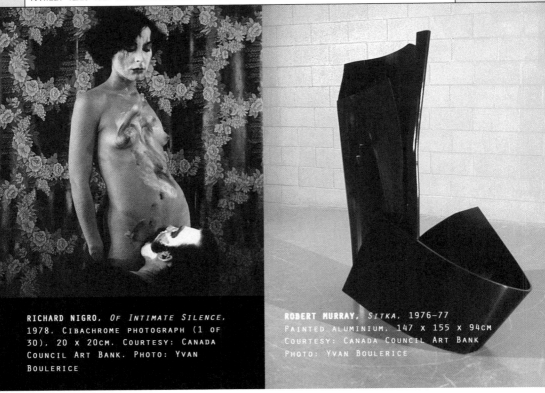

RICHARD NIGRO, *OF INTIMATE SILENCE*, 1978. CIBACHROME PHOTOGRAPH (1 OF 30), 20 x 20CM. COURTESY: CANADA COUNCIL ART BANK. PHOTO: YVAN BOULERICE

ROBERT MURRAY, *SITKA*, 1976–77 PAINTED ALUMINIUM, 147 x 155 x 94CM COURTESY: CANADA COUNCIL ART BANK PHOTO: YVAN BOULERICE

increased over time. David Silcox, who served as an Art Bank juror in 1972–73, believed himself to be familiar with the work and intentions of all the artists in Canada.[33] This confidence was warranted when the Art Bank was purchasing a great deal of work from firmly established artists. It would have been difficult to sustain through the 1970s. In 1979, Canada Council chair Mavor Moore described the situation thus:

> [I]n the visual arts we are living in a period of great aesthetic uncertainty; there
> are few current orthodoxies and the sheer multiplicity of artistic production poses
> a difficult, if exhilarating, problem for any public support system. . . .[34]

Some artists complained that jurors were unable to comprehend or adequately assess their work. Toronto-based artist Vera Frenkel wrote to the Art Bank following a jury visit in 1979:

> Certain difficulties existed, partly due to circumstances, partly to the scale and nature of my work, and partly due to the interests of the jury. I'm left with the feeling that the kind of work I value and do is for all three men generally outside their major interests. I have no doubt that they will be as fair as they can be, ... but I have to say that for me it was an unusually strained experience, with no indication of any shared frame of reference. I had the impression that it was hard for them too.[35]

As the visual arts milieu matured and became more complex in Canada, new pressures to respond to changing conditions developed within the arts support system.

Nationalism was a hot issue for the Canada Council and the Art Bank in the late 1970s. In 1979, artist Bill Lobchuk wrote a stridently nationalistic letter in CARFAC *News* calling for the restriction of government cultural support programs to Canadian citizens, and accusing the Canada Council Visual Arts head of "cultural colonialism."[36] This was part of a broader movement of cultural nationalism that often took the form of anti-Americanism. Anxiety was expressed in a 1978 report, *The Future of the Canada Council*, which pointed out the vulnerability of Canadian cultural identity to the "AMERICAN GIANT."[37] Artists Jo Manning and Greg Curnoe objected to U.S. domination of the arts publications that shaped taste in Canada. Manning said that these "glossy" art magazines undermined support for "an art that reflects our unique Canadian experience," and Curnoe pointed out that U.S.-trained teachers dominated Canadian art schools.[38] Although Curnoe identified Ontario as the site of Canadian nationalism, concerns were expressed across the country.[39] Jo Manning articulated specific concern over displacement of Canadian values and conventions, accusing the Canada Council of bias against the "grass roots school" of printmakers in favour of U.S.-trained printmakers who came to Canada during the Vietnam War and established large professional print shops. Manning felt that the local "cottage industry" was neglected because it developed outside what she described as the arts establishment.[40]

Prior to 1978, landed immigrants could apply to Canada Council programs after twelve months of Canadian residence, although this requirement could be waived for "exceptional" artists. As a result of lobbying by CARFAC (Canadian Artists' Representation/Le Front des Artistes Canadiens) and the Writer's Union, citizenship rules were tightened in April 1978: after three years of residence, landed immigrants were required to become Canadian citizens in order to qualify for Canada Council support unless they were deemed to have made an exceptional contribution to art.

To what extent were concerns about non-Canadian access to government arts support warranted? According to writer Susan Crean, 6.3% of Art Bank purchases from 1972 to 1978 were from non-Canadians, a small but evidently

unacceptable number.[41] Records of Art Bank purchases across the first decade of its operation suggest that the number of artists of extra-national birth among artists whose work was purchased increased slightly, from 28% to 32%. This latter figure is twice the rate for the population at large at that time, suggesting an on-going net import of visual artists.

Controversy over the citizenship requirement and the relationship between Canadian and American culture continued to rage.[42] Kelly Morgan (a.k.a. Robert Park), an American artist living in Canada, objected to the citizen requirement, calling it "political interference" and a "coercive nationalistic move" in an open letter of July 1978. Later in the same year, a work by this artist was purchased by the Art Bank under the exception rule. It is typical of this era that rules put in place for political expediency were circumvented as administrators saw fit under the banner of universalist standards of excellence.

Morgan's accusation of political interference was, in the broadest sense, correct: allocation of cultural support dollars became highly politicized in this period as various groups sought a share of public resources. The restrictive regulations were quietly lifted in 1983; the surge of nationalism in this arena was a temporally specific expression of cultural anxiety.

Regional rivalry was another expression of competition for government funding. Luke Rombout became aware of the chauvinism of the provinces at the outset and, by 1978, writers such as George Woodcock discerned the "growing regionalist consciousness of Canadian artists."[43] Artists complained of neglect, and a lack of comprehension of the nature of their work on the part of Art Bank juries. Most felt that such understanding developed from long residence in a region. Réshard Gool challenged universalist notions of quality:

> Until you live long enough in a region, you do not "see" its values. The problem with Maritime art is that those who judge it, do so with Toronto or New York or European eyes.[44]

Aware of the inherent tension between centrally administered standards and cultural pluralism, artists in the Atlantic region complained of central Canadian domination of the Art Bank and requested increased representation of the region on juries.

These complaints were seldom heard from central Canada: Jo Manning's study of Visual Arts grant recipients revealed that repeat grants were concentrated in central Canada, a validation pattern similar to the pattern of high-purchase-price artists in the Art Bank.[45] A note in the Art Bank files suggests, however,

that some artists in rural areas of central Canada felt that they were on the periphery, facing neglect because they were outside the large urban areas. Similarly, some provinces objected to centrally defined regions, feeling that individual provinces could be neglected within a region. These various perceptions of region remind us that such divisions are constructs that are infinitesimally divisible. And, for some artists outside central Canada, the Art Bank offered a new opportunity for recognition as well as a new market. These artists felt well-served by the central mechanism.

Pressure was brought to bear on the Canada Council to change the constitution of juries. The Canada Council's submission to the 1981 Federal Cultural Review Committee pointed out that "cultural expression in Canada has a strong regional basis," but went on to say, in an elliptical argument against regional allocation of funds, that the regions could not be geographically defined. While seeming to recognize cultural clusters, the Council reaffirmed its governing principle of "equal opportunity for individuals."

In large measure, the exclusion or under-representation of specific groups of individuals remained unacknowledged until the institution of Council's Racial Equity Initiatives in 1991; however, the need for greater participation of women was recognized much sooner. Women artists, even well-established professionals, continued to face barriers in the field. In 1978, CARFAC recommended that more women be included on juries. Addressing this issue was a priority under Kirby's administration and increased representation of women on juries did result in increased acquisition of works by women artists.[46]

Criticism of the Art Bank diminished after William Kirby became director in 1981. He stated his intention to have juries travel to each region annually and to increase regional representation on juries. Despite continuing decline in acquisition of work from the Atlantic region, at least one report suggested that the region felt Kirby had been responsive to their concerns and had clarified Art Bank policies, demonstrating the importance of diplomatic communication for sustaining support for the Art Bank. Canada Council support of regions outside central Canada remains a sensitive issue.[47]

Some in the arts community opposed regional representation, regarding it as an inappropriate politicization of process and compromise to (centrally defined) standards. An unnamed critic quoted in Dale McConathy's 1975 article accused the Art Bank of "too determined an effort to be representative."[48] In the same vein, a group of Toronto dealers lobbied the Canada Council in 1984, accusing the Art Bank of supporting "mediocrity" by including criteria of geographical distribution and rentability. Kirby denied these were factors.[49] Commercial galleries concentrated in major urban centres have an interest in sustaining a strong centralist conception of quality, as does a federal program

with a mandate to cultivate a national culture, to support works deemed to be of national significance.

Although the Art Bank holds the country's largest collection of contemporary Canadian art, it is not *conceived* of as a repository of significant visual art but rather as a by-product of activities. Some policies have thwarted the development of suitable pride in and attention to the collection. For example, the re-purchase program instituted by Chris Youngs in 1977, in an over-zealous application of the "bank" concept, permitted artists to "withdraw" works from the Art Bank for the purchase price plus an administrative fee. Many artists took advantage of the program.[50]

The re-purchase program drew criticism from the Bank's founders. Luke Rombout questioned the withdrawal of work: "The Bank has clearly forfeited the objective of having an important collection of Canadian contemporary art." He pointed out that the early purchasing strategy "made a special attempt to get early works by contemporary Canadian artists, in order to build up a base of quality." Rombout feared allowing re-purchase would reduce the collection to "a hodge-podge of trends." Similarly, Suzanne Rivard-Lemoyne expressed alarm: "This buy-back policy weakens the collection terribly."[51]

On this issue, the 1979 Dunton report recommended that "sustaining the strength of the collection should be a primary consideration." And, while Geoffrey James stated that the Art Bank could refuse to sell a work if "the collection were to be denuded of the works of an important artist," such requests were not turned down.[52] The early acquisition of historical works was rendered pointless by the withdrawal from the Art Bank of works by earlier generations, works by such artists as Goodridge Roberts, Stanley Cosgrove, Philip Surrey, and Carl Schaefer. More recent extractions include works by Paterson Ewen, Gathie Falk, and Betty Goodwin.

William Kirby downplayed the idea of preserving the integrity of the collection, describing Art Bank holdings as "less a collection than an amalgamation of juries' decisions."[53] Kirby's equanimity over the removal from the Art Bank of significant works by well-known artists arose from his view of the Art Bank as a process rather than an institution of collection and preservation. While some artists and dealers favour the right to re-purchase work in order to benefit from its increase in value, it worked to the detriment of what might otherwise be a more valuable public asset, and a source of pride and political good will.

Despite response to and accommodation of evolving pressures, long-term erosion of perceived efficacy weakened the Bank's position within the Canada Council. In the face of massive funding cuts, the Art Bank's nearly $2-million annual operating deficit was deemed untenable and Council announced the closure of the program in 1995. This decision provoked howls of dismay from artists, dealers, and scholars and outright defiance by a committee of experts convened to oversee the dissolution of the Bank. In the same year, Council asked Luke Rombout, the visionary first director of the Art Bank, to explore the program's viability, with the understanding that life-after-death must include a plan to approach the long-anticipated nirvana of meeting operating expenses through rental revenues.

The appointment of Victoria Henry as director in 1999 was expected to bring marketing savvy and cost-effective management to the Bank—skills garnered during sixteen years as owner/director of Ottawa's Ufundi Gallery and, more recently, in senior marketing posts at the Canadian Museum of Civilization. The new Art Bank is actively pursuing rental to corporations in the private sector and, despite having to make up for rental contracts expired since 1995, Henry estimates that the financial break-even point will come as early as the 2001–2002 fiscal year. If reduction of storage expenses and more aggressive placement of works is successful, purchases of new work may be resumed but only, it should be noted, on a self-funded basis.

In the re-working of the institution, hybrid public/private values are finding new ways to co-exist. For example, the Report of the Art Bank Transition Committee confirms not-for-profit principles while, in the same breath, recommending "financial incentives linked to performance." Works in the collection will "earn their keep, " to borrow a phrase from Lesley Alway, former director of Australia's Artbank, the model for the Canadian Art Bank's renewal. While artistic merit remains a key criterion for the collection, other measures, such as the suitability of the medium to rental, will be applied. It's a sign of the Bank's revised frame of reference that the re-purchase program was finally suspended in 1996, although the fractious issue of a deaccessioning policy is not yet settled. The challenges of accommodating cultural and commercial goals within the Art Bank remain, but it's clear that, in the interests of survival, accountability to artists' desire for state support of unfettered expression will be subject to the discipline of fiscal self-sufficiency.◼

1968 — OPERATION DÉCLIC—FOR THE TWENTIETH ANNIVERSARY OF THE REFUS GLOBAL, BERNARD TESSEYDRE, A FRENCH ART HISTORIAN THEN TEACHING AT THE UNIVERSITY OF MONTREAL, ORGANIZED A SERIES OF MEETINGS AND EVENTS FOR THE PURPOSE OF FIGHTING "*THE SCLEROSIS PARALYZING THE ACTION OF ARTISTS....THE BASIC IDEOLOGY OF OPERATION DÉCLIC WAS: TO UNIFY ARTISTS, POSE THE QUESTION OF ART WITHIN SOCIETY, FIGHT THE SCLEROSIS OF BUREAUCRATS, PROMOTE INTERDISCIPLINARY EXCHANGES, FORMULATE A NEW ANIMATION AND CULTURAL PROMOTION POLICY*" (QUÉBEC UNDERGROUND MONTREAL: EDITIONS MEDIART, 1973, 354, QUOTED IN *FROM SEA TO SHINING SEA*, 40.)

NOTES

1 Inspired by ideals espoused by French Culture Minister André Malraux, it was Pelletier's ambition to make culture accessible to all classes in all regions of Canada.

2 The Canada Council, *17th Annual Report of the Canada Council, 1973–74* (Ottawa: Government of Canada, 1974), 22.

3 For accounts of the Art Bank formation, see Dale McConathy, "The Canadian Cultural Revolution: An Appraisal of the Politics and Economics of Art," *Artscanada* (Autumn 1975), 4–7; *CARFAC News* 4 (February 1979), 2; Julia Moore, "Canada's Art Bank," *Art in America* 61 (November 1973), 43, and 17th *Annual Report*, 22.

4 Rowan in McConathy, 91. Angela Marcus, "Interview with Guy Robert: Re-evaluating the Role of the Artist," *Ottawa Revue*, 16:22 (September 1982), 6.

5 *The Canada Council, 16th Annual Report of the Canada Council 1972–73* (Ottawa: Government of Canada, 1973), 16.

6 Réshard Gool, "An Appetite for Life: The Canada Council Art Bank," *ArtsAtlantic* (Autumn 1982), 19. See also Bernard Ostry, *The Cultural Connection: An Essay on Culture and Government Policy in Canada* (Toronto: McClelland & Stewart, 1978), 28.

7 Chris Youngs, "Art Bank: A Hit or a Myth," *CARFAC News* 4 (February 1979), 4. The Canada Council defiantly reallocated funds internally in order to sustain the purchase program.

8 Bellet and Moira Farrow, "Canada's Cultural Watchdog: Is It Worth All the Money?" *Vancouver Sun*, September 11, 1982, in Clippings File, Resource Centre, Canada Council Art Bank, Ottawa (hereafter CF).

9 "Small hierarchy" in Catherine Bates, "All Our Own Assets," *Montreal Star*, November 3, 1973, in CF. Jennifer Dickson, "A Personal View of the Art Bank," *CARFAC News* 4 (February 1979), 7. An example of Littman's work, which post-dates Dickson's reference, is "Who's Who in Judging Art Grants," *Toronto Star: Sunday Star*, February 24, 1980, B2. Concern regarding inward-looking and narrow juries was expressed by Arnold Edinborough, "Canada Council Fumbles in Mapping Course to Future," *Financial Post*, March 4, 1978, 44.

10 Davidson Dunton, Canada Council, *A Report Commissioned from: Davidson Dunton* (Ottawa: Government of Canada, 1979).

11 Laurent Mailhot and Benoît Melançon, *Le Conseil des Arts du Canada 1957–1982* (Ottawa: Les Editions Leméac, 1982), 164.

12 Virginia Nixon, "Art Bank Holds Double Exhibition in Town," *The Gazette* [Montreal],

September 20, 1980, in CF. See Lorna Hawrysh, "Art Bank Peddles Porn?" *Ottawa Revue*, June 19–25, 1980, in CF and Robert Enright, "Officials Wary of Art Bank Exhibit," *Winnipeg Tribune*, June 3, 1980, in CF. Borowski quoted in Peter Carlyle-Gordge, "An Erotic Error that Titillates," *Maclean's*, June 30, 1980, 19. Barbara Robson, "Borowski Agents Will Scrutinize Art Bank Show," *Winnipeg Free Press*, May 8, 1982, 17. Borowski used the term fellatio in the charges; they were dismissed when it was shown that the photographs depict cunnilingus, not fellatio.

13 *Of Intimate Silence* has never been rented, but it has been loaned for exhibition on three occasions.

14 Kathleen Walker and Tim Harper, "Residents Sign Up for Sculpture War," *Ottawa Citizen*, June 19, 1980, 3. See "Formal Installation Cancelled for Controversial Sculptures," *Ottawa Citizen*, July 7, 1980, in CF and Chris Youngs, "Art Exhibit Had Approval," *Ottawa Citizen*, August 8, 1980, in CF. Sheila Robertson, "Ottawa 'Junk' Becomes Saskatoon Art," *StarPhoenix* [Saskatoon], April 24, 1981, in CF. Mailhot and Melançon, 164. Conservative Member of Parliament Tom Cossitt denied the works the status of art, saying, "They are not really sculptures, but are constructed of mostly twisted steel and some aluminum." See "Rockcliffe 'Sculptures' Waste of Money," *Ottawa Citizen*, June 19, 1980. See also Tom Kent, "Let's Not Call Junk Work of Art," *Ottawa Citizen*, June 25, 1980, 6.

15 Mailhot and Melançon, 165.

16 Re lectures: Canada Council, *Twenty Plus Five*, 16, and Geoffrey James, in Canada Council, *17th Annual Report of the Canada Council, 1973–74* (Ottawa: Government of Canada, 1974), 24. Re "taste gap": according to Geoffrey James "[t]he public is still grappling with 1913 taste." Quoted in Roy Bongartz, "Banking Art in Ottawa," *Artnews* 76 (April 1977), 84.

17 Nixon. Videos have never been rented. According to Victoria Henry, exhibition rights were not obtained at the time of purchase.

18 Regarding international exhibitions, see Stephen Godfrey, "The Art Bank Turns Twenty," *Canadian Art* 9 (Summer 1992), 20. Regarding performance and conceptual art, see Dian Kinder, "Canada Council Art Bank at I.G.A. Gallery," *Artmagazine* (May/June/July 1982), 55.

19 Adele Freedman, "The Canada Council's Fall from Grace," *Artnews* 81 (February 1982), 86.

20 The dollar value of these purchases would be higher percentages of the whole, reflecting the higher average prices paid for works purchased through dealers.

21 Godard in McConathy, 40. Robert Fulford, "Workable Bank is Breeding Imitators," *Toronto Star*, November 29, 1975.

22 See Kathleen Walker, "Art Bank: An Interview with Director Chris Youngs," *Ottawa Citizen*, June 15, 1976, in CF. The objections of the Professional Art Dealers to this program are discussed in Chris Youngs' report to the Canada Council, *Art Bank Report: The First Five Years* (Ottawa: December 1977), 4.

23 Littman, and Gool, "An Appetite for Life," 20.

24 Dickson, 7.

25 See Jo Manning, "The Canada Council and the Visual Arts," *The Print and Drawing Council of Canada Newsletter* 2:2, (Calgary: University of Calgary Art Gallery, 1978), n.p., and Jo Manning, "Art Bank Analysis," *CARFAC News* 4 (July 1979), 1.

26 Jan Allen, "The Anatomy of Excellence: The Canada Council Art Bank Collection, 1972–1983," MA Thesis, Queen's University, 1992, 88.

27 Clive Robertson, "Art Bank: Is Investment More Than a Word?" *CARFAC News* 4, after February 1979, in CF. This review of *CARFAC News* 4 (February 1979) was originally printed in *Centrefold Magazine*.

28 See, for example, Rombout in *17th Annual Report*, 22.

29 Manning, letter to the editor, *The Print and Drawing Council of Canada Newsletter* 3:2, 6, and "Art Bank Analysis," 1.

30 Kirby, personal interview, July 16, 1992. Re in-depth purchasing: Marianne Heggtveit, Art Bank Purchase Programs Officer, personal interview, February 28, 1992. Re "decisive support": Joan Lowndes, "The Government, it seems, has taste," *Vancouver Sun*, December 22, 1975. Re "continuing commitment": Bruce Ferguson, "Introduction," *Contemporary Canadian Art: A Selection from the Canada Council Art Bank* (East Hanover, N.J.:1980), n.p. See also Allen, 76–79.

31 Art Bank Purchase Files.

32 Joan Lowndes, "What Have We Got in the Art Bank?" *Vancouver Sun*, April 30, 1976, in CF. Chris Youngs makes reference to exhausting days "looking at thousands and thousands of slides," in Bongartz, 81.

33 David Silcox, telephone interview, May 27, 1992.

34 *23rd Annual Report of the Canada Council 1979–80* (Ottawa: Government of Canada, 1980), 22.

35 Art Bank Purchase Files.

36 Bill Lobchuk, "Canada Council Conned by Office Boys," *CARFAC News* 4 (July 1979), 1.

37 *The Future of the Canada Council* (Ottawa: Government of Canada, 1978).

38 Jo Manning, "The Canada Council." Greg Curnoe, "Quantity, Quality Now Characterize Our Visual Arts," *The Arts in Canada: Today and Tomorrow,* ed. Dean Walker (Toronto: Yorkminster, 1976), 76–77.

39 See McConathy, 49, 92; and Gool, "An Appetite for Life", 21. In an amusing passage, Gool blames a corrosive doubt of the "Conradian 'Canada within'" for our failure to celebrate regional expression. See also Laurent-Michel Vacher, *Pamphlet sur la Situation des Arts au Québec* (Montréal: Les Editions de L'Aurore, 1975), 15. Vacher cites Saint-Pierre, "A Québec Scenic Art Tour," *Opus International* 35 (1972), 16–23.

40 "Grass-roots" in Jo Manning, "The Canada Council." "Cottage industry" in letter to the author from Jo Manning, March 15, 1992.

41 Susan Crean, "Citizenship and the Canada Council," *Canadian Forum* 58 (August 1978), 4–5.

42 For the tone and content of this debate, see the following series of articles: Robert Fulford, "Canada's Restive Nationalism," *Artnews* (April 1977), 76–78; Robert Fulford,

"The Canada Council Shuts the Doors to Foreigners," *Saturday Night* (April 1978), 13–14; Susan Crean, "Citizenship and the Canada Council," 4–5; Robert Fulford and S.M. Crean, "Letters," *Canadian Forum* (October/November 1978), 41, and Barbara Amiel, "These Foreigners Ought to Thank Us for Helping Them Suffer for Their Art," *Maclean's*, August 21, 1978, 50.

43 George Woodcock, "There are no Universal Landscapes," *Documents in Canadian Art*, Douglas Fetherling, ed. (Peterborough: Broadview Press, 1987), 257. Originally published in *Artscanada* (October 1978). Rombout quote from McConathy, 7.

44 Réshard Gool, *Eyescapes: Drawings by Hilda Woolnough*, introduction (Charlottetown: Square Deal Publications, 1978), n.p. See also Linda Robertson, "Artists Complaining of Art Bank Policies," *Leader-Post* [Regina], June 23, 1983, 35 and Christina Sabat, *Fredericton Gleaner*, November 14, 1981, in CF.

45 Allen, "The Anatomy of Excellence," Table 5, 137.

46 CARFAC membership was 47.5% women (see Jane Martin, "Who Judges Whom: A Study of Some Male/Female Percentages in the Art World," *Atlantis* 5 (Fall 1979), 129). Re increases: see Allen, "The Anatomy of Excellence," Table 6, 137, discussion 85–87.

47 Christina Sabat, "Visual Arts in Review," *Fredericton Gleaner*, June 12, 1982, and November 13, 1982, in CF. Re on-going concerns: see, for example, Andrew Terris, "Beyond Excellence: The Canada Council and Regional Cultural Development," *ArtsAtlantic* 39 (Winter 1991), 42–43.

48 McConathy, 25.

49 John Bentley Mays, "Art Bank is Defended," *Globe and Mail*, February 16, 1984, in CF.

50 Between 1977 and 1990, seventy-eight artists re-purchased 176 works for the original price plus a 20% fee. Canada Council Art Bank, "Facts" pamphlet (Ottawa: 1990).

51 Re "forfeited": see Stephen Godfrey, "Overdrawn at the Bank?" *Globe and Mail*, April 8, 1989, in CF. Re "hodge-podge": see Nixon. Rivard-Lemoyne in Godfrey, "The Art Bank Turns Twenty," 20.

52 Geoffrey James, letter to the editor under "Art Bank Responses," *CARFAC News* 4 (July 1979), 1.

53 Quoted in Godfrey, "Overdrawn at the Bank."

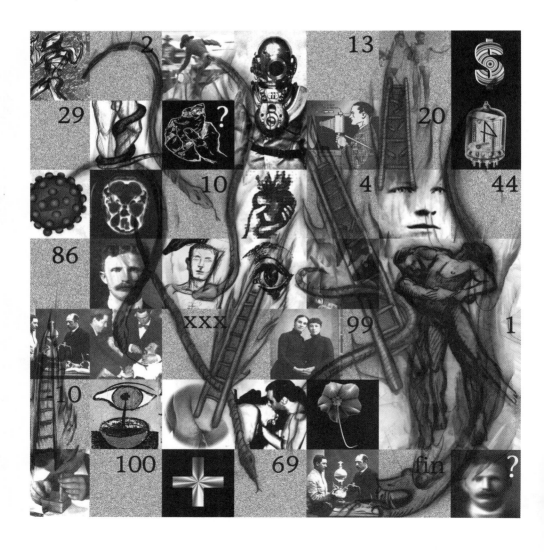

> MICHAEL BALSER AND ANDY FABO

Stakes and Tatters

PLAYERS BEWARE

This game is governed by the laws of thermo-dynamics. You can neither win nor break even. To begin, choose an icon: Entropy, Chaos, Audience, Media, e-Motion, Strategy.

Entropy Chaos Audience Media e-Motion Strategy

1 > The End. You have chosen a career in the arts but find yourself unable to navigate the vast wasteland of culture. In your dreams you have conjured smooth sailing and a highly refined lifestyle. In your dreams you have circum-navigated the globe on a full-tilt promotional tour of your new CD-ROM projection, work-in-progress performance installation. In your dreams ...

13 > Art school is such a drag. Plagued by assignments and deadlines, you opt for the course of least resistance. Remarks such as, "I'm producing a feature-length film version of a performance piece!" keep your instructors and fellow students in awe of your unbridled talents. Move to the end of the game.

14 > When your professor of film theory voices skepticism, he appears envious and loses credibility with the faculty. You are on the right path. Inherit 50,000 bonus points.

99 > Drugs and drink assist in escaping the inevitable stresses and struggles of your chosen career. Stagger into an opening at a public gallery and announce in a loud voice that someone has stolen your ideas and is marketing them in Japan.

1969 – LIBERAL TRUDEAU GOVERNMENT CREATES FEDERAL CABINET COMMITTEE ON CULTURE AND INFORMATION, PRESIDED OVER BY SECRETARY OF STATE.

22 > But what of the well-trod path of enlightenment through one's soulful search for the truth? Oh no, it's too late. The curator is at the door with a contract for full buyout, reproduction rights, and marketing strategies.

50 > Go back 50 blocks. Art school is the prison of your talents. Your altruistic pursuit of excellence in developing your craft is rapidly replaced with a new mirror of the art world. Networking (read, ass-kissing) is the course in which you score well. You get the best marks for the least work. Adopt a façade of anarchy and move forward 20 blocks, or at least to an upscale neighbourhood.

66 > Bone up on Bahktin, Wedekind, and Gramsci for intellectual credibility. Refuse assignments and exhibitions on principle. Change your hair colour every day. Call everybody you know and scream, "censorship." Move back 6 blocks.

2 > Even though you've done everything in your power to avoid descending into the abyss of fame, you accidentally become famous by appearing on the evening news. Having been pushed in front of the cameras while leaving a hair and piercing boutique, your surprise appearance at an anti-poverty demon-stration give new meaning to the word *serendipity*.

32 > (XXX) You pose nude for an international contemporary art magazine and receive very bad reviews. Move forward at random.

33⅓> Marry a porn star. Claim that it is true love, not a publicity stunt. Create gigantic digital enlargements of your intimate acts. Display the new work at an international art expo.

33⅔> Get less than favourable reviews. Get a divorce. Assign 10 points for each future divorce.

33³/₃> Come out of the closet. Wait for press response. Make multiple diagonal moves until your agent calls with news that you have been cast as "an aging art star" on a situation comedy with bad ratings. Move up, then down.

40 > Reconsider your position and re-strategize. Lose all your previous points. Sell your computer, sound equipment, rare artworks, and unattractive jewelry from 1986.

34 › Apply for every arts council, foundation, and government grant on the planet. If you don't meet the rigorous application criteria, make modest adjustments to your CV.

86 › Even in your protected, upscale, SoHo-style, live—work studio loft environment, you cannot escape the awful truth: you have no inspiration. You feel fragmented. Contemplate spearheading a resurrection of post-modernism.

87 › Receive an ugly award statuette. Claim to be unimpressed by material acquisitions. Remember that the work is its own reward. Hire a guru and become the centre of attention by incinerating a giant inflatable of the award in front of the local museum of antiquities.

64 › Misinterpret the work of an inexplicably popular international installation artist. Claim that she has stolen your ideas. Pursue a course of legal action. As a performance art intervention, represent yourself in the legal proceedings. Lose the case.
Lose a turn.

88 › Order every medical examination available through your medical insurance. A brain scan reveals nothing abnormal. Stay in this spot and plot a new career strategy for several months, then move forward one space.

89 › Lateral move, any direction. No extra points.

99 › Announce to the press that you are retiring from interactive, digital, cyber-art and returning to the use of primitive tools and techniques.

90 › Disappear to a small town. Spread rumours of a new body of work. Collect folk art from local residents. Photograph the folk art. Have giant photo blow-ups made. Exhibit them anywhere in Europe.

100 › The beginning. The day that you first imagined that you could be an artist. In your dreams you conceived of your future as a giant gameboard. You climbed ladders as you honed artistic skills, made contacts in the art world and sold works to major museums. You imagined avoiding the slippery, snaky slopes, bad reviews from repressed critics, and the devious strategies of competitive peers. In your dreams ... ▪

1970 — 71. CREATION OF FEDERAL OFY (OPPORTUNITIES FOR YOUTH) AND LIP (LOCAL INITIATIVES PROGRAM), PROGRAMS AIMED AT YOUTH UNEMPLOYMENT AND (NON-PROFIT) COMMUNITY YOUTH-AUTHORED SERVICES. THE PRIME INTENTION OF THESE GRANTS WAS ARGUABLY TO COMBAT JUVENILE AND YOUTH DELINQUENCY. NEW ARTS ORGANIZATIONS DEVELOPED FROM THESE PROGRAM PROJECTS (INCLUDING ARTIST-RUN CENTRES) ARE PICKED UP BY THE CANADA COUNCIL.

IN NOTES FROM A MEETING WITH PRIME MINISTER PIERRE TRUDEAU, CANADA COUNCIL DIRECTOR PETER DWYER REMARKS THAT, "THE PRIME MINISTER SAID THAT HE COULD SEE NO REASON WHY THE CANADA COUNCIL SHOULD BE EXEMPTED FROM THE CURRENT GENERAL GOVERNMENT REQUIREMENTS THAT EXPENDITURES OF PUBLIC FUNDS SHOULD BE DIRECTED TO THE PRESENT NEEDS OF OUR SOCIETY" (KEVIN DOWLER, "INTERSTITIAL AESTHETICS AND THE POLITICS OF VIDEO AT THE CANADA COUNCIL," *MIRROR MACHINE: VIDEO AND IDENTITY*, JANINE MARCHESSAULT, ED. (TORONTO: YYZ BOOKS, 1995), 37).

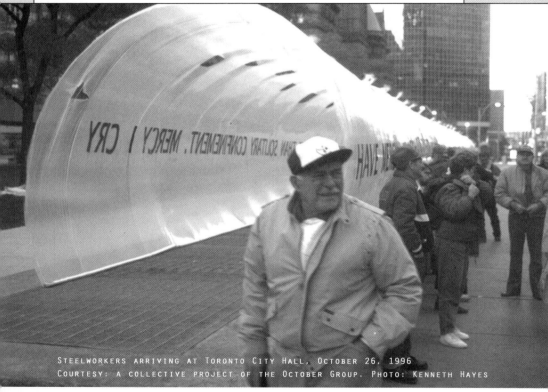

STEELWORKERS ARRIVING AT TORONTO CITY HALL, OCTOBER 26, 1996
COURTESY: A COLLECTIVE PROJECT OF THE OCTOBER GROUP. PHOTO: KENNETH HAYES

BARBARA GODARD

Resignifying Culture
Notes from the Ontario Culture Wars

Public culture is at risk of disappearing in Ontario. Government policy and structural economic changes have had devastating effects on the lives of Ontarians since the provincial Tories and their Common Sense Revolution came to power in June 1995. Recent governmental policies have sought to eliminate the state from any positive action in the public sphere. Clear-cutting first, the government later re-injected some money into health and education just before the 1999 elections in widely advertised gestures staged for their promotional effect. Such token sums in no way compensate for the structural damage inflicted on the social system.

Funding to the arts has been included in these drastic cuts—more than 40% of the Ontario Arts Council's budget was slashed in the first two years under the Tory government with additional decreases of 59.2% in funding for the Ministry of Citizenship, Culture and Recreation in 1996.[1] However, there was no re-allocation of funds for the arts in the pre-election flurry that attempted to camouflage the Tory program of dismantling government. The relative privileging of support for health and education over culture is a long-standing social configuration that the Ontario Arts Council was initially designed to change. That no new public resources have currently been allocated to cultural initiatives looms ominously. The flourishing cultural life established with the seed money of the Ontario Arts Council and other arts councils, the vibrant and diverse cultural opportunities made available by talented and energetic arts organizations who have used OAC funds to entertain and inform Ontario citizens—all have made Ontario the dynamic centre of artistic activity in Canada in the last forty years—seem now on the verge of vanishing. Withdrawal of government intervention to support culture radically transforms the role and function of the state which, since the 1940s in Canada, whether in the name of humanist values of self-development or of nationalist values of self-

1971 - IN ORDER TO PROTEST THE LACK OF PROVINCIAL SUPPORT FOR VISUAL ARTS IN QUÉBEC, ARTISTS AND ARTISTS' ASSOCIATIONS STAGED A BALE OF HAY CONTEST. THE PROVINCIAL GOVERNMENT RESPONDED BY COMMISSIONING THREE UNIMPLEMENTED STUDIES ON THE VISUAL ARTS.

determination, has worked through the representational practices of culture to make citizens. Transformations currently underway at OAC reconfigure citizens as consumers while contradictorily promoting a quest for beauty separated from the complexities of life. Culture is disembedded from the economy as its longstanding discourse of socio-economic relations is reframed as one of individualized aesthetic excellence.

Since June 1998, the predicament of culture in Ontario has focused on more than protesting cutbacks. What is at issue is who decides how funds are to be distributed. A culture war has been underway over the policies of the Ontario Arts Council.[2] At stake is what's happening to the Council itself. Does it have a future? Has it abandoned its function of stimulating and supporting cultural initiatives? Do its policies constitute a radical transformation or just a refinement of tradition? On the one hand, the arts community protests against the necessity for "crisis management" in adjustments during a "chaotic period."[3] It also contests the lack of consultation by OAC in making radical alterations in funding criteria. Fearing this signals that the OAC is losing its longstanding arm's length relationship with government, artists upset by such changes formed a Coalition to Save the Ontario Arts Council to strategize on how to reach audiences in a time of diminished funding and to challenge the OAC's abrogation of longstanding policies: institutional autonomy, peer assessment, and community consultation.

At the OAC, on the contrary, everything's business-as-usual, contends Gwen Setterfield, then executive director, and Henry N.R. Jackman, chair of the OAC board, in an unprecedented flurry of pamphleteering. There's been "no major shift," Setterfield asserted: "It's not as if we turned everything upside down. It's a broadening of something we were already doing."[4] Jackman, not content with being interviewed, took up the pen himself in the *Globe and Mail* to put forward his views on arts funding, in particular to justify the inclusion of non-artists on OAC's advisory panels determining annual grants to arts organizations. "Volunteers" from the corporate sector introduced into this decision-making process will not change or compromise it, he claims, for they have long served as directors on the boards of many arts organizations "with no apparent adverse effect."[5] Indeed, they will attract more corporate support for these organizations. "This initiative," Jackman argues, with a twist on the meaning of inclusivity, "is the very opposite of the elitism" decried by the arts community. Moreover, it fosters "diversity" since volunteers have different tastes and preferences in contrast to government of which there is "only one, or at best two." The "private sector" with "its many

individuals, companies, and charitable foundations" should have "a more important role," Jackman contends, since "diversity" is the "hallmark of artistic expression." Substituting numerical difference of individuals for the representational processes of democratic governance, Jackman refigures diversity to equate the arts with the corporate sector. Even though drawn from many aesthetic schools, ethnic groups, and geographical regions, and with its composition changing every season, a jury of artist/peers is deemed unitary and elitist while a self-selected and relatively small group of rich people is considered diversified and representative. Wealthy patrons should play a "starring role," Jackman contends, with government merely following the leadership of the corporate sector to provide "matching funds" dollar-for-dollar with monies raised for endowments.[6] Protests by the arts community against the change in jury composition compounded the problems brought on by government cutbacks, argued Setterfield, artists becoming thus inadvertently "enemies of culture."[7] The rhetoric of continuity is prominent also in "Meet the OAC Board," the lead article in the OAC *Notepad*, an occasional publication which has become the forum for policy pronouncements in another departure from tradition. Here the newly appointed members of the board, which sets priorities and policy for OAC, are deemed "no different" from the members of the last thirty-five years: "artists, arts administrators, community leaders— all staunch arts supporters with the community and public profile needed for the job."[8] Moreover, the *Notepad* reminds us, Jackman, the chair of the new board, was previously Lieutenant-Governor of Ontario just like the first chair in 1963, the Honourable J. Keiller Mackay.

Such comparisons attempt to create consensus by presenting rupture as continuity and so manage what is in fact a radical resignifying of "culture" produced by public policy and institutional structural changes. Not only is the vocal presence of Jackman and Setterfield in the media out of synch with traditional OAC practice of downplaying individuals behind an institutional voice, but the policies they have been so actively defending re-articulate "culture" as high art in a forceful social distinction between the cultural and specialized economic relations decoupled from the polity in what is a reversal of the OAC policy of 1963. The severing of these mutually defining, heteronomous value spheres from any unifying principles of religion or metaphysics in the development of their own internal norms, procedures, and institutional matrices has been identified with modernity. Insisting on culture considered as an autonomous and differentiated realm of value, the spokespersons for the OAC are re-enacting the "diremption of value" characteristic of capitalism within modernity whereby the economic, "crystallized" out of the social matrix and founded on the principle of self-interested rationality,"[9] becomes hegemonic within the

social arena. Through this process of separation and abstraction, money is posited as a commodity exchangeable for itself so that exchange, not use, becomes the sole criterion of value. In a developed system of exchange, as Marx argued, "the ties of personal dependence, of distinction, of education ... are ripped up ... and individuals are seen as independent" rather than imbricated within mediating social relations.[10]

The new discourse emanating from the OAC marks a continuity not with OAC's history but with the processes of the modern capitalist economy to separate it from non-economic institutions and social purposes. In a related process, "culture" is disentangled from pre-capitalist traditional life-ways and positioned as a countervailing force within a social whole subordinate to "economic" ends. Beauty, knowledge, health, community—nothing must interfere with the bottom line! The OAC's discourse now forcefully advances a capitalist agenda where "culture" as an autonomous and self-regulating field of social reproduction and domain of human "value" is positioned asymmetrically in relation to the economy, whose rationalizing operations increasingly model society in its image and every domain of life becomes subject to calculation, measurement, and control. Tellingly, the same issue of *Notepad* announces a new handbook, *Measuring the Economic Impact of Arts Organizations*, developed by Informetrica for the OAC, complete with a model on computer disk and workbook to help arts organizations generate "impact numbers" and use them "in *credible* arguments for the arts" in order to stand up "to challenges from a budget committee or local business association." Without apparent cynicism, the handbook even offers a model for calculating "the economic value of volunteers."[11] The tentacles of managerial culture have invaded artistic practices, foisting their technocratic solutions on artists and so diverting their focus from creative processes to the collection of information quantifying "outcomes." Now corporate donors and not taxpayers are the supporters to whom artists and their organizations must be accountable—as accountants.

The resignification of cultural value follows upon several years of financial chaos for the non-profit arts community when, following an initial period of active growth during a deep recession of the economy, the non-profit arts community failed to benefit from economic recovery, experiencing instead a sharp downturn after deep cuts by the new Ontario government, which reduced the OAC's 1998–99 budget to what it was in 1974 after inflation is taken into account.[12] The effects of this cutting to the bone were immediately felt in the downsizing of the OAC. Reductions in staff and other internal costs to preserve what was possible of grant monies resulted in swift and frequent restructuring, adoption of new strategic priorities, and elimination of programs.

Shifting remaining staff into areas outside their fields led to staff under stress, and hemorrhaging of experienced arts managers with a consequent loss of critical expertise.[13] Not only is this happening in the public sector funding bodies, but more dramatically in arts organizations. The overload is occurring, moreover, just when changing policies are placing rising demands on staff. As grants have declined, more paperwork is required to justify them. New sources of funding must be sought both by establishing strategic alliances within the community to attract private sector funding and by responding to a shift in public sector funding from grants subsidizing core operations to project-based grants. Arts organizations are driven to "create a project" to fit a funding opportunity. Such special project money creates organizational distortions when planning is directed not by an organization's own momentum and priorities but by the need for cash.

Not only does this heavily tax the financial and human resources of an organization with the need to make frequent applications for grants, turning artists into grant-writing machines. Implicitly, too, it transfers direction of the arts' creative agenda to the public sector funding bodies and now, more frequently, to the private sector bodies who provide sponsorships. Corporations are increasingly describing their contributions to the arts as "strategic community investments" not as "donations" and targetting them to specific activities—performances, exhibitions, outreach activities, job creation—with measurable results.[14] What counts as art is being determined by fewer and fewer individuals. A top-down model of bureaucratic control is displacing the diversity of grassroots creative initiatives enabled by stable operational funding. Shifting the funding to target individual artists over arts service organizations— which, as sites for establishing connections among dispersed artists, have enabled the articulation and circulation of discourses on the arts—signifies the political stakes of such downsizing in public support for culture as an attempt to silence artists' claims upon civil society for equal participation, so positioning the artist as isolated outsider.

Already in 1996 the effect of cutbacks was considerable. *The Cost of Cutting*, a survey by the Toronto Arts Council, tells a disturbing story of shrinking opportunities in the not-for-profit cultural sector which are bound to accelerate since it is necessary "to spend dollars to earn them."[15] Always undercapitalized and underfinanced, the arts community lost a significant amount of working capital and hence the potential for generating more. For most, the fall in cash flow led to sharp declines in service and accessibility. Fewer performances or exhibitions were scheduled, new creations eliminated, prices raised, marketing reduced, staff fired, leading to a further decline in audience and revenue. While the balance sheet

Arts grants changes loom

might have improved, this was at the expense of the number and variety of arts and cultural activities and overall level of revenue. Fewer productions resulted in fewer applications to Foreign Affairs for international tours, exchanges, and exhibitions.[16] Less foreign exposure, in turn, negatively affects revenue and so survival at home, accelerating the downward spiral. With a consequent shrinkage in opportunities for emerging artists from diverse cultural communities, expatriate may once again become a synonym for artist, as it was in the 1950s. Paradoxically, it was just the lack of creative opportunities produced by unpredictable funding that the OAC was founded to overcome. Should individual artists leave, the talent and imagination which impelled the extraordinary expansion of the arts will also vanish, imperiling future sustainability. Efforts to adapt to this new climate by "dumbing down" programming to increase self-generated revenue from audiences and lessen dependence on government funding places remaining grants in jeopardy, unsettling as it does the delicate balance between art and audience, between beauty and profit. Already walking "a razor's edge" between conflicting demands to expand audiences and make an economic impact locally and to respond to imperatives of the Canada Council for "innovative, risk-taking work," the challenge is "getting the *balance* right between the two."[17]

Cogently formulated here in a key signifier, "balance" is a contradiction that has persisted in the discourses on cultural value in Canada, which have been informed by three contending models: market, welfare, and nationalist. A divergence occurs among the conflicting objectives of profit, where value is determined by supply and demand through the exchange of works with consumers; of access, where cultural inequities of regional, ethnic, or linguistic varieties will be reduced among citizens; of collective identity, where national awareness will be developed among patriots to overcome the distortion of colonialism. Each of these models sets out a different relationship between the field of cultural production and the state. Each constitutes subjects within a different modality of relations. What this divergence highlights is that the state is not a given but a work in progress constituted through discursive struggle. Framing interaction in a field of power relations as struggle acknowledges difference in relation to the symbolic as a matter of politics and posits culture as constitutive of the polity, and so potentially contestatory.

The political dimension of the current restructuring of the field of cultural production in Ontario to make it more market-driven and less troubled by concerns of equity or identity is adumbrated in Jackman's apologia for his programme. He records his differences with artists in an opposition between

Budget down from
$42 million to $25 million

an American market model with the corporate sector taking a leading role, and a European welfare model in which citizens have a claim on the equitable distribution of the resources of the state. In an ideal world, he suggests, he would combine both an increased level of government funding and the generous support to the arts of the private sector. Such "a careful balance of public and private investment" is indeed a goal the arts community would embrace. A "balance" of this kind was what supported the successful growth of the arts community over the last thirty years.[18] In 2000, however, "balance" can only be invoked in the past tense, as something now lost or fast vanishing. The "mixed public/private sector model," which the Canadian Conference of the Arts calls "the Canadian model," is widely supported by Canadians and highly successful, responsible as it has been "for the extraordinary diversity and range of cultural opportunities now available to Canadians."[19] "Balance" for Jackman means something quite different, not equilibrium of a heteronomy or equity of access to cultural production but transformation and consolidation in a singular framing of the cultural: "The balance of arts funding is changing, away from governments and toward the private sector."[20] Jackman advocates private-sector leadership, not private-sector participation. Exemplified here is his rhetorical manoeuvre for managing consent by reworking the commonly used signifiers of cultural value to make them articulate something quite different from what they have historically. Change is presented as continuity, in that "balance" has been a key trope in the discursive struggle over culture.

Tories scolded for cutback: after arts council head quit

Contradiction has long marked the discourses on culture in Canada as nationalist, welfare, and market models have contended for pre-eminence. In the present conjuncture, these forces are undergoing realignment as intimated in Jackman's inflection of "balance" as transformation and "partnership," in the language of corporate mergers. The implications of this change may be read in the shifting metaphors for cultural intervention as recorded in the OAC reports which provide some measure of the change in discourses of value over the last thirty-five years. Critical here is the reworking of the notion of "balance" in regard to the activity of the state. Culture is now a countervailing force to democracy, no longer to materialism as it was in the 1960s. In the report on its inaugural year, 1963–64, a detailed description of the scope of the OAC's particular sphere of action and declaration of its mandate is configured in a medical or juridical metaphor of balance where the state will intervene to guard against

1972 - GERARD PELLETIER, SECRETARY OF STATE IN TRUDEAU'S LIBERAL GOVERNMENT, MAKES SPEECH EXTENDING PRINCIPLES OF "DEMOCRATIZATION AND DECENTRALIZATION" TO CULTURE, PELLETIER TAKING CUE FROM FRENCH CULTURE MINISTER ANDRÉ MALRAUX (1968). PELLETIER ALSO ANNOUNCES FORMATION OF NATIONAL MUSEUMS OF CANADA WITH BUDGET OF $9.1 MILLION.

the "deformity" of "one-sided development" in a heteronomous field of values by "strengthening and deepening in the minds of our people a richer and fuller appreciation of the quality, character and majesty of intellectual and cultural pursuits." While knowledge of the arts is considered a good in and of itself—"a noble, vital, permanent element of human life and happiness"— it is also a necessary complement to avoid specialization that would impede "real progress" which requires the development of "all the faculties belonging to our nature." Variety or diversity is important along with justice and equity. Classical ideals of harmony are joined to humanist values of self-knowledge in which artistic pursuits contribute to individual edification or *Bildung*. Especially, however, this cultural knowledge in virtue of its concept of non-alienated praxis is necessary to counteract materialism: "If a great increase of wealth takes place and, with that increase of wealth, a powerful stimulus to the invention of mere luxury, that, if it stands alone, is not and never can be progress."[21] Here, in its clearest formulation, is articulated the lofty cultural principle of idealism associated with "literature" in Canada at the end of the nineteenth century, Arnoldian values which still held sway in the middle of the twentieth century and informed the report of the Massey—Lévesque Commission that initiated the Canada Council for the Arts in 1957 where the claims of "culture" are counterposed antithetically to those of a mechanical or materialist civilization within a residual tradition of romantic anti-capitalism.

Significantly, in the 1963 report the words *arts* and *culture* are used inter-changeably in the terms of abstraction and absolute emerging during the nineteenth century. Divorced from processes, they became synonyms, according to Raymond Williams, for a "whole way of life, material, intellectual and spiritual." Separating certain moral and intellectual activities from the "driven impetus" of a new kind of society, then functioning as court of appeal or "mitigating and rallying alternative" to this society, arts and culture are a complex response to both industry and democracy. "Culture" comes to be defined relationally to the economic as an alternative realm of non-instrumental human value in opposition to the realm of utility and means. "Culture," in the restricted sense of the expressive arts, serves as a counterforce of non-differentiated praxis to unify a variety of discourses on modernity and its discontents. Artists had to face the resulting contradictions in their social role. Civilizing? Or disrupting? Were they Shelley's "unacknowledged legislators of the world," society's guides, or seers who mediated between humans and nature? Or were they rather the interpreters of a superior reality, misunderstood

and scorned by society whose vulgarity they, in turn, despised?

Both the artist's social responsibilities and the aestheticism of art-for-art's-sake are upheld in the inaugural statement of the OAC chair, J. Keiller Mackay. The same contradictions are manifest in the first executive director's sense of his mission to develop a "Peace Corps of the arts" which will send professionals touring the province "to train and inspire the amateurs"—the arts as welfare work in a cultural backwater or colonial state of underdevelopment—and the report's utopian vision of the results of this initiative where "the present renaissance going on in the arts would blossom into a truly Golden Age"—idealism where, extending beyond the deformed present, culture prefigures a future in which the values and activities it categorizes would hold sway. As a non-alienated praxis, culture holds forth the promise of social transformation in its transcendence of material necessity. Nonetheless, in the view of the OAC, although they do constitute a special sphere, the arts are not necessarily opposed to the marketplace. Culture and economy are understood to work in a complementary fashion as the expression of an integral social formation. With no tradition of cultural philanthropy in Canada, the Council envisages itself not as public patron commissioning art, but as "catalyst" operating at arm's length to facilitate interactions between separated spheres, convening meetings of businessmen and industrialists in order to induce them to place the arts higher in their priorities for corporate donations.[22] For, in the absence of "fantastically wealthy foundations that give $50 million annually to the arts in the U.S.," Ontario is going to have to rely more on "business and industry for help." The OAC would make "strong pleas to them for the artistic spirit of man." Cultural and material orders, it is hoped, can be made to work harmoniously and equitably.

Pro-active in wooing business support, the OAC was also pro-active in educating citizens. Performing a pedagogic function, culture would promote social harmony. Traces of elitism in the discourse of artistic excellence are moderated by one of democratization through education. Photographs on the cover of the 1963–64 report highlight the Council's training of amateurs: a small boy paints while, the caption tells us, his parents take classes at the Hockley Valley Summer School. A gently corrective, paternalistic tone highlights the connection to government through the Ministry of Education, whose Community Programs Branch the OAC expanded so that community involvement became a major funding principle. Sending elite artists into the schools and communities throughout the province to give performances and adjudicate competitions increased their income, so enabling them to pursue a career in Ontario. This policy also developed the aesthetic standards of audiences and set higher goals for aspiring young artists, so promoting artistic excellence

indirectly. Training for the future was emphasized broadly rather than narrowly, though direct support was given to some organizations exclusively devoted to arts education. The linking of arts to education underlines the persisting force of the idealist epistemology reigning in Canadian cultural circles since the 1880s on the formulation of theories and policies of culture to exert a civilizing influence through exposure to the "best that is thought and known" believed to stimulate a dormant capacity to appreciate the eternal. Such idealism has privileged literature over rhetoric in education, the heritage of past greatness over the articulation of the radically new. This emphasis relates to a suspicion of democracy valuing free speech and to a disdain for seeking economic advantage. Both these values were invoked during the 1950s to support a growing Canadian nationalism that sought to establish distinctions from American society, which was considered overly materialistic, where the establishment of arts councils to channel public support for the expressive arts would fill a compensatory function as an alternative to American modernity. A model for developing audience taste through the practice of the arts as well as through attending arts events that attain European and American standards of artistic excellence, the OAC's emphasis on creativity and imagination reflects both a reformist zeal to counter materialism and a utopian belief in the advent of a leisure sociey, a residual form of romantic anti-capitalism.

Democratization of the arts through education for personal development was paradoxically linked to elitism in producing occasions for the perfection of specialized skills and artistic standards that would attract larger, more discriminating audiences. Support was focused on organizations who "will use any profits they make to continue and extend their programs year after year," rather than on exceptional individuals. Stability and longer seasons were considered crucial to artistic excellence and were achieved through the maintenance of professional companies who would otherwise lose their artists to higher paying and more artistically challenging companies in the U.K. and the U.S. Emphasis on organization and performance advantaged certain arts over others: theatre, ballet, and music, which involve groups of artists, received much greater funding than individual artists concentrated in the visual arts and literature, excluded at the beginning. Relations with individual artists have continued to be indirect. The 1963 report describes the purchase by the Art Institute of Ontario of individual artworks for its touring artmobile. This was a forerunner of the OAC's unique modality of awarding grants to individuals only on third person recommendation of OAC-funded organizations. However, the organizational emphasis also instantiated a consumption-

rather than production-driven model of cultural policy. As it unfolded, OAC policy fostered a symbiotic relationship of artists and milieu through a network of arts organizations that mediated interactions among artists and between artists and Ontario citizens, so constituting an important position for the arts within civil society.

The 1992–93 report is a much briefer document although it covers a greater number of fields and grants. However, the space of "culture" has narrowed in the multiplication so that it no longer constitutes a residual sphere of anti-capitalism. "Culture" and "art" do not figure as idealized abstractions or distinct ways of life "balancing" other spheres of human activity. The arts are considered as social engineering: culture is neither singular nor isomorphic with nation and state, despite the populist address of the report to "Ontarians." Technology, linking the arts and industry, will lead the way in the unification of the many cultures of Ontario in a morphing of the social.

Mixing is the crucial trope in this report. The chair's opening remarks offer no general pronouncements on the value of the arts, as had the report of 1963, but zoom in on economics to underline the favourable cost/benefit ratio of investments in the arts. With a minimal budget, the OAC has "promoted" and "invested" in activities that have "improved the quality of life everywhere." A rapid enumeration of the many activities of the Council follows with active verbs ("fostered," "encouraged," "funded") supported by statistics to demonstrate the number of citizens involved—for instance, 700,000 students are in education programs providing an "appreciation" of the arts. Presented in a list that denies it any special status or sphere, "art" is linked to institutions: OAC

Coalition fights arts group changes

Ontario's move to use non-artists sparks battle

collaborated with "artists, art and professional organizations, municipalities, school boards and 100,000 volunteers and art lovers." Education remains an important function of art but offers training in complex technologies, motor of economic progress, rather than development of a balanced, whole person. No release from industry, no "frill, a time-filler between science and math classes," any experience in the arts is touted as "one of the best ways to develop the skills necessary in a high-tech society that values problem solving." In its creative relation to new technologies, art is claimed to have a leading edge over science or business training in that it specifically highlights experiment. Innovation derives from new technologies and cross-disciplinary projects supported by the Venture Fund, no longer from the artist's imagination.

Value is measured in terms of the balance sheet: "For very little money, the

1973 - Artists Iain and Ingrid Baxter (of Vancouver-based N.E.Thing Co.), York University Associate Dean of Fine Arts David Silcox, real estate broker Murray Frum, and Assistant Toronto Dominion Bank branch manager Sandy Thompson played Monopoly at Toronto's York University with real money (borrowed from the TD Bank). This game was an attempt "to bridge the gap between the art community and the business community" (Iain Baxter, quoted in Bronson, 69.)

arts play a vigorous role in stimulating local economies and creating employment."
Emphasis is placed on the excellence of investment in the arts in a competition
for scarce resources. Comparative statistics are provided to show that public
funds spent on the arts ($4.38) are much lower on a per capita basis than those
spent on health ($1, 681) or education ($614). Culture is highly profitable:
there is a "real return on the modest sums allocated to artistic creation."
Organizations remain central to funding. Although a rhetoric of service figures
the OAC as handmaid to the arts, the Council focuses on organizational
administrative functions that only indirectly help individual artistic creation, as
with a grant to the Small Theatre Administrative Facility in order to remedy a
perceived weakness in administrative infrastructure. Better business practice for
theatre is also sound economics for the OAC, helping to "stretch scarce
resources." In defending its management practices and decisions, OAC is
undoubtedly attempting to prevent further cuts to its own budget and so protect
public support of the arts. But its claims are couched in the discourse of the
marketplace which has become a goal in and of itself, an absolute that has
engulfed culture and threatens the polity.

Broadly inclusive though it is, culture is not conceived anthropologically as the
everyday practices of a distinct social group. Rather, culture is defined in
populist terms as recreation that includes forms of mass culture and com-
munication, of passive consumption, as well as of active production. Citizens
showed their "attachment to the arts" as consumers, not creators. They "purchased
theatre and concert tickets, books, magazines, pictures and handicrafts, visiting
museums and art galleries, attending festivals, registering their children for
courses or local artistic activities, and listening to radio or television programs
which owe their existence to artistic creation." The OAC is no longer a "catalyst"
in a process of individual and social transformation, but a facilitator
or distributor of "services," responsive to citizens' needs and to the market.
Distinctions between "high" and "low" culture are deliberately blurred in an
effort to demonstrate the mass involvement of Ontario citizens in cultural
activities. "Soundings," or "information meetings" allow the OAC to "listen
to artists and communities": "Everywhere, people wanted the arts to be part of
their lives." Faced with a difficult choice, the OAC has chosen to spread more
than to raise, to involve more and more people and communities in the arts,
rather than to develop the skills of a few to a higher level. Numerical inclusivity
constitutes evidence of the importance of the arts' claims on the public purse

in comparison to the claims of health and education which were linked as preferred social values in the 1963–64 report. The concept of culture as absolute is replaced by universal access as touchstone of value.

Within participatory democracy, culture becomes a mode of disjunctive synthesis yoking contraries. What is at stake is not "culture" but cultures. The 1992–93 report is bilingual, in French and English, and underlines the autonomy of the Franco-Ontario Office. A poster image from *True Colours*, a festival organized by Full Screen in Toronto, celebrates filmmakers of colour. Information throughout the report records the achievements of First Nations' artists. In this democratic approach to cultures the question has been reframed from "Which Culture?" (high or low) to "Whose Culture?" Fictions of identity are no longer thought within the frame of nation or province, or even region, but of language and ethnicity. Culture versus nation. Against figurations of culture as unified, singular in the Frygean myths of concern and identity through which government reports carry out operations of symmetrization—figurations underpinning the OAC report of 1963–64—the report of 1992–93 operates under the sign of difference stressing a heteroglossic struggle among cultures. Everyone will become involved in the web of culture spun by the OAC within a dynamic field of differences. One text, "Mirror, mirror, on the wall," for example, figures identity as resemblance only to reconceptualize it as diversity and mobility: "Ontario reflects a world of difference that touches every aspect of the arts…. Ontario isn't what it used to be." Now, there are not only "more of us" but there are "more kinds of us too." Immigration has brought a richer diversity of people from the world to Ontario. "The gay and lesbian community has become a potent and recognized cultural force." The First Nations peoples here from the beginning "are creating a cultural renaissance of their own." There is an ambiguity of address in this document in the shifting "we" that continually realigns the boundaries between inside and outside, between speaking subject and addressee. Who is this "we"? Women or "lesbians"? Old Anglo-Ontario? Newcomer? Or conquered other? Ontario has the renaissance promised thirty years earlier, though not at a site which its culture as absolute could have conceptualized, and in the image of a "Bronze" rather than "Golden Age." The mobile boundaries redistribute around the category of artist as well as of citizen so that by turns "we" are all artists wherever "we" come from. It is art that unites "us" in a common activity, connecting us as a population for governmentalizing operations that work through representations upon bodies to inscribe subjectivities and produce citizens.

Innovation, introduced in relation to ethnic and racial diversity, is more closely identified in the report with technology as a way of linking differences

1974 - Vincent Trasov, a founder of both Image Bank and Western Front, runs for mayor of Vancouver under the shell or moniker of "Mr. Peanut." In his peanut costume, and dancing to speeches written and mouthed by campaign manager artist John Mitchell, Mr. Peanut received 5% of the vote in the 1974 mayoral election. Mr. Peanut's art platform consisted of P for performance, E for elegance, A for art, N for nonsense, U for uniqueness, and T for talent.

within a field of continuous change. Artists have become seers and guides to new technologies, producing hitherto unimaginable fields of art practices that "blur out the neat little compartments we all learned about in school." This concept of art overturns the idealist focus on inherited greatness and fosters a revolving door policy—of constant rotation of juries, of grants to new individual artists—that keeps everything moving, everyone mixing. Blurring also prepares for alignments with industry that constitute a new figuration of unity in a high-tech society. Youth may help "identify new trends." Yet Murray Schafer, "accomplished and celebrated composer," is the metonymic "artist" who sanctions the equalizing effects of the technological imperative. As keynote speaker at a conference on art education, he connects the challenges of cross-cultural education to the technological world of young people, which both require radically new forms of intervention. The OAC identifies itself with Shafer's transformative view of art as "destructively creative." Recognizable here is a modernist version of the Orphic myth of dying into creation, of fragmentation merging into a new formal unity on a higher level of resolution. The utopian promise of culture can be achieved only in a project that works to restore its social pre-conditions within the exigencies of modern economic life. Technology or modality rather than education or enlightenment become the means to this collective project of society.

Diversity is managed by technological blurring to produce internal hybridity rather than by promoting equity among differences. This contrasts with the care and tends to produce balance among discrete, heteronomous elements in the 1960s project of civil society. However, the figuration of the artist as outsider/outrider producing excellence "on the cutting edge" is a fleeting backward glance to the Peace Corps vision of 1963–64, in which the elitist scorn and disruption of the Romantic are brought into the service of society to contain dissent. Culture as a residual impulse becomes a key means of registering a diffuse range of dissatisfactions with an emergent capitalist order. Signifying art as "making it new" does move away from a nostalgic focus on transmitting the best of the past, but nonetheless opens the path for a depoliticized contemporaneity that places on the artist a burden of constant renewal with a consequent valuing of the fashionable, the trendy, in a continuous effort to overcome complacency with what may too quickly become familiar. Technology, not art, came to define the model of interpellation and incorporation of the population by government in the making of citizens. This function is

officially accorded to the arts in the OAC's institutional positioning in 1992–93 where it reports to the Ministry of Citizenship, Culture and Recreation and no longer to the Ministry of Education, such structural transformations signifying changes in public policy. Through the differing probable fictions that represent a population to itself as a cohesive "people," such governmentality constitutes the imagined community of "Ontario."

Constants in the reports of the OAC for 1963 and 1993 are the triumvirate of state, education, and business through whose interaction culture is articulated and managed. This power/knowledge nexus orders specific practices affecting what and who gets funded to constitute symbolic capital, so mobilizing desire for cultural recognition in the work of subject constitution and class differ- entiation. If knowledge gleamed brightest in the 1963–64 report, where the arts create new forms of understanding, technology speaks loudest in that of 1992–93, where the arts work though new media in a morphing of the social. That business has long been the hesitant partner reluctant to recognize the embeddedness of its social relations with their communal ties to art or polity is indicated in the contradictory discourse on culture of the first report. That business has become the dominant force to be courted is indicated in the discourse of the 1992–93 report which is framed in the truth claims of the balance sheet. In the interval, "balance" has been reconfigured so that instead of being a figure of mediation among competing claims, it has become the restrictive figure of a single framing of the social: the bottom line.

By 1996–97, the language of balance and diversity had been replaced by praise for innovative "partnerships" linking individual arts organizations with specific "private" enterprises or wealthy benefactors. In a complete reversal, "private" is resignified as "public interest." This semantic reconfiguration naturalized a radical shift in social relations of power to privilege economic relations producing surplus value manifest in the changing discourses of the OAC. Its annual report for 1996–97, reduced to a balance sheet, includes only a brief prefatory "message" from the executive director, Gwen Setterfield, that enumerates some examples of how the Ontario arts community over the year was "adapting to change, creatively." In the face of massive financial cutbacks, a downsizing in the staff of OAC, and reductions in grants for the arts, "creativity" was directed toward "survival" where it was "an essential tool" sparking such lauded "partnership" initiatives as the "fundrais- ing" of the Tom Thomson Memorial Art Gallery in Owen Sound through community film nights, auctions, and other events to build new gallery space, the pooling of resources to market small theatre group productions initiated by the Go-7 group in Toronto, or the "private sector partnerships" of the Ottawa Council for the Arts with a local software company to establish the

Corel Endowment for the Arts. Fewer resources forced the arts community to find "creative" ways to continue supporting the arts, while maintaining "an appropriate level of service." Dominant in that service for Setterfield is "the financial management of our funding programmes" whose considerable impact on the Ontario economy was demonstrated in the 1996 research study undertaken by Informetrica, *The Economic Impact of OAC-funded Arts Organizations*, which revealed "compelling evidence about the value of public funding of the arts"—economic value, that is, in terms of jobs, direct expenditures, and "tax revenues."

Such economic imperatives are paramount for Jackman in 1998. They are no longer couched in the language of prudent husbanding of the resources of the state to fulfill its mandate of good government used by Setterfield, but those of "job creation, skills training, visitor attraction, urban renewal, economic development, corporate marketing and consumer attractiveness" which make them "one of the soundest investments" for government. "The arts are partnerships," he declares, not a strategy for survival, as Setterfield put it, but the mode of institutional structure appropriate for business. Vanished are the ethics of concern attending to alterity that will produce enlightenment through the arts in the rhetoric of the sixties, or managing diversity through the production of hybridity that will create innovative (social) technologies through the arts in the rhetoric of the early nineties. Creativity manifests itself in "creating partnerships, alliances, and other *imaginative* ways of earning revenue that companies the world over are fashioning every day."[23] For Jackman, the imagination is most powerfully engaged in fashioning corporate structures for artistic practices. This is in no way continuous with the figuration of state intervention in cultural and social relations that has been traditional in the discourses of the OAC. An inversion, rather. Instead of intervening to persuade business to donate to the arts and so yoke together these heteronomous spheres, the OAC now restricts itself to providing tools for arts organizations so that they can individually, and in competition with each other, beg for corporate funding. The emphasis on corporate institutionalization is, however, in alignment with the new managerial structures that have been set in place at OAC in the course of downsizing. Whereas previously the officers with multiple fields of expertise worked in a collegium as intermediaries between the arts communities and state funders, generating policy through consultation with both and coordinating juries' assessments of artists, re-organization of the OAC along the hierarchical lines of a corporate bureaucracy has established a top-down structure whereby officers report to an executive committee in charge of various programs, so centralizing enforcement of policy directives.

"Soundings" to consult with the arts community have been replaced by letters signed by the OAC executive director or chair announcing changes to grant recipients. Such institutional administrative changes make it easier for policy initiatives of the OAC board to affect all aspects of the operation of the OAC. No longer functioning autonomously within a field of self-regulating cultural production, the OAC is being re-established along the lines of a ministry as an agent of government administrative authority where the heavy hand of Cabinet touches every decision.

The change is palpable in the pro-active role taken by Jackman as chair of the board both in initiating policies, as he claims in regards to the Arts Endowment Fund, and to the soliciting of Donna Scott's candidacy as new executive director, and in taking to the hustings to have his say in the struggle over the resignification of culture as a business corporation. Signing his name as Hal in the *Globe and Mail*, rather than Henry or H.N.R. as he appears in the official publications of OAC, Jackman assumes the guise of ordinary citizen. Nonetheless, this move to articulate OAC policy in opinion pieces in the daily newspaper has affinities with the Tories' recourse to government-paid advertising of programs through which to engage Ontarians directly as consumers, not as citizens through elected representatives in the Legislative Assembly, and so interpellate them as subjects of the official discourse all the while neutralizing its political agenda by presenting values as naturalized facts. This opinion piece is in keeping with changes at OAC when policy statements are no longer made in the annual report but emerge as publicity, sent out as press releases to the newspaper, elaborated in occasional publications such as *Notepad*, conveyed in letters to organizations and individuals from the arts community where they announce surprising changes in grant criteria.

In our current market-dominated society, a society in which to be outside of the market amounts to being outside of society itself, it becomes nearly impossible to circulate alternate discourses of value. When the market is deregulated at the same time as government sources of financial support diminish, the problem is accentuated since in the general scramble to survive, ethical, intellectual, and social values are increasingly downplayed or neutralized. Nonetheless, claims on the polity in the name of a heteronomous project of society are still being advanced by the arts community in a web of interconnected relations tying cultural productions to the social matrix that contrasts with Jackman's attempt to sever such relations. The "careful balance" of public and private sector support of the arts "has been fundamentally altered," warns the Toronto Arts Council which conceptualizes culture as a "complex combination" whose dynamism is related to the mediation of social relations, to which it contributes even as it depends upon mediation. Government support of the

Ontario arts funding under fire

arts should "enhance, not diminish, artists' opportunities to contribute to their community."[24] Maintaining a balance between different cultural communities both large and small sustains the "arts ecology" of the city, the province.[25] Publicly funded art contributes to "collective well-being" within a network of interacting processes. Subscribing to this vision of art's dynamism in the constitution of civil society, the Canadian Conference of the Arts configures the diversity and interdependency of "the Canadian model, with a *balance* of public and private sector support" in a metaphor of "ecology" instead of justice or metamorphosis: "Any funder's actions can impact on individual organizations and the whole ecology of cultural communities. This interdependency of public programs is inadequately recognized."[26]

Ecology, a concept increasingly operative in political discourses, is in fact not a science of "balance" but of fragility and fluctuation. In contrast to capitalism under modernity, which works by separation and abstraction to constitute discrete spheres, ecology takes a syncretic approach to a whole considered greater than the sum of its parts and examines how variations in one part have direct and indirect repercussions on others. This model of synergistic, interlocking processes has, through its future-oriented focus, lent itself to progressive politics by challenging Darwinian models of competitive individualism with their hierarchies of dominance to advocate more cooperation in social relations so as to overcome the fluctuations produced by exploitative changes to any single part of the system. Certainly, the ecological notion of a field of dynamic, differential relations in which cultural processes are imbricated in social environments contrasts with the unilinear, hierarchical model of culture currently promoted at the OAC. But the ecological model of society as a criss-crossing network of relations can only be implemented by governments who would override individual greed for the benefit of society as a whole.[27] On this question of state intervention in the arts, Jackman's politics diverge from those of the arts community.

Political struggle is organized through signs whereby discursive contestation is dispersed over different institutional sites, each questioning and reworking culturally pertinent signifiers—balance, in the present instance. Since the eighteenth century, the idea of an autonomous, unregulated marketplace that could adjudicate among social purposes has fostered a faith in the market as a progressive institution in which self-serving individual choices will ultimately

benefit all. Now, the invisible hand of the market is poised to grab complete sway over the public sphere and public policy. In so doing, it labels all value except exchange as of "special" rather than of general interest. This semantic resignification of "public interest" constitutes an intervention by neo-liberalism to delegitimize collective struggles for social justice and equality and so stifle public debate on what is a radical restructuring of economic and social policies underway in Ontario. This not only serves to legitimize cutbacks in government activity in its redistributive function, where wealth considered to be "national" is used to improve the life of citizens, cutbacks in funding which have seriously affected the arts as well as education and health, but also transforms the discourses of value by restricting the claims that may be made on the polity in the name of a "civil society" or a collective project of society.

A series of initiatives launched in 1998 should be considered within this context of the long reach of neo-liberalism extending throughout OAC to resignify culture. Since the new board took over, changes have proceeded on the double fronts of institutional restructuring of arts funding and of reworking the criteria of eligibility to change what counts as art—literature, in particular. Together these have refigured artistic practice within the purview of competitive individualism while disavowing the artist's place within the polity. Continuous with the logic of cuts to arts service organizations in order to focus support to individual artists, the OAC's reconfiguration of the literary has the effect of reinstating a concept of the artist as heroic individual transcending the polity, which its policies had long worked to undermine. In 1998, the Council announced it would no longer fund non-fiction books but only novels and poetry. However, it retracted this attempt to exclude non-fiction from a culture's literature when faced with historical evidence furnished by the Writers' Union: Donne's sermons, Milton's essays and other such classics. Subsequently, the OAC board revised grants to periodicals according to the same logic, deeming "literary" only those magazines "substantially devoted to publishing original works of fiction and poetry" or "substantially devoted to critical coverage of the contemporary arts."[28] These new policies carve out an autonomous domain for literature and establish a hierarchy of genres more in keeping with Modernism's valorization of "pure" art than with contemporary theories embracing the blurring of borders and the death of genre. Borders are what is at stake, those between the field of cultural production and the field of

Arts council chief ready to talk to alarmed artists about grants

power, whose relation the dialectic of distinction works to disavow in consti-tuting art as aesthetic or symbolic. A process of differentiating among fields of artistic practice produces "pure" art—art-as-pure-signification differentiat-ed from art-as-commodity—that reproduces a prior differentiation of the social structures of which they are constituted as an abstraction. Disinterestedness, the spontaneity of innate inspiration, insight into a superior reality, constitute the symbolic capital of the author as autonomous genius who is accorded recognition in a rejection of the interchangeable products or collective production of the economic order. Fixing the boundary and establishing a closed field that translates all external determinations into its own principles of functioning and so makes them irreducible to factors of economic, political, or social differentiation—this is the operation of symbolic consecration which recognizes in the literary field as symbolically dominant that which is economically dominated. Culture in the restricted sense of the expressive arts entertains thus a chiastic relation to the field of power. Art disembedded from the web of socio-economic relations and everyday culture serves as a rallying point in the present instance as an alternative to participatory democracy, no longer to industry.

These abrupt changes were fraught with implications for a number of peri-odicals broadly classified under the category of cultural studies which review and analyze contemporary cultural production in a number of media, situating works of art within socio-ideological contexts. Among these, *Queen's Quarterly* and the *Canadian Forum* (the leading publishers of innovative poetry and fiction from the 1920s to the 1940s) represent a venerable practice in Canadian peri-odical publishing stretching back into the nineteenth century that proposed a broad definition of literature as "belles lettres" including works of history, geography, and the economy, as well those in high literary genres, a tradition continued in *The Literary History of Canada* (1965/1990). Taken together with unan-nounced cuts to the professional development programs of Equity Showcase and Theatre Ontario and withdrawal of support to training institutions, the OAC's reluctance to entertain arguments for the pro-active role of little maga-zines in making culture highlights a radical shift in orientation from its initial pedagogical mandate under the Ministry of Education. Art is being redefined in terms of the excellence of the artistic product rather than as a process in which all members of a democratic society are involved for their personal and/or collective development as students or amateurs or professionals. This move helps increase the symbolic capital of consecrated works by canonized European masters over the productions of living Ontario artists which speak to the present moment and local struggles. Such a mummification of culture offers a

neo-colonial model of citizenship. Containing dissent, the current policy of the OAC is yet another arena of the Ontario economy in which wealth generated by the entire society is being transferred into the hands of its richest members.

The ideal of balance in the distribution of resources has not been fully met with the abdication of business from "investment" in the arts, and its weakening sense of the obligations of the polity. At the same time, the corporate sector imposes its concept of value as exchange as absolute. [29] In this privileging of a single fiction (monetary exchange) as constituting the "real," the kind of exploration that makes demands beyond the instrumental, beyond the individual, and of any transformation other than exchange, is constricted which, in turn, has a repressive effect on diversity and dissent. The sense of collective belonging withers in the current proliferation of metaphors of cocooning and dispersed systems. A force of private interest threatening to overflow its limits and to dissolve the bonds of the state is what Hegel considers the most significant menace to civil society. Reframing this move as a political struggle over discourses organizing the social in which the arts play a key role is to underline the discourse of exchange value as only one potential fiction framing the real. ∎

NOTES

1 *To 2001: Toronto Arts Council's Action Plans 1997–2000* (Toronto: Toronto Arts Council, 1997), 23.

2 Military metaphors are prominent in newspaper headlines, for example: "Ontario Arts Funding Under Fire," *Globe and Mail,* July 16, 1998, D2; "Magazines wilt under arts council's fist," *Globe and Mail,* July 10, 1998, C1.

3 *The Cost of Cutting: A Report on Financial Trends in Toronto's Non-profit Arts and Culture Community from 1991 to 1996* (Toronto: Toronto Arts Council, 1999), 4.

4 Elizabeth Renzetti, "Coalition fights arts group changes,"*Globe and Mail,* July 30, 1998, C1.

5 Hal Jackman, "Why the OAC is adding non-artists to its panels," *Globe and Mail,* July 31, 1998, A15.

6 H.N.R. Jackman, "Time to cast the private sector in a starring role?" *Globe and Mail,* January 10, 2000, R4.

7 Gwen Setterfield, "We've met the barbarians, and they're us," *Globe and Mail,* 16 August, 1999, C1.

8 All eleven members have been appointed by the Conservative government since 1996. The only "author" is Linda Frum, daughter of Murray Frum (new chair of the OAC Foundation) and sister of right-wing politicologue David Frum. Jackman's arrival as chair of the OAC board coincided with this revamping of the board. In his position piece in the *Globe,* Jackman explicitly takes credit for another new initiative of the OAC, the Arts Endowment Fund (OAC *Notepad,* December 1998, 1). Jackman's influence as chair extended to inviting Donna Scott to apply for the position of executive director, which she took up in July 1999 (Susan Walker, "New arts council chief looks gentle, talks tough," *Toronto Star,* August 30, 1999, C3).

1976 — *CORIDART*, AN OUTDOOR ART EXHIBITION AS THE VISUAL ARTS COMPONENT OF CULTURAL PRO-
GRAMMING FOR MONTREAL'S OLYMPICS, IS DESTROYED AT NIGHT BY MUNICIPAL AUTHORITIES AFTER BEING ON
DISPLAY FOR ONE DAY. MANY OF THE ARTWORKS HAD ANNOYED MAYOR JEAN DRAPEAU, AS THEY CRITICIZED
AUTHORIZED DESTRUCTION OF THE CITY IN RELATION TO THE OLYMPICS. SOME OF THE ANGRY ARTISTS SUED
THE CITY BUT THE PREVAILING JUDGE RULED THAT THE ARTISTS' CONCERN WERE "FOREIGN TO THE CONCERNS
OF REAL... ART" (BRONSON, 93).

9 Roby Rajan, "Erasures of Economy," *Rethinking Marxism* 9:4 (1996–97), 63.

10 Karl Marx, *Grundrisse* (Middlesex: Penguin, 1973), 163.

11 OAC *Notepad*, December 1998, 5.

12 *The Cost of Cutting*, 6. Arts organizations in Toronto continued to grow between 1986 and
1991, with the number funded rising impressively from 190 to 290. Employment in the
non-profit arts and culture community increased by 11% between 1988 and 1992 to attain
10% of the Toronto workforce, making Toronto the leading centre of cultural production
(*To 2001*, 15; *The Cost of Cutting*, 11). By 1994, the non-profit sector generated a national
economic impact exceeding $1 billion (*To 2001*, 19). Despite a subsequent general improvement
in the economy, the non-profit arts community experienced a sharp downturn. Sudden, deep
cuts by the Tory government of Ontario reduced the OAC's budget by more than 40%. In
1998–99 the budget was $25.3 million, the same as it was in 1974.

13 This disruption of lines of transmission of expertise and tradition is a strategy for
exercizing greater bureaucratic control to implement new policies.

14 *Arts in Transition 2: Harmonizing Public Policies with the New Realities* (Ottawa: Canadian Conference
of the Arts, 1996), 19–20.

15 *The Cost of Cutting*, 13. Ironically, the new lean arts organizations created by government
"savings" of $41 million resulted in a loss in potential tax revenues for governments of
almost twice this sum ($80 million) in the period 1991–96. By 1996, thirty-one of 300 arts
organizations had disappeared (*The Cost of Cutting*, 5). Further cutbacks to OAC funding in the
following year would undoubtedly have multiplied these losses in income and tax revenue.
However, the infusion of one-time only funds by the Toronto Arts Council in 1997 to
enable arts groups to develop strategies to mitigate the impact of the province's cuts, and a
similar short-term increase in the base budget of the Canada Council, softened the impact of
the OAC's abrupt removal of millions of dollars from organizations' cash flows (Ibid., 13).

16 *To 2001*, 39.

17 Ibid., 25.

18 *The Cost of Cutting*, 4.

19 *Arts in Transition 2*, 4. The statistical impact of these opportunities in different cultural
sectors is revealed in "Can Cult Boom" (*Time*, August 9, 1999, 47–69). The article also
reports the results of a poll that found 81% of Canadians thought government support
for culture should stay at the same levels or be increased.

20 Jackman, 1998, A15.

21 Ontario Arts Council, Annual Report, 1963–64.

22 Roy MacSkimming observes that the Council began as "A Gleam in Robarts' Eye" in an
ironically (?) titled *For Art's Sake: A History of the Ontario Arts Council*. Core funding for arts
organizations resulted from the collaboration between John Robarts, a minister of
education recently become premier, and Arthur Gelber, a businessman, active on the
board of the National Ballet and president of the Canadian Conference of the Arts who,

with other such directors tired of repeatedly begging money for their organizations under the table, convinced the new premier to institute public funding for the arts on a stable basis. Significantly, Arthur Gelber died in the fall of 1998 in the midst of the struggle over cultural policy when the OAC seemed to be returning to the very situation he had sought to escape with arts organizations engaging in repeated appeals to diverse bodies for occasional funds.

23 Jackman, 1998, A15.

24 *The Cost of Cutting*, 4; *To 2001*, 16, 28.

25 *Renovating for the Future* (Toronto: Toronto Arts Council, 1998), 9, 32.

26 Ibid., 10.

27 Ecology as a concept is ambiguous in that its emphasis on aggregation and community have also produced conservative discourses of ecologism advocating less government.

28 "Substantially" was first defined as 80% but fixed at 90% in July 1999. The arbitrariness of this "archaic" definition of culture, which considered an article expanded into a book to be art, but not so when in a magazine, was denounced in the national press. For further analysis of these changing definitions see my "Privatizing the Public," *FUSE* 22:3 (Autumn 1999), 27–33.

29 The replacement of the executive director and the chair of the board in 1999 raised hopes for a reversal of these changes in the cultural discourses and policies of the Ontario Arts Council, which since 1963 had shifted from a nationalist, through a participatory model to a market model of the arts. Under Donna Scott's brief tenure as executive director, the OAC continued to cut an already lean administration and so managed to increase grants by 4% in 2000—the first increase in nine years. But "it's not enough," Scott proclaimed in announcing her resignation after only eighteen months. She left her job, she explained in the *Globe and Mail*, because it is impossible for her to "preside over an organization that cannot perform its core functions or undertake necessary new initiatives because its resources are inadequate." Her resignation will focus attention on the dire economic straits of the OAC, she hopes, so as to restore "adequate public funding for the arts." Scott's denunciation of current government arts policy in this article contrasts with her position in the fall of 1999 when she defended the policies of the OAC and identified her own recent initiatives in a critical response (Donna Scott, Letter to the Editor, *FUSE* 22:4 (December 1999), 9) to my analysis of the crisis ("Privatizing the Public," *FUSE* 22:3 (September 1999), 27–33). In justifying her resignation, she develops a line of argument parallel to mine and contrasts Ontario cultural policy of the period 1963–94 with the withdrawal since 1995 of stable annual operating funding that has had a "monumentally negative effect." She too highlights the problems arising from the shift to financing the arts through the Arts Endowment Fund, the Cultural Attractions Fund, and the Trillium Fund that favour arts organizations in large communities with major industries able to enter into partnerships and so foster regional inequalities. Neither do these new sources of income finance arts education, a long-standing, important aspect of the OAC's activity. Nor do they assist individual artists in any way—concentrating support in organizations for the performing arts to the detriment of writers, painters, filmmakers, etc. Scott's analysis of the impact of these changes in funding the arts further supports my contention that culture is being redefined as a product of consumption for the wealthy rather than a process in which all members of society are involved. Her resignation has initiated no institutional change at the OAC, which is currently under an interim director, John Brotman. (Donna Scott, "Why I Quit," *Globe and Mail*, December 4, 2000, A17.)

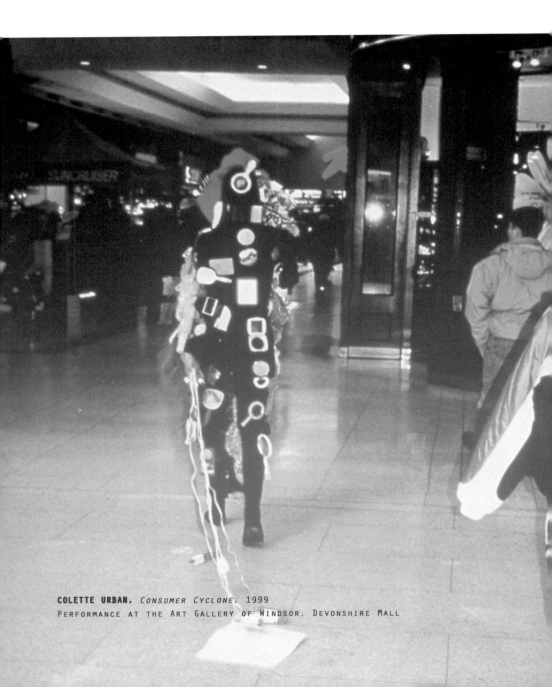

COLETTE URBAN, *Consumer Cyclone,* 1999
PERFORMANCE AT THE ART GALLERY OF WINDSOR, DEVONSHIRE MALL

> ANDREW JOHNSON

The House Always Has the Edge
The Art Gallery of Windsor and the
Ontario Casino Corporation

The context

In the early 1990s, the mood must have been very grim for the folks running the Art Gallery of Windsor (AGW). The gallery was running chronic, unsustainable operating deficits of a couple of hundred thousand dollars a year with no real way out of its dilemma, aside from laying off staff or cutting programming. Outside its walls, the economy—local, provincial and national—was so badly off that nobody imagined any increase in arts funding would happen any time soon. All signs pointed to decreases in arts funding, and only tougher times ahead.

Locally, the cross-border shopping phenomenon saw scores of Windsorites head to Michigan to buy everything from cheap smokes to gas and bread, and in the process threaten the viability of literally hundreds of city businesses. Windsor's unemployment rate sat at about 14%, among the highest in a country that was itself locked into a serious economic recession. That recession was largely blamed on government mismanagement of the public purse by running up uncontrollable debt while overtaxing the citizenry.

Ontario's then New Democratic Party (NDP) government, grappling with a deficit that was growing almost exponentially, was forced to get drastic with public spending, and instituted what came to be known as "Rae-days"(after premier Bob Rae). A share-the-pain approach to addressing its fiscal problems, the plan meant that civil servants were essentially put out of work for better than two weeks per year, without pay. Politically, Rae-days were no better than an unpaid holiday wherein public employees could afford to do little more than ruminate on how much they hated the NDP. Then an innovative way to bring vast numbers of new dollars into public coffers presented itself to the Ontario government: casino gambling.

Casinos were springing up all over North America, including venues in each of Canada's western provinces, turning economic dead-zones into powerful revenue generators. And what better place to plunk down Ontario's first casino than in historically NDP-friendly, economically depressed Windsor — which incidently had a long tradition of being vice-friendly, especially when it meant making a lot of money from the people living on the other side of the Detroit River. The home of rum-running during U.S. Prohibition, Windsor also hosted scores of backroom gambling operations, especially during the 1950s. More recently, Windsor had been known in Michigan and environs as the home of many stripper bars and host to American youngsters enjoying the low legal drinking age.

Besides the vast sprawl of Metro Detroit, only minutes away over (or under) the mile-wide Detroit River, sizable populations of potential casino gamblers were living in places such as Flint, Lansing, Toledo, Akron, and Cleveland, all large cities that are a reasonably short drive from Windsor. With that catchment area, the government was not simply looking at shifting the same dollars around the province, as happens with lotteries. It was looking at bringing in huge amounts of American money, while conveniently leaving many of the expensive social problems associated with gambling on the other side of the border. This new kind of revenue provides governments with the ability to keep lots of people happy: people get jobs, the municipal government gets tax dollars, the casino hands out cash to worthy motherhood-issue charities such as hospitals, the police force gets more cops, etc., etc.

Once Windsor's involvement in the gambling initiative was announced, people in the city switched from talking about the recession to talking about revitalization. There were even rumours of land speculation in downtown Windsor. Enthusing about the news, an editorial in *The Windsor Star* stated, "This was the first tangible sign that there might be light at the end of the recession tunnel. And no one in Windsor had felt that confident about the local economy in a very long time."[1] Everyone wanted a piece of the action, including the AGW.

At the time Ron Ianni, the University of Windsor's president and incoming chair of the AGW board of directors, also sat on an ad hoc committee set up by the city to advise on its burgeoning interests in casino development. Ianni quickly grasped the fact that while many in Windsor were anticipating a big payout, there was no guarantee that either the city government (which I will refer to as "the city") would get what it wanted, or that any of the money would end up in the gallery's pockets. Besides, with nothing more than more AGW deficits to look forward to, it was time to act, and act they did.

Ianni spearheaded the nomination of the downtown, riverfront AGW building as the site for the interim casino. A permanent casino would be years away and opening an interim casino somewhere in Windsor would allow the province to start cashing in right away. The AGW was suddenly in possession of something that could be exchanged for the right price, identifying its building and location as negotiable assets. While many galleries are synonymous with the space that they occupy (the Art Gallery of Ontario, for instance), the AGW did not share that burden. Although no one could wish for a better location, looking over the river towards the towering buildings of Detroit, the building itself was a renovated beer warehouse that was arguably too big for the AGW's budget. Also, its ceilings were too low and it stood in need of some serious repairs, such as a costly new roof. In February 1993 Nataley Nagy, who at the time was the incoming director and did not yet have a home in Windsor, prudently consulted with two board members about Dr. Ianni's radical plan. What she heard from them was rather blunt: "The casino's coming to town and everyone is going to make out. What are we going to do? Let's get into the action now."

The deal

On June 30, 1993, it was announced that the gallery would in fact be the site of the interim casino. The deal between the AGW and the Province of Ontario (soon to be overseen by the Ontario Casino Corporation, a.k.a. the OCC, now known as the Ontario Lottery and Gaming Corporation) specified that the casino would occupy the gallery's space until a permanent casino was built, and that the gallery would be returned to its downtown location in just under three years. During that time the gallery would take up occupancy in the huge, suburban Devonshire Mall, in the space of a former furniture store. The casino would have a free hand to renovate the gallery, making it appropriate for its enterprise, then retrofit the building for the AGW's return, restoring it to the "quality, nature, and function" of the former gallery. The gallery would receive $2 million per year in rent from the Province, out of which it would in turn pay for the leasing and renovation of its mall location. What was left over would be retained by the Art Gallery of Windsor Foundation.

The AGW was acting like a private enterprise: signing big-money deals, acting as landlord to the OCC and their casino, and making a tidy profit in doing so. It needed to retain its charitable status, however, and so it used the Art Gallery of Windsor Foundation to receive and administer the funds. Governed by a separate board of trustees (including powerful members of the gallery's board,

namely the president, the gallery director and the past president), the foundation "receives and administers gifts and bequests on behalf of the Art Gallery."

The endowment of the foundation was a key component to the gallery's long-term strategy. Although the gallery had a number of funds in place, earmarked for such things as future building expenses and the development of the permanent collection, these funds were restricted and did not even equal the gallery's operating expenses for one year. This, according to experts in the area of museum administration, was a dangerous situation for an institution such as the AGW to be in. In a report on endowment funds, *Museum News*, a glossy magazine for museum professionals, argued that "a minimum prudent ratio for an endowment to operating fund is 3 : 1 to 5 : 1. That is, if a museum's operating fund is $1 million annually, it should have at least $3 million to $5 million permanently invested, with interest income generating 15 to 25 percent of operations."[2] By taking the development of the foundation seriously, the gallery was operating in terms of the best practices of the culture industry.

In its most recent (1998) annual report, the AGW reported that its foundation was worth $7,645,833, approximately four times the annual operating budget of the AGW. The foundation's nest egg grew as large as it did as the result of the OCC twice extending its lease. In the process, they accepted terms that were favourable to the gallery (for instance, the AGW was able to raise the annual rent from $2 million to $2,342,000), while reflecting the value that the facility had to the OCC. While the foundation money is, for the time being, set aside for whatever the future may hold, the interest on that money, between $500,000 and $600,000 a year, goes towards running the AGW. Nagy contends that that money simply makes up the former operating deficit, or as she puts it, it "just plugs the leak" that would never have gone away if the OCC deal had not come along. In other words, despite its new relative wealth, the gallery has not radically changed its operations. The staff has not ballooned. The library is still sporadically run by the volunteers. There are no over-the-top catalogues accompanying each new show.

In its first year of operation Casino Windsor, housed in the old AGW site, pulled in $419 million in gross gambling revenue, with 20% of that (that is, nearly $84 million) going directly to the Province. Of course that is merely a drop in the bucket when compared with the true windfall of tax dollars that the introduction of gambling, with all of the union wage jobs and other assorted spending associated with the casino, provided for all three levels of government. In a press release put out after its first year of operation, the OCC claimed

that "the federal government received $96 million, the provincial treasury received $264 million, and Windsor-area municipalities received $20 million. These revenues include personal and corporate income taxes, goods and services tax, tariffs, the win tax, provincial sales tax, property and business taxes, etc." Even if the press release indulged in a bit of hyperbole when citing its figures by, say, not accounting for how much running such an operation costs each level of government (for example, the cost of renting the AGW's space or the cost of creating a new bureaucracy such as the OCC), the fact remains that gambling resulted in huge economic gains.

Being asked to rationalize operations, focus on core competencies, generate revenue, and operate in terms of good business practices, all add up to being accountable to (government) funders, and thus to taxpayers. It is about justifying one's operation not in terms of what you do, but how you do it. If you are given a certain amount of money and you manage it in the way that is demanded of you, then you must be managing it well. If you are a gallery, the fact that you may or may not be doing good programming is beside the point, mostly because that is not easily quantifiable. One signal of approval for the way the AGW was carrying out its business came in 1996 when the gallery won one of the Lieutenant Governor's Awards for the Arts. The award, and a cheque for $10,000, was given not for excellence in curatorial practice, not for outstanding outreach programs, but because the gallery was good at attracting money from businesses and donors. Director Nagy wrote in the gallery's quarterly newsletter, "This award recognizes the AGW's success in increasing private sector and community support over the past three years." That is, in the years since the gallery cast in its lot with the casino.

Devonshire Mall

While the AGW, as a regional art gallery, was and is a major cultural force in Windsor, its national profile was pretty well non-existent. But when the gallery opened at the Devonshire Mall the event was reported in newspapers across the country. Shirley Thomson, a former Windsorite who was then serving as the director of the National Gallery, was quoted in the *Ottawa Citizen* as saying that the AGW's move to the mall "was an ingenious solution to a delicate problem...." Tellingly, no one mentioned what art was on the walls or how it was displayed. The cultural conversation was wholly displaced by the conversation about money, about the economics of culture and its latest upshot: art goes to the mall.

In its tenure at the mall, the AGW has continuously and ambitiously exhibited and programmed. They have originated major contemporary shows such as

1977 – FEDERAL PARLIAMENTARY STANDING COMMITTEE ON BROADCASTING, FILM, AND ASSISTANCE TO THE ARTS QUESTIONED AWARDS TO QUÉBEC ARTISTS WHO OVERTLY SUPPORTED QUÉBEC INDEPENDENCE (WOODCOCK, 100).

Studiolo: Collaborative Works of Lyne Lapointe and Martha Fleming, an amazing display of assemblages and artifacts drawn from the work of the former collaborators' site-specific installations. In the area of historical exhibitions, *Making it New! (The Big Sixties Show)* featured the locally infamous Les Levine performance that involved spreading box upon box of cornflakes on an open field. Although the performance yielded a storm of protest, whipped up by fairly obvious antagonism towards the AGW by *The Windsor Star*'s editors, it did manage to draw a large number of visitors into the gallery. Viewers of that show were treated to a snapshot of the exciting burst of artistic energy that hit Canada in the 1960s courtesy of Greg Curnoe, Michael Snow, Iain Baxter, Joyce Wieland, and many others.

Yet despite some excitement about being out at the mall, bolstered by an initial surge in attendance, the potentially potent curatorial engagement with the mall never fully materialized. Conceding that its current location has been a "stimulation" to programming, contemporary curator Helga Pakasaar is quick to get back to the realities of the retail world. As she puts it, "Even though [the mall] is often billed as a kind of public space or a town square, it is in fact a very corporate space and the managers have very particular ideas about how the consumers have to be not distracted...." Similar observations are made by Rachelle Viader Knowles, who for a time acted as the gallery's education curator: "The minute you do anything out of the ordinary you get questioned." Knowles relates the story of how, during an afternoon of mall-management approved performance art, security guards tried their best to stop artist Colette Urban from speed-walking through mall corridors wearing a catsuit covered in corporate logos and vanity mirrors alternately calling out to shoppers "Look at me! Look at you!" and honking a horn. While you could say that such a reaction merely adds some colour to the performance, not to mention vividly demonstrating that the performance is as effective as it is political, it did nothing to encourage exploring connections between the gallery and the mall. In fact, according to Knowles, it puts those responsible for proposing projects to mall administrators in the position of "almost having to pull the wool over their eyes." The mall administrators have not shown themselves to be particularly receptive to consumers experiencing art, especially if that experience breaks the flow of shopping (not to mention calling into question the consumer experience), and gallery staff are put in the uncomfortable position of having to downplay the potential impact of anything they propose.

Anticipating its post-mall future, the gallery's website states: "When the AGW leaves the mall, we will have learned more about how art finds its place in our culture." What this wonderfully elliptical statement does not specify is

exactly *what* the gallery will have learned. Perhaps the lesson is that art finds its place in our culture only when it crashes the party, when it imposes itself or perhaps stands there unannounced to be stumbled over. Either way, it is not welcomed precisely because, as the gallery's website also points out, "In shopper's paradise the gallery offers one of those few things in life you do not need to purchase to possess." If it does not create a return, profit-oriented interests want no part of it. Renting out a building through which huge amounts of money can be made is okay. Being a major tenant in a shopping mall is okay. Presenting art, in a community like Windsor, that may at times challenge, upset, or otherwise get in the way … that's not okay.

Goin' downtown

The fact that the gallery is a gallery and not a business, no matter how much it may at times look and act like one, became abundantly clear as the end of construction on the permanent casino was within sight. The city and the OCC now wanted the gallery to move into a new $154-million hotel/office tower development (slated to become the new headquarters for Chrysler Canada— one of Windsor's largest employers) in the city's core. The gallery, however, had other plans. In November 1998, with site planning studies complete, the AGW made the surprising announcement that it still intended to return to its old site, with a retrofit from the departing casino. The government's office tower proposal was deemed unacceptable for a number of reasons, not least of which was the fact that the gallery, while offered a massive 113,000 square foot space, would again be a tenant in someone else's building, humbly playing by the landlord's rules. Further, the gallery would not be on the ground floor, open and inviting to the public, but would be up an elevator sitting above the development's convention space.

One reason that observers were taken aback by the gallery's decision to return to its former home was the fact that another development had been proposed for land that included the site. The so-called Western Super Anchor was to be a $79-million multi-purpose development, including commercial property and a sports and entertainment arena. According to Nagy, what that development really needed for it to work was a casino. Without it, no one would be willing to carry through with the balance of the project. The well-connected Nagy matter-of-factly points out, "We knew from the inside that the casino was not going back there."

For many in Windsor, it was accepted wisdom that the AGW's former home would simply become another permanent casino, leaving Windsor's downtown

core with gambling at its far east and far west ends. The city was already used to the idea of having two casinos, since the overwhelming success of the interim casino had lead to the temporary introduction of the Northern Belle, a paddle wheeler-cum-casino that was docked in the Detroit River. Recalls Nagy, "I heard again and again that the interim casino would not close." As early as the day after the interim Casino Windsor opened in 1994, *The Windsor Star* ran a story on the persistent rumours concerning the fact that the gallery would never return to its former site. In the story Nagy acknowledged that she had toured a number of locations that were being proposed as alternative homes for the gallery. Still, she reiterated the independence of the gallery and its insistence on making its own decisions, on its own terms: "It's our decision to make. It's very possible that we'll say, 'No thank you'."[3]

Yet when the gallery gave notice that it intended to return to its former location, both the city and the Western Super Anchor developers called foul. Mike Hurst, the longtime mayor of Windsor, argued that because the gallery had, over twenty years, received $25 million from the city and its taxpayers, it could not consider itself wholly independent of the city and its priorities. In other words, while the gallery was in fact within its rights to follow through on the terms of the contract it signed with the Province of Ontario, it should not have done so. Because the city and its private partners had something bigger and better up their sleeves, the gallery should have made way. That sort of reaction definitely rankled with some in Windsor's cultural community. As Christine Burchnall, one of the directors of the artist-run centre Artcite puts it, "I don't think the fact that the AGW receives money from the city means that it should serve the interests of a private developer."

The problem of course is that there is no way to fairly and adequately make compromises between a community's desire to express itself culturally and its need to secure for itself an economically viable future. When times are bad, when gallery staff are starting to fear layoffs given that no one else in the city is working, then compromise and dealing in good faith are the order of the day. When times are good, when the half-billion dollar Casino Windsor is going in down the street and builders are setting their sights on the balance of the downtown's real estate, figuring out how to get the biggest bang for the buck is the new bottom line.

By March 1999, a complex deal was completed that made all the principle players—the city, the gallery, and the OCC—happy. The gallery received $20 million from the OCC to construct a new, purpose-built building, a first for the gallery in its fifty-plus year history. In turn the city was able to purchase

the most westerly part of the block containing the former gallery for $2 million from the AGW. With the city holding title to the western portion of the gallery's old site it would be able to tear down the former beer warehouse/ gallery/casino and keep alive the plan that someone would use that land and adjacent property for the development of the Western Super Anchor. The city also spent another $4.9 million on buying out a private developer who held a long-term lease on one of Windsor's great albatrosses, a burnt-out former Ramada Inn that sat on the city's waterfront. With plans to knock that ruin down, the city would then secure for the citizens of Windsor a riverside park that would stretch uninterrupted from the Ambassador Bridge on the city's west side to the Hiram Walker distillery on the city's east side, a demonstration of public civility that few cities in Canada can come close to matching. The OCC, aside from its monetary commitment to the new gallery, purchased the city's former farmer's market site for $6.5 million. There are a few rumours that the OCC will simply put in a commercial retail development, but they are, after all, in the casino business. The pragmatic observer must assume that when the time is right the OCC will set up another gambling facility, especially given that Detroit is in the process of bringing in a number of very large casinos. That argument simply follows the inexorable logic of the gambling business that the only way to compete with size is to get even bigger.

Conclusion: Doin' business with business

In the context of dismissing the idea that museums could aim to be "exciting spaces" or "interesting spaces," artist and thinker Robert Smithson stated flatly that "utility and art don't mix."[4] Smithson, conscious that he was merely repeating a fairly old idea, was reminding us that what makes art interesting is the fact that it is useless, it has no utility, it does nothing. Although art may look like a sign that points somewhere, it can never get us there. We may be unsettled by art, or think about it, or laugh at it or whatever. Yet we do so precisely because art confounds our desire for it to do something. If art was actually able to do something, it would be exhausted as soon as its task was complete. The object, the scene, the gesture, the sound or whatever mode of expression is chosen takes on its status as art because it is not doing anything else but being art. In our present context this idea highlights the reason why the private sector cannot be counted on to fund art making, or the exhibition of art, in a way that would allow those activities to become economically self-sustaining. Such an act would be an investment in something that does not provide the kind of return that can be added up to create an even greater

return. The reason that the AGW was able to bring the OCC to the point of spending over $40 million on a deal with an art gallery was the fact that the OCC got a massive return for its investment. Although it is a public organization, the OCC is operated as a business. It carries out its enterprise at arm's length from its political masters, currently the Ministry of Tourism, Culture, and Recreation, which is lead by an elected Cabinet minister. The executive of the OCC are hired to run the operation as a business. And like all good businesses, they set out to make as much money as they possibly can.

The private sector will be glad, for instance, to underwrite a show if it gets something out of it. These days private companies seem to see some high-profile public galleries as a vehicle for marketing their image as a plugged-in, relevant corporate entity, often times through the repetition of the logo on signage and promotional materials. As Robert McKaskell, the AGW's curator of historical art and the collections, describes it, the presence of corporate marketing materials in our art galleries no longer makes an impact because it has "become part of the mental habit of this time."

One of the most serious concerns of the AGW will be its ability to continue to raise funds in a community where, for the last seven years, it has been connected to an organization that is associated with extremely large amounts of money. Nagy points out that when everything is added up—the lawyers' fees, the consultants' fees, the direct payments, etc., etc.,—the deal between the OCC and the AGW was worth over $40 million, but quickly adds, "I don't like to say that too much." Her reluctance to quote that figure is not because the deal has cost so much, it is because of the possible public perception problem (the kind of thing that risk-averse businesses have to think about, and manage). If people hear that you have been the recipient of that kind of money, they might think to themselves, "Why should I give them any money? I hear they got $40 million from the casino." Of course, the money did not go directly to the gallery per se, it went to many other outstretched hands (the above-mentioned lawyers, consultants, along with architects, accountants, etc.), along with the foundation, which is responsible for providing for the gallery over the long haul. If the foundation is going to be able to keep its money in trust for the future of the gallery, the gallery will certainly have to continue to rely on the all three levels of government—and yes, on private sector partners—for its funding.

This need will be felt even more acutely in the new gallery location, not only because that building will cost more to run (no one could tell me how much more, although architect Gene Kinoshita maintains that the AGW will have to hire an engineer just to run the building's sophisticated systems), but because

the building will not be completed when the gallery is opened to the public. The $20 million originally given to the gallery by the OCC is simply not enough to construct the building that was designed for them. While the new building will be up and running and able to function, some areas of the gallery will merely be roughed in. Rather than scale back the plans, or cut back on the quality of materials, Kinoshita maintains that, "We would rather defer things." What that translates into is if, for instance, they decide that they cannot afford the full complement of lighting originally called for, they will put in place an infrastructure that will accommodate the desired amount of lighting, but cut back on the number of fixtures that are purchased. Alternatively, if they cannot afford to furnish a given room in the way that it was intended, they may decide to leave it unfurnished and offer to name the room for a patron in exchange for completing the work on that room.

Ironically, the reason that the gallery will most certainly cost more than the originally budgeted $20 million is due to the fact that Windsor, in stark contrast to the early 1990s, is going through an economic boom. While the casino has certainly provided lots of high-paying union wage jobs, it is the auto industry that really makes the town click, and that industry has been making money hand over fist for the past few years. More than just putting mini-vans together for Chrysler and engines together for GM, Windsor has also capitalized on technological changes in the industry and made itself the epicentre of mold-making. Given that few parts in today's cars can be made without a mold, and each car has thousands upon thousands of individual parts, that has translated into a great deal of money for a lot of people in Windsor. What all of that translates into is a great number of new buildings going up in Windsor and the surrounding area. Of course, where there is greater demand on everything from tradespeople to building materials, the price just keeps going up. The more prices go up, the less will get done in the new Art Gallery of Windsor before it opens its doors. Of course, that is just the cost of doing business.

NOTES

1 Editorial, "Royal flush: The economy wins," *The Windsor Star*, October 7, 1992, A6.

2 Joan Marshall and Anne Farrell, "The Endowment: Securing the Future Now," *Museum News*, July/August 1999, 54.

3 Gary Rennie, "Art gallery director unfazed by rumours," *The Windsor Star*, May 18, 1994, A3.

4 Robert Smithson, "What is a Museum?: A Dialogue Between Allan Kaprow and Robert Smithson" in *Robert Smithson: The Collected Writings*, Jack Flam, ed. (Berkeley, CA: University of California Press, 1996).

1978 - Federal MPs (including two from British Columbia) launch crusade against Canada Council funding of obscene art. Singled out are a performance involving dead animals at the Western Front by Hermann Nitsch and allegedly pornographic writings by poet Bill Bissett. In the aftermath, the B.C. Cultural Front reduces Western Front's operating grant although Canada Council director Tim Porteus decides that the Nitsch performance was aesthetic, not pornographic.

U1 DOG TRACK AND BARS

U2 ROLLER RINKS: DISCO AND HOCKEY.

U3 DANCEATERIA WITH D.J. BOOTH

U4 SCRATCH + SNIFF GALLERY

U5 MEMBERS EXHIBITION AREA

U6 THE MONEY HOUSE FOUNDATION

U7 CLOTHES SWAPPING ROOMS

U8 ARCHETORTURE THERAPY SUITE

U9-12 HETROSEXUAL ACTIVITY ROOMS

U13-17 ARTIST STUDIO'S

U18-20 FREE PARKING MEMORIAL WING

U19 ESCAPE HATCH

U21 HOMO EROTIC VOYUER PARLOUR

Art Gallery of

UL
Upper
Level

BLADE RAMP ↑↓

BAR U1

U1

ntario **Floor Plan** (Better Use)

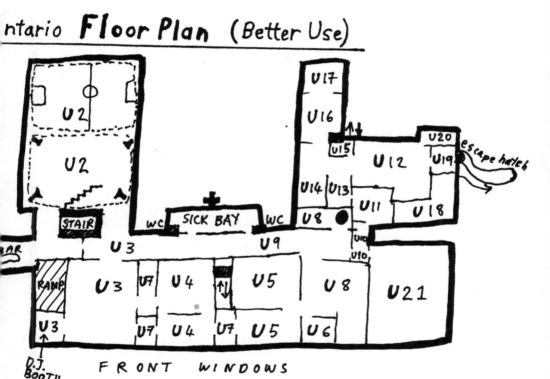

1978 - THE CANADA COUNCIL INTERVENES IN CONTROVERSY AROUND TORONTO'S A SPACE'S ALLEGED FINANCIAL MISMANAGEMENT, PROBLEMATIC PROGRAMMING, AND LACK OF ACCESSIBILITY. THE COUNCIL FREEZES THE GALLERY'S OPERATING FUNDS BUT ALLOTTED A SPACE $10,000 TO PREPARE A STUDY AND SUBSEQUENT PLAN FOR REHABILITATION. THE GALLERY RELOCATES AND RESTRUCTURES ITSELF WITH AN EMPHASIS ON "SATELLITE PROGRAMMING." PROGRAMMING BY THE GALLERY'S STAFF IS REPLACED BY THAT SELECTED BY INDIVIDUAL CURATORS FOR VARIOUS DISCIPLINES.

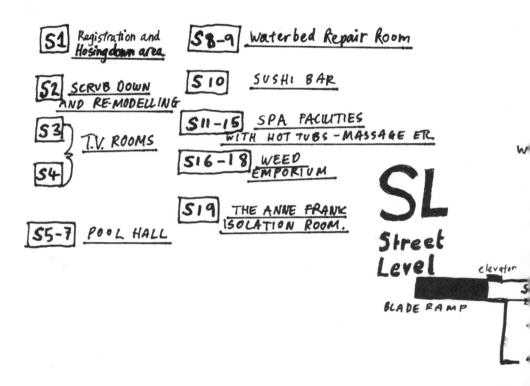

Art Gallery of

S1 Registration and Hosing down area

S8-9 Waterbed Repair Room

S2 SCRUB DOWN AND RE-MODELLING

S10 SUSHI BAR

S3 } T.V. ROOMS
S4 }

S11-15 SPA FACILITIES WITH HOT TUBS - MASSAGE ETC.

S16-18 WEED EMPORIUM

S19 THE ANNE FRANK ISOLATION ROOM.

S5-7 POOL HALL

SL
Street
Level

elevator

BLADE RAMP

MAI
Entr

tario *Better Use FloorPlan*

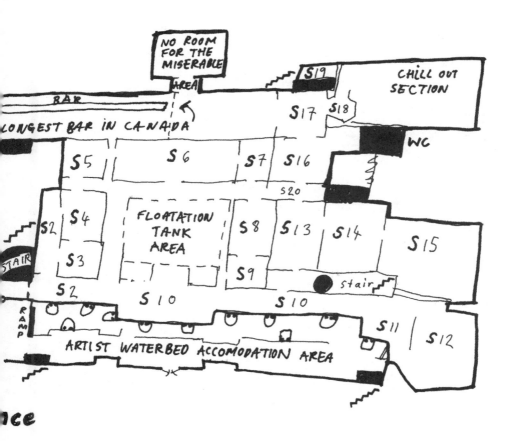

NO ROOM
FOR THE
MISERABLE
AREA

CHILL OUT
SECTION

S19

BAR

LONGEST BAR IN CANADA

S17 S18

S5 S6 S7 S16

WC

S20

S2 S4 FLOATATION
TANK
AREA

S8 S13 S14 S15

STAIR

S3

S9

S2 S10 S10 stair

S11 S12

RAMP

ARTIST WATERBED ACCOMODATION AREA

ce

1978 - FEDERAL CONSERVATIVE MP TOM COSSIT CALLS FOR JUDICIAL INQUIRY INTO OPERATIONS OF THE CANADA COUNCIL, IN RESPONSE TO CENTRE FOR EXPERIMENTAL ART AND COMMUNICATION (CEAC) PUBLISHED EDITORIAL IN THE PERIODICAL *STRIKE* ADVOCATING TERRORIST ACTIONS À LA ITALIAN RED BRIGADE. THE MP'S MOTION IS VOTED DOWN, BUT FEDERAL, PROVINCIAL, AND MUNICIPAL FUNDING AGENCIES WITHDRAW FUNDING TO CEAC (DOT TUER, "THE CEAC WAS BANNED IN CANADA," *C* MAGAZINE, VOL. 11, 1986).

of Ontario Floor Plan .

artment and services

.

L 10
E. JAMES

N

L 11
J. HENDRIX

L 9
L. DORSEY

L 12
C. CARTER

L 8
C. TWITTY

L 7
A. GREEN

L 6
B. WHITE

GROUP
ENTRANCE

cafe 📷 Photo 🍸 martini

Favourites

L1 = One of those nights
L2 = Is that all there is?
L3 = Hold on, I'm Coming
L4 = Half Breed / The beat goes on.
L5 = I put a spell on you / Do you really love me, baby?
L6 = Can't get enough of your love, Babe.

L7 = So good to be here
L8 = Is a blue bird blue?
L9 = Ride your pony
L10 = At last / Baby, what you want me to do (Live)

L11 = Foxy Lady / Angel
L12 = Soul Deep
L13 = I want to take U higher
L14 = Get it while you can

1979 — FORMATION OF THE ASSEMBLY OF BRITISH COLUMBIA ARTS COUNCILS AS AN ADVISORY ORGAN-
IZATION FOR REGIONAL ARTS COUNCILS IN THE PROVINCE.

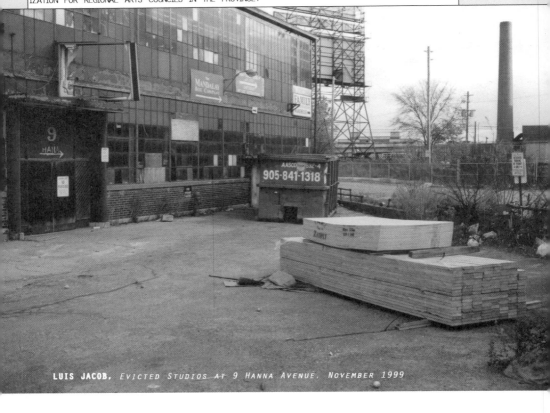

LUIS JACOB. *Evicted Studios at 9 Hanna Avenue. November 1999*

> LUIS JACOB

Evicted Studios at 9 Hanna Avenue, November 1999

These images depict several spaces at 9 Hanna Avenue—an immense old industrial building in the King/Dufferin district of Toronto. As industries trickled away from this area through the years, this and surrounding buildings were changed to provide various businesses with warehouse space, and various artists with the space for living and working. Frequently it was these artists themselves who transformed raw space into working/living space with plumbing, heating, ventilation, and other necessary amenities. For many years now, the area at King/Dufferin has been synonymous with artists' studios.

During the final months of 1999—in what turned out to be only a first phase of evictions—everyone renting the spaces at the western part of 9 Hanna Avenue was evicted, to make room for the demolition of that part of the building, and its conversion to parking space for the automobiles of the building's projected tenants. *Evicted Studios at 9 Hanna Avenue, November 1999* documents the remains of these hollowed-out spaces.

There's an irony in how artists themselves participate in the processes of a city's gentrification, and in their own displacement. While it is futile to bemoan changes in a city's working and living spaces—for artists and non-artists alike—simply because these are changes, we might give thought to the relationship in society between those who live in a space and those who own it. The people who live in a space, who work to make it what it is, who dwell there and are most affected by the kind of space that it becomes—are all too often not the same people who have ownership of the space, who make decisions over it, and who finally have authority over it. The relationship between these two groups is characterized by a constant, one might say "normal" violence—though one which from time to time erupts in the experience of forced evictions or resistance.

1979 - LIVING MUSEUM COLLOQUIUM, ORGANIZED BY ANNPAC AND SPONSORED BY THE CANADA COUNCIL, IS HELD IN GRAND VALLEY, ONTARIO. THERE WERE SIXTEEN PARTICIPANTS, CHOSEN ACCORDING TO REGION AND ARTISTIC DISCIPLINE.

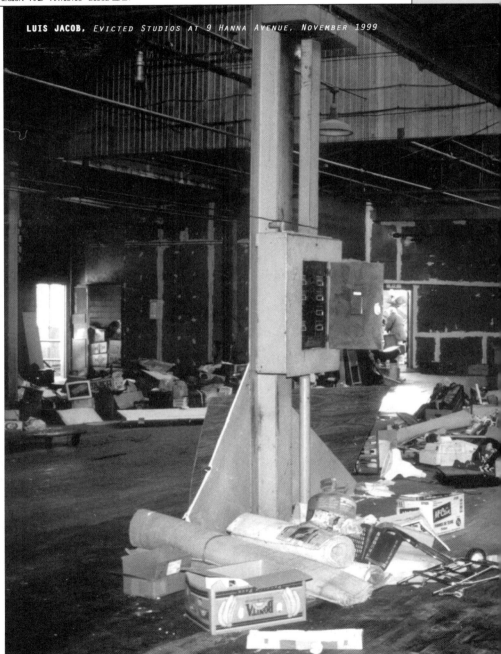

LUIS JACOB, *EVICTED STUDIOS AT 9 HANNA AVENUE, NOVEMBER 1999*

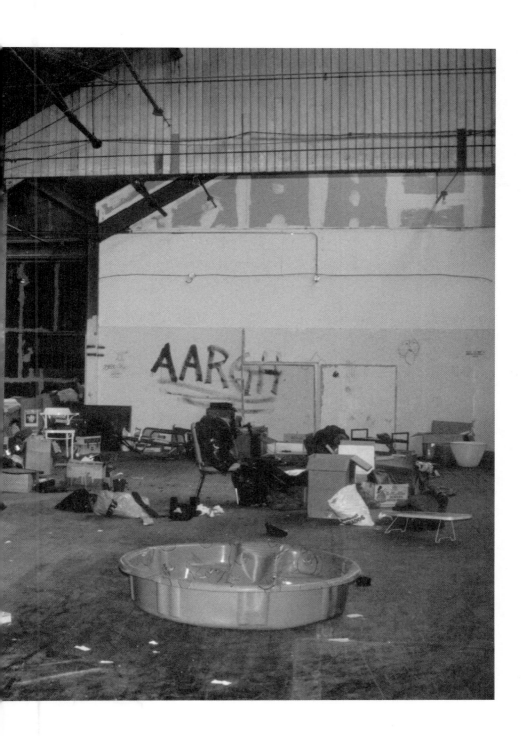

1979 - MEMBERS OF QUÉBEC CITY'S ARTISTIC COMMUNITY PROTEST VIGOROUSLY AND EFFECTIVELY AGAINST A GOVERNMENT PLAN TO CONVERT THE MUSÉE DU QUÉBEC INTO A CIVILIZATION MUSEUM AT THE EXPENSE OF CONTEMPORARY ARTISTS. QUÉBEC'S MINISTER OF CULTURAL AFFAIRS, DENIS VAUGEOIS, EVENTUALLY MEETS WITH THE ARTISTS AND MODIFIES HIS ORIGINAL PLAN.

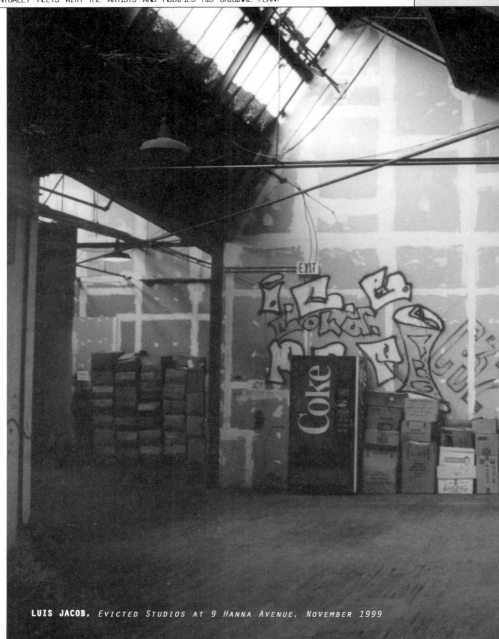

LUIS JACOB, *EVICTED STUDIOS AT 9 HANNA AVENUE, NOVEMBER 1999*

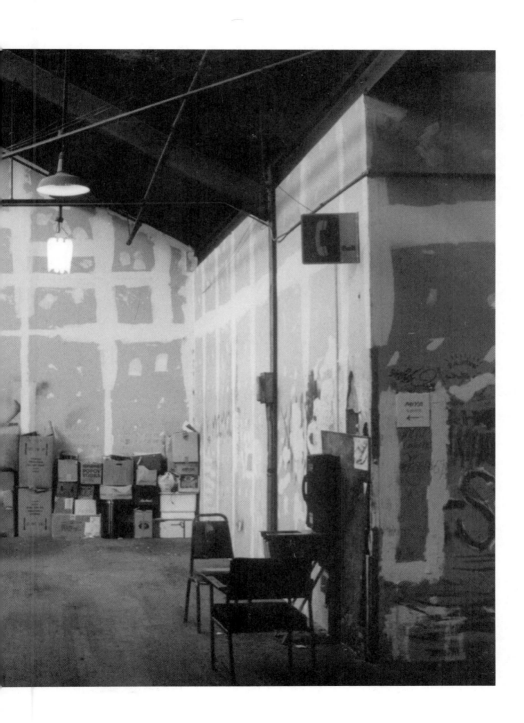

1980 - Transfer of cultural affairs from Secretary of State to Ministry of Communications.

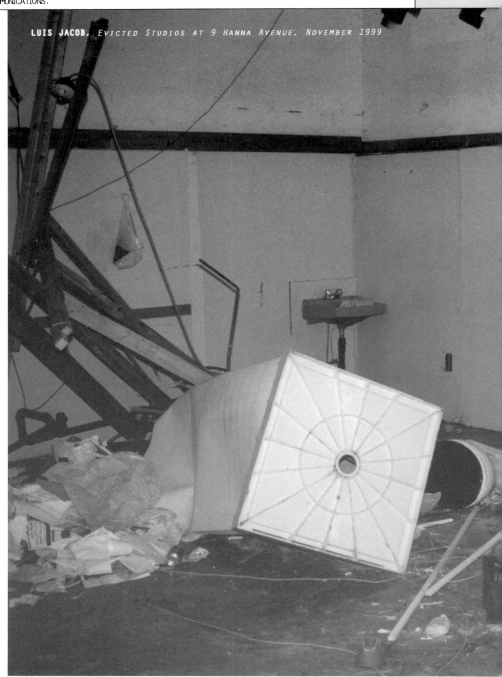

LUIS JACOB, *Evicted Studios at 9 Hanna Avenue, November 1999*

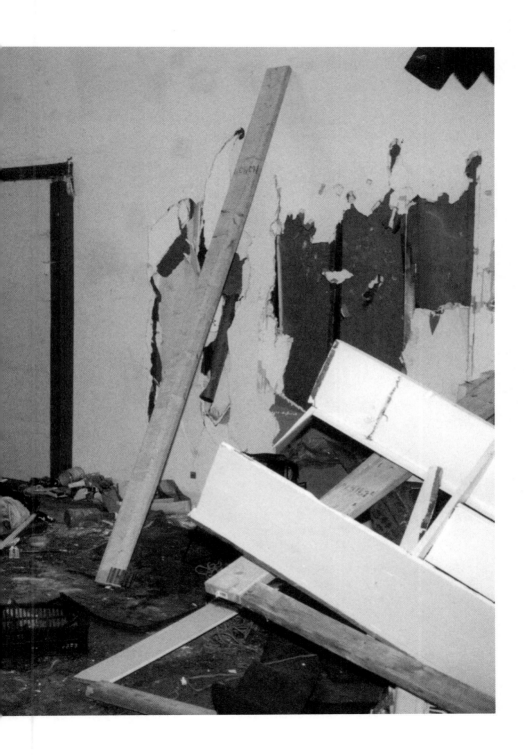

1980 - FORMATION OF CULTURAL WORKERS ALLIANCE AT THREE-DAY CONFERENCE IN PETERBOROUGH, ONTARIO.

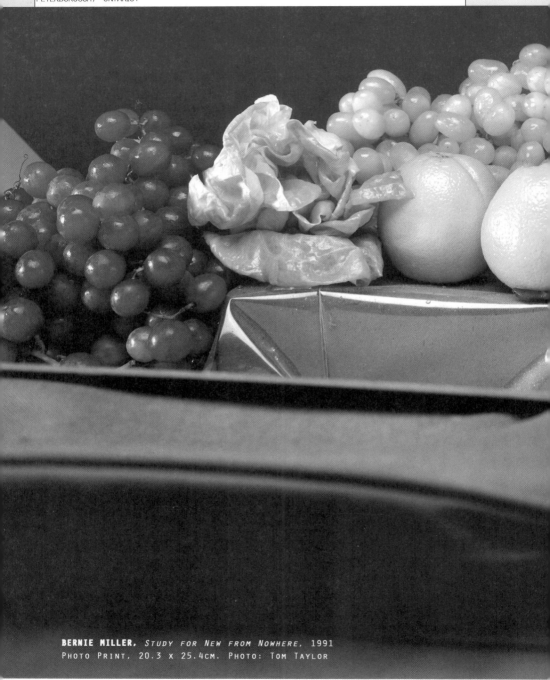

BERNIE MILLER, *STUDY FOR NEW FROM NOWHERE*, 1991
PHOTO PRINT, 20.3 x 25.4CM. PHOTO: TOM TAYLOR

› BERNIE MILLER

Red Goods, White Goods [1]

Red goods, according to the dictionary of slang, are those goods which are most perishable, such as fruit and vegetables if you are in the grocery business or short-shelf-life books headed for the remainder pile if you are in the publishing business. White goods are such items as washers, dryers, fridges, and stoves, probably even cars. The term *white goods* is interchangeable with durable goods, the trade of which is used as an index of consumer spending. These are the types of things you would only buy a few times in your lifetime, supposedly. In my household, we have a fridge from the 1940s, a Crosley Pushbutton Shelvadore—"the first refrigerator with shelves in its door"—and our car is fifteen years old. They are both endearing and enduring.

I hate economics and it shows. Tax time is depressing to me for all the wrong reasons. I have found out recently that it is not just me. That makes me feel worse. It probably shouldn't but it does. Between the years 1971 and 1981 in Canada, artists achieved an average yearly income of $6,500. It's depressing enough thinking of this as an average, never mind contemplating the nadir of such a graph. I believe the official Canadian poverty line of the 1970s hovered around the $10,000 mark. I read last week in the *Toronto Star*, in the context of a piece about impossibly high rents and the gentrification cycle generated by artists settling into a neighbourhood, that the current average annual income for artists is $8,000. My guess is that in constant 1980s dollars this is barely the same as the above unspeakable amount. You do the math.

Historically the suffering of artists is as interesting as their work.

Apparently, the public likes its artists to be poor. History bears this out. There is even a thirst for the suffering artist as a kind of product in and of itself. The musical *Rent* springs most readily to mind, but there have always

been media glamorizations of the artist in the garret. The sufferings of artists, whether physical or mental, have always been marketable. By extension: why are we surprised by the swelling of interest when artists reach the end of their lives? I probably am not the first artist to wonder whether a well-placed rumour here or there might breathe life (so to speak) into one's own economic decline.

I had always assumed that this fascination for the suffering and poverty of artists was just a disgusting middle-class nostalgia about "the road not taken," or a vicarious indulgence without the risk of personal ickiness (slumming in bohemia?), or a smug affirmation that they had made all the right choices after all. Then again I have always been annoyed when there is more attention paid to an artist's lifestyle than to the things for which they would prefer being noticed. (Such as, for instance, their artworks?) So there is this first idea of the arts and economics, this strange mixture actually: the aestheticization of poverty itself.

There is this other idea, another complicated mixture of art and economics too, the idea that suffering and failure add value to art.

It turns out, historically, that it's not just the middle class; everyone prefers their artists poor. Even artists, according to Hans Abbing, know that suffer-ing—and, better yet, failure—add value.[2] Abbing, a Dutch economist who is also a practising artist, is well-situated to provide some intriguing background to this uneasy relationship between art and economics:

> ...[M]any artists do not learn the codes which are necessary for catering to other parts of the market. Frustrated, they leave the market—often after a long time of trying in vain to find a demand for their art. In no other profession are people so persevering. This must be due to the magic of the arts.... The earnings and prestige of the successful part of the profession rely on this magic, and so depend on the many failures. *The failures co-produce the high value of art and culture.* [italics mine][3]

By *magic* Abbing must mean: not only to survive and endure the insult of poverty but also, in a Cinderella-like way, to enter the magic castle of material wealth. If this were religion we would call it an "apotheosis," but in the parlance of the marketplace it is "value added." These ideas, unfortunately, privilege the marketplace in the sense that any value art has must always be converted back into market value. There is no stopping over at the idea that art has its own intrinsic value that is the measure of other values. The value of art, in this commonly held view, is a veiled economic valuation.

Yet another idea about art and economics makes a saint out of the suffering artist, a saint in the religion of individuality and liberty. The resistance to economic reward reinforces the ideal of the artist as free individual, a Renaissance ideal, actually.

Here, Abbing posits that "the idealising of individuality through public authenticity ... account(s) for the resistance toward making money explicit in the arts."[4] He articulates what we all intuitively understand, that:

> **The rewards in the arts are both monetary and non-monetary. Prestige and status are the main components of the latter. Prestige generally coincides with financial income but that is not always the case in the arts. The origin of the high prestige of artists dates from the Renaissance and the emergence of the character of the individual. Before that, people were submerged in the collective with its clear standards of right and wrong. Now ... people are required to be individuals, each with their own conscience. Artists have symbolised this spirit of independence. Their work is seen as authentic.... A deep underlying wish of our society to be independent, authentic and irreplaceable is involved.... We want the artist, our model-individual, to be ... independent ... selfless and care only about the authenticity of his work and not about the financial rewards.[5]**

A not unrelated idea appears in the writing of the French sociologist Pierre Bourdieu:

> [I]n the 1850s invention of the "life of the artist" ... the artist's disinterestedness, [becomes] the Christ-like suffering that is the proof of extraordinary vision and the dialectic of distinction.[6]

None of these ideas have any particular appeal for me. The idea of long-suffering self-sacrifice upon the altar of art to uphold the ideal of the liberated and independent individual might hold more allure if there existed a vast audience that was actally paying attention. But it seems to me the actual audience for art is minuscule. How can the greater public be appreciative when art is just not on their radar screen?

Perhaps a little review of the history of the bohemian type will suggest some other, more greatly inspiring reason(s) why the artist should remain economically "pure."

In a more sustained contemplation of artists' relation to economy and to society at large, Pierre Bourdieu delves into the details of the relationship between class structure (a veiled relation as well) and the arts. He lifts the whole of economics and its relation to the arts onto the level of a discussion of "the dominant" and "the dominated." I found this quite fascinating because I had always dismissed the old simplistic leftist equation of the arts with super-structure. It had seemed to me, previously, that tendencies of all political stripes, historically as well as currently, are present in the arts. If anything, it seemed to me, the arts basically and simply reflected the divisions

1981 – INAUGURATION OF CHROMAZONE PAINTERS' COLLECTIVE, EXHIBITING AT 320 SPADINA AVENUE IN TORONTO (THE APARTMENT OF PAINTER FOUNDING MEMBER OLIVER GIRLING). COLLECTIVE IS FORMED BY A GROUP OF PAINTERS DISSATISFIED BY STERILITY OF COMMERCIAL GALLERIES AND THE EXCESSIVE BUREAUCRACY AND HOSTILITY TO PAINTING CHARACTERIZING ARTIST-RUN CENTRES. CHROMAZONE PROVIDES EXHIBITION SPACE NOT ONLY FOR COLLECTIVE MEMBERS BUT FOR MANY OLDER AND YOUNGER ARTISTS AND, IN MANY WAYS, ANTICIPATES COTERIE OF ARTISTS' COLLECTIVES WORKING OUTSIDE OF MUSEUMS AND ESTABLISHED EXHIBITION SPACES.

within society at large. This I thought was simply a function of bohemia being a refuge for all classes. Bourdieu, however, has made it clear through field study that artists derive predominantly from one particular class—the dominant social stratum. Here is some bohemian history: according to Bourdieu, the first bohemians were neither dominant nor dominated.

> [These] occupants of the Romantic Bohemia of the 1830s inherited their cultural attitudes from the remaining artisan cultures of wandering "masterless men": magicians, clowns, jugglers, singers.... [This may account for] the bohemian principles of erotic and alcoholic excess, love and opium, creating a culture of transgression, further sustained by songs, linguistic puns and jokes.[7]

The association of freedom with bohemianism continued through changes in the economic structures of society. A transformation of bohemia subsequently emerged during an economic boom of "unprecedented profits and an accelerated entry of domestic workers into factories." In this aggressive capitalism Bourdieu sees "proletarianisation and bohemian-isation as twin processes, tied to increased market freedom, with bohemia as a protective sanctuary against the fate of free labour."[8]

This particular bohemia was a movement of internal exiles, initially from both the dominant *and* the dominated classes.

Next there emerged a "realist" bohemia, a transitional, transient phase during the 1840s. The 1830s to 1840s (also) engendered a restricted field of artistic activity. The choice of secession from commercial, large-scale culture industries became possible. Yet, in turn, within this restricted field itself, an opposition became distinguishable between the bourgeois art of official artists in salons and the artists outside the salons. The avant-garde art of "bohemia" was itself extended beyond those outside the salons.

Then, in the 1850s, in the aftermath of Louis Napoleon's seizing power, an autonomous art world emerged under a brutally repressive political regime.

Under this dictatorial Bonapartiste regime, which had suspended parliament and union activity, censored and imprisoned political dissidents including

artists, a "heroic period" of oppositional activity in bohemia manifested itself. The oppositional character of this bohemia had its origins in the transgressive nature of the first bohemia and subsequently was reinforced by the position taken up by the avant-garde against the establishment of the academy and its official artists. "Bohemia (at that time) was the home both of deracinated bourgeois groups and of stigmatised minorities. The bohemia of this time was dominated by artists of artisan or poor petty-bourgeois origins."[9]

But the changes that separated out an autonomous field of art activity soon set the scene for subsequent class affiliation:

> ...[B]ohemia of the 1850s and 1860s was drawn from the dominated fraction of the dominant class. For writers at this time, like Baudelaire, distance from commercial writers and from the need to get a living by discovering the taste of the wider public was ... granted by the inner assurance of economic independence.... The bohemian affiliation permits the fullest development of the artistic "habitus." A precondition for this is a mastery of the collective labour of the field, that is, artistic inheritance.... This (mastery) requires social time ... only available to the children of the dominant class.[10]

Because economic independence was an asset in gaining the knowledge of art history and practices,

> [T]he artist with cultural capital, and especially with knowledge of the collective inheritance of art [became singularly] capable of becoming a powerful player. Unresourced by rent and undercapitalised with education, rural plebeian intellectuals are eclipsed by their more favourably placed rivals. The fate of the plebeians was typically to retreat from the metropolis and seek refuge outside it. It is for these reasons that the bohemia of autonomous art is based on a "double rupture," a simultaneous recoil both from bougeois culture and from popular culture.... The ethical gaze of the artist (of the 1840s "realist" bohemia) was silenced by ... exclusive focus on the means of representation alone."[11]

Artists become marginalized because of their specialized knowledge (what Martha Rosler has referred to as a "restricted universe of discourse"[12]), which is not available to a wider public but which, however, the dominant class has the time and means to acquire. But because of economic (and possibly political) differences, artists do not belong to this class either.

> Bourdieu's major emphasis is thus on the "contradictory class location" of the artist, a space which is simultaneously dominated and dominant. This site engenders

1982 - APPLEBAUM-HÉBERT COMMITTEE REPORT RECOMMENDS NEW LEGISLATION TO CLARIFY DEGREES OF POLITICAL AUTONOMY FOR THE CANADA COUNCIL, THE SOCIAL SCIENCES AND HUMANITIES RESEARCH COUNCIL, THE NATIONAL FILM BOARD, THE CANADIAN BROADCASTING CORPORATION, AND OTHER GOVERNMENT CULTURAL AGENCIES. THE REPORT REAFFIRMS ARM'S LENGTH PEER-ASSESSMENT PROCESS AS THE IDEAL MODEL FOR THE FUNDING OF CREATIVE INDIVIDUALS OR ARTISTS. THE REPORT IS CRITICIZED BY MANY FOR LARGELY IGNORING SOCIAL CONTEXTS AND CONSTRUCTS FOR ARTISTIC CULTURAL PRODUCTION AND FOR REINFORCING PROBLEMATIC BINARY BETWEEN "PURE ART" AND CULTURAL PRODUCTION ACTIVITIES. IN CONTRAST, LIBERTARIANS SUCH AS GEORGE WOODCOCK PERCEIVE "APPLEBERT" AS A FURTHER REINFORCEMENT OF MARXIST-FLAVOURED PRODUCTION APPROACH TO ART BY FEDERAL GOVERNMENT.

> a sense of marginality.... At the same time [the artists'] location threatens constantly to reduce their accountability to the wider public and to narrow their world-vision to that of the cultivated members of the ruling class.... It is the nature of the cultural field itself—and also the relatively privileged social origins of bohemian artists—that leads them to associate true disinterestedness with rarity. They seek distinction, not solidarity.[13]

There is a dilemma here that Bourdieu points out: should an artist seek popular understanding or become more obscure through increasingly arcane knowledge acquisition?

"This is surely a 'fragile alliance of artists and people' politically, but creates the classic dilemma: whether to remain popular (that is, comprehensible) or whether to appear to abandon the initial public by going for a more difficult form. It is the nature of the cultural field itself."[14]

That was then, this is now[15]

In Canada current arts funding assumes a graduation into the market. In my view this "market" is largely an illusory phenomenon.

Funding for individual Canadian visual arts producers probably originated with the idea that artists needed to be given a "head start" before the market's momentum carried their productions upward into economic viability. No one seemed to notice that there is very little private funding or private not-for-profit support for the arts. The market, at least for Canadian visual arts, was not then and certainly is not now nearly as developed as the European market. And it is certainly nowhere near the New York market, not by a long shot. The biggest buyers in the market are publicly funded institutions. Tax breaks available for the purchase and donation of artworks to charitable institutions, including museums, are in fact indirectly, publicly funding the market. "The Canadian Market" is imaginary.

Even if there were a market it would not accommodate all practices. For many artists the marketplace is not the place to resolve the economics of their production, even if they can get over the idea that economic interest contaminates their productive freedom. The private market only applies to a very narrow band of cultural production at best. It favours the sort of object that doesn't take up too much real estate, or fits well into the aesthetic surround of private homes and workplaces. But the market solution falls short in other ways too:

> The market cannot reflect ... lasting benefits. To the writer, the composer, the painter or the scholar, the market presents a demand that reflects, at best, only the benefits to his or her own generation. Yet each generation must not only preserve and pass on all that is significant in its own cultural inheritance, but must also add to that stock new elements of its own creation ... from which large future benefits may flow. In a sense, then, it is the crucial function of the patron of culture—whether a Medici or a Canada Council—to serve as agent on behalf of the future, a surrogate for later generations.... The market can never recover the cost of the creation [of cultural products] from those who benefit.[16]

All these market considerations shade toward an economist's reasons for advocating public funding for the arts, that is as a compensation for "market failure." This view of compensating for market inadequacies assumes that the market is the first place to sort out the economics of culture. But there are very good reasons why this should not be considered ideal. Specifically:

> the "economists'" arguments for government intervention in support of cultural activity all relate to the failure of the market to function properly, "the market" being shorthand for the sum of the multitude of individual transactions which govern the allocation throughout society of resources and services. If the market fails to register the full benefits conferred by a particular activity, that activity will be denied its proper share of resources. Incomes associated with it will be curtailed. Justifications for government support of cultural activity involve exactly this kind of market "failure."[17]

Since we don't ascribe cultural values to artworks—as expressions of a pattern of living and thinking characteristic of their own time and place—we don't really take steps to preserve them. The longevity of such productions is certainly unaccounted for in the market.

The market "failure" argument for government funding of the arts, then, overlooks not only the long-term value for future generations but also the value of cultural practice that serves to give positive value to general creativity and to culture as ethical steward. There are three important aspects of cultural

1982 - Toronto-based performance theatre group The Hummer Sisters run for city mayor on a campaign slogan of "Art vs. Art." As there was no "official" candidate running against incumbent Arthur Eggleton, the Hummers received one vote in ten and placed second in the race.

activity bound up in this "market failure" critique that may be an aid in sorting out the economic relations of culture: the long-term value for the future; a positive valuation of creativity; and the idea of critical scrutiny.

One particular aspect of cultural activity may never be accounted for in the market, "failed" or otherwise. I will briefly outline this mode of cultural activity before going on to those aspects that, in keeping with the intent of this text, have more direct economic implications.

Canadian society is an "aggregate of separate spheres," say Louis Applebaum and Jacques Hébert in their introduction to the report of the Federal Cultural Policy Review Committee. They take a wonderfully high-minded view of the relations of culture to society in general and to government in particular. They see these distinctive spheres of activity as including, among others, the cultural, which articulates society's needs, and the political, which influences society, including culture. These spheres are quite interdependent but qualitatively at odds. There is also one important aspect of this relation that requires that the cultural sphere does not become subordinate to the political sphere. And that is that society is best served when artistic endeavour exercises critical scrutiny toward all spheres of activity, even political. If it is subordinate to the political then this important ethical role is compromised. This role of "critical scrutiny" derives from that historic strain of oppositional activity present in the transgressive beginnings of bohemia.

> The political order—the state—is one of these great spheres and institutional systems; the cultural world is another.... Inevitably, they intersect. The human wants, perceptions and prejudices by which governments are driven or constrained are, in large part, expressions of the culture. Conversely, the system of government influences all social activity, and all spheres of society, including the cultural.... But there is a danger in this seemingly happy interdependence of government and culture, for they do not pursue the same ends. Government serves the social need for order, predictability and control—seeking consensus, establishing norms, and offering uniformity of treatment. Cultural activity, by contrast, thrives on spontaneity and accepts diversity, discord and dissent as natural conditions—and withers if it is legislated or directed. The well-being of society is threatened if the state intrudes into the cultural realm in ways that subordinate the role and purposes of the latter to the role and purposes of government itself—or of any other spheres of activity. Moreover, the cultural sphere, embracing as it does artistic and intellectual activity, has as one of its central functions the critical scrutiny of

all other spheres including the political. On this score alone it cannot be subor-
dinated to the others.[18]

It may go without saying, but I may as well underline it since it is important to
the discussion here: the "market" is one such sphere that may come under
"critical scrutiny" and therefore it would serve society best if the cultural
sphere were not subordinated in this instance either.

Another aspect of cultural activity highlighted in the critique of the "market
failure" view of public funding of the arts is the value that artists' productive
efforts have for the future.

No one can predict the future. It follows then that we do not really know what
sorts of work will be a valuable legacy for future generations. Some may even
say that there is no future anymore—only futures, imagined scenarios. As an
exercise, useful perhaps in showing how a small, overlooked detail of the pres-
ent may affect an unforeseen deflection in what seems an obvious time line, I
would like to digress momentarily into a speculative reverie. In fact I feel
slightly obliged to do so in recognition of the momentous roll-over of num-
bers in the current calendar.
 Currently, economic emphasis is shifting from material production to
immaterial production, which could be considered quite timely, considering
the pressures on certain natural resources. Michael Hutter, an economist at
Witten Herdecke University in Germany, delineates this shift in emphasis:

> Economic valuation often refers to natural things, like bread, or cars, or houses.
> More and more, it refers to fiction—to stories, or tunes, or images. In artistic play,
> such fiction emerges constantly. The works of imagination are built according to
> and evaluated by artistic quality standards. In economic play, they appear as something
> that is different, difficult to do and, therefore, amenable to being considered
> scarce. Thus, the fictional works, created in the outside play of Art, become source
> events for the Economy. The implications of this argument are rather vast. A world
> that is inevitably running out of natural resources cannot maintain or even
> increase the volume of material production at length. Creative work, however,
> provides an enexhaustible stream of scarce items. The emphasis of economic
> evaluation is shifting from the transformation of wood and metal into payment, to
> the transformation of stories, tunes, images or performances into payment.[19]

Not only is production becoming more immaterial, the distinction between
consumption and production is becoming less sharp.

1983 - B.C. PAINTER TONI ONLEY THREATENS TO BURN A THOUSAND PRINTS PUBLICLY, AFTER BEING INFORMED BY REVENUE CANADA AUDITORS THAT HE "COULD FOLLOW THE EXAMPLE OF MANU- FACTURERS WHO MELTED DOWN UNSALEABLE PRODUCTS AND RECOVERED THE RAW MATERIALS" (WOODCOCK, 151). AFTER PANICKED REACTIONS FROM LIBERAL MINISTER OF COMMUNICATIONS FRANCIS FOX AND OPPOSITION LEADER JOE CLARK, ONLEY SYMBOLICALLY BURNS ONE PRINT ON VANCOUVER'S WRECK BEACH. CLARK PLEADS FOR MORE SYMPATHETIC EVALUATION OF ARTISTS BY REVENUE CANADA IN LIEU OF IDIOSYNCRASIES OR PECULIARITIES OF THEIR OCCUPATION, LEADING TO ESTABLISHMENT OF STANDING COMMITTEE OF CULTURE AND COMMUNICATIONS.

This trend has taken a sharper upward turn as the new digital media delivery system is being patched together. New ways of socializing, getting information, shopping, advertising, and being interactively entertained are initiating a sea change in consumption and production. Not only is there a turn toward a relatively immaterial consumption, it is my contention that the classically modernist division between consumption and production will be greatly blurred. Consumables are becoming more and more supplies for production as symbolic capital. Symbolic exchange has begun to dominate the productive sector. Currently, consumption patterns are driven by the need to accumulate goods, which are used to symbolize distinction, status.

At some point, crude symbolization through positional goods will no longer be enough for "consumers" to construct their public identities. As the economy becomes less material, symbolic capital becomes a more important sign of distinction. Included in this new accumulative behaviour, and we already see signs of this, will be the need to not only express to others what niche you personally occupy in the food chain, but what sort of person you think you "really" are. In other words, individuals will have a need to broadcast more sophisticated messages about themselves and in the process will more carefully construct their identities. At first these will be very strong, singular identities as they symbolize what they feel to be an authentic identity that is uncovered or expressed. Once the discovery is made that identities exist solely through symbolization, a great flood of symbolic consumption will ensue, which in turn will demand a greater flood of symbolic production. In fact production (largely outside of the material base) will converge with consumption in a cycle of symbolic exchange.

Recently certain retail catalogues have become lifestyle magazines that offer entire identities, complete with colour co-ordinated ideas. (In my speculative future scenario I take this small detail as the overlooked detail that signals a deviation in current time-line projections.) Eventually one-stop shopping for identities will give way to market fragmented identity construction. This will be truly a convergence of production and consumption.

I have noticed recently that several large retailers are selling (can you believe

it, selling?) catalogues of their wares. The reason they are able to sell what you think would ordinarily be given away is that they contain articles along with the usual spread of wares. These are informative articles which they think would interest the kind of people who buy their stuff. It seems not unrelated to the internet shopping phenomena of zeroing in, quickly, on your particular demographic niche (truly a market segmentation) with the old "If you liked that, then perhaps you might like this (related item appears on the screen)." In this "catazine" or "magalogue" phenomenon "lifestyles" are being proffered, yes—so what else is new? But there is something else ("but wait, there's more!") when articles about the world at large, a sort of soft news, are mixed in with material "life-style" wares, then what is being consumed/produced are identities. One does this in the course of one's daily routine, as it is, but here it is guided by the one-stop shopping approach. It may seem scary, but it's coming, and it will be here sooner than you think when this much-announced broad-band delivery system is in place. Optimistically I think that these one-stop-shopping, snap-on identities will be so easy to spot that people will become quite coy about their assembled identities (and ensembles) and this will be truly the beginning of the kind of production/consumption convergence that is my delusion here.

I will end this speculative reverie short of inventing the place that artists would have in this strange vision of the future, but I will say that artists have on occasion anticipated and even influenced shifts in world views before.

I will pass on to the reader two short items of historic note that come to me by way of Michael Hutter:

> The European concept of time changed in the 13th century from a circular, repetitive pattern to a linear form under the influence of new, rythmically organized musical pieces (Hutter 1987). The concept of space changed in the 15th century due to inventions in painting, particularly the invention of central perspective (Hutter 1992b). The change in the communication forms available implied a change in context for the economy. It can be shown that the new spatial conventions led to an increase in planning horizons, and to new instruments for navigation, among other things. While the pervasive influence of another play of meaning, namely science, on the economy is well recognized, the influence of these less visible effects of the art play on economic events has hardly been noticed.[20]

The one other remaining aspect of cultural activity foregrounded in the critique of the "market failure" argument for public funding is the notion that artists are exemplars of creativity proper.

The merit of releasing the creative potential of a society is not necessarily recognized and acknowledged by the market, which is to say it is another of those

market failures put forth by the economists when they come out in support of public funding for the arts.[21] (We could say of this argument that it is one of those things about which everything is right but for all the wrong reasons.)

The "merit of releasing the creative potential of a society" is a merit that cultural activity confers on the public, or some significant part of it, that the public is simply unaware of: there is, in effect, a failure of information. Through consciousness raising such merits of culture could become benefits which people feel, but which would remain largely ignored by the market, and we are back to the original problem of market failure.[22]

The public unawareness that the authors refer to may be a result of a difference in values.[23] The public is increasingly more likely to respond to values generated out of the sphere of economics. But there are divergent value systems operant in economics and in the arts. Consequent to studying the world of the arts, economists have been compelled to change their strategy and to look for an alternative framework. Michael Hutter offers this experience of these divergent value scales:

> The problem is … how to deal with value scales that differ from one realm of discourse to another…. I have found that in order to account for different value scales you need to turn to a more general social theory…. I find that the juxtaposition of economy and art brings out the existence of different scales in the most evident way. The continuous public discussion between those two worlds makes the clash in values obvious.[24]

Economic values may even be destructive to artistic values.

This separation of values may be ultimately for the greater good. Economic interest of the market tends to upset a delicate ecology of innovation that artistic activity is predicated upon. (As artists we have to have patience while well-meaning theorists from other disciplines labour with what seems to us obvious.) Hutter offers another insight:

> Many observers perceive art as a social form that has its own way of organizing itself. Marketable products are seen as spin-offs of that process, not as its cause, as in the case of conventional industries.[25]

This spin-off phenomenon will perhaps be more recognizable to some in an example such as NASA, the American space program that was initiated as a propagandistic exercise to get a man on the moon. But without NASA we would not have satellite telecommunications, let alone pens that can write

upside down and underwater or, that mainstay of all survivalist camping trips, freeze-dried ice cream. (And without the National Association of Stock Car Auto Racing (NASCAR) we might not have side-impact bars and tires that do not go flat when punctured with five-inch spikes.)

A simple hands-off encouragement of a creative environment respects the happenstance nature of creativity and innovation best. Creation on demand is nominally possible but is qualitatively lacking.

The picture that is emerging here seems to be this: in order for real-world applications of innovation to take place they must, paradoxically, be encouraged in environments in which the real world is held at bay. Originary thought and innovation, as any artist or break-through research scientist will attest, arrives in its own time, not when it is called upon. Likewise it chooses its own place and its own circumstance. If we were able to create on demand, to truly originate when most needed, technical progress, for instance, would be much, much further along than it is now. And all artists, nay the entire population even, if they chose, would produce works of awe-inspiring genius. Advertisements would be works of "art" holding us all in their sway. Likewise the design of ordinary household objects would induce rapture.

Creativity, probably because there is such an element of chance to it, displays some of the characteristics of the behaviour of complex dynamic systems, in that specifics are unknowable but tendencies can be articulated.

In a less scientific, more socio-political manner, Bourdieu has articulated a similar relation between transgressive innovation and the security of material ease and social assurance. I am reminded of the term "holding environment" in the following citation:[26]

> Paradoxically, those who have the most independent social power are those who tend to become heretics—and, later, consecrated heretics. Material ease gives them the social assurance that permits innovation, often through the transgression of disciplinary boundaries.[27]

Again, demand does not hold any guarantee of innovation, however a secure holding environment may be another matter.

A secure holding environment encourages play, play being the impulse to follow chance developments without regard to practicality or practical application. It is an evocation of outcomes as they follow out of each other, not as planned or expected. This is the setting for innovation and breakthrough. No matter how intense the demand for innovation and breakthrough, demand alone will not guarantee specific innovation. Innovation and discovery emerge from environments suffused with a great deal of faith.

1984 — Outgoing Trudeau Liberal government proposes Bill C-24 in attempt to rein in Canada Council, Canadian Broadcasting Corporation, Canadian Film Development Corporation, and National Arts Centre. The government "wanted control over corporate plan and operating budget, power to impose directives, control of by-laws, and power of dismissal" (Robertson, 43).

The above are all good arguments for the separation and independence of cultural activity from various other spheres of activity in society. But we have a major conundrum here and that is the need for cultural independence, not only important to creativity and innovation but also to the "critical scrutiny of both the market and of the political sphere," creating the very practical problem of going about the business of procuring material well-being and security for artists—in short, a holding environment.

There are unique conditions in Canada vis à vis the achievement of material well-being and security for our artists.

In Canada access to education has reduced the effect of acquisition of cultural capital as readable and serviceable signs of societal distinction. The demand, being as a consequence reduced, creates zero relation to the economic sphere, let alone a "veiled" relation. A condition of surplus prevails rather than one of scarcity. And, as a general principle, surplus goods cannot be used as positional goods.

Even if a market solution were to be considered, the "failure of the market," attributable, perhaps in part, to a general democratization of post-secondary education in Canada, makes it even more remote. People from all classes may end up in cultural pursuits. This democratization has reduced the need for economic security as the foundation for accumulation of cultural capital, especially at the outset of an artist's professional career. But if the accumulation of cultural capital is no longer much of a sign of distinction, cultural capital will not so readily transpose into social capital, or into—what is important to the discussion here—economic capital. Take away any semblance of a "true" or substantial market, and there is certainly no need, as a demonstration of "purity," for a *veiled* relation to the economic sphere. Nor, then, is there a need for the "convoluted bohemian dance" of disinterested interest.[28] State funding, it appears, is by default the only recourse, not one among others. And this, fortunately, in its most general aspect, jives conveniently with the philosophical thrust of this text.

Fortunately, too, there are beneficiaries of cultural activity in Canada aside from the government itself and by extension the future of Canadian citizens. There is, according to my reading, an economic impact of the arts. The so-called multiplier effect notwithstanding, there are even more beneficiaries.

Most immediate and therefore most obvious is the real estate industry. The

rentals market certainly benefits from the increase in activity and "magic" when an artistic community establishes itself in a particular neighbourhood. The advertising industry benefits when it sources new ideas to feed its own creative machinery. The tourist industry prefers the colour and vitality that increased cultural activity adds to a city. Head offices like to locate their top executives in a setting that has all the amenities, which always include cultural institutions. The best designers, who supply shape, colour, and packaging to industry, flourish in an environment that is itself flowering with culture. A critical mass of culture is part of big city life.

Because of its close relation to the kind of cultural activity I've been talking about, culture industry itself needs to be based in cities in which this sphere is strongest.

I wish to suggest, then, that cultural life is a kind of non-material infrastructure, accessed by sectors of the economy to whose products and activities such an infrastructure adds value. These activities and products remain undeniably marketable. However, this creative infrastructure, which is so very crucial, is taken for granted, like the air we breathe. It is outside, all around, and inherently abundant, regardless of the industries it nourishes.

I am not only making a practical argument for increased and more universalized public funding for the arts. I am also making, by implication, the argument that we cannot leave the development of a creative, innovative environment to the demands of the marketplace. The market is too self-interested. The market does not reward the entire environment for the innovative products of a single artist or scientist. Transaction occurs at the nodal points of a specific product of genius, at the point where there is something, a product, already in existence. The market in general, or the transaction in particular, does not pay back the circumstances that make the marketable production possible. And the circumstances are the creative infrastructure.

The market is largely uncoordinated because of self-interest and specificity. The market would never maintain a system or environment unless there was a very noticeable loss of productive capability in some way visibly attributable to erosion of such an infrastructure. The market, not having had the experience of a properly maintained creative infrastructure, does not find the long-term benefits as obvious.

Because this conception of an infrastructure is more about a process than its material manifestations, it may not be as easy to visualize as the kinds of infrastructure we are most familiar with. If we could look at a material infra-structure momentarily as a model, we might be able to glimpse some of the less foreseeable benefits.

1984 — FORMATION OF INTERNATIONAL ARTISTS' UNION (IAU), TORONTO LOCAL, WITH INTENTION OF FORMING COLLECTIVE BARGAINING VOICE FOR SOCIAL AND ECONOMIC CONCERNS OF ARTISTS. THE UNION ASSERTS THAT SINCE CULTURE PROVIDES A SOCIAL IMAGE OF CANADA, AS WELL AS PROMOTING TRADE AND TOURISM, CULTURAL WORKERS SHOULD RECEIVE A LIVING WAGE AND BENEFITS. (COUNTRIES THAT HAVE OFFERED LIVING OR MINIMUM WAGES FOR ARTISTS INCLUDE HOLLAND, SWEDEN, DENMARK, IRELAND.)

A system of trucks and highways being material, therefore more obvious, may be an analogy worth pursuing: individual trucking companies cannot coordinate their self-interest in the creation of an efficient network of highways that endures and proliferates. Yet with such an infrastructure in place, each company's productivity, and the entire industry, benefits.

I am suggesting that there is a similar infrastructure requirement for an environment of creativity and innovation. At present that infrastructure is shoddy, piecemeal, catch-as-catch-can, and tragic. It is an environment that is subsidized by individual artists, by their families, by their friends, through part-time jobs and scanty sales here and there. It may be an efficient system in some respects in that it is very low maintenance and given that there is *some* ecomomic impact of the arts through the multiplier effect.[29]

It is true also that there has been a lot of public money spent already, but that expenditure is in decline. At their peak, those expenditures were not good enough, as can be seen in a cursory review of the economic statistics over the last two decades, particularly in the area of artists' earnings compared to the poverty line.

Since we are able to identify beneficiaries, and since there appear to be no more public funds available for the arts from general revenue, it makes perfect sense to institute a very specific tax on those identified beneficiaries and earmark revenue from this source to be redistributed to local arts groups and producers. Such a tax would be indexed to profit, thus the well-being of the beneficiaries would be reflected in the well-being of the cultural infrastructure.

Taxation not being my area of expertise, I would be best advised at this point to back away from any further technical detailing of this general suggestion, leaving the rest to any enthusiastic professionals.

I do want to add, however, one philosophical note, and that is: taxation and re-distribution are very effective ways of reducing the subordinating relation that the market would otherwise fall into, a relation which, as I have pointed out already, can be counterproductive to general creativity. Here also is that separation and independence of cultural activity from various other spheres of activity in society referred to previously.

In closing I would like to re-emphasize current inadequate conditions within the cultural sphere.

The current "creative infrastructure," if we may call it that, remains a system that engenders and is dependent upon a lot of professional and personal tragedy. The system has become dependent upon the enthusiasm, hope, and energy of the young. When such energy wanes, when the constant sacrifice

mounts, and when futility creeps in, fresh volunteers step to the task. In short, every career is expendable.

These are the perishable red goods of the system. Each artist hopes, however, that their productive life will be the enduring white goods. Even if the current system is economically efficient, it is not, in cultural terms, civilized.▪

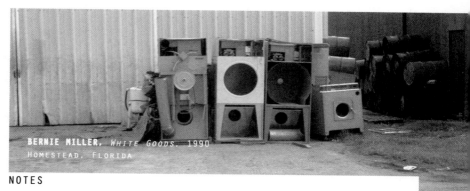

BERNIE MILLER, *WHITE GOODS,* 1990
HOMESTEAD, FLORIDA

NOTES

1 "Red goods n.pl. [Advertising, Commerce] products that are frequently purchased, speedily consumed, soon replaced in the shop and then purchased again, e.g. fresh foods. Red goods rarely offer the seller high profits." Jonathon Green, *Dictionary of Jargon* (London: Routledge and Kegan Paul, 1987), 448, 594.

2 Hans Abbing, "The Artistic Conscience and the Production of Value" in *The Value of Culture,* Arjo Klamer, ed. (Amsterdam: Amsterdam University Press, 1996), 144.

3 Ibid., 144.

4 Ibid., 141.

5 Ibid.

6 Bridget Fowler, *Pierre Bourdieu and Cultural Theory: Critical Investigations* (London: Sage, 1997), 51.

7 Ibid.

8 Ibid.

9 Ibid., 53.

10 Ibid.

11 Ibid.

12 Martha Rosler, "Place, Position, Power, Politics," in *The Subversive Imagination: Artists, Society and Social Responsibility,* Carol Becker, ed. (Routledge: London and New York, 1994), 60.

13 Fowler, 51–52. Many of my references to the writing of Bourdieu have been paraphrased from Fowler's book.

14 Fowler, 54.

15 In Canada, currently the arts comprise a significant portion of the economy, at least in numbers employed: "Arts-related employment is as large as the agricultural sector or as federal government employment including Crown corporations.... [A] comparative

1984 – Vancouver Art Gallery (VAG) cancels scheduled exhibition "Confused-Sexual Views," by Paul Wong, after VAG director Luke Rombout decides video works have "no connection to visual art." Wong undertakes legal action against VAG for damages to career, work, and reputation.

analysis ... in 1981 reveals that the cultural sector was the largest in terms of employment; the sixth largest with salaries and wages of $2.5 billion; and the eleventh largest with revenues from all sources of $7.7 billion. Revenues in this sector increased, from 1977 to 1981, at an average annual rate of 13 per cent." *The Role of the Arts and the Cultural Industries in the Canadian Economy* (Ottawa: The Canadian Conference of the Arts, 1985), 5.

16 Louis Applebaum and Jacques Hébert, introduction to the Report of the Federal Cultural Policy Review Committee, 1982, 65.

17 Ibid., 65.

18 Ibid., 16.

19 Michael Hutter, "The Value of Play," in *The Value of Culture*, 130–31.

20 Ibid., 132.

21 It may be said that art and culture generally have merit and should be supported for this reason alone. It is, worthwhile, however, to ask for whom it has merit. Money spent on art and culture multiplies through encouragement to spend on related events or items. "Multiplier Effects: In addition to the direct expenditures in the arts and culture industries, which of themselves indicate an economic activity of significant impact, there are important multiplier effects which spread out from the activities.... In attracting people with disposable income out of their homes, the performing arts (for example) represent a direct stimulus to economic activity (with) a multiplier of 3:1 (for every three dollars spent directly another one dollar would be spent on related non-art activities)." Joan Horsman and Brian Dixon, *The Hard Facts of Arts and Culture* (Toronto: Canadian Conference of the Arts, 1978), 7.

Canada is next to the bottom of a list of Western nations when it comes to public expenditure on the arts.

As a proportion of direct spending, Canada spends 0.34% on the arts. This represents the second lowest, next to the U.S., of the following countries: France, Germany, Netherlands, Sweden, and the U.K. Germany spends the most at 0.79% of their public spending. Indirect public spending on the arts (per capita) in Canada does not fare much better at 28.3%, third lowest above the U.K. and the U.S. who check in at 16% and 3.3% respectively. Sweden tops the list with 45.2%. Joseph J. Cordes and Robert S. Goldfarb, "The Value of Public Art as Public Culture," *The Value of Culture*, 79.

22 Applebaum and Hébert, 68.

23 Ibid.

Further to a discussion strictly of value, there is a concept out there of "merit goods": "The notion of a category of goods and services that deserve to be fostered, in both their production and public enjoyment, irrespective of how the market may measure costs and

benefits—simply because they are meritorious. [There is a] manifest value [for] cultural activity in releasing the creative potential of a society, and in illuminating and enriching the human condition—celebrating its strengths and exposing its frailties." Art is recognized as a public good, ethically, morally, and aesthetically. There is also a special place for national identity in a list of merits: "A nation is a people with a common self-image and purpose with respect to the moral nature and institutional framework of their society which is both comprehensive (modes of association in law, politics, economics, technology, *arts*, religion and many other areas of social life) and bounded (safe) boundaries." Jos de Beus, "The Value of National Identity" in *The Value of Culture*, 167.

National identity "constitute(s) an encompassing culture with distinctive characteristics, landscape, architecture, *the arts*, food, sports, ceremonies and holidays, and much more." (It is not without some irony that I note certain objects of art, valued so highly in performance of diplomatic service, often arrive out of economically-abject circumstances.) The list of merit continues with: national cultural heritage, public placemaking, repositories of the highest of our humane values such as compassion, civility, freedoms of speech and action, records of the tenor of the times, sites of philosophical development, and of exposure of sociological injustices.

And so forth and so on, in fact meritorious values of such high standing that it seems crude of me to even mention the lowest of the low, the value at the bottom of most artists' lists: "the bottom line." But of course this is the task that I have taken on with this text. It is as if I were inquiring, discreetly of course: To whom should we send the invoice for all this?

24 Hutter, 135–6.

25 Ibid., 122.

26 Jeanne Randolph has given currency to this term within art theory. It originated with psychoanalyst D.W. Winnicott and is a central concept in object relations theory. Randolph, "What Don't Women Want," in *Symbolization and its Discontents* (Toronto: YYZ Books, 1997), 22–24.

27 Fowler, 32.

28 Tom Wolfe, *The Painted Word* (New York: Farrar, Straus and Giroux, 1975), 21. I am paraphrasing Wolfe's cynical interpretation of such matters. He characterizes a kind of bohemian dance in which artists are all too willing to sell their products while feigning a lack of interest in the actual exchange for money.

29 The "multiplier effect"—the idea that a given government expenditure will be exceeded by the consequent tax yield—is often cited as an economic justification for government subsidy of the arts. This argument has credence in some circles (see note 20, above) but for Applebaum and Hébert it is an economic argument that "strains the bounds of human credulity" because they say what this argument overlooks is "that when resources are applied in one direction they cannot be applied in others which might have yielded even greater benefits" (64).

1984 - DEFEAT OF TRUDEAU'S LIBERAL GOVERNMENT BY CONSERVATIVE PARTY LED BY BRIAN MULRONEY. DURING 1983 PARTY LEADERSHIP CAMPAIGN, MULRONEY INSISTED THAT HE WAS AGAINST FREE TRADE WITH THE UNITED STATES. AFTER 1984 LANDSLIDE FEDERAL ELECTION VICTORY, MULRONEY ALMOST IMMEDIATELY ACTIVATES FREE TRADE NEGOTIATIONS WITH AMERICAN REPRESENTATIVES.

THE AUTHOR AT HIS FIRST JOB, AS A COWBOY, AGE 15

> PIERRE BEAUDOIN

The Mad Whims of Pierre B.

For some time now I have dreamed of earning a decent salary. After years of charitable work in the visual arts, I'm still waiting, still looking for the magic formula. I've often thought of leaving the art world, which fits me like a glove, and changing directions. I'd just have to get another glove. But until this happens I remain a professional in the world of underpaid artists. Of course I'm not the only one navigating these troubled waters: many of us believe in our profession and struggle against the storms which, believe it or not, keep our mental health at an acceptable level. We like our little world. But at what cost? Sometimes I simply break down, yearning for more, craving respect and recognition for my so-called professionalism.

Even the most optimistic among us have to admit that we reach peak altitude very early. After exhausting the cycle of job programs (which serve mostly to distort unemployment figures) and the handful of artist-run centres or art centres, our possibilities are excruciatingly limited. Positions in museums are virtually non-existent and those with teaching aspirations have a long wait ahead of them. A full-time position? Be serious. Years will pass before an opening arises. There are, of course, lecturer positions, though they're few and appear only sporadically. Or you can try the public sector and become an art bureaucrat, though even there the jobs are scarce. So the principal pastime of us cultural workers ends up being ... envying, coveting. We mark time, tread water, run on the spot. That way it's easier to keep our eye on our unhittable targets. We're like vultures circling endlessly, in vain. As soon as a position opens up in one of these venerable cultural institutions (if the position isn't made redundant) we lunge at it, hoping against hope that we will be the fortunate one. As for the "losers," they hang on to the tentacles of the multiple-contract beast.

Sometimes I envy erotic dancers. Even though my chances are slim in this regard—age discrimination and all that. I should have thought of it before. In

the early 1980s, at an age when I could have been an erotic dancer, I was working at a care facility for the elderly. Kitchen assistant, where I made the same salary as in my previous job as co-director of an artist-run centre. I am still trying to figure out how this payroll mistake occurred, if it was a mistake.... Should I regret leaving this job, which was so far from my desires, but which paid so well? Or should I carry on regardless, telling myself that at least I'm floundering in an area where I belong, and not in some wasteland bog?

If I had been athletically inclined, my future would be assured. Hockey player, baseball player ... safe within the real North American culture, shielded from the abuse that our fascinating society hurls upon contemporary art, art that is no longer even used to decorate our beautiful homes. People have turned their backs on art, preferring to watch figure skating on TV. It's more elegant! Or wrestling—it's more exciting, easier to understand....

I covet, crave, lust for things I don't have. It's become a habit—I really have to cut down. I burst with envy for everyone around me. I'm even jealous of supermarket cashiers. Their salary is no doubt higher than mine (when, of course, I'm working). I have to admit that sometimes hatred is mixed in with this envy. What a confession! So, yes, I'm using this pulpit for my confessions, my purification. It's true, I envy others. I'm seized by these mad whims and the vogue of the mid-life "career change." By the allure of becoming an insurance salesman or parking-lot attendant. These jobs pay well, don't they? I get this uncontrollable desire to hear the jingling sound of dollars piling up in my savings account, RRSPs and early-retirement packages that blind me to the future! In moments of despair, I see myself becoming an automobile show or home show representative. I'm sure I'm not the only one to entertain these ideas. I'm sure all of us at some point lust for success, regardless of the means!

Even subway ads torture me with their temptations. My head spins round and round. I must turn things around, get back on course. The visual arts have become a sub-culture of culture. It's beyond all comprehension. Who should I look to, who should I emulate, who can pull me back to the surface? The only things you can turn to are your noblest sentiments, the stirrings of your soul, the ardent desire to persist without doubting yourself. To your "professionalism."

And although this professionalism sometimes gets lost in the fires of passion, generosity, love of art, it will endure if our faith endures. It is this very passion, however, this artistic drive, that is being jeopardized by the impoverished state of artists. Our vocation is surely unique: maintaining our passion while resisting the urge to fill the void. And it is this complicated mental zone—passion fraught with jealousy and envy—that I am struggling to navigate. How to escape? Pretend that everything is fine? Covet thy neighbour? Dream? Persevere?

This, then, is my current state of delirium. And once again, I choose to

persevere. I forge ahead, I believe in the cause. But I still look at everyone around me—with burning envy.

Post-scriptum: Spring 2000

This text first appeared as an editorial in the now-defunct magazine *Cube* (no. 5, special issue on Envy/Jealousy). I am dusting it off because, ironically, it is still relevant two years later. Sad reality. My situation has changed little, except that I have added the title of performance artist to my résumé—an addition that simply increases the precariousness of my state. And why not? Suffering becomes us so well. Masochism is our adoptive parent.

Don't misunderstand me. I have not fallen into the vortex of the perpetually complaining loser. I have chosen my field, I accept it, and sometimes the odd

THE AUTHOR WORKING AS A DISHWASHER, AGE 21

moment of glory comes with it. Besides, with regard to the arts community, there have been some attempts to relieve its poverty.

Since January 1999, I've had the honour of being the project coordinator for the Conseil québécois des ressources humaines en culture (CQRHC), a new para-governmental organization that functions like a sectorial manpower committee. Financed entirely by Emploi-Québec, the younger brother of Human Resources Development Canada, the CQRHC attempts ardently to resolve some of the difficult employment problems in the cultural sector. The CQRHC has produced studies on the employment situation, a dictionary of management, production, and distribution in the performing arts (the other fields will eventually have theirs as well), an analysis of the profession of association director, as well as regional portraits of the cultural situation outside the metropolis. In close collaboration with the Ministère de la culture et des communications, the CQRHC is also preparing to initiate a development

1986 - FEDERAL GOVERNMENT STRIKES TASK FORCE ON THE STATUS OF THE ARTIST. THE TASK FORCE WAS HEADED BY PAUL SIREN, GENERAL SECRETARY EMERITUS OF ACTRA, AND GRATIEN GELINAS, FORMER VICE-PRESIDENT OF THE UNION DES ARTISTES. THE RESULTING LEGISLATION IS UNFORTUNATELY ONLY APPLICABLE TO FEDERAL INSTITUTIONS THAT EXHIBIT OR PURCHASE ART. THE MAJORITY OF INSTITUTIONS AND PRIVATE DEALERS FALL UNDER PROVINCIAL JURISDICTIONS.

strategy in cultural human resources that involves no money for the moment. This, then, is a rough outline of the Council, which is endeavouring to support and organize Québec's cultural workforce.

There is also the Mouvement des arts et des lettres (MAL, an acronym that can also mean, as a word: pain, to hurt, harm, trouble, difficulty, evil, wrong, badly, poorly, ill, unwell), a coalition of cultural association directors formed last fall with a view to securing budget increases for the Conseil des arts et des lettres du Québec. A sum of $45 million has been requested to alleviate the financial problems and precariousness of cultural vocations. This movement is much more aggressive than the CQRHC, with a media strategy involving press conferences and public actions. In addition, the MAL has demanded public hearings on culture, which have been continually postponed by the Ministère de la culture et des communications. This coalition has succeeded in mobilizing the entire cultural sector—all disciplines—which has not happened in many years. This mobilization has demonstrated that all cultural workers are suffering from the same *mal*, the same lack of money and government support for arts and letters in *la belle province* ... whose motto is *Je me souviens*: I remember. And what does it remember? To forget. When the new budget was announced in February, we learned that the CALQ was to receive no increases and that $20 million was earmarked for a consolidation fund. Insulted and disappointed, especially after the public hearings that appeared to have been consigned to oblivion, the MAL counterattacked, attempting to salvage a portion of this sum for the CALQ. After some stormy meetings, it managed to secure a non-recurring $12 million—an insufficient amount to resolve the lack of income in the arts. The battle to obtain equitable and recurring increases is therefore still on-going.

Thus, two years later, with an extra $12 million in our pockets and a few employment studies, a dictionary, and an analysis in hand, the situation stagnates. The arts community is left ... wanting. As for me, I'm managing to survive without too much envy and jealousy of everyone in sight.

TRANSLATION: JEFFREY MOORE

> SCOTT McLEOD

Security

BELL CANADA

1986 - International Artists' Union (IAU) publishes "The Social and Economic Status of the Artist in English Canada" in *FUSE*.

REVENUE CANADA TAXATION

JOHN HANCOCK FINANCIAL SERVICES

1986 - VAL SPONSORS "STRATEGIES FOR SURVIVAL: STATE OF THE ARTS THE ART OF ALTERNATIVES."

CANADIAN IMPERIAL BANK OF COMMERCE

NATIONWIDE INSURANCE

1986 – Formation of Cold City Gallery in Toronto by coterie of artists exploring alternatives to both commercial galleries and artist-run centres. The co-operative offered individual artists "the same sustained exposure as private galleries with the exception that in Cold City the artists represent themselves" (Doyle, 39).

GENERIC PATTERN

UNITY SCHOOL OF CHRISTIANITY

1986 - CC MAKES ONE-TIME ALLOCATION OF $800,000 TO ATLANTIC PROJECTS FUND (APF). CRITERIA OF PROGRAM SEEMINGLY FAVOURS RESEARCH AND ANALYSIS RATHER THAN PRODUCTION (CRAIG, 20–23).

CANADA TRUST

BANK OF CANADA

1986 – QUÉBEC CAUCUS OF ANNPAC/RACA FORMS LE REGROUPEMENT DES CENTRES AUTOGÉRÉS D'ARTISTES DU QUÉBEC (RCAAQ) AND COPYRIGHT ORGANIZATION (AADRAV), PROVINCIAL VERSIONS OF EQUIVALENT FEDERAL ORGANIZATIONS.

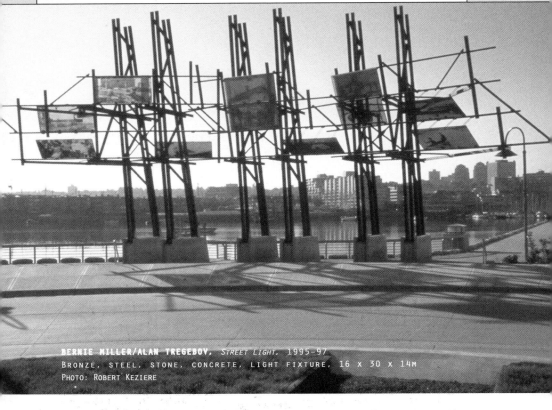

BERNIE MILLER/ALAN TREGEBOV, *STREET LIGHT*, 1995-97
BRONZE, STEEL, STONE, CONCRETE, LIGHT FIXTURE, 16 x 30 x 14M
PHOTO: ROBERT KEZIERE

Reconsidering the Risks of Civic Public Art Funding

With headlines such as "The Good, the Bad, and the Ugly" and "The Perils of Public Art," writers have been having a lot of fun with the subject of public art and the programs that support this work. Art journalists and theorists took strong positions in their responses to the introduction of civic public art programs in most Canadian cities during the late 1980s and early 1990s. A characteristic feature of this new model of art funding is the involvement of both corporate and citizen representation.

Some pundits embraced these programs as a way to produce art for public spaces, with an emphasis on process that would head off controversy in the press and rejection from the average citizen. Arguing the merits of Toronto's then-new program, the *Globe and Mail*'s Kate Taylor created new slurs for the much-mocked monument to Canadian airmen (commonly known as "Gumby"), which had been produced just prior to the introduction of the city's policy. Taylor used the criteria of which works "could give Gumby a run for his money in the ugly sculpture sweepstakes" to assess "the pitfalls of public art"[1] in Canada. By contrast, other journalists vehemently opposed the bureaucratic quality of civic programs and lack of interesting aesthetics or political effect that result from this form of art policy. Michael Scott of the *Vancouver Sun* suggested that the city's program produces "namby-pamby public art"[2] while Bronwyn Drainie argued that we need an "artistic guerrilla" to counteract the "sober, responsible processes for choosing . . . public art in Canada."[3]

My assessment of responses in art magazines and newspapers to civic public art policy over the last decade indicates that critics, in addition to having an inventive stock of insults, do not focus on the stakes involved with assessing the merit of such programs. Those opposed argue that the programs are not worth considering—essentially, they would like the programs to simply vanish (but presumably still have the money spent on the arts). Those in favour value the

1987 – CARFAC HOLDS ACTION NOW!, A THREE-DAY SYMPOSIUM ON ARTS AND CANADIAN SOCIETY
AT CHURCH POINT, NOVA SCOTIA.

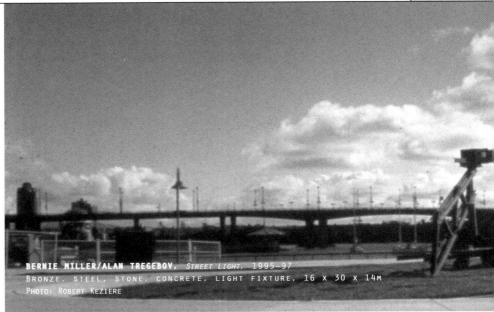

BERNIE MILLER/ALAN TREGEBOV, *STREET LIGHT*, 1995-97
BRONZE, STEEL, STONE, CONCRETE, LIGHT FIXTURE, 16 x 30 x 14M
PHOTO: ROBERT KEZIERE

programs' ability to reach consensus and prevent controversy within the given
city. When opponents to such programs deride the artworks, supporters rally
around the art and artists. In none of these arguments does the discussion
seriously consider the larger issues involved with the appearance of such programs
across the country at around the same time. Instead, the focus is usually on the
individual cases of each art project.

One common argument against civic programs involves comparing their
projects with the kind of politically active projects that artists can produce with
independent grants and through artist-run centres. In other words, though it
is not usually stated explicitly, writers assume arm's length funding support as
the standard. In an article discussing a billboard art project sponsored by the
Windsor artist-run centre Artcite, Ray Cronin establishes his support of the
exhibition's political quality by comparing it to the "consensus model of art in
public plazas."[4] Cronin's interest is in the representational strategies
demonstrated by the works in the Artcite exhibition and their contribution to
social issues by causing debate within Windsor. He raises the "consensus model"
as part of his attention to the works themselves, but he is not concerned with
the variation in policy frameworks that produced such different work.

Some critics argue that the civic policy should be altered or abolished.
Michael Scott rejects Vancouver's program in a number of articles that set the

civic work against that produced through both public and private galleries. In "Whose art is this?" Scott examines twenty public artworks in the city, rating them with letter grades. The ranked projects include three works produced through the civic public art program: Scott gives Daniel Laskarin's *Working Landscape* (1998) and Bernie Miller and Alan Tregebov's *Street Light* (1997) each an "F" and Gwen Boyle's *New Currents, An Ancient Stream* (1996) a "C+." He spends the bulk of the article lambasting the "shallow and largely mediocre" work which inevitably results from a public art process that is "swaddled by bureaucratic committee."[5]

"Failed" artist Laskarin wrote a response focusing on Scott's method:

> **The criteria he employs have little to do with the particular character of individual works of art, do little to elucidate them and less to appraise them in terms of how they may be relevant to their social context or to us. Instead, he offers us a facile judgement and grading system that either ignores or fails to understand how art operates.[6]**

I agree with Laskarin that Scott's "public art report card" does not produce any insights about the twenty works he addresses, regardless of whether he likes them or not. More importantly, the lack of effective analysis here is an example

of a larger problem in discourse concerning public art. The policy involved in the commissioning of a particular art project should be regarded as a major factor in how that art operates.

The complexity of this terrain, with myriad overlapping issues, makes it difficult to sort out new possibilities for more effective analysis. One step is to recognize that policy issues should be considered separately from the spatial aspects of public/urban locations. Attention must be paid to how these two areas are imbricated but also to each at its own level. Focusing on the reactions to public art programs in connection to attacks on other forms of arts funding furthers the entrenchment of opposing positions. When a critic such as Scott lambastes the civic program, other writers and artists rush to embrace the art in question because of the need to stand together in the face of funding cuts and repeated attacks on the arts. From this perspective it appears that there are similar stakes involved with the civic public art programs and with arm's length funding.

Whether for or against the newer form with its corporate and citizen interests, it is worth examining the justification for the civic programs in terms of what we can learn about the general area of arts funding in Canada. At one level, attention to the policy involved can enable a better understanding of how to work with this structure—simply condemning or embracing the projects does not advance strategies to work with the programs; at another level, this analysis could improve the justification by arts professionals of our multi-levelled form of arts policy—understanding how the new form came into existence could update the arguments for the older form.

Frustrated with the inability of arts professionals to effectively counter attacks on the arts, writers often assume that the unique quality of art itself is the source of the problem in mounting an effective defence. For example, Robert Labossière argues that:

> In the past four years the neo-conservative attack on public arts funding has done extensive damage. The merit of particular art has been questioned, aspersions have been cast upon the way in which funding decisions are made and public confidence in the concept of government programmes to foster the arts has eroded.... The arts community has had difficulty defending itself against even the most obviously ill-thought-out, bombastic, transparently political attacks. This is partly because it is difficult to explain art in non-specialized terms and partly because the rationale for public funding is equally complex and difficult to explain.[7]

Because this defensive assumption is prevalent among those who work in the arts, supporters of public funding do not see the flaw in the logic behind this argument: if art and arts funding are virtually impossible to justify, then how did the Canada Council for the Arts or regional bodies ever come into existence in the first place?

Right from the onset of recent attacks on the arts, proponents of public funding have been puzzled as to how each uninformed and self-serving assault has actually managed to succeed in gaining recognition and to erode support of culture. Arts professionals have been retreading this terrain for more than a decade. However, by looking at the issue as solely located within the domain of the arts, it is not possible to examine larger social discourses that could be involved with this specific area of debate. A new perspective on this deadlock is made possible by examining arts policy in relation to an approach in social theory that looks at large-scale discourses that produce/are reproduced by governmental processes.[8]

In his essay "Government, Authority and Expertise in Advanced Liberalism," Nikolas Rose details trends that characterize alterations in liberal democracies across several different areas. He describes the association of early twentieth-century liberalism and "the state of welfare." Rose asserts that in this form, "the truth claims of expertise" were crucial in governmental strategies because "through the powers of truth, distant events and persons could be governed 'at arms length': political rule would not itself set out the norms of individual conduct, but would install and empower a variety of 'professionals' who would, investing them with authority to act as experts in the devices of social rule."[9] The common examples for Rose's type of argument are arm's length medical bodies or the system of social welfare, but the Canadian arm's length arts funding framework also fits within the rationale that Rose describes. For example, the staff of the Canada Council for the Arts and the provincial arts councils consist of arts professionals who arrange for other arts professionals to serve on juries that determine the allocation of funds and the federal or provincial government invests these professionals with the authority that validates and enables such a process.

Rose's framework demonstrates how it was possible to justify arm's length public arts funding in the time period when these arts organizations were formed and Canadian liberalism was in full swing. Furthermore, his analysis helps explain why the arguments that used to win favour have now lost their status. The focus of Rose's argument is that here at the end of the twentieth century, the discourses of governance have changed fundamentally. He argues that:

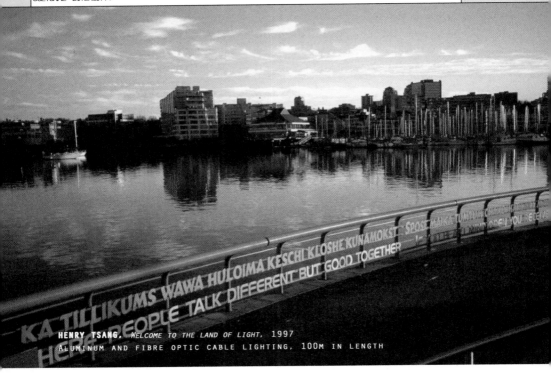

HENRY TSANG, *WELCOME TO THE LAND OF LIGHT*, 1997
ALUMINUM AND FIBRE OPTIC CABLE LIGHTING, 100M IN LENGTH

> A new formula of rule is taking shape, one that we can perhaps best term "advanced liberal." Advanced liberal rule depends upon expertise in a different way, and articulates experts differently into the apparatus of rule. It does not seek to govern through "society," but through the regulated choices of individual citizens. And it seeks to detach the substantive authority of expertise from the apparatuses of political rule, relocating experts within a market governed by the rationalities of competition, accountability and consumer demand.[10]

In addition to providing insight into the decline of the welfare state in general, this major alteration of the relationship between government and the authority of expertise describes a significant aspect of the rationale that supports the attacks on the Canadian arm's length arts funding system. Opposition to granting agencies, individual artists' projects, or gallery acquisitions all cite the same arguments of respecting citizens' opinions, subjecting the arts to the laws of market competition, producing accountability to taxpayers, acknowledging the consumer demands of audiences, and dismissing the opinions of arts professionals. Repeatedly, art experts inadequately respond by reverting

to their authority as professionals and attempting to reassert the superiority of their truth claims—and then are dismayed when their claims to expertise are rejected. In order to strengthen their arguments, arts professionals need to understand the ways in which debates about public arts funding connect to discourses that transcend the Canadian situation and the art realm. Certainly there is specificity to this domain, but there are also connections to larger governmental practices as described by theorists such as Rose.

Civic public art programs, and the arguments that arts professionals make about these programs, provide an effective site from which to analyse larger issues of arts policy and governmental discourses. Far from being bland and dull, these programs have been situated at a defining point for the arts in the last decade. They were instituted during the period when attacks on arm's length funding first proliferated, they are still expected to meet the same expectations as the earlier form although their structure is significantly different, and they exist within the new climate of anti-expertise.

The structure of Vancouver's public art program provides strong evidence of this tension between the older form of arm's length bodies and the new civic public art programs. The proposal that founded the formation of the program gives a condensed picture of the justifying arguments involved with this policy. In the document *Art in Public Places Progress Report*, by the Vancouver Special Committee on the Arts, the main conclusion is that the city should create a public art advisory board. The council committee defines the board as "a citizens' committee, made up of art professionals and other experts as necessary," and argues that the committee had already acted in this capacity because it "functioned as a citizens' public art advisory board."[11] Essentially, "art professionals" and "citizens" are the two significant groups who would participate in making decisions about public art for the city. The council committee provides a role for both art professionals and citizens to air concerns about public art and also includes these two types of people as the appropriate sources for jury members. Thus, the proposal mixes the two designations which are in direct conflict in the different formulas of liberal rule.

Rose's analysis of governmental strategies that link liberal democracies, and the changes of rule within these nations, helps to explain larger forces that drive the creation of new public art programs. As long as the opinions of experts such as artists or patrons held value, cities such as Vancouver did not need a public art program. Spokespersons for the average citizens did not have the authority to make arguments against decisions made by art connoisseurs concerning a given sculpture for a public space. With the current movement towards including "the man on the street," the opinion of a non-expert has much greater weight when used by a newspaper, a politician, or a city council.

From this view, the creation of a public art program fits within a strategy to salvage authority for art professionals within the production of civic public art. The initial advisory committee consisted of experts from a variety of arts fields who presumably would like to see a level of professionalism included within a civic public art program.[12] With the move away from valuing expertise, the proposal for Vancouver's program had to include business interests (the developers who must allot a portion of their budget to public art) and citizens or members of the community (as if artists or curators were not also citizens or members of the community).

If we consider the internal tension that exists within the civic public art program because it attempts to exist within both older notions of arts funding as well as within the expectations of late twentieth-century governmental discourses, it begins to seem unfair to simply condemn art projects produced through such programs for not effecting the same (ideal) result as an arm's length project. After reading Scott's shellacking of the Vancouver program, I undertook a walking tour of the program's highest profile component, the Concord Pacific Place development in False Creek. By the time I had a chance to see the development, I had already heard the debate about the works, including Miller and Tregebov's *Street Light* and Henry Tsang's *Welcome to the land of light* (1997). In addition to Scott's failing grade, general opinion held that these works were uninteresting and some residents of the chic condominiums even complained that *Street Light* is an eyesore that reduces their property values. Supporters had rallied around the stated goals of these works, defended their complex invocation of the labour and cultural history of the False Creek site and argued that opponents were actually opposed to the identity politics produced by the works.

Filled with all this information and my own desire to support public art, I was eager to engage with the works installed along a section of seawall adjacent to the high-tech, high-priced development. I took the time to read every bit of text for each work and look at them from every angle. *Street Light* consists of metal scaffolding extending about forty feet into the air with metal grills suspended between the bars. Similar to the effect of newspaper images, the dots and spaces of the grills reproduce photographic images of the various incarnations of the neighbourhood. Over the years, it has been the site of sawmills and floating labour camps as well as the grounds of Expo '86, which paved the way, literally, for corporate development. Dates and descriptions of each image are engraved into the concrete supports of their respective scaffolds as is a text listing the artists, title, and date. The images are easily visible if one looks up on approaching the work. They are also meant to appear at the base,

cast in shadow, but considering the paucity of strong sunshine in Vancouver this second component has been less than successful. Thus, the connection between texts and images only occurs if viewers go to the trouble that I did of stepping back and forth between reading the text at the base and craning up at the panels.

A short walk along the seawall leads to Tsang's *Welcome to the land of light*. This piece consists of a double line of texts that runs along the railing of the seawall. The top line is in what the panels identify as Chinook Jargon and the bottom in oddly structured English, which suggests that it is a direct translation of the first text. For example, the first phrase reads, "Greetings! Good you arrive here, where light be under land," and the second, "Future it be now. Here, you begin live like new." In addition, there are three separate plaques spaced apart in the middle of the work. The first lists the title, artist's name, and all of the texts, and has a border of simply drawn icons representing various forms of communication (such as a satellite, a telephone, and clasped hands). The other two can only be called didactic panels. The central one includes four photographs of various historical incarnations of the False Creek site and states, rather redundantly, that *Welcome to the land of light* is "An art installation on the seawall handrail with aluminum letters and fibre optic lighting." As well, a paragraph of text provides the interpretation of the work, including: "This public artwork speaks about how technology promises to bring cultures together in the new global village on this site." The third panel explains how Chinook Jargon arose from the needs of labourers from various cultures to communicate with each other and that this "nineteenth century lingua franca" is a "dialect of the Columbia River Chinook in Oregon with elements from English, French and Nootkan (Nuu-chan-nulth)." My main reaction to the work was to wonder how a text-based public artwork ended up with three different panels to explain its meaning to would-be viewers.

Assessing my tour of these two works and the others in the project, I could not reach a simple conclusion based only on attention to the artworks. They did not seem to fit either pole: bland failure or successful producer of complex cultural identity. There are intriguing elements and strong ideas in all of them and yet they do not come together in an effective manner. But this should not be the only criteria for discussing how the works operate. By assessing these projects as examples of the first results of a program situated at such a contra-dictory site in relation to art and social discourses, I have to conclude that the artists did indeed take risks. The problems in producing an end result in line with the initial intent go beyond difficulties inherent to the political goal of each work—for example, engaging with the history of the False Creek site in a modern sprawling city whose apparent mandate is to forget and destroy anything

1988 — FOUNDING OF PURPLE INSTITUTE IN TORONTO, A QUASI-ANARCHIST GALLERY/PERFORMANCE SPACE. IN A 1989 INTERVIEW WITH TORONTO STAR ART CRITIC CHRISTOPHER HUME, A PURPLE INSTITUTE MEMBER BOLDLY DECLARES THAT THE INSTITUTE WILL AVOID GOVERNMENT-GRANT DEPENDENCY IN ORDER TO MAINTAIN SPONTANEITY AND AVOID UNNECESSARY BUREAUCRATIZATION.

over twenty years old. The artists' risk is that they produced work within this new form of arts policy and thereby had to answer not only to the developers and the civic program, but also to the assumptions associated with the older, arm's length system of funding. As much as I would like to see a totally successful negotiation of these discourses, I cannot say that these works have achieved that. However, neither condemning them, nor embracing them because one shares their goals, will help to create effective strategies for working with civic programs and the current governmental processes.

In short, if the projects are not what one would like to see, then how can we learn from the gap between intention and realization in order to develop more effective strategies? Whether one thinks there is positive potential in civic programs or that they have no value because they could never produce radical work, it is useful to consider the rationale that enabled a form of arts funding to appear during the onslaught of anti-arts funding discourses. For the latter, this approach assists in understanding that the preferred arm's length funding is not a naturally occurring formation, but a policy that arose during an era and was justifiable in relation to certain discourses of the time. Finding ways to keep the strengths of that system involves developing arguments that can successfully engage current discourses. As well, attention to the specificity of arts policy clarifies the difference in expectations one needs to bring to each, particularly around the notion of politics. By looking at factors that transcend the art domain, it becomes clear that civic projects are political and engaged with social debate and that these issues involve more than representational strategies or relation to site.

NOTES

1 Kate Taylor, "The perils of public art," Globe and Mail, August 13, 1994, C1.

2 Michael Scott, "Critical art under assault," Vancouver Sun, November 8, 1997, C7.

3 Bronwyn Drainie, "An artistic guerilla strikes at night and John Q. Public loves it," Globe and Mail, July 14, 1990, C1.

4 Ray Cronin, "Temporary Public Art in Windsor," Parallélogramme 17:3 (1991–92), 41–42.

5 Michael Scott, "Whose art is this?" Vancouver Sun, July 22, 1998, C5.

6 Ibid., C8.

7 Robert Labossière, "A Newer Laocoön: Toward a Defence of Artists' Self-determination through Public Arts Funding," FUSE 18:5 (1995), 15.

8 For a detailed discussion of Michel Foucault's concept of governmentality, refer to *The Foucault Effect: Studies in Governmentality*, G. Burchell, C. Gordon and P. Miller, eds. (Chicago: University of Chicago Press, 1991), especially for Foucault's article "Governmentality" and Gordon's article "On Governmentality." Tony Bennett develops the notion of governmentality specifically for cultural analysis in "Useful Culture," *Relocating Cultural Studies: Developments in Theory and Research*, V. Blundell, J. Sheperd, and I. Taylor, eds. (London: Routledge, 1993).

9 Nikolas Rose, "Government, Authority and Expertise in Advanced Liberalism," *Economy and Society* 22:3 (August 1993), 285.

10 Ibid.

11 *Art in Public Places Progress Report*, Vancouver Special Committee on the Arts, February 14, 1990.

12 Chris Dafoe explains that "The city assembled a blue-ribbon committee—among the participants were curators Doris Shadbolt, artist Al McWilliams and architect Jeffrey Massey." "Going public, Vancouver style," *Globe and Mail*, October 30, 1993, E2.

1989 - FREE TRADE AGREEMENT (FTA) PASSED AFTER SECOND CONSECUTIVE FEDERAL VICTORY BY PRIME MINISTER MULRONEY AND CONSERVATIVE PARTY.

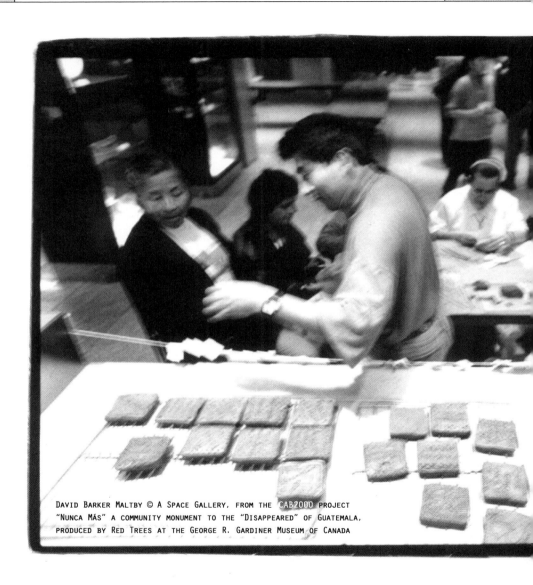

DAVID BARKER MALTBY © A SPACE GALLERY, FROM THE CAB2000 PROJECT "NUNCA MÁS" A COMMUNITY MONUMENT TO THE "DISAPPEARED" OF GUATEMALA, PRODUCED BY RED TREES AT THE GEORGE R. GARDINER MUSEUM OF CANADA

> ROBIN C. PACIFIC

Initiatives in Cultural Democracy

Introduction

In March 1999, I was asked by the Laidlaw Foundation to research the field of community art in Canada, the United States, Britain, and Australia, and to make recommendations for a funding program that would be consistent with Laidlaw's philosophy.[1] I knew there was a great deal of information about community art available, and that doing the project successfully would depend on my ability to focus and select very carefully. I even thought, at the outset, that I knew quite a lot about the subject, having been a practitioner for some twenty years. I was, however, unprepared for the incredible volume and variety of material available on a wide range of practices, policies, and funding programs. I was also not aware of how rapidly the field is changing, and how quickly it is being integrated with areas of public life that have not previously been identified with the arts: community economic development, activism, planning, community health promotion, trade unions, and so on. As Deborah Myers, director of the Assembly of B.C. Arts Councils, says, "Because of low levels of funding and the collapse of a resource-based economy, there's a critical mass of despair and disillusion, and there's a hunger for new ways of doing things, a hunger for arts processes and practices."

During the course of my research, I have found words and phrases such as *intersectoral, thinking out of the silo, and communicating across the mountaintops* cropping up again and again, in a range of contexts. Suddenly it seems that cultural policy makers in arts councils at all three levels of government, and in advocacy groups such as the Canadian Conference of the Arts, are all talkin' community. And, while this is less true in Canada than elsewhere, community groups are increasingly talkin' art. Cultural development, cultural planning, cultural capital... There is, in short, a great deal of very interesting and careful thinking

going on out there. There is also some ambiguity about terminology. The phrases *community* and *community art* have become portmanteau words. In the run-up to Y1K, people looked to God for salvation. As we round the corner of Y2K, God has been supplanted by an equally omnipresent concept: community.

Community has been appropriated, generalized, mis-used, and summoned as the mystical answer to just about all of society's problems. It has come to mean everything and nothing. It has come to mean, "when two or more are gathered together..."

The term *community art* is similarly vague and ill-defined. It reminds me of the story of six blind men and an elephant, only in reverse. Six blind men all examine the same animal, one feeling the trunk, one the legs, one the belly, and so on. The result is six different descriptions of the same animal. When it comes to community art, six people can use the same language, identical words and phrases, but they are in fact talking about six different animals.

Eventually it became clear to me that the community art practices I was reading and hearing about were determined by different philosophical or ideological perspectives. This is why, even when the same terminology is used, the aims of the endeavour may be quite dissimilar. The seven different perspectives I've identified are very general guides. They often overlap. Furthermore, actual projects might look the same, but be driven by very different ideas, visions, and goals. What follows is an initial effort to iron out some of the wrinkles.

Philosophical Frameworks

1. The Opposition Model

This model supports subversive art that brings political issues to the forefront. The approach is currently quite unfashionable. It assumes that society is class divided, that for the most part structures (or "social relations") of culture are "bourgeois" and used to maintain the power of the ruling classes over the subordinate ones. Therefore community art is supported when it seeks out and strengthens those aspects of working class culture which are seen to be oppositional, rather than those which result from the passive consumption of popular culture. Some interesting thinking around these issues came out of the various arts and recreation committees of the Greater London Council in the early 1980s just before it was terminated by Margaret Thatcher.

The issue of taste, of where to draw the line between good and bad, high and low, the ugly and the beautiful, the ephemeral and the substantial, is an explicitly political one. The principle of pure taste is constructed as a refusal of the popular, the vulgar, as an opposition between the cultivated bourgeoisie and the people.... But the realm of taste functions ... as an economy: there is competition over prices, there are criteria of supply and demand, producers and consumers, and the question of value. The cultural field is an analogous form of economy where agents are endowed with specific cultural "capitals" arising from educational opportunity, where one class ... possesses the "cultural capital" and another does not[2]

In my research, I found less antipathy to these ideas than I expected. As Greg Baeker, head of The Arts in a Pluralist Society at Scarborough College, says, "It's time for the reintegration of the social critique from the sixties and seventies, to re-marry it to cultural industry. Let's bring the ideology of resistance into cultural production."[3]

2. The Transformation Model

This model can be traced through many by-ways, back to the work of the Italian philosopher Antonio Gramsci. Gramsci talked about "organic intellectuals of the working class"—artist/intellectuals seen to have a central role in animating both public debate and communities.[4] Carol Becker, Dean of the School of the Art Institute of Chicago and author of some of the most valuable critical discourse about community art, refers to "the artist as public intellectual."[5] The latest publication of Americans for the Arts is called *Animating Democracy: The Artistic Imagination as a Force in Civic Dialogue*.

Another Gramscian concept comes from his deep questioning of how Italian fascism was able to capture the imagination of the Italian people, especially the youth. He concluded that this happened through cultural institutions and infrastructures in neighbourhood communities, and argued for organizational models that would be capable of transforming individuals from passive objects to active subjects. This has been extrapolated by a model of community art that fosters the transformation of whole communities (both geographical and "of interest"), providing a sense of identity and power to groups through their active participation and collaboration in a creative process.

With many variations and reinterpretations, this is the model used by Carol Becker, John McKnight,[6] the Urban Issues program of the Samuel and Saidye Bronfman Family Foundation, the Australia Council, and the Ontario Arts Council.

1989 - United States Senate passes Helms Amendment, forbidding NEA funding of "obscene" art. This hysteria has definite ripple effects throughout Canada, particularly with regard to queer art and artists, and instigates threats from federal and various politicians to existing arm's length status of funding agencies.

3. The Identity Model (This Is Not a Benetton Ad)

Community art gives voice to those individuals and groups whose voices have been silenced, for example, ethnic minorities, youth, gays and lesbians. This model differs from the preceding ones because it includes promoting artwork by professional artists from these communities, and not necessarily works of collaboration with group members. The wide-ranging, exemplary work of A Space Gallery, which identifies itself as a community art organization, is the best example I know of this model.

4. The Village Model

June Clarke, Community Liaison Officer at the Toronto Arts Council, looks at Native Canadian and African cultures to provide the metaphor of a village to define community art. In the village, some members have an esoteric talent that is indigenous to that culture, and all others take pride in it. Or, as community artist Elizabeth Cinello puts it, "Community art has always been there—everywhere—and it used to be tied to the act of living."[7] Funding practices focus on ways to strengthen the art and culture that already exists in the "village," through nurturing the talent within a community rather than encouraging it to leave through dreams of celebrity. The challenge, according to June, is how to translate that pride to the larger community, how to encourage it and not have it commodified. The work of William Strickland of the Manchester Craftsmen's Guild in Pittsburgh is a good example of this philosophy.

William Strickland, the Guild's director, is the Grand Old Man of community art in the United States. As a young man growing up in the Pittsburgh projects, his artistic talent was recognized by his teachers and he was encouraged to go on to university. He became an architect, but couldn't stop thinking about children like himself. He decided to return to the neighbourhood of his youth and reach out to others. From this was born one of the finest examples anywhere of community art education for children, and Mr. Strickland now sits on the President's Committee for the Arts and numerous prestigious boards, and is the recipient of many awards and honorary degrees.

Too narrowly defined, this model potentially deprives the larger culture of talented "village" artists, and the artists of the chance to interact with the larger culture. In 1995 when the Art Gallery of Ontario approached Art Starts[8] to

consider being one of seven community groups to do an installation in conjunction with the Group of Seven exhibit scheduled for 1996, the Art Starts staff discussed if and how we would participate. My concerns about being appropriated by a mainstream art institution were overridden by the consideration that Stephen Fakiyesi, one of our most outstanding resident artists, should not be deprived of a chance to exhibit in a gallery that doesn't have a great track record seeking out young, male African-Canadian artists. We ended up doing an installation-as-process, artwork by Stephen, which asked questions about the distance between Eglinton Avenue, home of Art Starts, and Dundas Street, home of the AGO. The AGO wanted us to run programs to bring members of our community into the gallery; instead, we created invitations with people in our neighbourhood, which became part of the installation. We thus invited AGO viewers to a "vessel-making" workshop at Art Starts, which was attended by our usual community participants and members of the regular AGO audience. The vessels were then placed in the installation, in a ceremony at the AGO, at the end of a "CookUp" performance with the usual Art Starts mix of Italian opera, reggae-cize, clown theatre, and so on.

5. The Pluralism Model (This Is a Benetton Ad)

This version of community art looks at fostering communication and collaboration among a range of "stakeholders," including artists, community groups, community development corporations, and the private sector. It focuses on similarities rather than differences, looking for the common human links among participants, blurring questions of power and who does and does not possess it. The community art policies of the National Endowment for the Arts are relevant here, as are the funding priorities of major foundations such as Ford and Rockefeller. I suspect that the cultural policies of the twenty-three out of twenty-six centre-left coalitions in the Council of Europe are not dissimilar, although they have a more sophisticated and organized trade union movement to accommodate.

6. The Audience Development Model

Here the function of community art is to make art accessible, and to create new audiences for the arts. This is the raison d'être of regional arts councils in Canada. Karin Eaton, director of the Scarborough Arts Council, defines it as "art that is available to the community, in any form."[9] Similarly, one of the two guidelines given by the Canada Council Artists and Communities Program was to "create greater awareness and appreciation of the value of the

role of the artist in society." In this model, community art can also mean new ways for artists to create and promote their work. The Ford Foundation's $4-million grant program, "Meet the Composers," created opportunities for musicians to work with communities in finding new subject matter. Sometimes community workshops were conducted, and ideas and opinions solicited, but the works themselves were not collaborative.

7. The Neoconservative Model
(Beat Them Up, then Sell Them the Bandaid)

First social infrastructures that make communities possible (health, education, and culture) are dismantled, then policies are introduced that focus on volunteerism—the actual work is done by community members for free—and "community experts"—the actual control is wielded by members of elites. This model relies on a nostalgic, idealized view of community life that is a throwback to the 1950s (itself a nostalgic ideal that never existed, anywhere, ever).

As Angela Lee, former program director of Art Starts, points out, there are plenty of communities out there making community art, without assistance from professional artists—they just don't call it that. Elizabeth Cinello's mother has belonged to a women's club for over thirty years. The five hundred members all come from the same region in Italy, and are all in their fifties, sixties, and seventies. Every year they put on a play. One woman writes it, and three or four always act in it. But then someone will say, "I have a cat costume," so a cat gets written into the script. They all sew, so the costumes are extraordinary. "The plays are hilarious, they always show the energy and sexuality of their youth, that they were thinking about sex when they officially weren't supposed to. The plays show their inspiration and desire for a better life. It's all funny and very moving. Last year's skit ended with them getting on the plane to Canada."[10]

Another example: Robin Wright, coordinator of Laidlaw's Youth Engagement Program, describes the drop-in program for homeless youth run by Native Child and Family Services. In addition to doctors volunteering, a peer-mentoring program, and the development of a special school to address the young people's needs, there is a project called Image Maker. This is a small business which creates murals commissioned by businesses, government agencies, and individuals.

With one obvious exception, I think all of these practices are worthwhile, very much in the public interest, and useful examples of art that challenges elitist cultural practices.

Project Modalities

There have been hundreds, maybe thousands, of community art projects created in the English-speaking world over the last twenty years. I will look at five different categories or classifications of community art practices, using examples as illustrations. Again, these are over-simplifications, and again there may be many overlapping edges. Although some lines can be drawn connecting the practices to the philosophies in the preceding section, there are no neat equations. Different philosophies may drive similar practices, and a philosophical framework may elaborate several different kinds of projects.

1. Community Economic Development

Art—any art—is a means to economically revitalize a geographical community, usually one that has undergone economic upheaval with the disappearance of an industry or major employer. The small town of Peekskill, New York, is an example. Town planners first made inexpensive work/live space available to artists with the expectation (a correct one) that a small business, tourism-generating infrastructure would follow. "Handmade in America" is a movement of economic redevelopment through a state-wide craft cooperative in North Carolina. "Public Row Houses" in Houston is a slightly different approach. Artists move into an abandoned urban street and remodel and redecorate the streetscape. The move to have Toronto's "Oakwood Village" (the area bounded by St. Clair, Oakwood, Vaughan Road, and Bathurst) declared an official arts district is a local example.

2. Community Organizing

Here the initiators of the community art project are not artists but community activists/organizers, or, more often, social service providers. These projects are often inspired by the ideas of John McKnight, who advocates building on strengths in the community (social capital) rather than continuing to provide services to perceived "victims" in a climate of dwindling public funds. Social capital is seen to include cultural capital. An example close to home is Café Depot in Notre-Dame-de-Grace, Montreal. This is a monthly cabaret at the food bank, plus a community publication called Cornucopia.

3. Artists-in-Community Residencies

The focus is on the artist working in a given community with such aims as finding new sources of material, new ideas for artworks, potentially new audiences

1990 - BILL C-12, OR MUSEUMS ACT, MANDATES THE NATIONAL GALLERY TO "PRESERVE AND PROMOTE THE HERITAGE OF CANADA AND ALL ITS PEOPLE THROUGHOUT CANADA AND ABROAD, AND [TO] CONTRIBUTE TO THE COLLECTIVE MEMORY AND SENSE OF IDENTITY OF ALL CANADIANS" (WHITELAW, 127).

through workshops and contacts. There is a range of possibilities within this model. The aforementioned "Meet the Composers," funded by the Ford Foundation, enabled composers to give workshops, find new material, and broaden their audiences.

While this is doubtless beneficial to communities, there are other examples of artist-in-community residencies that have involved the participants differently. One example is Pam Hall, an artist in Newfoundland funded by the Canada Council to continue her residency in the Memorial University Faculty of Medicine. Another is Mierle Laderman Ukeles, artist-in-residence for the New York City sanitation department since 1981. Ms. Ukeles spent a year shaking hands with each of the 10,000 sanitation workers in New York. She was appointed Honorary Deputy Commissioner of Sanitation and made an honorary Teamster. During her meetings, she learned all the derogatory words used against garbage collectors. She wrote these words and phrases on a gallery wall. At the opening, workers, the public and city officials were greeted with buckets of soapy water and brushes, and asked to scrub off the offending language.

A variation of this model is residencies of performing arts groups. These tend to mirror the issues in a community back to its members. A very early example is the Newfoundland Mummers Troupe, the first popular theatre in Canada. They went around the province living in different communities, researching local issues, interviewing people, then creating and performing a play about them. These plays were seen specifically as tools for political mobilization. A more recent example is the London Shipyards Project. The Liz Lerman Dance Exchange from Washington, D.C., was funded by the Lila Wallace Readers Digest Fund to spend eighteen months working with people in the shipyards and creating a dance performance based on their stories.

(The community art residency program run by the Vancouver Parks Board links artists with community centres for a three-month period. This is a different model, however, because these projects are all collaborative. It is described in detail in the "State of the Art" section below.)

4. Collaborative Projects

The artist works with community members and evolves a collaborative methodology and form of artistic expression in which all participate. There

are countless examples; suffice to say that again there is a range of possibilities. The artist may have one central idea, and community members execute it, with greater or lesser artistic decision-making. Examples are North Coast Net, a fishing net made of nettles, in the traditional way, by a small community in British Columbia, one of the Canada Council Artist and Communities projects, or cj fleury's flower mandala, described in the Ontario Arts Council's *Community Arts Workbook*. Community members gathered materials from nature and made a giant mandala on the floor of a vacant firehall in Wakefield/La Peche, Québec. Or the artist may give workshops in, for example, painting, and the participants' work is exhibited. Such a project is ARTJAM in Guelph, another Artist and Communities project, where afternoon painting workshops are held for $5, and the results hung all over the city, indoors and out. A project involving even less intervention by an artist is *Gibber*, an Australian publication of writing and graphics by street youth where everything is accepted as submitted, and there is no editing of grammar or spelling.

In the course of some collaborative projects, participants may be galvanized to effect social change. Or the outcomes may be more indirect and subtle—an increased awareness of one's inner self, greater tolerance towards others, a deeper appreciation for art, a sense of oneself as an active agent in the community, and so on.

In a sense, all collaborative community art projects are also residencies. Laurie McGauley, activist, artist, and coordinator of the Myths and Mirrors project in Sudbury, says: "More and more, I like the term artist-in-residence to describe the role of the artist in a successful community arts project. It puts the artist in the community, in a figurative if not a literal way. A successful community artist has to be aware of all the factors that affect the collective creative process, and be ready and willing to deal with them."

5. Combination Projects

Some of the best community art practices combine features of the collaborative and artist-in-residence models—with artists and community members exhibiting together around a common theme. Examples are "The Art of Nursing," an exhibition of artworks by nurses and artworks by established artists about nursing, funded by the Australia Council in 1994. Likewise Persimmon Blackridge's project for the Canada Council Program in B.C., about institutions for developmentally delayed adults, had an exhibit of art by residents and her own art about the institutions, their histories, and inhabitants.

The State of the Art

During the course of my research, I tried to get a brief overview of the development of community art in Canada, the United States, England, and Australia. I had long and illuminating conversations with Loraine Leeson in London, England, and Kathie Muir in Adelaide, Australia. Both are community arts practitioners with twenty years' experience; both were guests at the Ontario Arts Council's international community art conference (Vital Links, Toronto, September 1997); and both were able to give me a capsule history of community art in their respective countries.

There was not an analogous person in the United States, where the field is so vast and so regionally based. My information mostly comes from an organization called Americans for the Arts, set up by the National Endowment for the Arts in the wake of the infamous controversy about censorship that took place ten years ago.

In Canada, although the field is smaller, regional differences are even greater. I will limit my comments to two provinces: Ontario and British Columbia, and to Urban Issues, a program funded nationally by the Samuel and Saidye Bronfman Foundation. With these qualifications in mind, I ask the reader to consider the following remarks as, indeed, "notes."

1. Notes on Community Art in England

Loraine Leeson does not call herself a "community artist." According to Loraine, community art got a very bad name in England and is almost never used. She and her partner, Peter Dunn, formed a company in the early nineties called "The Art of Change." They do commissioned work, for which they receive corporate sponsorship, sponsorship by major institutions (such as the Tate Gallery), and some arts council funding.

Here is Loraine's capsule summary of the rise and fall of community art in England. Following the election of a Labour majority in 1974 to the Greater London Council, the new government undertook a wide-ranging, participatory policy discussion about the role of the arts in the community. They then spent large sums of money to underwrite projects consistent with their new policies. The arts climate in London changed radically, and a great many community art projects were created. When Margaret Thatcher disbanded the Greater London Council in 1986, arts organizations "went down like packs of cards." It is in this period, according to Loraine, that community art got its bad reputation. With the sudden move to the right, everything to do with "community" was out, and in that context community art could be sneered at.

Loraine feels that much of the work that gave community art a bad name was, in fact, of inferior quality, art projects that encouraged creativity with no regard for artistic excellence. "Although some good work, and some good artwork, was done, we ended up with a lot of bad murals."

A few years ago, England for the first time had a national lottery, and the financial fortunes of the arts world shot up again. The Arts Council of England is gradually being disbanded, and lottery funds are going to regional arts councils for, among other things, capital projects—arts facilities and public art. (Incidentally, there is no jury process in many British regional arts boards; decisions are the sole responsibility of the grant officer.) It is in the realm of public art that community art (but not called community art) is resurfacing. Because there was so much unsuccessful public art, the arts community was able to lobby effectively so that communities now have a significant say in how and what public art is produced. Also, many of the projects undertaken by the Art of Change are funded by education departments. Thus public art and art education are the new venues and funding sources for community art in England.

The Art of Change model, however, exemplifies many of the best features of what we call community art. It is collaborative; it works with grass-roots groups, and with people who are disenfranchised from the cultural mainstream. The participants' ideas and their works appear in the completed projects. The professional artists provide the project ideas and the framework that allows the others' work to shine.

The Art of Change's rationale for excellence is hardly elitist, and consistent with the goals of community art. Leeson believes that if the finished product can stand as excellent art, the participants will be proud of it and their role in it.

Leeson's remarks notwithstanding, there are, in the United Kingdom, a network of cultural community centres, and of community and private foundations (often called trusts) that initiate and underwrite a broad range of community art activities.

An example is the community art program carried out by the Calouste Gulbenkian Foundation. The Gulbenkian Foundation runs three art programs at any given time, for three to five years; then they are replaced by others. The art director chooses each program, but researches the area for at least one year. Their Participatory Music program just completed its second year, funding twenty-one non-professional music groups throughout the U.K. Although, again, this program is not called community art, the principles ring true: "There should be easy access to music making for everyone in the country. Everyone knows where to go if they want to take up any kind of sport. The same should be true for music"; and "The world turned upside down, so that we

1990 - SECRETARY OF STATE'S NATIVE COMMUNICATIONS PROGRAM IS WIPED OUT WHEN ITS ENTIRE $3.4-MILLION BUDGET IS CUT. THE PROGRAM HAD BEEN VITAL IN ESTABLISHING AND THEN MAINTAINING INFORMATION NETWORKING AMONG NATIVE PEOPLES OF CANADA.

were able to look at music making from the ground first, not from the lofty heights of professionalism. We recommend this new perspective."[11]

As exemplary as these practices are, we can see from the above that in England, as in Canada, there has been no systematic public policy debate concerning community art. For this, we must turn to Australia.

2. Notes on Community Art in Australia

Kathie Muir, currently taking a leave from her community art practice to complete a doctorate, was in on the ground floor. She was hired as an "arts organizer" (what we might call a facilitator or animator) by the Australia Council in 1980. Kathie worked as a local organizer with the town council of Prospect (population 20,000) for three years, and for three years subsequently as an arts organizer for the Trades and Labour Council. Such organizers were hired throughout Australia in a concerted effort to sew community art into the fabric of public life. Funding was divided three ways: the Australia Council, the regional arts council, and either the municipal council, or a local community group such as a trade union council or a health organization. This latter third of shared funding could be in kind; if the local council or group was unable to fund even this much, the Australia Council topped up its share.

Kathie's mandate was to work with the community to assist the community to realize its arts and cultural ideas, and to manage some arts and recreation initiatives of the council itself (an annual art fair, art programs in the library, and so on). She was, in short, to be a resource person for various groups. As a result, there was a strong local arts network, funding for a gallery, a mural group, and a strong lasting commitment to involving residents in cultural planning. Projects included oral histories with seniors and exhibitions of local peoples' creative work.

There has been some debate about whether the organizer model is a good or bad thing. There's an argument that people become dependent on the organizer, or that the organizer controls projects, or just that it creates a layer of bureaucracy. While acknowledging these criticisms, Kathie maintains that the value of organizers, or animators, is that they give focus, give perspective on a range of issues, and can build up a range of practices quickly. It's important, she says, not to bureaucratize the practice, but to keep it flexible and responsive.

The organizer model of community art was in its infancy, and much of the original work was ephemeral—after all, they didn't yet have the examples that they themselves created! Asked about different philosophical perspectives,

Kathie said that there was an uneasy balance between using community art to develop audiences for mainstream art, and using it for community transformation, with the state arts councils leaning toward the former, the national arts council (the Australia Council) toward the latter. The main objective, according to Kathie, is to assist groups in using culture for self-determination, using the arts to find and use their voice.

As in England until recently, Australia suffers an ultra-conservative federal government. Some progressive local governments have been eliminated, and arts funding has been radically decreased. The enlightened cultural policies of the Australia Council, however, have continued, only with less funding. Some major arts institutions are saying they'll go under without more funding, and their needs should be a priority over community art. The federal government has banned any state funding to unions; policies of amalgamation and the impact of declining membership have also depleted budgets. Only one trade union council still funds a full-time arts officer. Despite this depressingly familiar picture of doom and gloom, artists are still able to access local and state government funds for things such as a percentage for arts in development projects. A local council upgrading a park might make funds available for community consultation and an artist might be paid to participate in this.

In terms of a national policy around community art, changes were underway notwithstanding a political agenda. About five or six years ago, "community arts organizers" were replaced by the appointments of "artists as cultural planners," as both the Australia Council and Regional Community Arts Network became more concerned with infrastructure and long-term planning. Further, the community art centres and facilities have to spend all their energy running their own programs and seldom get the opportunity to do things with more lasting impact. The cultural planners take assessment of cultural capital and cultural needs in a local area and then work with planners and developers. They also continue to develop projects with groups such as migrants, immigrant women, and street youth under the rubric of "public art." The instigation of cultural planners was the second stage of community art practice in Australia to build on the successes of the first, or "organizer" stage.

Now there is a new, "third wave" of community art policy called "place making" or Community Environment Art and Design projects (CEAD) with "a whole series of personalities and debates of its own." The purpose of CEAD is to transform public space and facilities so that they have a distinctive design and feel particular to their community. At worst, the community gets merely to choose between three different designs for a public sculpture. At best, these projects involve writers, artists, artisans, designers, planners, and architects working with communities. They raise issues of ownership of public space,

1990 - ANNOUNCEMENT OF NATIONAL GALLERY'S $1.76-MILLION ACQUISITION OF AMERICAN ABSTRAC-
TIONIST BARNETT NEWMAN'S PAINTING *VOICE OF FIRE* PROMPTS OUTRAGE FROM POLITICIANS, TAXPAYER
SPOKESPERSONS, CULTURAL NATIONALISTS, AND SOME ARTS AND ARTISTS' ADVOCATES. FELIX HOLTMANN,
CHAIRMAN OF THE STANDING COMMITTEE ON COMMUNICATIONS AND CULTURE, REMARKS THAT "IT LOOKS LIKE
TWO CANS OF PAINT AND TWO ROLLERS AND ABOUT TEN MINUTES WOULD DO THE TRICK." DEFENDERS OF
THE GALLERY'S ACQUISITION AND OF CURATORIAL AUTONOMY MADE HAY OF HOLTMANN'S BEING A PIG OR
DIRT FARMER. ON MARCH 26, ALLAN GOTTLIEB, THE CANADA COUNCIL'S CHAIR, WEIGHED IN, WARNING OF
THE NEED TO RESIST POLITICAL INTERFERENCE IN THE ARTS.

and can change how people live, work, and play within those places. There can
be a subtle shift of power regarding policy and control of public environments.
According to Kathie, successful CEAD projects are a major leap forward from the
work done fifteen to twenty years ago. Not too many councils are prepared to put
the time and money into a CEAD project, but "the ones that work are fabulous."

3. Notes on Community Art in the United States

There is currently a nationwide policy debate taking place, as well as a major
increase in the amount of community art activity—thanks to an organization
called "Americans for the Arts." This broadly based advocacy group (which
does not limit its work to community art) was set up, as I mentioned, in the
aftermath of the attack on the National Endowment for the Arts by the
Christian right, led by Jesse Helms. Helms and Co. launched an effective
campaign against freedom of expression which resulted in direct and indirect
censorship of art in the United States. The peer review process has been
dismantled or altered, and the NEA no longer funds individual artists. One
more time, there are NO federal government subsidies in the U.S. for
individual artists. The NEA even demanded, for a time, a written promise
that groups receiving grants would not "offend community standards."
Although this throwback to McCarthyism has been rescinded, many groups
who refused to sign are now out of the NEA funding loop.

I mention this because I believe that the work of Americans for the Arts needs
to be seen in context. Much of their policy and advocacy work on behalf of
community art is outstanding. Many of the arguments put forward in *American
Canvas*, the book published summarizing consultations in all fifty states, are
compelling in their critique of elitist art practices, and cultural and economic
barriers that make the "high" arts inaccessible to the majority of citizens.

**In the course of its justifiable concern with professionalization, institution-
building, and experimentation during the 60s and 70s, for example, the arts com-
munity neglected those aspects of participation, democratization, and popularization
that might have helped sustain the arts when the political climate turned sour.**

> The legacy of the future ... will be the art that is woven through the social fabric, that contributes to the quality of life, fosters civic pride and participation, stimulates the economy and attracts tourists, revitalizes neighbourhoods and addresses social problems. Great works of the past won't be excluded from this tapestry—the $60 million in revenues generated by the Cezanne exhibition at the Philadelphia Museum of Art last year is evidence of the power of past masters—but the new cloth of culture will be much more of a quilt, joining a vast array of new patterns that range from folk, vernacular, and popular expressions, to social, political, and experimental works.[12]

The art world can at times appear to be a self-referential, self-indulgent, hermetically sealed world. Art institutions often do pay only lip service to gender and race issues, and certainly perpetuate, through such things as control of the definition of "taste," class divisions.

On the other hand, a hallmark of liberal democracies is to sanction a wholly uncensored place for freedom of expression in the arts, guaranteed by principles of arm's length funding and peer review. No doubt some foolishness happens here (there are some silly community art projects as well); yet in a world where culture is increasingly commodified, where public and private space is occupied by the corporate advertising agenda, it is in the public good to maintain space for artists to make the art they choose. *Initiatives in community art cannot and must not be used to supplant funds to individual artists and other forms of artistic expression.* This would be of no social benefit and would split an arts community that needs more, not less, understanding of the goals of community art. Deborah Myers, director of the Assembly of B.C. Arts Councils, puts it well: "There is a continuum of art practices. We need to draw it longer, and with more circularity. People can enter and exit at different points and different times."[13]

It should be noted that NEA censorship continues, and certain squares of "the quilt" described so eloquently in *American Canvas* get snipped right out. Only now it's not just homoerotic art, or outrageous feminist performance art: "Just this month, the agency revoked a grant to publish a bilingual book of children's fairy tales from an American publisher when NEA chairman William Ivey discovered the author was Subcommandante Marcos, the leader of the Zapatista rebel movement in the state of Chiapas in southern Mexico."[14]

The latest publication of Americans for the Arts, *Animating Democracy: The Artistic Imagination as a Force in Civic Dialogue*, contextualizes community art as a means for citizens to engage in debates about complex and divisive issues. It looks at art as a way to re-invigorate democracy through public discourse: "Polarization of opinion along ideological, racial, gender, and class lines; exclusive social structures separating rich from poor [and] a sense of individual disempowerment

1990 - Bill C-12, or the Museums Act, mandates the National Gallery to "preserve and promote the heritage of Canada and all its people throughout Canada and abroad, and (to) contribute to the collective memory and sense of identity of all Canadians" (Whitelaw, 127).

are listed as factors which diminish opportunities for 'civic dialogue.'... Likewise, partisan politics and commercially driven news media engender an atmosphere of antagonism, rather than education and exchange." The report calls for "art [that] consciously incorporates civic dialogue as part of an aesthetic strategy" and identifies civic issues of interest that are "complex or multidimensional; cross-cutting, that is, of concern to multiple segments of a community; and contested by various stakeholders, eliciting multiple and often conflicting perspectives on the issue."[15]

Four art events which purport to fulfill this role are highlighted. In some, it appears that the artwork provided a container for all contested opinions to be heard in a way that blurred and disguised issues of power; in others, such issues were brought to the surface in ways that genuinely challenge the perceptions of who has power and who does not.

For example, the theme of the 1995 Oregon Bach Festival was "War, Reconciliation and Peace." The text of the St. John Passion, the piece selected for performance, blames Jews for the death of Christ, and was used as a justification for the persecution of Jews for hundreds of years. A number of public forums were held and the issues were debated. It is not clear from the description just how much the Jewish community participated, although there was definitely some participation. "On the night of the performance, St. John Passion was picketed by an Orthodox rabbi who passed out a handbill ... appealing to audience members to stand and turn their backs to the performers during the anti-Semitic parts of the work.... Festival staff endorsed the rabbi's efforts, believing it was crucial for conflicting perspectives to be heard."[16]

It is also not clear if the staff merely endorsed the rabbi's right to picket, or if they actually encouraged the audience to turn their backs. It's an important difference, underlining whether such "art for civic dialogue" is simply absorbing disagreement, or actually making changes in accordance with the public's demands.

Another example documented by the study, however, demonstrates the possibility of more challenging and controversial work. After a year-long residency at the Maryland Historical Society in North Baltimore, artist Fred Wilson designed an exhibit that brought national news coverage and attendance by significant numbers of first-time visitors from the African-American community.

In a standard exhibition case labeled simply, "Metalwork, 1723–1880," slave shackles appeared in a case alongside an ornate silver tea service. Elsewhere,

Victorian chairs were positioned in front of a whipping post.... Wilson turned a dainty Victorian dollhouse into a scene of mayhem, playing out a slave's fantasy rebellion against slave owners.[17]

4. Notes on Community Art in Canada

When Naomi Lightbourne retired as the Community Arts Officer of the Ontario Arts Council, Melanie Fernandez was hired with a mandate to revamp and revitalize the program to bring it more in line with contemporary community art practices. Melanie undertook a consultation process with a representative committee (of which I was a member) and developed a project-based funding program. Projects can be initiated by artists or community groups but, consistent with the OAC's mandate, only individual professional artists are funded. The OAC held an international conference on community art, called Vital Links, in September 1997, and published *Community Arts Workbook: Another Vital Link* in 1998. This exceptionally valuable publication is, I believe, the only one of its kind in North America, offering both artists and community groups wide-ranging practical advice and information.

Pilot projects, showcased at the Vital Links conference, were funded. The OAC also managed the adjudication of the Canada Council's "Artists and Communities" program for Ontario. These outstanding initiatives have helped an atomized field to connect, communicate, define, and legitimize itself. OAC's future plans include the research of community art training programs. Meanwhile, community arts projects continue to be funded annually with an application deadline in November, and awards announced in March.

The Assembly of B.C. Arts Councils and the Vancouver Park Board's Artist-in-Residence Program have initiated admirable policies and practices from which there is much to learn. The Assembly was founded in 1979 as an advocacy organization for regional arts councils. (The first peer review, arm's length arts council was not established in B.C. until 1995; before that, there were regional arts councils and a cultural services branch of the Vancouver municipal government.) There was a period of direct service provision, but for the last six or seven years, the Assembly has made community cultural development its priority and focus. Assembly director Deborah Myers told me that a seminal event took place in 1993—a weekend workshop sponsored by the Parks Board invited Marla Guppy from Australia and Suzanne Lacy from the U.S. to speak about community art. Deborah says that, at this significant turning point, "I suddenly saw a field that could be supported by an infrastructure and regional and province-wide bodies. I saw artists sitting at the table in other community settings. I saw that we could widen the focus beyond the arts councils."[18]

1991 - National Gallery again under parliamentary gun over exhibition of Jana Sterbak's Vanitas: Flesh Dress for An Albino Anorectic, a sculpture containing slabs of beef stitched to clearly resemble a dress. Complaints revolve not so much around any perceived waste of taxpayer's money but rather around more literal notions of waste and decomposition and the proper function of meat in relation to rising poverty levels.

In 1996 the Assembly organized a large-scale conference, and "ad hoc activity began to coalesce." In addition to the Parks Board residencies, the Assembly sponsored "The Turning Point," coordinated by Barbara Clausen, with Suzanne Lacy as lead artist. This was a two-year project with young women about how they are depicted in the media, which culminated in a performance piece called *Under Construction*, involving 277 young women talking on a construction site. In another performance, small tables were set up with intimate lighting, and two young women sat at each table, painting each other's hands with hennaed designs. (Suzanne Lacy's projects often involve intimate conversations in ritualized settings.) Deborah says that the project had mixed reviews. Although Lacy produced a powerful video, the actual experience was very frustrating for audience members. The project "raised questions of process, product, and who owns the work." Asked how the participants felt about the experience, Deborah said "it was profound for the young women."

The Assembly's immediate plans are for "The Learning Project." This is an educational initiative aimed at building community cultural development capacity through learning circles, print and electronic materials, and cultural animation. The animation component is in its infancy.

It takes time for people to build competency. It's time for infrastructure interventions. It's time for critical discourse. It's time to emerge a national strategy.[19]

I will describe in some detail the program of Artist-in-Community Residencies sponsored by the Vancouver Board of Parks. The Parks Board funds three to five community centres each year to work with an artist in residence for three months. The Board puts out the call to the community centres, which then develop a proposal and raise half the funds. There are twenty-two such centres in Greater Vancouver, which are jointly run by the Board and a community organization. The communities define themselves, their issues and facilities, and artists are then invited to submit proposals. These proposals are short—a one-page proposal, plus a one-page implementation plan and budget. A jury made up of professional artists and a representative from each of the participating centres makes a shortlist, then the community centres choose three or four artists to interview. A committee of people from the community select the artist. Artists are paid $4,000 (increasing to $5,000 this year) and up to $3,000 for materials.

Program coordinator jil p weaving says that the committee looks for projects that are flexible, that are able to tailor themselves to whatever comes out of the interaction between the artist and community. Sometimes the focus of the project will be issues, sometimes a locale. The success rate is one in eight.

When I asked jil to speak about what she saw as challenges in the program, she emphasized the lack of training in the field for artists. The skill set required for this kind of work is complex and varied. She longs for projects that can be fully funded, and decries the low artists' fees. Although the residencies are supposed to be part-time for three months, artists seldom manage that. "Outreach and organizing takes a long time."

On the other side, some community organizations' staff aren't trained in community development; they might have a background in sports and recreation, and they aren't equipped to work in this way.

> Sometimes they don't understand the artist's role, the responsibility of the artist for the overall aesthetic, for inventing creative collaborations. They only look at the hours the artist puts in on-site. And communities are rarely cohesive. One group might suddenly decide they don't like the project. Or the community may have expressed a wish to work on an issue, but then no one shows up for the first meeting.[20]

I spoke with an artist I know in Vancouver, and she maintains that there are some acute problems with this program around artist burn-out. She finds the fact that artists must attend three to five interviews before they know if they get the grant quite onerous. It would be useful as well to have feedback from participating community organizations, one more area beyond the scope of this report.

A look at the Urban Issues Program initiated by the Samuel and Saidye Bronfman Family Foundation concludes this discussion of community art practices in Canada. Urban Issues was set up after an extensive consultation process about heritage and urban conservation issues. A panel of architects, planners, and activists from around the world were invited to a retreat in North Hatley, Québec. They concluded that the best way to preserve heritage is to strengthen communities to resist development. Thus the marriage of conservation and community development—and some of the children of that marriage—are community art projects across the country, funded for three years at $30,000 per year.

Grants are made by a panel of consultants/jury members with a common philosophy. Most of the projects that receive grants are concerned with the preservation of urban heritage, and heritage is linked with popular education and community development. Now in its third year, the program has grown

from seven projects to twenty. Artists must be associated with a community organization to apply. Groups of artists and others can get together and apply but they must have a partner with a charitable number, and the partner manages the funds. There are annual reports required, and annual site visits. One member of the project is appointed to liaise with the Foundation.

Gisele Rucker, assistant executive director of the Bronfman Foundation, says she has learned that if projects don't ground themselves within the first year as a significant community effort, they tend to fall apart. She prefers projects to be "embedded in empowering organizations, or ones that have the potential to become empowering organizations." Asked what she would like to see happen with her programme in the future, Gisele responded:

> I would like people to understand how you form power. It's hard for one person to figure that out, to define it. How do you get people to join up with policy makers? … It's very glamorous to be a policy maker, but if you haven't gone to the groundswell of support, you can forget it.

> I want people to know about these communities and what they're doing. These are forgotten people, they have no representation. I'd like to see power decentralized.

> We need more media controlled by people, not Conrad Black.

> People can share information, but there's no way for people to act together across lines. Sometimes they don't even know who's on the next street....

Gisele's parting words might be the inspiration for a community artist some-where, sometime: "Why can't communities make their own soap operas?"[21]

Conclusion

My conclusion consists of musings around several keywords which form the basis for recommendations and further discussion. They are set within the framework of the Laidlaw Foundation's philosophy:

> The vision here is about human development, intergenerational reciprocity, the development of civic/common space, building social citizenship. Spirituality and the non-tangible aspects of art are more important than economic arguments.[22]

Transformation

The best community art projects will combine features of the Model of Transformation and the Opposition Model. They will be collaborative and participatory. They will use art as a transforming experience, one that helps people perceive themselves as active agents, rather than people manipulated into passive cultural choices that are merely consumption.

Courage

They will go beyond providing a "nice" experience for people—they will be courageous in their refusal to flinch from controversial subject matter, from pointing the finger when it needs to be pointed, and from real conflicts between real people.

Tough

Bruce Lourie, coordinator of Laidlaw's Environment Program: "I'd like to see art and environment projects that introduce the conflicts and ask tough questions about people's choices. So much of what I see is tinkering at the margins. No one wants to question what corporations are doing and at the end of the day you end up with pablum."

Excellent

Elizabeth Cinello, community artist and activist: "Art can become lost in service, in an educational or therapy agenda. But if the art is good, it will preserve its purpose and place." Deborah Myers, director, Assembly of B.C. Arts Councils: "For fifty years we've cut out half of the equation—everything but a narrow definition of cultural production and a very ethnocentric model at that. 'Good art' is individual, modernist, untempered in its vision and has a notion of entitlement; 'bad art' is participatory, process-oriented, post-modern; it doesn't have artistic integrity but it has accountability." Ingrid Mayrhofer, program director, A Space Gallery: "We're negotiating with the Canada Council to be able to make our own definition of artistic excellence." This lively debate will no doubt continue. It is clearly not resolvable at this moment in history. Meanwhile, let's all err a little on the side of the excellent, even as the definitions and criteria shift and change. There are community art projects out there that just, well, look bad—and that doesn't make anyone look good.

Gandhi March from SAHMAT
Photo: Ram Rahman

Power

There are communities and communities. Bankers are a community, as is the plastics industry, the readership of the *National Post*, Toronto Maple Leaf fans, and all those who believe that Daylight Savings Time is counter to the will of God. Cultural democracy, however, is about enfranchising the disenfranchised, providing the context for silenced voices to be heard, and creating alternatives to the global cultural agenda of marketing and consumption. It is about groups of people discovering power in a situation of perceived powerlessness. Communities to work with, therefore, will be grassroots, diverse, and otherwise not members of the power elite of our society.

Cartography

Communities and practices can be mapped, and maps can take many forms. A map of people's favourite neighbourhood hangouts. A map of the smells on a street. A map of community art projects across Canada. A map of community groups in one area. A map of groups thinking about similar issues.

Translation

June Clarke, Arts and Community Funding Officer, the Toronto Arts Council: "It is said that to learn a new language is to gain a new soul." I support practices that move across the lines, that blur the boundaries—between artistic disciplines, between communities, between funding sectors, between art and life. When you translate a word from one language to another, there is a third, unspoken word, a word beneath language. That is the space that lets you understand, simultaneously, two words for the same thing. It is in this space that we want to site cultural democracy, at the moment of the crossover, the chiasma, the place beyond definition or identity." ■

NOTES

1 Toronto-based Laidlaw Foundation supports work in the areas of the environment, child development, and the arts. Annual grants to performing arts projects total $1 million. (There is no connection between the Foundation and Laidlaw Transit Ltd. or Laidlaw Waste Systems Inc.)

2 Chair Report, Community Art Subcommittee, Arts and Recreation Committee, Greater London Council, October 18, 1982.

1992 — BILL C-93 INTRODUCED IN FEDERAL BUDGET. BILL PROPOSES TO AMALGAMATE OR ELIMINATE FORTY-SIX AGENCIES AND/OR COMMISSIONS. CANADA COUNCIL TO MERGE WITH SSHRC AND CERTAIN EXTERNAL AFFAIRS CULTURAL FUNCTIONS AND WILL NOW BE REFERRED TO AS CANADA COUNCIL FOR THE ARTS AND FOR RESEARCH IN THE SOCIAL SCIENCES AND HUMANITIES.

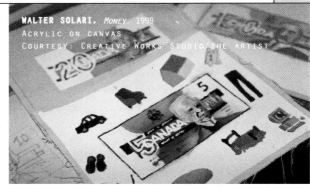

WALTER SOLARI, *Money,* 1999
ACRYLIC ON CANVAS
COURTESY: CREATIVE WORKS STUDIO/THE ARTIST

3 Interview, April 1999.

4 Antonio Gramsci, *The Prison Notebooks*, passim.

5 Carol Becker, "The Artist as Public Intellectual," *The Review of Education/ Pedagogy, Cultural Studies*, 17:9, 385–395.

6 John L. McKnight, Director of Community Studies, Institute for Policy Research, Northwestern University, is the author of two influential books about community development, *Building Communities from the Inside Out* (Chicago: Acta Publications, 1993) and *The Careless Society* (New York: Basic Books, 1995). He argues that social services keep clients in a state of dependency, and advocates building on people's strengths and capacities to re-create an active and involved citizenry.

7 Interview, April 1999.

8 Art Starts Neighbourhood Storefront Cultural Centre, founded in 1992 by the author and other community members, makes art with residents of the Oakwood-Vaughan neighbourhood in Toronto.

9 Interview, April 1999.

10 Interview, April 1999.

11 The Calouste Gulbenkian Foundation, U.K. Branch, *Annual Report*, 1997, 12. (According to the 1998 *Annual Report*, their publication *Joining In*, a comprehensive report about participatory music-making in the U.K., has inspired national debate.)

12 Gary O. Lawson, *American Canvas*, National Endowment for the Arts, 14–15.

13 Interview, April 1999.

14 *Globe and Mail*, March 29, 1999.

15 *Animating Democracy: The Artistic Imagination as a Force in Civic Dialogue, A Report to the Ford Foundation*, Executive Summary, i.

16 Ibid., 6.

17 Ibid., 8.

18 Interview, April 1999.

19 Ibid.

20 Interview, April 1999.

21 Interview, April 1999.

22 Conversation with Nathan Gilbert, Executive Director, Laidlaw Foundation.

Merging

Art is the highest form of hope.
—*Gerhard Richter*

When one speaks of division in the art community what comes to mind is opposition in opinion. But there is a hidden division in the art community and it is based on the ability to use language, either rhetorically or as one function of an artist's work. Language is a very useful and important component of the art world but over the last several decades it has become a dominating force, particularly by becoming a significant differentiation between public/ parallel galleries and market/community/member galleries. On the surface this simply reads as different agendas and doesn't seem to reflect a problem. But for artists with certain types of disabilities it is.

In all professions, specialized language is the boundary between those who belong and those who don't. Language is a measure of inclusion.

I assert that the power of language has become a distraction from a fundamental aspect of the visual arts. Validity is often based on verbal persuasion and intellectual theory. Yet visual intelligence is not necessarily bound to verbal facility. Whether or not one has an aptitude for organizing language does not have significant bearing on one's capacity to organize an aesthetic statement, and it has no bearing on the validity of such statements.

In spite of my own pleasure in and appreciation for written and verbal expression, I see it as a parallel activity to visual art. What if you are a visual artist who has intellectual or physical disabilities that affect your linguistic capacity? What kind of opportunities are there for someone who cannot use or does not require linguistic skills for their aesthetic expression? This question applies particularly to the public funding bodies, associations, and galleries as leaders in matters of equity. At present, gestures of inclusion have become

symbolic of a shallow political agenda. For example, exhibitions are sometimes curated on the basis of a specific community identity, and not on the merits of the artwork. This is anti-individual and, to my mind, anti-art.

Public art organizations have often become overburdened by a tacit allegiance to a narrow representation of artwork that often exploits social commentary. The emphasis of this commentary rests primarily on the subject of the artwork, and bears little relationship to the actual practices and policies regarding social issues of the organizations.

These allegiances are a result of pressure to serve current political obsessions and are probably a result of perceived or actual funding threats. In many respects this is no different than the art market. Certain success is obtained by meeting demand. In the public domain, ideology is attached to funding. In both communities, the success is the same: careers are launched, made, and work is eventually sold to prestigious public and or private collections. I see this as merely a fact and not a judgment.

The advantage of public organizations is to gradually influence ideological change. Certainly this is not without risks to funding. Because of these pressures, the validity of publicly funded organizations is always scrutinized. This tends to create a defensive posture which I believe has created an unbalanced approach to aesthetic discourse. Aesthetic discourse is contained in the work and is essentially nonverbal, whether language is used as support or as an integral part of the work. The discussion generated from the work is a parallel, linguistic, and different process. Aesthetic discourse can be rational or irrational. Yet the prevailing notions of intellect, hence validity and justification, appear to rest on linguistic facility and rationalization.

I assert that this bias toward linguistic facility has no bearing on the validity of an individual's aesthetic expression, but strongly impacts on his or her opportunity to participate in the arts community in general, and specifically affects opportunities to benefit from services and events offered by public arts organizations. At present I believe this issue is unrecognized and steeped in misunderstanding.

Some of this misunderstanding involves issues of qualification and artistic standards. These areas have been problematic within the recent history of the arts community and cannot be adequately resolved. The wise put their faith in the work itself and a demonstrated devotion on the part of the artist. Artists with disabilities deserve no less consideration.

This publication has created an opportunity to revisit the broader image of the arts community and the roles and functions of publicly funded arts

organizations. The irony of this work is that it is done on behalf of certain members of the public who at present are unable, for the most part, to participate in these activities. This in itself is social commentary.

The idea of using the creative process to merge with another individual or their community is quite different from the idea of integration. I chose this method because I believe it is a vital part of the artistic experience and essential to empathy. Integration revolves around remaining separate and visible within the context of the whole. This is in contrast to the artist's desire to be valued and/or appreciated for their work rather than their selves (except in the literal sense of performance art). For artists with disabilities it is more important to be acknowledged than seen. On the surface this may seem contrary to the anti-shame movements. The art is visible. The artist is not. Therefore the process for artists who need assistance in accessing public funding or submitting work to public or other galleries should be as seamless as is practical. Policies and practices like public advocacy specific to the arts community, which include government trust and support, would hopefully counteract the mythologies and prejudices that surround "art of the disabled."

Admittedly it is paradoxical to advocate for equity and simultaneously express concern for being categorized within a narrow political context. Policies around equity usually reinforce an identity of separateness. This, of course, has both positive and negative attributes.

It is very easy to comment on or describe the issues that artists with disabilities face. It is easy to generalize and define a situation for the sake of political leverage. But what about the people?

I decided to write this essay because of my personal experience and the experiences of other artists with disabilities with whom I have a working relationship. I especially wanted to highlight the difficulties of artists who are unable to advocate for themselves. Ironically, I ran into some of these sensitive issues when attempting to describe specific problems faced by some of the artists I know, while also trying to protect their privacy. What was re-emphasized for me was that ethical issues are contextual. The most vulnerable artists I know are forced to survive in a culture of complete (and sometimes uncomprehended) trust, which is foreign to the various practices of the arts industry. Although I feel that there are practical solutions to these difficulties, creating awareness is my foremost purpose at this time. After a lot of internal struggle, I decided to blend the stories into a compilation of anonymous statements with no particular sequence in time. A list, if you will, of experiences.

It seems important for the sake of empathy to relate these stories in the first person. It would be far too comfortable to keep the issues abstract, intellectual, and ultimately impersonal.

I base the following list on my own experience, what I have been told by others, and on my personal observations. I claim these statements as my own, to honour the spirit of merging and to recognize that each statement represents an experience I could have had, have had, or could possibly have by luck or fate.

Art has always been the focus of my life; it gives me purpose and meaning. It is what I am able to do. It is what I want to do. It is my freedom in a world of restrictions, caused by both my impairments and the consequences of my social status as an individual coping with a disability, who must rely on government support in order to survive.

I was in art college when I got sick with a severe psychiatric illness. I was unable to finish the program. I was hospitalized, then ended up in a boarding house. I continued to work on my art, relying on art supply handouts from people who still believed in me or felt pity. When I was re-hospitalized, the boarding house owner threw out all my possessions, including all my sketchbooks. Not only did I end up homeless again, all my art and references were gone. I had to start over.

I was thrown out of a sheltered workshop. I hated it. Because of my developmental disability, I had no way of communicating my dissatisfaction except by misbehaving. It was boring. People think that people with developmental disabilities don't get bored. Luckily I was sent to a community studio and found painting. I haven't been bored since and sell my work quite regularly. I feel proud and am respected for my talents, particularly by other artists who sometimes drop by to watch me work. My art is a way to become connected with other people and communities that I would not otherwise encounter.

Although I was able to complete my education, and have two diplomas from different art colleges, I am restricted in the pursuit of my career as an artist for a couple of reasons: I need support with the organizational/business side and if I make any money I risk losing my disability income. Even though the system is supposed to be set up to encourage people with disabilities to work at what they can, the system does not recognize the unpredictability of an artist's career. I was advised by a disability advocate not to draw attention to myself, that I should not declare the work I have sold, or list the shows I am in. I was advised to keep proof that I do not make any profit from my work. Gaining a reputation as an artist threatens my means of survival because there is no recognition that art is flexible as to how and when it is created and is not usually financially lucrative, regardless of apparent success or one's standing in the field. This is very discouraging. I feel forced underground and like a criminal in the pursuit of my area of competence.

I grew up in an environment surrounded by creative people. I practiced art most of my life. I was always involved in the arts programs in the schools I attended. When it became clear that I couldn't go any further with the standard education for a person with physical and developmental disabilities of my kind, the choices for my future became quite severely limited. I could enter a sheltered workshop or train for some other kind of menial work. At the time there was no arts facility that did not fall under a therapeutic or greeting card type of framework. Fortunately my parents understood my artistic capacity and created a studio/gallery where I and others with various disabilities have a chance to display and sell their work. People seem surprised when they find out the work they are admiring was done by someone with a developmental disability. My work is unique and complex. I have spent a lot of time developing my visual language, yet when prospective buyers find out about my disability they expect to pay a lot less for the work. I generally use artist-quality materials and I work at least six hours, five days a week on my art. I have had steady success over the years, and was a co-recipient for an arts award.

My career as an artist was just getting started when I had an accident and suffered a devastating brain injury. It has been a long recovery and I have been left with paralysis and aphasia. Because the accident happened in the studio, I was not covered by my day job's insurance and I could not get worker's compensation for the same reason. I had not yet started to claim my art career as self-employment and I was not in a financial situation where I could afford personal injury insurance. Yet I continued to pursue making art. Although it is different than before the accident, I am still able to uphold the same standards of quality as I did before. The art dealer who represented me has dramatically raised the prices of the work done before the accident. I need the money, but it sends out a pessimistic message: that there may be no interest in future work, that it is over, that I am artistically dead. This simply isn't true. So when I decided to withdraw my old work, I was very upset to realize that I couldn't even enter the gallery to ask for it back in person. The gallery is not wheelchair accessible. It was that day that it really struck me how many limitations there are as to where I can show and how much assistance I will need to do it.

All that any artist wants is a chance to practise and/or exhibit their work. There are enough obstacles faced by artists without disabilities, but there are far more for those artists who struggle with their visible or invisible disabilities on a daily basis.

It is my hope that this information will create interest and awareness, and stimulate change.

There are no images to accompany this text. I feel that within this context

the problems described should not become associated with or distract from the artwork of the individuals who have shared their stories with me. And on a whole, perhaps idealistically or naively, it is my hope that the difficulties outlined remain separate from the artwork and its eventual reception into the community, once provisions have been made for those with disabilities to have the same chances as any other artist.

This work is dedicated to the artists who work so hard, but have no voice in the community. I especially want to thank everyone at the Creative Spirit Art Centre for their insight, sensitivity, and the continued effort towards accessibility in the arts community. ■

> RINALDO WALCOTT

Blue Print for Resistance: Art, Nation, and Citizenship

Generally speaking, Negro writing in the past has been confined to humble novels, poems, and plays, prim and decorous ambassadors who went a-begging to white America. They entered the Court of American Public Opinion dressed in the knee-pants of servility, curtsying to show that the Negro was not inferior, that he was human, and that he had a life comparable to that of other people. For the most part these artistic ambassadors were received as though they were French poodles who do clever tricks.[1]

Introduction

This essay takes its title in part from Richard Wright's essay "Blue Print for Negro Writing," first published in 1937. I have no illusions that anything that I can or will say, will generate the kinds of responses that Wright's essay did. I also have no desire to pen a manifesto—which is the claim that every manifesto writer makes. However, I am taken with both Wright's essay and its title because it acts as a kind of guide to thinking about what is at stake when claims are made for the cultural expression of our humanity and what it might require to bring those claims to fruition. This essay is in part the attempt to claim and to map a space for the continued expressivity of a wide range of Black arts in Canada.

Equally importantly, this essay is an attempt to simultaneously offer a provocation of the relationship between the weak or poor funding of Black expressivity in Canada, and to enter into critique and dialogue with some aspects of Black artistic expressivity in Canada. I attempt to negotiate the space between the call for more representation and the ability to speak to the limitations of some of what exists and is celebrated. In some senses, then, this essay is an

1992 – REPORT ON STANDING COMMITTEE ON COMMUNICATIONS AND CULTURE DRAFTED IN PREPARATION FOR THE CHARLOTTETOWN ACCORD. THIS DOCUMENT, *THE TIES THAT BIND*, REITERATES THE INITIAL RECOMMENDATION OF THE MASSEY COMMISSION THAT NATIONAL CULTURE BE SUPPORTED AND PROTECTED BY STRONG CENTRALIZED CULTURAL INSTITUTIONS.

exercise in the desire for a funding structure that can provide for the proliferation of Black expressivity in a manner that when unsatisfying works are celebrated what is at stake in those celebrations is not as important because other sources and sites exist for the engagement with a wider range of Black representivity.

Multicultural Art?

Let me be clearer. In a 1999 meeting with the former chair of the Ontario Arts Council (OAC) Hal Jackman, it was suggested that the alternative art press (mainly magazines) was at least one source where a number of "racial minority" writers received the opportunity to showcase their work. Jackman's retort was rather telling. He insisted on making clear that, since the OAC did not fund the Highland Games (his example), he could not see why such information was being offered as evidence of the worth of Ontario's left-wing cultural magazines and racial minority contributions to them. In many respects Jackman's claim was both inaccurate and frighteningly on point. His comment suggested that the role of the racial minority artist is to produce static representations of cultural heritage, perhaps folk art, but this would clearly not be the kind of art a provincial arts organization should be funding. His inability to only think about racial minority artists as purveyors of static cultural practices is one of the long-term effects of how multiculturalism has been articulated and popularized in Canada. Jackman's comment betrays the success of multicultural discourse to potentially reduce all racial minority art to folk art. A frightening prospect.

But to make further sense of Jackman's claim we must revisit what in retrospect we can now call the foundations of contemporary racial minority artistic practice in Ontario, and more generally, in Canada. These would be the "glory" days of multicultural funding at both the provincial and federal levels. This funding, as we now belatedly understand it, was to fend off any radical attempts that minority groups might make as citizens against the state. This funding was to appease communities who called for more far-reaching representations of themselves in the Canadian polity than had previously existed. Much of this funding went to producing representations of cultural or ethnic groups which were easily recognizable to both insiders and outsiders.

This was funding for reproducing heritage as a recognizable trait. However, some of this funding also went to artists from recognizable cultural or ethnic groups who were doing and continue to do innovative work both drawing on and moving beyond heritable traits. It is this latter moment that is largely my focus. Importantly, as well, the discourse of multiculturalism led to the opening up of gallery spaces, artists' centres, theatre spaces, film venues, and a range of other venues to racial minority artists on greater terms.

The 1980s ushered in the dawn of multicultural arts funding in Canada. But as Nourbese Philip presciently observed in "The 'Multicultural' Whitewash: Racism in Ontario's Art Funding System," Black artists working within, with, renewing, overturning, reinventing, and reinvigorating traditions is very different from the static heritage "arts" that merely reproduce assumed representative cultural practices.[2] Her distinction is useful for making sense of Jackman's response because it lies at the heart of where "ethnic" artists will find themselves, as art becomes more corporatized. The 1980s saw both the ushering in of imaginative works by artists from various ethnic communities formerly cut out of the funding process and then included through the route of multicultural concessions. But it also saw the cementing of "ethnic" art as a kind of repository of unchanging practices from elsewhere. Thus the multicultural moment created a double move for ethnic artists to the extent that in the aftermath of multicultural funding two important points of distinction and contention emerge. These two related but very different moments require careful analysis.

First, artists working within and renewing traditions are often dismissed too easily as doing heritage-type work, which means that their craft and critical theoretical innovations are undervalued and overlooked. And second, many funding bodies operating from what they know of static heritage type "art" expression believe that they now entirely understand what a given ethnic artist might be doing because they have "seen it before." This double move in the aftermath of the multicultural arts wars has in retrospect both assured the ground upon which racial minority artists will continue to exist, and simultaneously aided in the denial of what could be a wider proliferation and complexity to racial minority artwork in Canada. So in some respects one of the outcomes of the multicultural wars has been the production of a kind of formulaic racial minority artwork, work that gestures only at crass traces of ethnic heritage too easily recognizable without any critical restating.

In a rather interesting commentary, Peter Hudson in "Diary of a Queen Street Negro" writes in his assessment of Shawn Skeir's exhibit *Urban Primitives and Biomorphic Landscapes: Recent Paintings from Shawn Skeir* at the basement of Le ChateauWorks, Queen Street West, Toronto, that "[h]is paintings, not

1992 - CHARLOTTETOWN ACCORD OVERWHELMINGLY DEFEATED IN OCTOBER REFERENDUM. AMONG OTHER DECENTRALIZING PROPOSALS WITHIN THE ACCORD, THE MULRONEY CONSERVATIVE GOVERNMENT PROPOSED DEVOLVING RESPONSIBILITY FOR CULTURE AND CULTURAL FUNDING TO THE PROVINCES, IN ORDER TO PLACATE QUÉBEC NATIONALISTS AND FISCAL CONSERVATIVES (CREAN, 203-4).

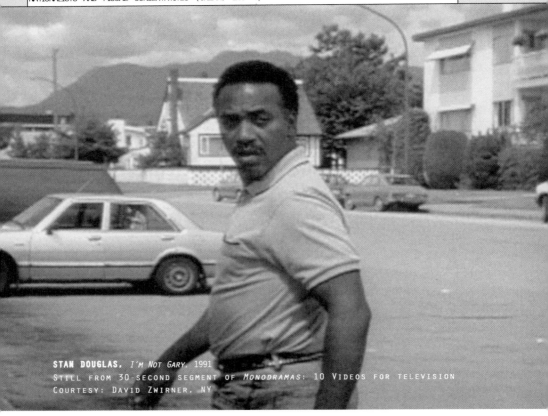

STAN DOUGLAS, *I'M NOT GARY*, 1991
STILL FROM 30-SECOND SEGMENT OF *MONODRAMAS: 10 VIDEOS FOR TELEVISION*
COURTESY: DAVID ZWIRNER, NY

unpleasing to the eye, employ an Africanist motif in a way that could be described as Afrocentricity-lite—lots of general references to spirituality and ancestors, little historical analysis."[3] Hudson identifies one of the ways in which an uncritical approach to heritage works in some artworks. But, as Hudson further argues, Skeir's intention is "to make affordable and beautiful black art that the average person can hang in their home."[4] While neither Hudson nor I would necessarily argue for the inaccessibility of art, Skeir seems to have already inserted his notion of artmaking into a commodity system. It is this insertion that requires easily identifiable heritage markers so that consumers have some sense of just exactly what they are consuming. What is important about Hudson's argument is that he identifies a generational break among artists such as Skeir. Hudson writes:

...[Tim] Blanks articulates the ethos of a Canadian demographic that suffered the perverse fate of growing up through the Mulroney 1980s. But black people of this generation were doubly fucked: not only was there the constant threat of nuclear annihilation looming over our shoulders, but this was also the era of the hegemony of the white-bread synth pop of the New Romantics and the jheri curl. It's a generation that is the unexpected byproduct of a national experiment in assimilation performed on the West Indian immigrants of the 1950s and 1960s. Betrayed by the bankruptcy of official multiculturalism and the devolution of the welfare state, we feel entitled to this country but are reluctant to call it home. We embrace the free market, both by default and because of capitalism's apparent success at erasing class and race by posing questions of difference as matters of style.[5]

What is at stake in Hudson's assessment of this generational break is its somewhat ahistorical response to what the 1980s have wrought. If blackness is reduced to style, or should we say fashion, and therefore commodified, then the certainty of blackness must also be secured so that consumers know what variations among a range of "blacknesses" they are consuming. Hudson is correct to identify the fictive notion of capitalism's power to erase class and race, among other social markers. But what remains a crucial and troubling aspect of this erasure is that for Black art to become commercial it must deny its complexities and instead portray its too easily identifiable qualities—critical engagement is, however, lost in the process.

So what is at stake then? First we might understand that racial minority artists also engage in the tradition of the artist as creator and innovator, and therefore forge what their cultural concerns, both internal and external, might be in their practice and their work. This work then might gesture to or even explicitly engage a "cultural tradition," but might not stop there. I think of Vancouver artist Stan Douglas's use of jazz. In Douglas's work jazz acts as a kind of covert and simultaneously modern "blackening" of his art in works that appear to be far removed from the discourse of race. Second, because the heritage-type model, with its numerous repetitions, can become fairly easily knowable and therefore easily identifiable, in the last resort the heritage model is much more marketable.

It is exactly the difference between these two kinds of "art" or expressivity that is at stake in terms of how we think about Black art and its continued public funding in Canada. For example, no one would argue that Caribana does not represent a major artistic expression, but its form of artmaking is much more easily marketable than, say, the sadomasochistic cinematic work of Deanna Bowen (I am thinking of her short film *Sadomasochism*). What is ironic is that both Bowen's work and Caribana as a festival take some kind of inspiration

1993 - THE MANAGEMENT COMMITTEE OF TORONTO'S METRO COUNCIL REFUSES TO RATIFY METRO COUNCIL'S RECOMMENDED AWARDS TO BUDDIES IN BAD TIMES (TORONTO'S MOST PROMINENT QUEER THEATRE COMPANY) AND THE INSIDE OUT GAY AND LESBIAN FILM AND VIDEO FESTIVAL ON THE GROUNDS THAT THEY HAVE VIOLATED COMMUNITY STANDARDS IN THEIR EXHIBITION AND PROMOTIONAL MATERIALS. AFTER SERIOUS DEBATE AND PROTESTING, BUDDIES' GRANT IS RESTORED WHILE INSIDE OUT'S IS REFUSED. METRO COUNCIL AT THIS TIME WAS NOT CONSTITUTIONALLY AT ARM'S LENGTH FROM POLITICAL COUNCIL THAT TECHNICALLY HAD POWER TO DENY RECOMMENDED FUNDING.

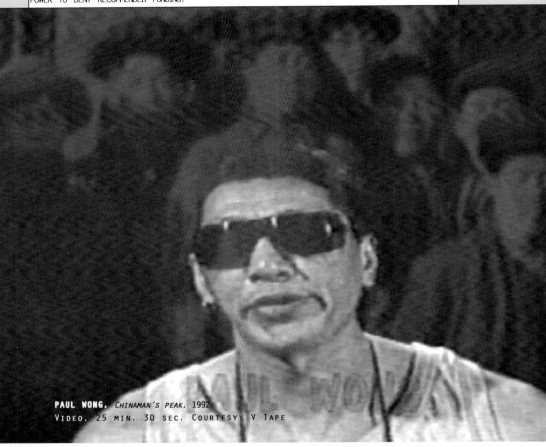

PAUL WONG, *CHINAMAN'S PEAK*, 1992.
VIDEO, 25 MIN. 30 SEC. COURTESY: V TAPE

from transatlantic slavery. Therefore, when arts funding becomes much more aligned to corporatized practices, the artwork of a Bowen is much more in jeopardy than art produced in the contexts of recognizable festivals. Would an installation piece staged concurrently with Caribana, addressing Caribana, count as art in Jackman's assessment? What is at stake here is the possibility of a range of expressive strategies around which large groups of people interested in something called Black cultures might engage. These are the broader, need I say more theoretical and conceptual, issues and questions that those of us

interested in preserving public arts funding and resisting the continued decimation of funding must work with and take a stand on. Not only is arts funding at stake, but also certain artists and their practices. This is a part of the conversation that we have not had, or when we have had it, we have not engaged it well.

In a recent interview with Richard Fung, Paul Wong reflected on some of these issues. His comments are quite applicable for what I have tried to address above.

> The entire art industry has systematically excluded the appreciation and inclusion of other artistic practices from other cultural perspectives. Contemporary art has been defined by and for whites. Looking around Vancouver, there has been very little change. The institutions are the same. They have not reallocated resources, they are not willing to share power and access. The hard fight for "funding for diversity" was hijacked. Monies didn't go to new initiatives by new communities, but instead to "inclusion" in existing institutions.[6]

While it is apparent from the interview as a whole that Wong is not calling for a separatist politics—as the excerpt I use here might suggest—his comments are important because as we resist the restructuring of the public arts sector in Canada, some communities remain in a very precarious position vis à vis the public discourses that constitute what counts as art. I am going to suggest that part of the resistance to the restructuring has to be a challenge to artists themselves to think in ways that move beyond any simple notion that all artists are under attack in the same way. This is an ethical demand. I want to emphatically make the claim that one of the real issues at stake for artists who are not of colour is for them to also recognize and resist the ways in which artists who are assumed to work on "identity," often meaning work that takes up race issues, might be seen as a "specially targeted" group that will most likely suffer more severely from the restructuring of the arts in Canada. In this sense, then, resistance to corporatization of arts funding is not just an issue that all artists must resist because all artists would be affected in the same way. At issue is the ethics of the response and included in this ethical dilemma is the question of how notions of what constitutes art will be grappled with by those who resist the restructuring of artmaking in Canada.

The multicultural wars of the eighties did much to open this up for debate. Racial minority writers, playwrights, directors, video makers, and a host of others working in different genres, made statements with their work. Many of these statements have become the foundation of what appears to be a kind of flourishing of racial minority artmaking across a range of disciplines today.

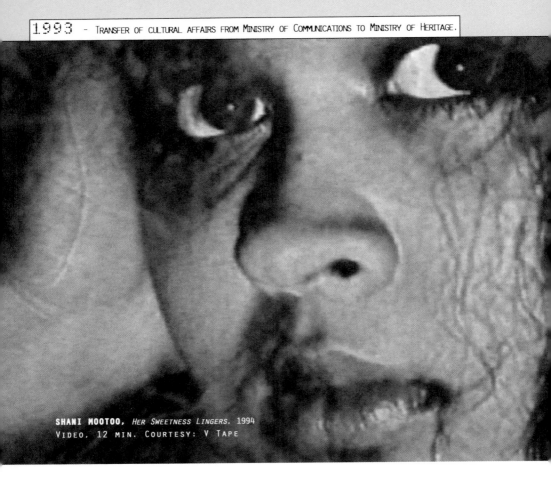

SHANI MOOTOO, *HER SWEETNESS LINGERS*, 1994
VIDEO, 12 MIN. COURTESY: V TAPE

But I want to insist on a caution—this proliferation, if we might call it that, is in jeopardy if we are incapable of reading racial minority artists' contributions beyond the category of identity and still hold that category in abeyance as something that might be useful. We sit on the verge of the racial minority artist going missing again. This is not the kind of missing that would necessitate emergency measures but it is the kind of missing that would privilege a few at the expense of a wider range of representations. I shall develop this thought further under the question of how we understand who belongs to the nation.

Art for a Nation?

The recourse to funding art on the basis of its marketability is one which, in the context of a racist Canada, has the potential to cut minority artists right

out of the field of representability. This concern must not be taken lightly. In fact, this concern sits at the heart of how the nation understands itself and who might and does belong to it. In fact, depending upon who is doing the reading or assessment, most Black art is in some ways oppositional to the nation. But simultaneously the nation and the narratives through which its bureaucracy works also finds it difficult to imagine blackness within its realm. Thus, Jackman can dismiss racial minority art as cultural heritage repetition, which sits outside some more sacred notion of "art." This kind of response is in part a measure of the ambiguous place that blackness has always occupied in narratives of the Canadian nation. Thus, assessments that read or interpret racial minority art in terms of limited notions of heritage are not dissimilar from other narratives that continue to place racial minorities outside the represen-tivity of Canadian-ness.

Gwen Setterfield, former executive director of the OAC, wrote not long ago that "[w]hen passion about the arts does emerge in public, it's usually from arts professionals concerned about funding, or from politicians worrying that some piece of art is violating community standards."[7] In what can only be read as a kind of defence of her years at the OAC, Setterfield means to say either that all artists are art professionals and therefore all the individual artists who have been agitating for better funding and resisting cuts whenever announced come under her rubric of "arts professionals," or she is suggesting that only arts-funding bureaucrats understand what is at stake in terms of the public funding of the arts. Similarly her concerns about politicians leave them outside the rubric of who makes the decisions concerning funding in the first instance. This kind of approach is what places minority art in a vicious and continuing cycle of low priority or lack of funding. Yet I am not suggesting that minority art is outside either. In fact, to the contrary, the 1990s has seemed something just short of a renaissance of minority work in Canada. But we must be cautious, and avoid any too-quick celebration, for what is at stake is not merely representation but the what, how, and why of representation. The relations of representation are at stake:

> In our culture there is, of course, no lack of representations of women—or, for that matter, of other marginalized groups (blacks, homosexuals, children, criminals, the insane...). However, it is precisely in being represented by the dominant culture that these groups have been rendered absences within it. Thus, it is not the ideological content of representations of these Others that is at issue. Nor do contemporary artists oppose their own representations to existing ones; they do not subscribe to the phallacy of the positive image. (To do so would be to oppose some "true" representivity to a "false" one.) Rather, these artists challenge

1993 – ANNPAC FRAGMENTS AND SUBSEQUENTLY DISSOLVES AFTER FRACTIOUS ANNUAL GENERAL MEETING IN CALGARY. THE MINQUON PANCHAYAT COMMITTEE, WHICH HAD BEEN FORMED IN 1992 IN ORDER TO INITIATE AND IMPLEMENT A RECONSTITUTION OF THE ORGANIZATION WITH REGARDS TO BOTH EQUITABLE OR DEMOGRAPHIC CONCERNS AS WELL AS DEFINITIONS OF "ARTIST-RUN CENTRE," RESIGNS FROM ITS MISSION OVER WHAT THEY PERCEIVE AS HOPELESS INFLEXIBILITY AMONG ESTABLISHED MEMBER-ORGANIZATIONS AND WITHIN THE ORGANIZATION'S FUNDAMENTAL STRUCTURE. PAARC (PACIFIC ASSOCIATION OF ARTIST-RUN CENTRES) RESIGNS FROM ANNPAC AS AN IMMEDIATE CONSEQUENCE, AND ANNPAC ITSELF DISSOLVES IN 1994.

the activity of representation itself which, by denying them speech, consciousness, the ability to represent themselves, stands indicted as the primary agent of domination.[8]

For example, it is now possible to choose between the work of, say, Colina Philips, Clement Virgo, Andrew Moodie, Djanet Sears, or George Elliott Clarke. In fact, the most recent work of Moodie (*A Common Man's Guide to Loving Women* and the Clarke/Virgo television movie *One Heart Broken Into Song*) leaves much to be desired. In both instances the thematics of the narratives remain locked into easy and stereotypical representations. But this kind of work is easy to market. Virgo's directorial eye saves the film from total loss and, as far as Moodie's play is concerned, its sitcom motif for the stage could have used a more honest rendition of what urban Black men in their late twenties and early thirties are dealing with beyond the clichés of various kinds of what I would call sexual dysfunction. Both *Common Man's Guide* and *One Heart* were possible because, unlike some of Virgo's earlier work and for example Moodie's *Riot*, not much was at stake in this later work. We are faced with a very serious question: is a depoliticized art what the nineties has inherited from the eighties? Or, as Angela McRobbie put it in the British context, will we be left with "art made for a prime-time society"?[9]

In an interview, interdisciplinary artist Shani Mootoo wondered why much of the artwork produced by minority artists of the eighties was not being collected by the institutions responsible for collecting art:

I didn't become an artist in order to deal with identity issues. Since that was a point of access several years ago for a lot of people and the most vibrant thing that was happening in ages in art across the country, there were curators, institutional administrators and critics who wanted to be part of it. If you notice, however, serious collectors of Canadian art are not collecting that period—such an important part of the country's history of art—work by artists of colour.[10]

In fact her query is an interesting one in many ways. It intersects with at least two problems that need to be accounted for in the post-eighties minority art scene (if such a thing exists). First, many young artists who have access to gallery space and festivals, etc., don't seem to understand or know the history

of how things came to be. Second, this moment of "multicultural" artmaking, while filled with much that we might want to forget, is also filled with much we should and might want to remember. The problem of work that is not collected is another place where the continued marginalization of Black artists resides. In fact, it is very clear from both anecdote and systematic study that the traditions of artworks that are collected are also the traditions that are continually funded. Therefore, when minority artworks go missing, and even when a period as significant as the 1980s is not substantially recognized for how it ushered in and was in fact the backbone of the 1990s, a great deal is lost. We need to access and recount the moment of the eighties, not always in reverence, for what it has wrought on or for the nineties. It is in fact making a wide range of connections, between what to some might seem like disparate elements, which will ensure a much more robust defence of the current and continuing threat to the public finding of the arts.

Let us return to the eighties one last time. Almost every art council has some kind of equity policy. These policies would not have been possible without the tough and diligent dedication of anti-racist artists who challenged a wide range of cultural institutions in the 1980s. These equity plans, officers, and committees have come about both because of multiculturalism and because racial minority artists, and those in solidarity with them, made decisions to go against the status quo of an arts establishment that refused to see racial minority artists as more than the repository of static cultural practices. The push in the eighties to open up arts funding to racial minority artists beyond the heritage industry resulted in some dramatic changes, in particular the establishment of equity officers and offices. The results of these changes are yet to be seen and assessed clearly.

Audiences? Citizenship? The Present—Future?

Ultimately the question of audience brings itself to bear on the issues that I have been attempting to articulate here. And I should say that the question of audience is heatedly being fought over in the terms of corporatization and the degree to which private interests will fund the arts in Canada. As I have stated above, this does not bode well for racial minority artists and in particular those artists whose work does not immediately embrace the nation and its normative discourses for belonging. At this historical moment it is crucial to understand that those who see themselves as the official guardians of Canadian culture hold much power to reconceptualize the tension between public and private. Their reconceptions will place much at stake for racial minority

1993 — TORONTO'S PROJECT P POLICE UNIT VISITS MERCER UNION GALLERY AND, AFTER AN EXTREMELY BRIEF VIEWING, DECLARES ARTIST ELI LANGER'S PAINTINGS AND DRAWINGS TO BE CHILD PORNOGRAPHY. THE ARTIST AND GALLERY DIRECTOR ARE ARRESTED. IN A SOMEWHAT UNUSUAL TWIST, IT IS THE ARTWORKS AND NOT THE ARTIST THAT ARE ULTIMATELY TRIED AND FOUND INNOCENT.

artists. I turn now to an analysis or at least a reading of an exchange among a trio of guardians—Shirley Thomson, the director of the Canada Council, Hal Jackman, former chair of the Ontario Arts Council, and Margaret Atwood, poet, novelist, and cultural gadfly. This exchange took place in the pages of the *Globe and Mail*.

Atwood weighs into the debate between Thomson and Jackman with a caution about Jackman's insistence that peer-jury systems are not the best way of adjudicating artist grants: "One has to query why Mr. Jackman thinks having these folks [rich people] in charge of artistic choices—who gets how much, for doing what—would be more democratic that the present system. There is no evidence that having a small number of rich people controlling taste would result in any more breadth and variety than at present, and some suspicion that it might well result in less."[11]

Her critique comes after a return volley by Hal Jackman in response to Thomson. Jackman writes: "There is no evidence to show that the peer-group assessment process as practiced by the Canada Council guarantees 'excellence' or 'creativity'."[12] Jackman is at pains to point out what he believes the problem of peer-assessment is and states, "the Canadian Group of Seven were *not* the result of some peer-assessment process" (emphasis in original).[13] All this in service of his attempt to push the idea that private money and its assessments should be an integral part of the process. It is exactly the link between private contributions to the arts and private assessments of what counts as art that worries many and correctly so. For as Atwood suggests, "If rich people and only rich people were in charge, it's an even bet we'd cease to see anything that might offend either them or their taste, especially in the performing arts."[14]

How does Thomson figure in this discursive war? Well, Thomson is apt to defend the Canada Council from all who would bring any trouble to its "arm's length status." But what is even more troubling is that her response is couched in very nationalist terms, a kind of nationalism that still requires the bully to the south to define Canadian-ness. Thomson concludes: "And as our economy and popular culture become more integrated with those of the United States, as the world shrinks, our best hope for preserving the multitude of voices that would address the abiding but shifting concerns of the human condition lies, *pace* Mr. Jackman, in the responsible exercise of leadership by our publicly funded cultural institutions."[15]

What is surprising, or at the least a point of contention, is that Canada Council policy only works as arm's length in one way—the artists' communities. There can be no more illusion that government policy beyond budget decisions does not affect the Canada Council's managerial decision-making. To believe so is to discount the ways in which public and private political positions influence policies in a wide array of spheres. As Clive Robertson has argued: "Arts councils in Canada have linked their survival to the perception of arm's length status both from government and the arts community. However, to effect policy changes, arts councils have strategically relinquished different aspects of their legislated autonomy to the government and to various emerging and residual constituencies within the arts community."[16] Even more clearly, Robertson writes: "Bobbing along in the political swift currents, as politicians ridicule the democratic value of public cultural subsidy, the Canada Council has clearly signalled its transitional status."[17] This has an ominous tone to it and we know that the underbelly of political discourse on restructuring has been an attack on equity-seeking groups (to use their term) and this will undoubtedly have its impact in the arts as well. I do not mean to sound or signal a conspiratorial note.

Or, as Barbara Godard has detailed, in the Ontario Arts Council version of these events the OAC "envisages itself not as public patron commissioning art, but as catalyst operating at arm's length to facilitate interactions between separate spheres by convening meetings of businessmen and industrialists in order to induce them to place arts higher in their priorities for corporate donations."[18] But as Godard further suggests, this kind of approach does not bode well for those who are either newcomers to Ontario or for older communities that have found a public voice and intend to participate. In her assessment, diversity is being played off against balance and balance means "the bottom line."[19] All of this raises the question: how will the next generation of racial minority artists find their work taken into and taken up by the world of art? In a nation where racial minority art is generally understood within the terms of the special effect, how will the restructuring of public funding to private enterprise initiative determine what counts as racial minority art? Will Hudson's claim of a Black art without intellectual and conceptual tension become *de rigeur* or will art that engages the political contexts, histories, pleasures, disappointments, fascinations, and other elements in a critical fashion exist only for those of us with the time, energy, and possibly the cash to find it?

An acclaimed artist such as Paul Wong understands his beginning in art-making as tied to the public funding structures and Wong identifies two programs from which he got his start as a young artist—the Local Initiative Projects and Opportunities for Youth—both programs from the Trudeau years, meant in Wong's words to "appease the youth rebellion."[20] But we now live in an era

where rebellious youth take to various forms of complex and innovative job creation programs in the culture industries that are sometimes subversive but most times not, for example the emergence of the DJ as artist. But this new trend in youth job creation do-it-yourself programs does not bode well for challenging elected officials and arts bureaucrats to devise new and innovative programs that will encourage a renewed interest in the making of art as a larger project of the public good and equally important as a source of income. What I am suggesting is that we should not reproduce, in our resistance to the restructuring of public funding of the arts in Canada, the image of the artist as poor outsider, doing it merely for the love of the work. In this time of restructuring we must up the ante and argue for a public arts funding policy that allows artists to have a livable wage. Yes, it smacks of old-time socialism but not everything about socialism was wrong or wrong-headed.

Finally, to return to Mootoo's comments concerning the lack of collecting the work of racial minority artists—especially their important work of the eighties. Such a practice has a number of consequences that bear heavily on the new restructuring. First, racial minorities are repeatedly being read outside the nation, their status always in question when their works are not collected and archived. Second, the lack of a historical record and archive that can be accessed by a range of young and emerging artists means that some of the crucial links between generations go missing. So while some folks can't get lost in the archive of racial minority artmaking of the eighties, what also goes missing is the public record of struggle, resistance, and the contingent remaking of the political sphere of artmaking in all its manifest forms. Third, there is an implicit indication that an audience of "readers" does not exist for racial minority art. While clear-thinking minds know this not to be the case, it remains a persistent thorn for racial minority artists who move beyond the heritage industry repetitions to produce art that asks us to think. It is from this perspective that I am suggesting that any fight for the rescue and the upgrading of the public funding of the arts in Canada must take as its ethical stand the racial minority artists in our midst who refuse to celebrate in simple and uncomplicated terms the discourse of heritage.

Coda

Recently, I saw *Cradle Will Rock*, a 1999 Tim Robbins film that draws heavily on the U.S. federal Work Program for artists in the 1930s. In Robbins' rendition of that history, the power of federal funding not only to nurture out-

of-work artists during the Great Depression but also to build audiences for the theatre is rendered in a remarkable fashion. What I found interesting about the film was its explicit politics in which a call was made for a practice of theatre that might attract audiences without dumbing down its content. There are at least two important ways in which the film points to this concern. First, the Congressional hearings in the film on the use of funds and the recurring Communist boogieman is the clearest signal. But the film's conclusion—the cut to a "renewed" Times Square and its Disneyfication—can also be read as either subtle or overt. Robbins' choice explicitly states the question of what happens to art when it is entirely commodified and corporatized. Now there is an irony here: Robbins' film is produced within the belly of corporate filmmaking, but we must read the commentary of the film as signalling a much more complex terrain, for it is not that all corporatization is wrong or bad but rather what is at stake in the overwhelming desire for corporatizing art and its funding. It seems to me that what is at stake is the political, and in particular the potential for radical art to connect with political communities that might attempt to change something about how we currently live our lives.

It is in fact also the political that is at stake in the current restructuring of cultural funding in Canada and with that restructuring the lives of racial minority artists swing in the balance. I, however, am not pessimistic about the
ıns that we must resist, organize, and
ı for the survival of public funding for

o Writing," *Within the Circle: An Anthology
the Harlem Renaissance to the Present*, A.
ıiversity Press, 1994).
Whitewash: Racism in Ontario's Arts
ings on Racism and Culture (Toronto: The

et Negro," *FUSE* 21:3 (1998), 14.

isfits Together: Paul Wong on Art,
ıos and '80s," *FUSE* 21:3 (1998), 46.
ırians, and they are us," *Globe and Mail*,

1994 - North American Free Trade Agreement (NAFTA) with Canada, U.S. and Mexico is sealed and cemented after 1993 federal election defeat of Mulroney and the Conservatives. Incoming Liberal Prime Minister Jean Chrétien had campaigned against Mulroney's continentalism and uncritical distance from American politicians and multinationals.

8 Craig Owens, "'The Indignity of Speaking for Others': An Imaginary Interview," *Beyond Recognition: Representation, Power, and Culture*, S. Bryson, B. Kruger, L. Tillman, J. Weinstock, eds. (Berkeley: University of California Press, 1992), 262.

9 Angela McRobbie, *In the Culture Society: Art, Fashion and Popular Music* (London: Routledge, 1999), 6.

10 Shani Mootoo (with Sarindar Dhaliwal), "Shifting Perceptions, Changing Practices," *FUSE* 22:2 (1999), 21.

11 Margaret Atwood, "Let's not paint artists into a patronage corner," *Globe and Mail*, January 19, 2000, A17.

12 Hal Jackman, "Time to cast the private sector in a starring role?," *Globe and Mail*, January 10, 2000, R4.

13 Ibid.

14 Atwood, A17.

15 Shirley Thomson, "Why the public must fund the arts," *Globe and Mail*, December 21, 1999, A17.

16 Clive Robertson, "Custody Battles: Changing the Rules at the Canada Council," *FUSE* 22:3 (1999), 37.

17 Ibid.

18 Barbara Godard, "Privatizing the Public: Notes from the Ontario Culture Wars," *FUSE* 22:3 (1999), 30.

19 Ibid., 31.

20 Wong, 41.

> DAVID McINTOSH

Memes, Genes, and Monoculture

Pent-up apocalyptic Y2K desires and X-Files alien/humanoid interbreeding fantasies of the late twentieth century have recombined into a new kind of extropianism at the outset of the twenty-first century in the form of accelerated evolutionary promises of the "New Economy." The merger mania orgasm of the $160-billion AOL/TimeWarner transmedia mega-deal in January 2000— a union widely described as "genetically programmed"—provoked "bigger is better" hysteria and capitalized on fears of being left behind on the lonely analogue planet. One of the more dramatic effects of this deal has been a frenzy of investment in digital media, chip manufacture, and biotech research stocks, leading to a seventy-eight-fold over-valuation of these stocks in comparison to their potential earnings. This lemming-like mass investment in the vague promise of some future disembodied and deterritorialized artificial life spawned accompanying waves of terminology shifts—e-commerce, dotcom sector, B2B—all culminating in the February 2000 pronouncement of the "New Economy."

Juxtaposed in a harsh duality with the "Old" and more obviously state-regulated biomass economy of bricks, mortar, mining, grocery stores, and automobile manufacture, the "New Economy" evokes a new binarism, as if the discrete constituent components of digital culture—0's and 1's—have worked their way up the food chain of signification to recast all possible forms of exchange. This essentialist binarism is not limited to conceptual frameworks of new and old, but extends into the forms of corporate organization emerging around digital prospects. In other words, the AOL/TimeWarner giant is locked into a dualistic Megalon versus Mothra struggle with the ATT/MediaOne behemoth; this binaristic battle spills over into Canada, where the Rogers/Maclean's/Microsoft/ATT agglomeration is in direct opposition to the BCE/Nortel/CTV/Lycos/Sympatico sprawl. Increasingly,

naively utopian-democratic netizens do not work the freedom frontier, but belong to one or the other Akira-like mutating corporate terrains—except perhaps for infamous hacker Mafiaboy and his computer zombie attack on dotcoms, which was really nothing more than an inversion of corporate spam techniques.

If the notion of the "New Economy" eclipsing the "Old" seems like a manipulative, self-serving, and short-sighted over-valuation, that's because anyone alive in the industrialized world has experienced firsthand any number of purportedly revolutionary technology shifts—from satellite television to MP3—and knows full well that new technologies don't replace the old, but that all technologies accumulate, overlap, and complexify. If the "New Economy" seems like a never-ending, overly familiar promise, that's because digital convergence has been debated and prophesied for over a quarter of a century; even the Canadian federal Department of Communications (now the Ministry of Heritage) was publishing "sky is falling" convergence warnings in the mid-1970s. And if the corporate binarism that has consolidated within the "New Economy" incites a déjà vu, that's because it is a throwback to and replay of eighteenth-century European colonial mercantilism where competing empires carved up the globe into exclusive zones of absolute ownership and exploitation.

As the notion of the "new" digital commercial and corporate culture has ascended, revisiting the "old" seems to have taken on increased resonance. A flurry of histories of scientific and technological change, a significant number of them by Canadian authors, has been published over the course of the last year. Some, like Wade Rowland's *Spirit of the Web: The Age of Information from Telegraph to Internet*, are simplistic positivist journeys through inventions from the past aimed at justifying the inevitability of global digital democracy and commerce. Others, like Donald Gutstein's *E.con: How the Internet Undermines Democracy* are critically informed analyses of the more nefarious impacts, intentions, and operational mechanisms of monopoly-oriented U.S.-based multinational multimedia corporations. Some histories delve much deeper into the past and techno-philosophy; a good example of this approach is Erik Davis's *Techgnosis: Myth, Magic and Mysticism in the Age of Information*, which traces the course of early Christian religious imaginaries through the history of communications technologies and demonstrates how those early imaginaries continue to drive

the contemporary digital techno-unconscious. In *A Thousand Years of Nonlinear History*, Manuel De Landa applies analytical processes borrowed from the science disciplines of thermodynamics, population genetics, and mathematico-linguistics to re-assess the millennium just closed and to confirm the need for a critical stance, in the face of the New Economy, that transcends positivist, unidirectional concepts of progress and evolution:

> Reality is a single matter-energy undergoing phase transitions of various kinds, with each new layer of accumulated "stuff" simply enriching the reservoir of non-linear dynamics and nonlinear combinatorics available for the generation of novel structures and processes. Instead of a unique and simple form of stability, we now have multiple coexisting forms of varying complexity... when we study a given physical system, we need to know its history to understand its current dynamical state.[1]

The ability to resist the seduction of a disembodied monocultural future and to comprehend the relevance of a unified field of digital storage and distribution technology to a throwback binarist corporate mercantilism would seem to necessarily involve an interdisciplinary re-examination of history. Deconstruction of the false economy of the new/old economy split requires analytical tools that are more complex than 0/1 or on/off switches and that can model the underpinnings of the emergence of what De Landa would call a new dynamic stable state and what theorist Paul Gilroy has called "the changing same."

The deployment of technological and organizational change in digital terms is not simply a matter of irrepressible forces of nature propelling evolutionary change in the digital direction. In fact the evolutionary phase, or phase transition, before us is a constrained, forced, and constructed evolutionary attempt, being accomplished through the conscious distillation and application of deeply imbedded laws and calculated formulae, which are themselves constructs of the last 250 years of economic and biological thought and practice. Like some of the works referred to, the following study loops through history, shifting between the end of the imperial bio-mercantilist moment and the arrival of the global corporate digital mercantilist moment. Within this framework, the natural laws of free markets, free trade, competition, and the supremacy of the bounded economic individual are examined as they are converted from speculation and ideology into a memic structure transmitted across centuries and generations, assuming equivalency to the genic transmission of hereditary traits. More specifically, this study examines the role of contemporary rule of law free trade instruments, such as NAFTA, as incubators of the global corporate formula—grounded in expanding patent law, intellectual property law, and

1994 - AN ANONYMOUS HALIFAX ARTIST PLACES HOMEMADE COOKIES IN A LOCAL SOBEY'S GROCERY STORE. THE COOKIES WERE SHAPED LIKE LETTERS, SPELLING OUT "WORDS." THE PACKAGES INCLUDED SOBEY'S-STYLE BAR CODE STICKERS. SOBEY'S ENGAGED THE RCMP, BUT TO NO AVAIL.

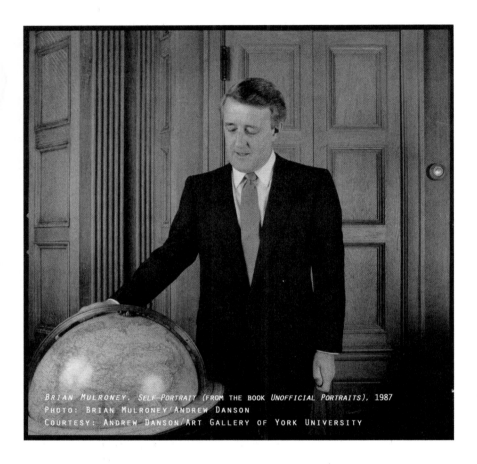

BRIAN MULRONEY, SELF-PORTRAIT (FROM THE BOOK UNOFFICIAL PORTRAITS), 1987
PHOTO: BRIAN MULRONEY/ANDREW DANSON
COURTESY: ANDREW DANSON/ART GALLERY OF YORK UNIVERSITY

investment rights—for digital monopoly and mercantilism. And finally, the work recourses to oppositional biological discourse to counter the controlling meme of competition with genic and molecular notions of diversity, mutualism, boundaries, self-organization, and embodied territories.

The Growth of the Rule of Laws: Market Utopianism and Naturalized Free Trade Ideology

The economic ideology of competition, free markets, and free trade under-pinning globalization has not altered significantly from its origins in late

eighteenth-century and early nineteeth-century economic, moral, and scientific theories, but the tools of international trade law, used to propagate, implement, and enforce those theories, have changed dramatically in the last decade and have in turn produced dramatic changes in the shape, scale, and organization of economic practice, as evident in millennial merger mania. As such, when digital globalization is broken down into its constituent parts, it can be seen to be a process of both continuity and ruptures, a dynamic changing same produced by a feedback loop that ensures continual shifts from stable state to stable state.

Writing within the overarching Enlightenment parameters of reason, materialism, empirical method, and the application of universal natural laws to human activities, Adam Smith laid the groundwork for the discipline of political-economy with the publication of *An Inquiry into the Nature and Causes of the Wealth of Nations* in 1776. Smith's "market theology," so called for its reliance on a deistic concept of perfect design revealed in natural, economic, and moral order, proposed the rational individual as the guarantor of societal wealth and well-being and the commercial republic as the tonic to mercantilist protectionism. In an era when extreme protection of national and imperial economies was the norm and the occasional negotiated reciprocal trade agreement across national borders the anomaly, Smith theorized universal laws of economic exchange and profit guided by the "invisible hand" of nature's perfect, God-given design and based on natural, absolute, individual advantage wherein the "selfish economic agent promotes common interest"[2]:

> Every individual is continually exerting himself to find the most advantageous employment for whatever capital he can command. It is his own advantage, indeed, and not that of the society, which he has in view. But the study of his own advantage naturally, or rather necessarily, leads him to prefer that employment which is most advantageous to the society... he intends only his gain, and in this led by an invisible hand to promote an end which was no part of his intention.[3]

Twenty-one years after Smith's initial theorization of *homo economicus* and market efficiencies resulting from specialization, competition and self-interest, Rev. Thomas Malthus, an economist for the East India Company, published his crucial work, *An Essay on the Principle of Population* (1797), in which he proposed the relatively simple theory that there are natural limits to human progress and perfection given the discrepancy between food supplies, which increase arithmetically, and population, which increases geometrically. This universal law suggested that there would always be competition for resources and that overpopulation had to be checked by the natural forces, or invisible hand, of

death, disease, war, and famine playing themselves out without human or state intervention. Malthus's simple formulation of natural law was taken up as the theory for the rising industrial middle class to promulgate and put into practice self-interested measures imposing ruthless competition and instating a low-wage, high-profit capitalist society in 1830s Britain. At that time, Britain was experiencing depression, starvation, mass unemployment, and emigration due to the Industrial Revolution's shift of the population from rural to urban life, in conjunction with extensive crop failure in a highly protected national agricultural system held firmly in the control of intransigent inherited aristocratic and religious interests. An active and self-interested political crusader himself, Malthus saw his notions of natural competition work their way though the political and industrial system, first with the passing of the New Poor Laws in 1834, which removed every form of state welfare from the poor, exacerbating starvation, disease, and death among the unemployed working class, and then with the repeal of the Corn Laws in 1846.

An act that is generally accepted as signalling the dismantling of mercantilist protectionism and the birth of the practice of international free trade, the 1846 repeal of the Corn Laws, which had previously protected British agriculture, was effected by Prime Minister Peel as a practical and theoretical compromise measure that would live up to industrial, trading, and intellectual middle class demands for competition, market efficiency, and self-organizing society and that would allow importation of low-cost foods into the country to combat working class starvation. This dramatic shift in nineteenth-century trade practice is noteworthy historically in that it is the first and possibly the only instance of unilateral free trade; the Corn Laws were not repealed on the basis of negotiated nation-to-nation reciprocal treaties for tariff reduction, the most common practice then and now in international trade agreements, but rather on the basis of a unilateral single-nation declaration of open borders. The change in international trade practice effected by the repeal of the Corn Laws is also historically significant in that it was produced from a complex amalgamation of the natural economic, material, and moral laws of competition developed by Smith and Malthus, a tightly self-referential, cross-disciplinary ideological knot producing a universal narrative of competition that was activated in Peel's utopian national free trade regime in the 1840s and transcended the status of naturalized ideology to become the meme driving the FTA-NAFTA continental free trade regime in the 1990s.

In many ways, Darwin's 1859 *On the Origin of Species* served to naturalize this ideological knot irrevocably in drawing on these same sources of moral and

economic law as well as the science disciplines of biology and geology to develop the theory of evolution and natural selection. Darwin appended the Malthusian social/economic formula of struggle for scarce resources to his own theories of mutation in the non-human organic world, claiming competition as the driving force behind all evolution and merging the human and non-human organic world into one naturalized evolutionary effect:

> When two races of men meet, they act precisely like two species of animals—they fight, eat each other, bring diseases to each other &c, but then comes the more deadly struggle, namely which have the best fitted organization or instincts to gain the day.... The stronger are always extirpating the weaker.[4]

Darwin not only drew on prevailing scientific, economic, and moral law, he somewhat cravenly and self-interestedly tailored his theories to his class interests, building complicity with middle class industrial and political interests into his notions of evolution, competition, and natural selection:

> Darwin's biological initiative matched advanced Whig social thinking.... At last he had a mechanism that was compatible with the competitive, free-trade ideals of the ultra-Whigs; open struggle with no hand-outs to the losers was the Whig way.... Darwin was living on a family fortune and thrusting bitter competition on a starving world for its own good. From now on he could appeal to a better class of audience....[5]

The naturalization of economic ideology as scientific theory was continued and transposed to the U.S. industrial capitalist ethos at the end of the nineteenth century through the writings of Herbert Spencer in works such as *The Man versus the State*. Spencer was referred to as a "social Darwinist" but was actually a Lamarckian who believed that there was a mysterious inner force that continuously promoted the improvement of the species, who espoused an extreme form of laissez-faire individualism involving the removal of the state from all human affairs except for external relations with other states and who considered modern industrial capitalism's embodiment of the Malthusian struggle for existence as a key step forward in human evolution.[6]

The Antimarket Stable State:
The Rule of International Trade Law and Memic Market Theory

How does the inherited capitalist economic ideology intersect with contemporary free trade and corporate globalization practices in North America?

1995 – CANADA COUNCIL PROPOSES STRATEGIC PLAN. 54% ADMINISTRATIVE CUTS RESULT IN CLOSING OF ART BANK, MOVING OF INDEPENDENT ARTS AWARDS SECTION INTO DISCIPLINARY HANDS, JURY AND ADVISORY COMMITTEE CUTS, AND TERMINATION OF FUNDS FOR ARTS SERVICE AND ADVOCACY ORGANIZATIONS (I.E., CARO). CANADA COUNCIL ACTUALLY DECLARES THAT IT WILL RE-INVENT ITSELF AS AN ADVOCATE FOR INDIVIDUAL ARTISTS AND ARTS ORGANIZATIONS.

Alternative and oppositional economic theories and practices have disrupted and still do disrupt the purity of the naturalized capitalist economic ideology, however, the focus here is on the post-1989 universalizing usage and reassertion of memic notions of perfect market competition.

One of the most significant shifts in the dynamics and motivations for free trade between 1840s Britain and 1990s North America, according to economic historian and theorist Jagdish Bhagwati, relates to the degree of purity achieved in the application of the meme of perfect market competition. A free trade purist, Bhagwati decries the motivations and enactments of bilateral and trilateral free trade agreements on the part of the Reagan–Bush regimes as unprincipled, hypocritical, and misnamed reciprocity, or fair trade, that betrays and stops far short of achieving the ideals of perfect competition and free markets:

> Robert Peel was converted to free trade by the principles of political economy and repealed the Corn Laws in 1846 to usher in free trade at the cost of his political career.... Peel's embrace of free trade had an ideological, cerebral basis.... By contrast, President Reagan's commitment to free trade appears to be instinctual ... it is doubtful he was animated by the theory of comparative advantage or that he now sits in his study reflecting on the wisdom of Adam Smith and David Ricardo. Rather, his attachment to free trade seems to reflect an intuitive sense of the Darwinian process and America's ability to come out as Number One.[7]

In other words, while lip-service was paid to the meme of perfect competition by Reaganite "intuitive Darwinian free-traders" in promoting the FTA and NAFTA agreements, there was never any possibility or intention of implementing the ideological construct practically or unilaterally, as the "cerebrally" motivated Peel did in 1846. In Bhagwati's framework, FTA and NAFTA are just protection by another name; Reaganomics rested on a semantic trick, shifting between the rhetorics of natural absolute or comparative advantage on one hand and interventionist-constructed competitive advantage on the other, while continuing to rely on a variety of state-enforced strategic trade mechanisms to maintain national self-interest. Such U.S. mechanisms range from sectoral binational managed trade, like the Canada–U.S. Auto Pact, and exacting voluntary export quotas from other nations, as in the case of Japan's auto and semiconductor industries, to direct state subsidy or tax exemptions to strategic

industries, such as aerospace and steel, and retaliation for restricted access to a foreign market in the form of a "trade war." Bhagwati's analysis of the pragmatics of U.S. economic policy points to the progressive withdrawal of ideals of natural economy, the economy of nature, and the rule of natural law from U.S. free trade practices and their substitution with brute enforcement of profitable anti-market political arrangements. It is also worth noting that at the same time as the inherited ideals of natural economy have receded into hyperbolic rhetoric, the extreme fundamentalist religious and political right has put the very prosaic "word of God as law" back into the machine, re-aligning the relationship between state and morality and instigating the so-called "culture wars" against homosexuals, artists, and abortionists.

Speaking from the opposite end of the political-economic spectrum, anti-corporate, direct democracy theorist Noam Chomsky affirms Bhagwati's analysis of the self-interested anti-market hypocrisy and duplicity of the Reagan deployment of the free market meme:

> Free market doctrine comes in two varieties. The first is the official doctrine that is taught to and by the educated classes and imposed on the defenseless. The second is what we might call "really existing free market doctrine": For thee but not for me, except for temporary advantage.... There was no need to explain "really existing free market doctrine" to the Reaganites, who were masters at the art, extolling the glories of the market to the poor at home and the service areas abroad while boasting proudly to the business world that Reagan had granted more relief to US industry than any of his predecessors in more than half a century... in fact it was more than all predecessors combined, as the Reaganites doubled import restrictions.[8]

However, Chomsky differs dramatically from Bhagwati in his comprehension of this particular doubling of economic theory and practice. Continuity of a stylized, removed ideal of natural economy and perfect free markets in conjunction with a shift in the political application of strategic self-interest has lead Chomsky to conclude that we are in a period of evolutionary regression or an evolutionary spiral, or possibly caught within a single-sided Moebius loop which has taken us back into a nation-state driven, protectionist mercantilism, now called free trade.

> The approved doctrines are carefully crafted for reasons of profit and power ... the international "triumph of the market" is based on a system of global corporate mercantilism in which "trade" consists in substantial measure of centrally managed intrafirm transactions and interactions among huge institutions, totalitarian in essence, designed to undermine democratic decision making and to safeguard the

1995 - ESTABLISHMENT OF ARM'S LENGTH, PEER-ASSESSED BRITISH COLUMBIA ARTS COUNCIL. THE COUNCIL, HOWEVER, IS NOT ALLOTTED MUCH FUNDING BY THE PROVINCIAL GOVERNMENT. (EVEN IN THE WAKE OF THE BARRAGE OF CUTS TO ONTARIO'S ARTS COUNCIL, B.C.'S STILL HAS LESS CASH TO WORK WITH AT THIS DATE.)

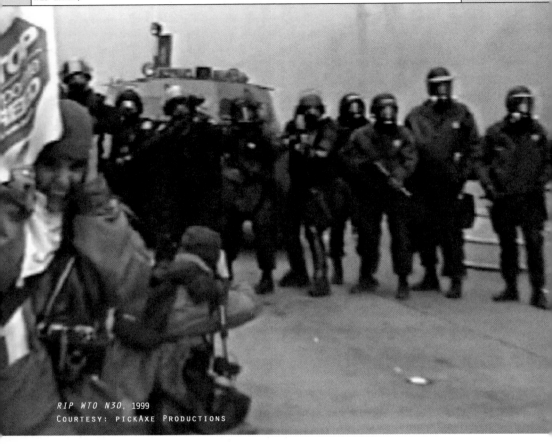

RIP WTO N30, 1999
COURTESY: PICKAXE PRODUCTIONS

masters from market discipline; a system in which oligopolistic competition and strategic interaction among firms and governments condition today's competitive advantage and international division of labour....[9]

Memic Market Constructs in Practice: FTA and NAFTA Trade Regimes

FTA and its continental successor, NAFTA, are powerful "rule of law" tools for the enactment of globalization, transposing Smith's "invisible hand" of natural law into civil law, rendering the utopian commercial republic a

pragmatic entrepreneurial state, constitutionalizing and giving predominance to self-interested individual and corporate rights over collective and nation-state rights and, ultimately, reshaping and controlling the direction of democratically self-organizing societies. These model agreements have already been put forward, with varying degrees of success, in broad international terms in the form of the MAI and in the forum of the WTO, and they continue to be resolutely deployed, nation-state by nation-state, throughout the Americas. Reaganite neo-liberal economic, political, and social ideology of the 1980s may well have changed the dynamic between competition and collectivity with its pseudo-memic inevitability, but it is nonetheless a strategic and contradictory construction. While the "New World Order" claims a link between free markets and democracy, the free trade tools of globalization are inherently anti-democratic and aimed at the containment and eventual elimination of nation-state collectivities, other than the U.S. entrepreneurial state.

> Transnational capital no longer needs to operate within the nation as a legal, political, cultural entity, but instead needs the nation as a means of regulating labor, materials and capital.... Nationalisms seek to control the deterritorializing flows of capitalist economies, whether externally imposed or internally emergent, but they do so in large part through the politicization of a population. Far from being a defense of original modes of social organization, nationalist mobilization effects the transformation of traditional "moral economies" into modern political economies regulated by the state. Simultaneously, the effect of this transformation is to produce the modern citizen-subject, the "interchangeable individual" of political economy and the social institutions—law, school, police—that permit the integration of any nation into the world economic system.[10]

> Because these texts are rules-driven rather than result-oriented, they favour the interests of the dominant and powerful over any substantive concept of the collective... wherever there is conflict between the provisions of the FTA and US law, US law will prevail... it has proven next to impossible to separate a country's external trade from its national economy and make it independent of its national self-interest.... Short of retaliation there is no provision in NAFTA to create objective standards or to rein in the protectionist elements within the US... NAFTA is an economic integration project driven by the strategic investments needs of the US.[11]

Far from being yesterday's news, the Canada–U.S. Free Trade Agreement (FTA), signed in 1989, and the subsequent North American Free Trade Agreement (NAFTA), signed in 1994 by Canada, Mexico, and the U.S., continue to redraw every aspect of nation-state legislation. They are the originary tools

1995 – National Gallery cancels scheduled exhibition of on-going painting project by Dennis Tourbin about media and October 1970 FLQ crisis, fearing political controversy in the context of upcoming Québec referendum on sovereignty.

for building an integrated, rule-of-law based continental economy and stand as models for the extension of U.S.-generated economic doctrines from continental to global terms. FTA–NAFTA is a 1,000-page, highly legal document that defies easy comprehension, but there are three fundamental aspects of the agreement that illuminate its impact as a formula. First, NAFTA is a standstill agreement that has rendered contingent economic policy constitutional. In other words, 1980s Reaganite economic policy of strategic state/corporate competitive advantage accompanied by a contradictory rhetoric of natural economy, free market competition, and elimination of state intervention, has been inscribed in law, a law that takes precedence over all other collectivities, from WTO and national law to provincial/state and municipal law. Second, NAFTA elevates the individual to the same status as the collective, homo economicus to the same status as the state. Defining any individual or corporation, in fact any site where financial transactions occur, as an "investing enterprise," the agreement then offers that investing enterprise equal rights to the nation-state, including the judicial right to seek financial compensation from the state for any decrease in or limitation on revenues or profits due to any state action, as well as a legal right to seek the imposition of punitive, retaliatory measures by the investing enterprise's state of residence. Third, NAFTA imposes severe restrictions on the ability of the nation-state or subnational collectivities to intervene in economic matters. Couched in terms such as *performance requirement, local presence, expropriation, foreign investment review, state enterprise and monopoly*, NAFTA sets out a complex and interlocking set of rules that effectively circumscribes all current state interactions with economic matters. For example, the chapter on investment exempts governments from the stringently entrepreneurial terms of the agreement in the areas of "law enforcement, correctional services, income security or insurance, social security or insurance, social welfare, public education, public training, health, and child care," but only if state efforts are implemented "in a manner that is not inconsistent with this Chapter."[12] In fact, the investment terms of Chapter 11 would prohibit all state intervention in these areas, so in fact the "exemption" is meaningless. And with direct reference to state cultural intervention, Exemption Article 2005 of the FTA (transposed intact to NAFTA) gives Canadian cultural industries an exemption from the terms of the agreement, but is immediately followed by a "notwithstanding" clause that takes it away. This clause allows the U.S. to take countermeasures of equivalent commercial effect on behalf of any U.S. investor or enterprise affected by any

actions of the Canadian state with regard to cultural industries deemed incon-
sistent with the broader terms of the agreement. This is exactly the threat
recently posed by U.S. trade representatives to Canadian magazine-support
legislation. The so-called cultural exemption from FTA–NAFTA is thus
toothless and irrelevant. And while the agreement lays out limitations on
state-economy interactions, there are no significant counterbalancing provisions
to limit corporate monopoly.

The New Dynamic Stable State:
The Triumph of the Monoculture Formula in Media History

> Today, wherever we turn, we witness a nasty wrestling match between a global consumer
> transculture and the resurgence of virulent ultranationalisms. Those in power
> insist that media, computer communications and the global economy have already
> created a single borderless world community. They speak of "total culture" and
> "total television", a grandiose pseudo-internationalist world view à la CNN that
> creates the illusion of immediacy, simultaneity and sameness, thus numbing our
> political will and homogenizing our identities. Through this lens, the entire world
> unfolds and changes in front of us, but nothing really matters. [13]

Perhaps one of the best ways to approach the development of this twenty-first
century formula for propelling the changing same into a new dynamic stable
state, as well as its global impact, is by examining how it has been deployed in
a specific cultural/industrial sector over the course of the preceding century.
Film theorist Stephen Heath has suggested that twentieth-century nationhood
is bound up in the institutional, structural, and semiotic representational
apparatus of cinema and the means by which it produces subjects and imagined
communities, much as nineteenth-century nationhood was bound up in the
novel. And, more prosaically, as the U.S. industry that currently ranks second
after the aerospace industry in generating foreign income world-wide, the
film industry holds a determining position in the U.S. balance of trade and as
such is key to the interests of the state. [14]

State intervention to regulate international trade in film products and to
develop, support, and protect national film production industries and markets
is almost as old as the medium itself. Through a series of legal, technical, and
corporate structural innovations in the U.S. motion picture industry in the
1920s and 1930s (motion picture technology patents control, centralization
of production in a limited number of studios, development of an industrial
division of labour for production based on New York garment-industry

1995 – ELECTION OF CONSERVATIVE GOVERNMENT IN ONTARIO, LED BY PREMIER MIKE "THE KNIFE" HARRIS. THE CONSERVATIVES EASILY DEFEAT BOTH THE DISGRACED INCUMBENT NDP LED BY BOB RAE AND THE INDECISIVE LIBERALS BY DECLARING THEMSELVES THE AGENTS OF THE "COMMON SENSE REVOLUTION." COMMON SENSE INVOLVES THE DRASTIC REDUCTION OF WASTE AND OR FRIVOLITIES—INCLUDING SOCIAL PROGRAMS AND ARTS CULTURAL FUNDING.

production lines, vertical integration of production, distribution, and exhibition, deployment of the Motion Picture Producers and Distributors Association (MPPDA) as an aggressive export association, and access to finance capital for the rapid shift to new sound technology), the U.S. film industry experienced a production and export surge that threatened the national cinemas of all film-producing countries. During this period, the international film industry shifted from a state of more or less generalized proliferation of production and equal exchange of cinema products across national borders to one of domination of national markets by U.S. product and distributors. The effect was felt most strongly in Britain where British film presence on national screens dropped drastically from 25% in 1914 to 10% in 1923.[15] In an effort to protect the domestic industry, the British government introduced the first direct state intervention in the film industry in 1927, imposing a minimum British film content quota of 7.5% rising to 20% over ten years for all distributors and exhibitors operating in Britain, regardless of national origin. This measure was followed in 1939 by a measure to limit American distributors' remittances on British income in hopes of encouraging the investment of unremittable U.S. profits in British production. Canadian film production was negligible in the 1930s, consisting of one or two Canadian-produced features a year. But since Canada was a Dominion of the British Empire, U.S. productions shot in Canada received Canadian/British status in order to circumvent the British import quota; between 1935 and 1939, twenty-three such "quota quickies" were made in Canada.[16] Both France and Mexico had similar responses to the U.S. export surge in the 1920s and 30s, with France instituting an import quota in 1928 of seven foreign films allowed in for each French film exhibited nationally,[17] and with Mexico's President Cardenas decreeing that all cinemas would have a quota of showing one Mexican film per month.[18] No nation's state intervention measures, other than those of the U.S., were completely effective in promoting domestic or local production, other than on a cyclical boom and bust basis.

The promotion and protection of the national interest by regulating the cinema through state intervention became even more extensive during and following the Second World War, when national cinemas were reconceived and repurposed as propaganda and of vital interest to the security of the nation-state. This development is most clearly articulated in U.S. intervention

in post-war Germany, where the highly centralized and prosperous pre-war film industry was dismantled by the Americans and the German market flooded by U.S. product with the aid of the 1948 Congressional Information Media Guarantee, a thinly disguised export and dumping subsidy. The extent of the strategic deployment of Hollywood cinema for corporate commercial interests as well as re-education and propaganda purposes is clearly evident in the words of 20th Century-Fox President Spyros Skouras: "It is a solemn responsibility of our industry to increase motion picture outlets throughout the free world because it has been shown that no medium can play a greater part than the motion picture industry in indoctrinating people into a free way of life."[19]

Individual national approaches to state intervention in cultural industries first moved toward global coordination in the late 1970s in response to the emergence of the "wired world" with the shift to electronic communications technologies. The critical study of monopolies of knowledge and electronic colonialism became the focus of much of UNESCO's activities, where an alliance of Soviet bloc and non-aligned states in Asia, Africa, the Caribbean, and South America constructed proposals to recognize information and culture as national resources to be managed in the developmental interests of the independent state and its people, much as mineral or agricultural resources were. This strategic alliance, known as the New World Information Order (NWIO), sought international agreements on state intervention mechanisms to ensure balanced flows of information between nations, access to telecommunications technologies and techniques, and the survival of national self-representational cultural processes. Despite support for NWIO initiatives by an overwhelming majority of UNESCO member-states, no international agreement reflecting their objectives was ever reached. The U.S. government, in alliance with multinational information corporations like IBM, IT&T, and Hearst Publications, refused to sign agreements that in any way impinged on U.S. constitutionally guaranteed freedom of expression or on the free market.[20] In tandem with the death of the NWIO's global regulatory approach to new digital communications technologies in 1983, longstanding state support and development mechanisms for the traditional medium of cinema began to disappear. Between 1983 and 1985, the Thatcher government eliminated all existing state interventions in the British film industry,[21] while IMF economic restructuring programs forced the elimination of state cinema support mechanisms in Argentina and Brazil by 1985.[22] In 1986, even the American Congress eliminated their ten-year-old tax-break incentive to film producers, an incentive offered to no other U.S. corporate taxpayer.[23]

However, national deregulation of film industries and rejection of global

1995 - IN A PERFORMANCE NEAR THE PARAMOUNT THEATRE ON HALIFAX'S BARRINGTON STREET, ARTIST STEPHEN CLAYTON ELLWOOD RELEASED NICKELS THAT HE HAD SOLICITED FROM POTENTIAL AUDIENCE MEMBERS BACK INTO THE PUBLIC REALM. THIS PERFORMANCE, FUNDED BY THE CANADA COUNCIL AND OO GALLERY IN CONJUNCTION WITH THE CANADA NOVA SCOTIA AGREEMENT ON CULTURAL DEVELOPMENT AS WELL AS BY OTHER REVENUE SOURCES, WAS DENOUNCED AS BEING A FRIVOLOUS WASTE OF TAXPAYERS' MONEY BY POLITICIANS AND JOURNALISTS. THE ARTIST'S AMERICAN CITIZENSHIP WAS ALSO A LIGHTNING ROD FOR CRITICISM.

regulation of digital information and communication industries were only symptoms of a much more extensive reshaping of the international trade agenda and corporate interests around new technological potentials in the 1980s, which amounted to a second surge in global penetration of markets by U.S. multinational media corporations. Digital technologies redefined the information/communications/culture/entertainment landscape as an integrated sphere of data that encompassed all media, from mechanico-chemical processes such as film, and electronic analogue media such as broadcast and cable television to fully digital computer software, satellite communications, and internet applications. American multinational media corporations maintained a historic strategic competitive advantage in global film and television industries and used this position to take advantage of the deployment and marketing of the new technology products of the U.S. state's program of "military Keynesianism"—it was in fact the U.S. Department of Defense ARPANET program that funded and developed the internet.[24] This convergence of historical competitive advantage in film and television industries with state/military-induced competitive advantage in emerging digital industries positioned U.S. multinational media corporations to reconfigure themselves around a new global growth and profit strategy based on securing the copyright for all forms of programming (films, television programs, software) in all media in all territories. Massive corporate reorganization to capture the global flow of information by extending networks of intrafirm corporate control through horizontal amalgamation and vertical integration began in the late 1980s and continues unabated, producing a concentrated number of monstrous corporate agglomerations such as Viacom (which owns Paramount, MGM, NYNEX, Blockbuster Video, Famous Players, Virgin Group, Showtime, Nickleodeon) and TimeWarner (which owns Time Magazine, Warner Bros, CNN, HBO, Cinemax, TimeWarner Cable, New Line Cinema, Fine Line Cinema). The surge in U.S. market penetration resulting from this new corporate strategy is evident in recent statistics for the international trade in audiovisual goods (film, television, computer software) in the European Union: U.S. sales of audiovisual programming in the E.U. rose from $330 million in 1984 to $3.6 billion in 1992, leaving the E.U. with an annual audiovisual trade deficit of $3.5 billion that year.[25]

The further extension of the commercial and ideological agenda of the U.S. state-multinational media corporation conjunction into the cultural realms of other nations through a singular application of international trade law can't really be considered a matter of free trade practice but rather a matter of elimination of all competition, given that current national positions in home film markets for those countries still producing film range from a high of 15% in Britain[26] to a low of less than 2% in English Canada,[27] while the presence of international cinema products in the U.S. market shrunk dramatically from 6% in 1986 to 0.75% in 1994.[28] The continued success of this virulent U.S. corporate strategy is dependent on maintaining centralized banks of programming copyright and extending intrafirm distribution networks globally, which in turn depend for their success on the global extension and enforcement of amenable copyright legislation and on the deregulation of national barriers to trade in services and investment through the rule of international trade law. In other words, the symmetry between the growth strategy of the core U.S.-based multinational media corporations and the U.S. state-driven international trade negotiation agenda of restructured investment and copyright law is virtually complete. And the tools for achieving this global market position are embodied in what are euphemistically called "free trade" agreements.

Memes and Genes: The Return of Repressed Evolutionary Discourse

The economy of nature is competitive from beginning to end…. Species are to evolutionary theory as firms are to economic theory. If it be true that only individuals compete, then species as well as organisms can compete just as corporations and craftsmen.[29]

The individual is not a neutral unit. Rather it serves to demarcate a boundary between unlike and unequal spheres—unequal not only in their scientific credibility, but in their political values as well.[30]

Much as social and political theories and practices in the early nineteenth century informed and shaped the Malthusian and Darwinian concepts of the economy of nature and the natural economy, concepts which were then fed back, naturalized, into the realm of the social and political, a similar cross-disciplinary dynamic characterizes contemporary evolutionary discourse, especially since the "discovery" of DNA and the growth of the field of molecular biology in the late 1950s. Eminent science historian Evelyn

1996 — Establishment of artist-run gallery Free Parking in Toronto by Institute for Optimistic Living (Jill Henderson, Michael Buckland, Anda Kubis). This predominantly self-funded operation (both artist-run and non-non-profit) became typical of a wave of largely self-funded storefront and other exhibition spaces characterized by an anti-museum aesthetic and a more direct proprietor-producer relationship than found in non-profit artist centres (former ANNPAC members).

Keller has investigated the manner in which the political, the economic, and the social have been imported into the structures of molecular biology research, describing semantic, conceptual, and ideological overlaps between the various fields. Keller has documented in great detail the demise of group selection and the rise of genic selection over the course of the 1960s and 1970s, a shift in the focus of scientists "from the group above to the gene below."[31] This shift down the scale of divisibility of organisms to the indivisible, purely selfish gene or "master molecule" can be seen as a parallel search for Adam Smith's theoretical self-interested homo economicus and NAFTA's constitutionalized entrepreneurial/corporate individual, and as seeking to reaffirm nature as competitive at its most basic level. Whereas the Darwinian unit of the biological individual was the organism, molecular biology came to extrapolate from the purported behaviour of the "atomic" individual of the gene to agglomerate, or collective, biological individuals such as species, groups, and organisms, or corporations, nations, and trading blocs.

Keller maintains that whatever the scale of individual under consideration, it serves as a boundary marker between two sets of related values:

1. autonomy, competition, simplicity and a theoretical privileging of chance and random interactions and the interchangeability of units;

2. interdependence, cooperation, complexity, the theoretical privileging of purposive and functional dynamics and often hierarchical organization.[32]

Keller has determined that when the individual gene is chosen as the unit of selection, characteristics set out in her second set of terms appear to "vanish entirely. With this new characterization of the individual, there is no field in which the dynamics of interdependence and mutualism that are necessary to maintain the internal cohesion of the genotype can operate. By default, as it were, genes are necessarily selfish."[33] In other words, the very concept of gene as indivisible individual demands the elimination of the concept of collectivity and of attendant dynamics of mutualism, cooperation, and complexity, and this to Keller is an indication of "systematic perceptual bias."[34]

In juxtaposing scientific methodological individualism with holism, she debunks some of the more ludicrous implications of this bias by examining

the dynamics of genic reproduction and establishing a practical limit to the boundaried independence of the genic unit. While genes do not reproduce sexually, requiring mates, they also do not make copies of themselves completely independently. Rather they are part of a complex copying network requiring enzymes from other genes to replicate. Elision of this most basic fact of genic behaviour adds further fuel to her argument that there is a systematic perceptual bias in evolutionary discourse in which "interactions between individuals are quite generally assumed to be *a priori* competitive."[35] Keller also points out the lack of scientific credibility in falsely naturalizing and extrapolating the assumed competitive qualities of the genic individual to a collectivity or aggregation of "individuals" (organisms, species, nations, corporations) without accounting for mutualism and cooperation:

> It may well be that the whole is equivalent to the reconstituted aggregate of its parts, if, in the process of aggregation or summation, all possible interactions among the parts are included. But if certain kinds of interactions are systematically excluded, our confidence in that program necessarily founders. My claim is that such systematic exclusion does occur.... The basic assumption is that competition is what is real, not because it is easier to model, but because it is what we expect. When the actual difficulties of modeling competition are suppressed we have the makings of a truly self-fulfilling prophecy.[36]

Other contemporary scientists and historians of science echo Keller's concerns with the biased, unfounded, and naturalized assumptions underpinning evolutionary and economic theories of competition. Techno- and cyber-feminist Donna Haraway theorizes a provocative, dystopian "genetic market-place" and a new discipline of sociobiology in which:

> the genetic calculus concerns maximization strategies of genes and combinations of genes. All sorts of phenomenal orders are possible, from asexual individuals to cast-structured insect societies with only one reproductive pair to role diversified societies with many reproducing members.... Bodies and societies are only the replicator's strategies for maximizing their own reproductive profit. Apparent cooperation of individuals may be a perfectly rational strategy, if long-term cost-benefit analyses are made at the level of the genes.... The novel dimension in late 20th century political and natural economy is the shared problem of understanding very complex forms of combination, which obscure the competitive bedrock with phenomena like altruism and liberal corporate responsibility in transnational enterprises.[37]

1996 – ESTABLISHMENT OF NOVA SCOTIA ARTS COUNCIL, OPERATING ALONG ARM'S LENGTH PEER-ASSESSMENT MODEL, AFTER AT LEAST TWENTY YEARS OF ARTISTS' AGITATION AND DISSATISFACTION WITH UNACCOUNTABILITY OF PROVINCE'S CULTURAL AFFAIRS DIVISION.

Further considerations of the mutability or inviolability of territorial borders of dynamic self structures and collective identity structures can be found in the discourse of science. Haraway transposes the self and identity structures under investigation to the field of molecules. The ideology of conventional genetics and molecular biology posits the immune system and its constituent molecular operators as impermeable, bounded, and unitary, to allow it to recognize self and to react to the foreign. Haraway, however, proposes that the specificities of the immune system are indefinite if not infinite and that they arise randomly to maintain individual bodily coherence. Haraway substantiates this position through the research of immunologist Niels Jerne's network theory of self-regulation where:

> the concatenation of internal recognitions and responses goes on indefinitely in a series of internal mirrorings of sites on immunoglobulin molecules, such that the immune system would always be in a state of dynamic internal responding. It would never be passive, awaiting an activating stimulus response from a hostile outside... there can be no exterior antigenic structure, no invader, that the immune system has not already seen and mirrored internally. "Self" and "other" lose their oppositional quality and become subtle plays of partially mirrored readings and responses.... The logic of the permeability among the textual, the technic and the biotic and of the deep theorization of all possible texts and bodies as strategic assemblages has made the notions of "organism" or individual extremely problematic.... The individual is a constrained accident, not the highest fruit of earth history's labours.[38]

Considered from the perspective of the basic molecular constituent units of the larger organism, "the body ceases to be a stable spatial map of normalized functions and instead emerges as a highly mobile field of strategic differences."[39] Haraway's concept of hybridizing and proliferating molecular identity structures, which constitute the dynamic assemblage of the body's immune system, problematizes unitary notions of organism and self. Rearticulated in Keller's holistic terms, it is possible to extrapolate from the genic individual to a range of scales of collectivities or aggregations of "individuals" (genes, organisms, species, nations, nation-states, corporations) without resorting to assumptions or biases about competition, but rather by examining the processes of mutualism.

Despite the progressive naturalization of the economic ideology of the individual, free markets, and perfect competition over the last two centuries

and the virtual domination of global economics since 1989 by an "intuitive Darwinian free trade" practice derived from that historical economic ideology, and despite the biological and historical naturalization of the boundaried "master molecule" in conflict and competition as a popular contemporary intuitive yet "scientific" image of the global economy in microcosm, Keller, Haraway, and other contemporary science studies writers have collectively demonstrated that there is not one economy of nature but multiple economies of nature, that the "natural economy" is not natural, essential, or universal but in fact naturalized, constructed, biased, and self-interestedly strategic, and that the boundaried, competitive individual (gene, organism, corporation or nation) as a fundamental fact is scientifically, economically, and socially untenable. Multiple, decentred science-based opposition poses crucial challenges to universalizing and legally entrenched tools of transnationalization and globalization such as NAFTA, and to its inherent individually competitive praxis for a self-organizing democratic society.

One of the more troubling questions this deconstruction produces revolves around the positioning of resistance to global corporate mercantilism, as the waning nation-state attempts to deliver its subjects to multinational corporate "atomic individual" consumer-citizenship. For example, the very rapid assimilation of North American queer cultural opposition into the corporate/ consumer imaginary and the constitutional rule of law raises the serious question of whether the development of oppositions as "autonomous regions," "meaningful methodological individuals," and "imagined collective identity structures" actually promotes proliferation or simply provides a more sharply focused target for global corporate consumerism. Cultural theorist Sean Cubitt echoes this question in terms of the autonomous region of oppositional nation reframed as "nomad," a once-chic artistic and academic concept:

> The nomadic tactic, which had appeared as an appropriate use of weakness to defeat the designs of power, has become the strategy of power itself, now rendered free of place by speed of communication. One fears that in the unstable form of regressive hyperindividuation, the contradictory formation of a narcissistic culture founded in the affirmation of selfhood, we are witnessing the emergence of a subject position modeled on the nomadic transnational corporation.[40]

Cubitt presents a narrative of hyperindividuated submission in a highly distributed technological environment while Paul Gilroy deploys microbiological discourse to frame a narrative of the disintegration of racial scales of identity and difference through the bio-political dispersal of the unitary body.

1996 - OCAD STUDENT AND SELF-DESCRIBED ANARCHIST/CRIMINAL JUBAL BROWN VOMITS BLUE FOOD-COLOURING ON MONDRIAN'S COMPOSITION IN RED WHITE AND BLUE AT NEW YORK'S MOMA. AT AN EARLIER DATE, THE PERFORMANCE ARTIST HAD PUKED RED ONTO A RAOUL DUFY CANVAS AT THE ART GALLERY OF ONTARIO. BROWN ALSO REVEALED HIMSELF TO BE A MEMBER OF AN ANONYMOUS GUERRILLA COLLECTIVE THAT HAD BEEN VANDALIZING FASHION ADVERTISEMENTS IN DOWNTOWN TORONTO BUS SHELTERS.

The history of racism is a narrative in which the congruency of micro- and macrocosm has been disrupted at the point of their analogical intersection: the human body... What does that trope "race" mean in an age of molecular biology [where] we have been estranged from anatomical scale? On what scale is human sameness, human difference now to be calibrated? Bio-politics laid the foundations for and was superseded by what can only be called "nanopolitics." This successor system not only departs from the scalar assumptions associated with anatomical difference but accelerates vertiginous, inward movement towards the explanatory power of ever-smaller scopic regimes. Scientific and biological, historical and cultural, rational and irrational, skin, bone and even blood are no longer primary referents of racial discourse... the aspiration to perceive and explain through recourse to the power of the minute, the microscopic, and now the molecular has been consolidated. In a space beyond comparative anatomy, the body and its obvious, functional components no longer delimit the scale upon which assessments of unity and variation of species are to be made.[41]

And We Break Up Just to Make Up: The Nature of Monoculture

The deployment of digital technologies and the accompanying reorganization of corporate, economic, and social structures to exploit those technologies is an incomplete process. But certain dynamics and overall shapes in this process are becoming clearer, if more contradictory and threatening. For the forces of corporate globalization and centralization of wealth, the historical memic structure of perfect natural competition and free markets has come to exist in a mutually reinforcing positive feedback loop with the science-based genic structure of natural molecular competition to produce a substantiating evolutionary myth mission or foundational algorithm. However, the same forces of corporate globalization are dependent on the rule of law of inter-ventionist states and protectionist trade agreements to extend and enforce this myth mission. This contradictory formula has produced the current configuration of global digital mercantilism—the duelling duality of ATT/MediaOne and AOL/TimeWarner—which is on the verge of reconfiguring itself yet again. Some might consider the U.S. government's Microsoft anti-trust actions and the impending break-up of that digital behemoth as an indication of the limits

of free markets and the return of the corporate evolutionary myth mission to the state. But this is sleight of hand. Break-up and subsequent reconfiguration are simply another strategy, perhaps best considered as a form of species variation and selection, in propelling global corporate concentration. ATT, the U.S. telephone monopoly which was forced to break up in 1984, has since recombined in a network of intricate stock ownership, joint venture, use deal, and sweetener relationships with virtually every competing media corporation, including Microsoft, to construct an all-encompassing anti-market digital cartel and intrafirm market which sits alluringly just beyond the reaches of anti-trust law.[42] The ATT *et al* cartel has emerged from nomadic fluidity as its own form of artificial life beyond human capacity, producing its own off-world, off-nation, off-biomass, off-body variations. In the face of this corporate monoculture, certain traditionally oppositional activists, including Ralph Nader and Jane Jacobs, have called for a return to the utopian memic/genic moment of "natural economy/economy of nature"—unfettered freedom from state and corporate monoculture as the means of preserving and continuing biomass variation and speciation. States such as Canada, within the limitations of encroaching trade law, claim to make efforts to protect and develop collective national endeavours such as media and cultural industries, but enact policies that end up pouring public funds into private enterprises, which are shoved up the food chain from local or national to transnational and so become unboundaried/undifferentiated corporate entities that are desirable takeover objects of the global digital cartel. The relationship between the corporate individual of the global digital monoculture cartel and the biological individual, as tenuous and problematic as the notion of boundaried individual on any scale, is also reconfiguring; within the severely patrolled borders of the monoculture intrafirm anti-market, biological individuals are accorded the status of fluid biomass rendered code, digital DNA within the corporate individual body where difference, variation, and identity are erased and reposed as sites for niche marketing. Terminologies, conceptual frameworks, and conditions in which effervescent and emergent biological life thrives are collapsing and being turned inside-out.

However, it is important to remember that this process of technological and organizational hyper-concentration remains incomplete. The purpose of this study is not to propose specific oppositional strategies but rather to outline the not-so-strange-attractor memic and genic structures that sustain and propel the nature of monoculture and its current dynamical state. Armed with these perceptions, it is hoped that many oppositions, at every scale of being, will emerge more virulently, randomly, and chaotically to cumulatively provoke a phase transition of a very different nature.

NOTES

1 Manuel De Landa, *A Thousand Years of Non-Linear History* (New York: Zone Books, 1997), 21.

2 John McMurtry, *Unequal Freedoms: The Global Market as an Ethical System* (Toronto: Garamond Press, 1998), 127.

3 Adam Smith, *An Inquiry into the Nature and Understanding of the Wealth of Nations* (New York: PF Collier and Son, 1909), 351–2.

4 Charles Darwin quoted in Andrew Desmond and James Moore, *Darwin: The Life of a Tormented Evolutionist* (New York: Norton, 1994), 267.

5 Desmond and Moore, 267.

6 Peter J. Bowler, *Evolution: The History of an Idea* (Berkeley: University of California Press, 1983), 287.

7 Jagdish Bhagwati, *Political Economy and International Economics* (Cambridge: MIT Press, 1996), 101.

8 Noam Chomsky, "Free Trade and Free Market: Pretense and Practice," *The Cultures of Globalization*, Fredric Jameson and Masao Miyoshi, eds. (Durham, NC: Duke University Press, 1998), 361–5.

9 Ibid., 367.

10 David Lloyd, "Nationalisms Against the State," *The Politics of Culture in the Shadow of Capital*, David Lloyd and Lisa Lowe, eds. (Durham, NC: Duke University Press, 1997), 175.

11 Daniel Drache, "The Limits of Trade Blocs: Dreaming Trade or Trading Dreams," unpublished paper delivered at York University, 1997, 12–14.

12 Barry Appleton, *Navigating NAFTA* (Toronto: Carswell Press, 1994), 87.

13 Guillermo Gomez-Peña, "The Free Art Agreement/El tratado de Libre Cultura," *The Subversive Imagination: Artists, Society and Responsibility* (New York: Routledge, 1994), 215.

14 Colin Hoskins, Adam Finn, and Stuart McFayden, "Television and Film in a Freer International Trade Environment: US Dominance and Canadian Responses," *Mass Media and Free Trade: NAFTA and the Cultural Industries* (Austin: Austin University Press, 1996), 64.

15 Sarah Street, *British National Cinema* (London: Routledge, 1997), 6.

16 16 Peter Morris, *Canadian Feature Films: 1913–1969* (Ottawa: Canadian Film Institute, 1970), 11–12.

17 Susan Hayward, *French National Cinema* (London: Routledge, 1993), 23.

18 Paolo Paranagua, *Mexican Cinema* (London: British Film Institute, 1995), 32.

19 Thomas Elsaesser, *New German Cinema: A History* (New Brunswick, New Jersey: Rutgers University Press, 1989), 9.

20 Thomas McPhail, *Electronic Colonialism: The Future of International Broadcasting and*

Communication (Austin: Sage Publications, 1981), 109.

21 Street, 16.

22 Zuzana Pick, *The New Latin American Cinema Movement: A Continental Project* (Austin: University of Texas Press, 1993), 47–55.

23 Angus Finney, *The State of European Cinema* (London: Cassell, 1996), 115.

24 Noam Chomsky, *World Orders Old and New* (New York: Columbia University Press, 1994), 102.

25 Finney, 5.

26 Ibid., 2.

27 Houle, unpublished study commissioned by Telefilm Canada, Montreal, 1997.

28 Finney, 15.

29 Michael Ghiselin, *Metaphysics and the Origin of Species* (Albany, NY: SUNY Press, 1997), 538.

30 Evelyn Fox Keller, *Secrets of Life, Secrets of Death: Essays on Language, Gender and Science* (New York: Routledge, 1992), 147.

31 Ibid., 150.

32 Ibid., 145.

33 Ibid., 147.

34 Ibid., 144.

35 Ibid., 146.

36 Ibid., 160.

37 Donna Haraway, *Simians, Cyborgs and Women: The Reinvention of Nature* (New York: Routledge, 1991), 60.

38 Ibid., 218–220.

39 Ibid., 218.

40 Sean Cubitt, "Supernatural Futures: Theses on Digital Aesthetics," *FutureNatural: Nature, Science, Culture*, J. Bird *et al.*, eds. (New York: Routledge, 1996), 252.

41 Paul Gilroy, "Scales and Eyes: 'Race' Making Difference," *The Eight Technologies of Otherness* (New York: Routledge, 1997), 192–4.

42 Consumers Union, *Breaking the Rules: ATT's Attempt to Buy a National Monopoly in Cable TV and Broadband Internet Services*, http://www.consumersunion.org/other/att.htm, 8.

Children's Letters to Charles Saatchi

A Modest Proposal to Boost the Profile of Canadian Art

Abroad

Children can amaze and disarm us with their questions as they seek answers to life's puzzles, such as "Why, given Canada's history of government funding for the arts, is Canadian art not more prominent on the world stage?" In those awkward moments some of us might be tempted to speak around the issue, to shelter curious children's precious innocence from the hopelessness that might settle upon them were they to dwell upon such quandaries. These fears are for naught, for what embodies the spirit of hope more than a child? Perhaps only a child gripped by an intense and informed passion for cutting-edge contemporary art.

By John Marriott

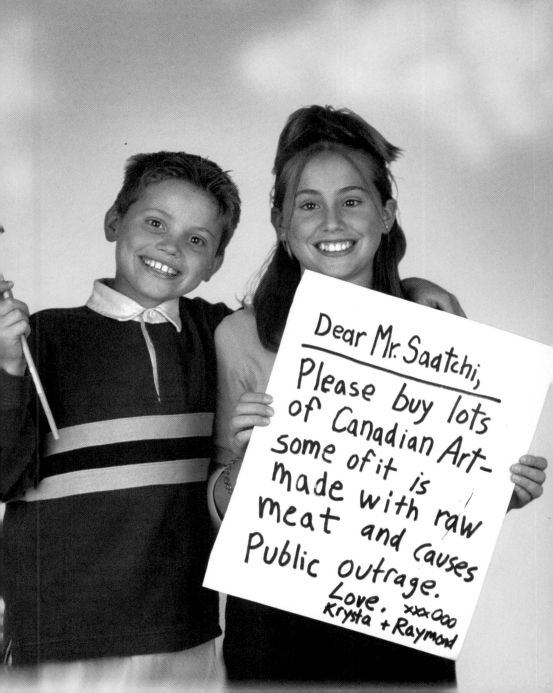

To such a child the answers to adult problems can seem so simple, "Our world class art deserves international collectors of vision such as Charles Saatchi, who will play their part to direct global attention and demand towards the Canadian art scene."

Kids are our unheralded ambassadors to a more robust art world presence. The young share a common vision with collectors. Many a young connoisseur's appetite has been cultivated by hoarding Beanie Babies and competing for Pokémon; in the playground, as in the international art market, trends move fast, grooming acquisitive youngsters who are restless hunters with steely aesthetic acumen. Because children are adorable, they can reach out with few adults able to resist their infectious laughter or tears brimming in their eyes. Tots of such breeding and poise are uniquely suited to play a vital role in promoting vanguard Canadian art internationally by demonstrating its appeal to like-minded cognoscenti and by encouraging bulk purchases of important works.

EVERY CHILD CAN

With the words of a child (specifically a child versed in the art of the Saatchi Collection) we might tip the scales in favour of Canadian art. "Children's Letters to Charles Saatchi" is a grass-roots proposal for each Canadian child to mount a cuddly appeal to this art-loving culture-broker. Saatchi is the man whose advertising profits established him, and the British artists whose work he acquired by the bin-full, as major players in the international art world. Surely he would not be unmoved by waves of heart-rending literary cuteness. Taking aim on this soft target, our children's pleas will compel Mr. Saatchi to buy Canadian and bestow upon us the kind of cultural boom and art world prominence that he has purchased for the U.K. and its artists.

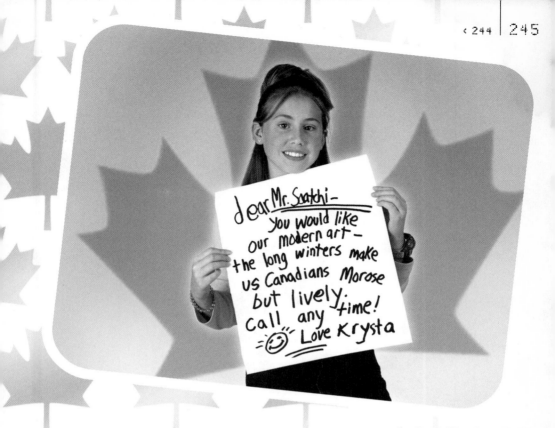

In the photo, a handwritten sign reads:

> dear Mr. Saatchi –
> you would like
> our modern art –
> the long winters make
> us Canadians Morose
> but lively: call any time!
> =☺" Love Krysta

PLAY A PART WRITE NOW!

Make sure that all letters and drawings are addressed to Mr. Charles Saatchi—do not refer to him as Saatchi Claus.

Letters should exude enthusiasm for Canadian artists, individual works by Canadian artists, and/or discourses within the Canadian aesthetic diaspora.

Allow your children's natural love of Canadian contemporary art to guide their words, while steering them clear of 'Wish Lists' and direct appeals for cash.

Be sweet and discreet. If your children have favourite vanguard works that they want Mr. Saatchi to be aware of, have the children draw reasonable facsimiles to send along with their letters. Do not attach photographs or reviews from art magazines. Remember that informality and the 'cuddle quotient' are key to our appeal.

FOR THE OFFICE OF SAATCHI & SAATCHI NEAREST TO YOU
SEE www.saatchi-saatchi.com

They migrate in groups

Fine Points on Memory and Escape

Creation, 3:30 p.m., the Fifth Day

A lynx prowls past in the shade of the porch, her tufted ears pricked to the
silent jangling of her many bracelets,

followed by her mate, the two leaving pawprints like walking fists across the
sand as they climb the dune and
disappear into the tamarisk on their rounds
of the Animal Kingdom.
I must not yet be here.

Diana Hartog

My thinking sometimes leaves small indentations. When my sisters and I were
little, when the older relatives were alive, and we had friends still living in the
country, we would visit. Up behind the house there were fields of long grass,
poison ivy, and flowers in the summer. We would lose ourselves and each
other. Our bodies in the heat trampled into the air with the smell of dust.
Below the mashed stalks, in the earth darkness, the sounds of insects hummed.
Sometimes we would burst through into a spot where a deer had crushed the
grass with its sleeping. Sometimes we would stumble back onto spots where we
had played before, areas flattened with our feet and bodies.

This is the image that comes to mind when there is a problem I am trying to
think through. It comes with the task of arranging the details, grasping the
threads of theories that become sudden moments of vision. This process is like
children's feet and bodies in a field, flattening and tramping down one small

To gain safety it gives
up its freedom

area of knowing. One could say that this paper marks an indentation I have stamped down around a single problem.

The problem in its most current form emerges around political and creative projects in the fine arts and the relationship of these initiatives to contemporary debates on government funding. At a recent panel in Toronto comprised of artists, arts activists, and cultural theorists, a member of the audience pointedly asked, "How can one be against the state and of the state at the same time?" This simple question provides a critical investigative wedge. How one answers it is key to unravelling the paradox that artists and government funding agencies have managed, with varying degrees of equanimity, for four decades. But the question posed to the panel does not simply concern the state, but also "one" (how can "one" be ...?). This "one," the subject, is pivotal to the formulation. So that in addition to wondering "how," let us also consider "who" by asking: who is the artist, the creative subject, who is also the subject who resists?

> Transformation currently underway at OAC reconfigures citizens as consumers while contradictorily disembedding culture from the economy by reframing its long-standing discourse of socio-economic relations as one of individualized aesthetic excellence.
>
> Barbara Godard,
> "Privatizing the Public"

The urgency behind these questions in Canada is attached to marked shifts in policy, discourse, and structure of government funding. Provincially, under Ontario's Harris government, these changes were precipitated by massive cuts to the Ontario Arts Council's budget in 1995 and again in 1996. At the federal level, the Canada Council lost $2.5 million in 1996–97. After significant administrative and service restructuring, the Council received a one-time government allocation of $25 million disbursed over five years.[1] At the receiving end, artists experienced a narrowing of opportunities as restrictions increased and the criteria of eligibility tightened.

If we think of theory as enabling our ability to see the concrete, empirical world, then developing a theoretical approach that crosses disciplines provides ways for posing different questions.[2] Theory should work back and forth between events and how we might think about them.

In taking up this problem of being simultaneously of the state and against it, I have drawn together approaches from cultural studies, from Michel Foucault's "history of the present," and governance theory. Tony Bennett's 1995 *Birth of the Museum* works a similar interdisciplinary terrain. As the title suggests, it references Foucault's *Birth of the Clinic*, and through its subject matter examines the museum as a cultural space, concerned with the dissemination, ordering, and meaning of cultural narratives. Bennett's elaboration of Foucault's thinking combines the French post-structuralist's work on disciplinary practices (*Discipline and Punish*) and governance with his less developed work the-

1997 - ALBERTA TREASURER STOCKWELL DAY (NOW LEADER OF THE CANADIAN ALLIANCE, SUCCESSOR TO REFORM PARTY OF CANADA) CALLS FOR REVOCATION OF $10,000 GRANT TO RED DEER MUSEUM FOR HISTORICAL STUDY OF QUEERS IN THE REGION.

> [W]e live inside a set of relations that delineates sites
>
> But among all these sites, I am interested in certain ones that have the curious property of being in relation to all other sites These spheres ... are of two main types. First there are the utopias ... [and] by way of contrast to utopias, heterotopias.
>
> Michel Foucault,
> "Of Other Spaces"

orizing space. Foucault's notion of the heterotopia is particularly valuable. These, Foucault describes as certain sites that while "closed or semi-closed," stand in relation to all others as well as in marked contradiction to them.[3]

Bennett conceives of the museum as not only a heterotopia, but also in relation to its opposite, the heterotopic space of the fair. As a public institution, the museum developed along with other institutional and disciplinary sites in the nineteenth century (the prison, the clinic, the psychiatric hospital, the public school). The museum's role, Bennett argues, was played out through practices of normalization and regulation of the population. But it was also broadly stitched into nationalist, nation-building practices and imperialism.[4] The interrelated themes of regulation, nationalism, the organization of cultural space, and internationalism continue to be relevant in our time. What Bennett does not develop is the role of the creative subject, nor is he concerned with questions of resistance.

In the following paper I am interested in looking at the relationship between cultural spaces, the nation state, artists, and radical practices. These connections, I suggest, are not arbitrary, but rather operate within a set of relations whose dimensions we can think of as governmental. Arguably, government, or what Foucault called "governmentality," may provide ways of thinking about possible connections between cultural spaces, the nation state, artists, and radical practices. Foucault suggests that government is an "exercise of power" that seeks to guide "the possibility of conduct."[5] As he explains, "to 'conduct' is at the same time to 'lead' others." In this sense, government is an activity concerned with a configuration of intersections "between self and self, private interpersonal relations involving some form of control or guidance, relations within social institutions and communities and, finally, relations concerned with the exercise of political sovereignty."[6] I imagine this configuration as a complex with a

Fig. 1

"Governmentality" diagram by Krys Verrall from Colin Gordon's definition in "Government Rationality"

dissimilar creatures
who co-operate

FIG. 2

ABOVE: **MICHAEL SNOW.** *PLUS TARD* (INSTALLATION VIEW), 1977, PHOTO: DENIS FARLEY

BELOW: **MICHAEL SNOW.** *PLUS TARD* (DETAIL), 1977, COURTESY: NATIONAL GALLERY OF CANADA

mobile boundary, crossing through private/public separations[7] (See Fig. I). The notion of an assemblage serves as an apt metaphor for how sets of relations make heterogeneous bits and pieces assembled from diverse political, non-political, discursive, self-regulating, and institutional elements. As a method of conceptualizing apparatuses of power, it is most evident in Nikolas Rose's work.[8] Paradoxically, these assemblages "'work' in the sense that they produce effects that have meaning and consequences for us"[9] and perpetually fail. As Rose and Peter Miller demonstrate, "'government' is a congenitally failing operation.... [because] 'reality' always escapes the theories that inform programmes and the ambitions that underpin them."[10]

> Each complex is an assemblage of diverse components—persons, forms of knowledge, technical procedures and modes of judgement and sanction—a machine ... in the sense of ... those machines constructed by Tinguely—... full of strange parts that come from elsewhere, strange couplings, chance relations, cogs and levers that don't work—and yet which "work"....
>
> Nicolas Rose,
> "Governing 'advanced' liberal democracies"

Rose and Miller[11] suggest that these assemblages can produce effects through strategies of "arm's length" or "government at a distance," which denotes an "extra-political sphere."[12] Through indirect mechanisms it becomes "possible to link calculations at one place with action at another" so that "persons, organizations, entities and locales which remain differentiated by space, time and formal boundaries can be brought into loose and approximate, and always mobile and indeterminant alignment."[13]

Not coincidentally, "arm's length" has also been one of the fundamental tenets of public arts funding. Arguably, there is a difference between Rose and Miller's description of how power presently operates and arm's length as a safeguard against inexpert, partisan, state interference in cultural production. These two interpretations lead us into the question of how "one" can be simultaneously of and against the state.

An analysis of the heterotopic spaces of culture, governance, the formation of creative subjectivies concerned with practices of resistance, is one of the strategies I will use in my attempt to stamp out a small area around the problem of public funding and artmaking.

In all the houses my family lived in across different cities and provinces, a large full-colour print of A.Y. Jackson's *Red Maple* hung above the sofa. It was a fixture, like the doors we passed through or the windows we looked out of onto the street. More than that, it existed as a picture of who we were; it went hand in glove with the tea service, and forks laid out on the table particularly so for every course; it went hand in glove with my family's religious fidelity,

difficult to shoot

and its activism in poverty movements and civil rights. At the kitchen table I would move my hand, confused, over reproductions of Gauguin's blue hills and torpid draperies. The eyes of Tahitian women gazed calmly out. All this formed a tapestry of more or less equal elements.

Certainly we can equate the paintings of the Group of Seven with nation building. This is apparent in how the National Gallery of Canada took up their work as emblematic of a "Canadian school" in the early part of the century.[14] Further, their portrayals of an unpeopled wilderness have made repetitive re-insertions into a popular, nationalist imaginary through massive "block buster" exhibition projects like the Oh! Canada Project (1996) at the Art Gallery of Ontario. We do not need to belabour the obvious signification. Nor is it surprising that the life of particular works of art take on independent existences in relation to a whole series of discourses and practices which do not stand still, but are continually re-invested and re-represented. We can see Michael Snow's *Plus Tard* (1977) as a post-modern reworking of familiar terrain.

Snow's work is made up of twenty-five photographs of different sizes, installed collectively around the four sides of one room. A frame provides each with a uniform outer dimension (86.4 x 107.2 cm). The photographs appear as glimpses of works by the Group of Seven. These are not reverential reproductions. The images are often out of focus. Within decentred compositions, the paintings sometimes threaten to slip right off the edges of the print. While our human eye would single out the works of art from extraneous details such as the texture of the walls, exit signs, or door openings, the photographs' mechanical vision presents every detail with equal emphasis. *Plus Tard* appears to capture the rapid glance of an impatient viewer, travelling hastily and indiscriminately from one painting to another.

There are three broad observations I would like to hinge on Snow's work. What I want to immediately flesh out is an understanding of the assemblage. In this case, we can see it looped through the red maple and *Plus Tard* as a "delicate affiliation" linking together political (national, activist), non-political (art, the living-rooms I grew up in, our family history), discursive (nationalist, progressive, and artistic), self-regulating (citizens, consumers of cultural products and narratives), and institutional (the gallery, the family, the church) forms. The other two observations involve more lengthy meditations. An exploration of cultural space and the materiality of culture's artifacts forms an integral component. The third and final observation is tied to my concluding reflections on resistance and subjectivity.

Cultural space, as I hope to delineate it, serves as a partial embodiment for the assemblage. The sites of artistic practice and dissemination are organized into private and public institutions: galleries and museums, collections,

1997 — 98 In lieu of serious restructuring at CC, government allocation increases by $25 million over five years. While public galleries and art museums receive $3.5 million of this cash flow, there are no increases to ARCs' operating grants. Acting head of Canada Council's Visual Arts Section, Joanne Morrow, accuses ARCs of being too "invisible."

foundations, councils, publishing organizations, professional associations, artist-run centres, business service providers, and schools. Although we may believe that artmaking is a solitary and inspired act, it often requires years of training and special facilities; it consumes specialized materials, and depends upon networks of financial and collegial support, advocates, and consumers. The ways that art and artistic practice are translated into the social, political, and cultural world are through cultural spaces, predominantly circumscribed by agencies and institutions. We can recognize these sites and the various actors who move through them as operating within interlocking networks. The temporary spectacle of the international fine art exhibition is a significant example.

The Venice Biennale, in operation for over a hundred years, stands as a unique and preeminent example. In his history of the Biennale, Lawrence Alloway wrote that while over time it "has been adaptive to social and political change ... it has not lost its core identity, its legibility as an institution."[15]

While an international site is not stable in the way that a museum or gallery or school might be, it nonetheless functions as an institution with distinct rules, boundaries, and identity. Of further significance is the fact that art and creative producers, like economies and capital, increasingly work transnationally. Daniel Palmer observed, on the occasion of the first Melbourne International Biennial in 1999: "Artists are especially mobile, and contemporary art is a floating world currency. For the present generation of artists, it has become exceptionally important to orient art practices internationally."[16] The international exhibition offers a particular opportunity to think critically about government, nations, artists, and practice.

If, as Bennett argues, we can think of the museum and its opposite, the fair, as heterotopias, then the Biennale also exists as a distinct "closed or semi-closed" domain. It is neither a museum, nor a fair, although it does possess elements of both. It has the authority of the former because of its ties to the state, but the temporality of the latter since it operates as single, albeit repetitive occasion. Foucault in "Of Other Spaces" suggested "that the anxiety of our era has to do fundamentally with space.... We do not live inside a void," he wrote, "we live inside a set of relations that delineates sites which are irreducible to one another and absolutely not super-imposable on one another."[17] Specifically, he was interested in those certain sites that while "closed or semi-closed,"

holds its breath

1998 - IN THE FACE OF SERIOUS DEFICIT, THE BOARD OF DIRECTORS FOR CANADIAN ARTISTS'
REPRESENTATION ONTARIO (CARO) CONCLUDES THAT REGULAR OFFICE HOURS AND EMPLOYMENT OF A FOUR-
PERSON STAFF ARE NO LONGER FEASIBLE. CONTROVERSY AMONG CARO MEMBERS FORCES A MEETING TO
ASCERTAIN WHETHER THERE IS CONFIDENCE IN THE CURRENT BOARD. AFTER A VOTE OF NON-CONFIDENCE, A
NEW INTERIM BOARD IS IMMEDIATELY ELECTED.

a low centre of
gravity

stand in relation to all others but in marked contra-
diction to them. These, he argued, fall into two
types: utopias and heterotopias. While the former
are ultimately unrealizable because they are fantasies,
it is the heterotopia that we live with. The honey-
moon suite, psychiatric hospitals, prisons, retirement
homes, the cemetery, the cinema, the garden, museum,
library, the festival, the Moslem haman, the
Scandinavian sauna, the school, the church, brothels,
colonies, are all examples of heterotopic spaces. But
there is an unassuagable character to their
dimensionality, and that is their materiality.

> [T]he boat is a floating piece of space,
> a place without a place, that exists by
> itself, that is closed in on itself and at
> the same time is given over to the
> infinity of the sea and that from port to
> port, from tack to tack, from brothel to
> brothel [t]he ship is the hetero-
> topia par excellence.
>
> Michel Foucault,
> "Of Other Spaces"

These sites are not metaphors. Nor are they merely inscribed or discursively
constructed. In the fine arts, all intention has its physical embodiment. The
Plus Tard photographs, layered between sheets of plexiglass, actually and symbol-
ically cast ghost shadows. Just as thought "seeks to render itself technical, to
insert itself into the world by 'realizing' itself as a practice,"[18] just as Foucault
records the carceral city as "a multiple network of diverse elements—walls,
space, institution, rules, discourse,"[19] locations such as a museum or the Venice
Biennale are the physical manifestation of thought and ambitions. When Susan
Buck-Morss introduces Walter Benjamin's *Passagen-Werk*, she emphasizes that
Benjamin's intention was to construct a history "out of historical material
itself, the outdated remains of those nineteenth-century buildings, technologies,
and commodities that were the precursors of his own era."[20] It is their
concreteness, their materiality that he wants to know, because "they were the
precise material replica of ... the unconscious dreaming collective."[21] In this
sense we can think of cultural spaces as types of heterotopias, existing with all
the physical density Benjamin found in the Arcades. Each type is closed off
and yet connected not only with other cultural sites, but with all other sites.[22]

Furthermore, as we have seen, the work of art is also material. The object has
an object life. It operates within an economy of other cultural objects, sales and
collections. Ironically, the installation of *Plus Tard*, like the works it re-
represents, belongs to the National Gallery of Canada's collection. The object
may be extremely valuable, like the red maple translated through paint and
colour onto canvas. Or, conversely, it may be quite valueless, like the reproduction of
the same painting I have lived with throughout my childhood. It may, through
various networks and opportunities, be parlayed into representing the country
as an example of artistic excellence in an international forum. Or lacking that
support and excellence, it may circulate amongst a more limited audience.[23]

1998 - Ontario Arts Council chairperson (and former Ontario Lieutenant-Governor) Henry N.R. Jackman attempts to revise guidelines for the funding of periodicals so that only those "magazines substantially devoted to publishing original works of fiction and poetry or magazines substantially devoted to critical coverage of the contemporary arts (literary, visual, performing)" would be eligible for funding. These attempted demarcations between art periodicals or publications and political counterparts is announced in tandem with Jackman's decision to include non-professionals from "the community" on arts advisory panels as these representatives of the private sector are, paradoxically, more representative of "the public" than the peer-evaluation system could possibly be. Periodicals under the gun include *This*, *Canadian Forum*, *Border Lines*, *Aboriginal Voices*, and others.

they migrate
unnoticed

Historically, the spectacle of world expositions rose contiguous with the modern, public museum in the nineteenth century. Alloway locates the forerunners of the Venice Biennale in the tradition of annual art exhibitions founded in the eighteenth century. He argues that because the "contents of the Biennale are works of art ... [w]e tend to relate them to humanism rather than to the competitive area of fairs and shows."[24] Although, as Alloway suggests, we may tend to make this distinction, my own tendency moves in the opposite direction. It is the designation of "world" that marks their commonality with each other more than anything else. Buck-Morss calls them the modern "folk festivals of capitalism."[25] Largely unmediated by the church or monarchy, the expositions formed complex arenas for interactions among sovereign states.

Certainly, we have witnessed a most potent example. In December 1999 television, newspapers, and electronic news media relayed coverage of civil disobedience and retaliatory violence in Seattle as 50,000 demonstrators attempted to block World Trade Organization delegates with their bodies. To think of the WTO talks as an international "space," consider its relationship to the city of Seattle which was the physical location and host to both the world and the nation, as well as the actual site of disruption. The nineteenth-century fairs were not limited to the fine arts. The Great Exhibition in London (1851) was an international trade fair. The first Olympic Games of the modern era took place in Athens in 1886, a year after Italy launched its ambitious, inaugural Biennale.

For these reasons, I find the early international events present two possibilities: a fellowship among nations on the one hand, aggression and competition between warring states on the other. The Great Exhibition in London, 1851, the Exposition Universelle in Paris, 1855, the International Exposition at the centenary of the French Revolution, 1889, the Venice Biennale, 1895, the first Olympic Games, 1896, the Paris International Exposition of 1900, Italy's first International Exposition of Modern Decorative Art, 1902, the Paris International Exposition of the Decorative Arts, 1925, and the International Colonial Exhibition, Paris 1931, in their celebratory cadences, proclaimed national and imperial interests. For it is at this very moment, simultaneous with the emergence of the international expositions, that we also find the formation of modern states in Europe (unification of Italy, 1870, the German Empire, 1871), North and South America (Mexico, independence in 1821, Canada in 1867), and Australia (1901); the consolidation of imperialist powers around the globe, particularly, in Africa, Asia, and the South Pacific; and war.[26] In the "world" of the international expositions, there is not a nation, or government, but an enclave of states among others. Of the Turin exposition in 1902, Buck-Morss writes, the "exhibits affirmed a 'universal'

2000 – VANCOUVER ART GALLERY DIRECTOR ALF BOGUSKY RESIGNS FROM HIS POSITION, AFTER THREE AND A HALF YEARS, ALLEGEDLY OVER THE GALLERY BOARD'S ENTHUSIASM FOR A PLAN TO HANG PHOTOGRAPHS OF FAMOUS CANADIAN WOMEN BY ROCK STAR BRYAN ADAMS AS PART OF A GALA FUND-RAISER EXPECTED TO RAISE $25,000 FOR THE GALLERY. ADAMS' PHOTOGRAPHS HAVE BEEN PUBLISHED IN A BOOK CALLED *MADE IN CANADA*, THE PROFITS FROM WHICH GO TO THE CANADIAN CANCER SOCIETY (*GLOBE AND MAIL*, APRIL 4, 2000, 3). VAG BOARD MEMBER AND SERIOUS ART COLLECTOR JOE MCHUGH IS APPOINTED ACTING DIRECTOR. A PETITION SIGNED BY "A WHO'S WHO OF THE VANCOUVER ART WORLD" CALLS FOR MCHUGH AND THE EXECUTIVE COMMITTEE OF THE VAG BOARD TO RESIGN AS SUCH AN APPOINTMENT IS BOTH UNPRECEDENTED AND SUSPECT (*GLOBE AND MAIL*, APRIL 18, 2000, 1).

stylistic transformation, [and] commercial competitiveness encouraged national differences for product-identification within the international market."[27] A transnational or "universal" style must be juxtaposed with international competition. Foucault's speculations were more grim. "The true nature of the state," he wrote, "is conceived as a set of forces and strengths that could be increased or weakened according to the politics followed by governments."

> These forces have to be increased since each state is in a permanent competition with other countries, other nations, other states, so that each state has nothing before it other than an indefinite future of struggles, or at least of competitions, with similar states Politics has now to deal with an irreducible multiplicity of states struggling and competing in a limited history.[28]

Arguably, this is the historical context in which we can situate the phenomenon of world expositions and the beginning of the fine art biennale.

In this milieu the fine arts, architecture, and design are deeply implicated since they produce in the moment the "precise material" of the "dreaming collective" so important to Benjamin. Like the vision of the red maple as Canadian and the nation in our living room, this precise material appears grandly in the public displays of the expositions and again in miniature in the privacy of bourgeois interiors. Roger Shattuck, writing in 1959, enthused that the Parisian "expositions turned every resident and visitor in the city into an actor in the extravaganza of human progress and vanity."[29] The massive iron and glass shells, housing the displays, became "the first international building style of the industrial era."[30] The exhibits at the 1889 Paris exposition "filled several buildings" with scientific displays "including the colossal Hall of Industry, a monument of structural steel" as well as an aggregate of representations and objects assembled from around the globe.[31] He described:

> A Cairo street scene was constructed with authentic imported Egyptians to live in it and perform the *danse du ventre*. The Javanese dancers became the rage of Paris,

marvelous sight

hibernates

influenced music-hall routines for twenty years, and confirmed Debussy in his
tendency toward Oriental harmonies.[32]

Away from the temporary but extravagant exhibitions, middle class interiors
filled up with "the trophies of [the] empire" such as "leopard skins, ostrich
feathers, Persian carpets, Chinese vases, Japanese silks."[33] A kind of cultural
internationalism permeated, glossing over imperial expansion and domination.

The notion of cultural space, as I have attempted to develop it, links up with
the idea of multiple and interconnected (political, non-political, discursive,
self-regulating, and institutional) elements into a loose assemblage. I have
described a specific kind of site, a temporary and international one, with set
activities, embodied by a location, architectural and design components, and
filled with displays and creative artifacts. As an example of this type I briefly
considered the inaugural exhibition of the Venice Biennale in the nineteenth
century. For these reasons we may consider it as a heterotopia.

The third broad observation, hinged at an earlier point to Snow's *Plus Tard*,
looks at the combined problem of resistance and subjectivity. Here we return
momentarily to the question, "How can one be against the state and of it at the
same time?" For it is the "one" identified in the question as the "subject who
acts,"[34] she is the "one" who resists the state and yet paradoxically hopes to be
folded within its care; the one who may appear hopelessly swallowed up in its
machinations, or who may seem to use it adroitly.

Arguably, the notion of arm's length, as it has served as the conceptual
cornerstone of public arts funding since the 1940s, has provided a perception
of institutional and creative autonomy. It was the theoretical premise whereby
it became possible to imagine being simultaneously of the state and against it.
Martha King, in her history of arm's length at the National Gallery of Canada
explains that although the "finance and administration [of the institution] ...
are guided by Canadian law and government regula-
tion [d]ecisions on artistic matters however, rest
with the collective expertise of staff, boards and
committees of that agency." Elected officials, "lack-
ing such expertise ... are not permitted to inter-
fere."[35] In this model, arm's length serves as a prac-
tice of containment, separating various agents and
agencies through rules and appropriate profession-
al conduct. It ensures freedom of creative expression
and vision, leaving the artist answerable only to the
rigours of excellence.

*The 1966 Biennale showed 2,785
works by artists from thirty-seven
countries; attendance was 181,383,
with eight hundred art critics, jour-
nalists, and free-wheelers in addition.
Sales amounted to around
141,684,690 lire.*

Lawrence Alloway,
The Venice Biennale
1895–1968

2000 – The Indian High Commission, acting under pressure from the Indian government, requests that an art exhibit at Toronto's Harbourfront York Quay Gallery be shut down. *Dust on the Road*, surveying work by artists associated with SAHMAT (Safdar Hashmi Memorial Trust), a Delhi-based activist and cultural organization. The exhibition presented openly political art-works depicting the rising tide of religious fundamentalism in India while advocating secularism and social justice. The exhibition also included work by Canadian artists in support of human rights. Funding for the exhibition was partially provided by the Shastri Indo-Canadian Institute, a bilateral research institution supported by both Indian and Canadian government agencies. Shastri requested that its name be removed from association with the exhibition, and the organizers returned the institute's $5,000 contribution. The exhibition was presented in Toronto in conjunction with the 2000 Community Arts Biennial coordinated by A Space, and was mounted by Hoopoe Curatorial: Phinder Dulai, Jamelie Hassan, and Peter White. Also, a conference slated for University of Waterloo called "Accommodating Diversity: Learning from the Indian and Canadian Experiences" was killed as Shastri president Hugh Johnston withdrew the institute's $27,000 support, citing pressure from Indian High Commissioner Rajnikant Varma (Sharlene Azam, "India wants to censor art show it says attacks policies," *Toronto Star*, August 22, 2000; Leah Rumack, "Indian diplomat leans on art show support: Human Rights," *NOW*, August 24-30, 2000; T. Sher Singh, "New Delhi's meddling tars Toronto art exhibit," *Toronto Star*, September 4, 2000).

Carries a spare bubble

In contrast, the notion of arm's length developed by Miller and Rose works as an extra-political sphere, diffuse throughout the operations of the welfare state. Rose and Miller call this "government at a distance," where, through "the construction of allied interests" and "complex mechanisms" a "translation" occurs "in which one actor or force is able to require or count upon a particular way of thinking and acting from another ... [P]ersons, organizations, entities, and locales which remain differentiated by space, time and formal boundaries can be brought into a loose and approximate, and always mobile and indeterminent alignment."[36] The authority of expertise is pivotal here. Instead of containing power, "government at a distance" disperses it. As a mode of indirect rule, it works across a series of sites, including not only that of the state, but up to and including that of the individual as well.

The notion of arm's length, as it has been cherished by artists, cultural professionals, and activists, mischaracterizes the possibility of freedom. Current restructuring of provincial and federal councils, and cutbacks in government support have seriously interfered with mechanisms that previously allowed at least the perception of arm's length as containment. Without it the demarcation between the sphere of the government and the sphere of profes- sional art practice threatens to collapse. Although we are witnessing a shift in the tactics of rule, arguably, the space of safety never existed. For with "government at a distance" there is no space outside of power. This is the dilemma in a nutshell: we cannot "cross the line."[37] There is no outside.

The problem is twofold: first, how can we understand this "one" who acts and the complex of ambitions surrounding her? And two, what are the possibilities for plausible or true resistance?

Colin Gordon's definition of governmentality groups three spheres into a perpetually inter-relating diagram preoccupied with conduct. How does one conduct oneself? How does one lead others? How is one acted upon, forced, or coerced into certain kinds of behaviour or to take certain actions? Simply, we can say that the three spheres concern relations between self and self, with others (both "private interpersonal relations" and "relations within social institutions and communities"), and with the state.

Following, I have drawn together tentative strands of thinking about this "one." Couze Venn, in working through his own project of "settling accounts," hopes for a "different way of thinking about subjec- tivity and the self." Venn, citing Paul Ricoeur, seeks to bind the individual "with solicitude for one's neighbour and with justice for each individual."[38]

> That's just like you, always with the same incapacity to cross the line, to pass to the other side ... it is always the same choice, for the side of power...
>
> Michel Foucault,
> cited by Deleuze in Foucault

2000 – Ontario Arts Council CEO Donna Scott abruptly resigns her position. Scott quits in protest of the fact that the provincial arts council doesn't have the budget to assist all who need assistance. New Democratic Party cultural critic (and former Culture and Recreation minister 1990–1995) Rosario Marchese lamented Scott's resignation by singing the tune "Yesterday" in the legislature.

warns his
fellows

Venn's strategies take up practices of mourning, reconciliation, and rememoration, through works of art "that exist at the limits of the sayable" and critique.[39] Buck-Morss finds in Benjamin a conscientious concern for the task of the politically committed intellectual. There was for him, she writes, a clear "connection between cognitive images and revolutionary praxis: 'Only images in the mind vitalize the will.'"[40] Foucault also directs our attention to reflect, "Where there is power there is resistance, and yet," he writes, "... this resistance is never in a position of exteriority in relation to power."[41]

> [T]o the extent that the governed are engaged in their individuality, by the propositions and provisions of government, government makes its own rationality intimately their affair: politics becomes, in a new sense, answerable to ethics.
>
> Colin Gordon,
> "Governmental Rationality"

This brings us to the second part of the problem of resistance in radical art. Andrew J. Paterson, thinking about some similar questions connected with public funding and politically important work, advances a few prescriptions for art activists. He advocates that "one" resist "divide and conquer" techniques, "combine personal funding strategies with public resources," and create "fresh options and strategies."[42] These suggestions may point out a plausible direction. But, as I have begun to outline, whatever strategies we pursue, the dimensions of the problem demand an engagement with history, theory, and materiality across several fronts. Foucault's reiterated and irreducible relationship of power and resistance does provide a key. Where there is one there is always the other because resistances "are the odd term in relations of power; they are inscribed in the latter as an irreducible opposite."[43] For instance, we might look to the mobilization of demonstrators at the WTO talks. If "this is the first movement born of the anarchic pathways of the Internet" then it might be possible "that the protesters in Seattle have been bitten by the globalization bug as surely as the trade lawyers inside the Seattle hotels—though by globalization of a different sort."[44] This example indicates that radical action is not static. Prescriptions, methods, alliances, effective once are not effective at all times or in all places. What does exist is compromised by its envelopment into some of the very things it seeks to strike out against. Foucault's caution, "always the same incapacity to cross the line, to pass to the other side [... of power]," bears reiteration. In Venn's closing remarks there is a useful thought. Regardless of whatever theoretical tools we might use to help us see the concrete, empirical world, one needs "a notion of a project" with clear ethical principles and political dimensions.[45] Buck-Morss laying out the fragments of Benjamin's *Passagen-Werk* makes a similar observation. She writes, "what saves the project from arbitrariness is Benjamin's political

2000 - THE ART FOUNDATION OF ALBERTA (AFA) ANNOUNCES FORTHCOMING FUNDING CHANGES. THE AFA WILL MOVE TO A COMMUNITY-DERIVED REVENUE FORMULA, AND INSTITUTIONAL GALLERIES HAVE BEEN INFORMED BY THE AFA THAT THEIR FUNDING WILL BE EXTINCT IN THREE YEARS.

concern."[46] I think that our effectiveness for future work depends upon how we identify such a project.

Certainly the small space that this bit of thinking and research has made is not complete. Questions remain. When I first saw *Plus Tard* at the National Gallery of Canada, I laughed. Its decentred compositions and blurred, out-of-focus images reminded me of some arrogance in myself. Sometimes when I am trying to explain to students how to see a work of art I am reminded of these photographs. There is a difference, I tell them, between a fast and a slow read. You stand in the doorway. You know what you're looking at. Paintings. And all paintings you've seen before. Why even go in? You can stand in the door, snap it all up in glance and then move on. *Plus Tard* exhales mockery, but also implies a caution. Critique, as Venn suggests, "needs the supplement of 'working through.'"[47] A slow read is laborious. It takes time and can be boring. My hope is that, if we re-pose our initial query, "How can one be of and against the state at the same time?" it might assume a slower, deeper cast. ■

NOTES

1 Clive Robertson, "Custody Battles: Changing the Rules at the Canada Council," *FUSE* 22:3 (1999), 45.

2 Thomas S. Popkewitz, *Struggling for the Soul: The Politics of Schooling and the Construction of the Teacher* (New York, London: Teachers College, Columbia University, 1998), 15.

3 Michel Foucault, "Of Other Spaces," Jay Miskowiec, trans., *diacritics* (Spring 1986), 24.

4 Tony Bennett, *The Birth of the Museum* (London, New York: Routledge, 1995).

5 Michel Foucault, "The Subject and Power," *Art After Modernism: Rethinking Representation*, Brian Wallis, ed. (New York: New Museum of Contemporary Art; Boston: D.R. Godine, 1984), 427.

6 Colin Gordon, "Governmental Rationality: An Introduction," *The Foucault Effect: Studies in Governmentality*, Graham Burchel, Colin Gordon, Peter Miller, eds. (Chicago: University of Chicago Press, 1991), 2.

7 Nikolas Rose, "Governing 'advanced' liberal democracies," *Foucault and Political Reason: Liberalism, Neo-liberalism and Rationalities of Governments*, Andrew Barry, Thomas Osborne, Nikolas Rose, eds. (Chicago: University of Chicago Press, 1996), 37.

8 Particularly Rose (1996), 37–38; Peter Miller and Nikolas Rose, "Governing Economic Life," *Foucault's New Domains*, Mike Gane and Terry Johnson, eds. (London: Routledge, 1993), 84–85.

9 Rose, 38.

10 Miller and Rose, 84–85.

11 Miller and Rose develop their argument of "government at a distance" from Bruno

2000 - Ontario's Conservative Harris government proposes Bill 112 that would limit the board of the McMichael Collection in Kleinburg, Ontario, to the original agreement of 1965 when Robert and Signe McMichael donated their 193 artworks and property for the purpose of focusing on the work of the Group of Seven and their contemporaries and "other artists who have made a contribution to the development of Canadian art." The McMichaels relinquished control of the gallery, whose collection now includes more than 6,000 works of art, in 1982, and were compensated by the provincial government. Supporters of Bill 112 argue that returning to the narrower definition of "developing Canadian art" and work in the spirit of the Group of Seven will boost attendance and help to combat the McMichael Collection's deficit. Opponents believe this bill to be another example of governmental violation of arm's length principles between government and institutions (Betsy Powell, "McMichael gallery saga moves to Queen's Park, *Toronto Star*, October 19, 2000, A35).

gentle and
inoffensive

Latour and Michel Callon's notion of "action at a distance" (Miller and Rose, 83–84).

12 Rose, 40.

13 Miller and Rose, 83–84.

14 Ellen Louise Ramsay, "The promotion of the fine arts in Canada, 1880–1924: The development of art patronage and the formation of public policy," Ph.D. diss., University of London, 1988.

15 Lawrence Alloway, *The Venice Biennale 1895–1968: From Salon to Goldfish Bowl* (Greenwich, CT: New York Graphic Society, 1968), 14.

16 Daniel Palmer, "Melbourne International Biennial: Collaborating Countries Projects," *globe E Journal: Current Journal of Contemporary Art*, Monash University, <arts.monash.edu.au/visarts/globe/issue10/dptxt.html>

17 Foucault, "Of Other Spaces," 23.

18 Rose, 41.

19 Michel Foucault, *Discipline & Punish: The Birth of the Prison* (New York: Vintage Books: 1995), 307.

20 Susan Buck-Morss, *The Dialectics of Seeing: Walter Benjamin and the Arcades Project* (Cambridge, MA: MIT Press, 1991), 3.

21 Ibid., 39.

22 For Foucault, the connection with all other sites is a condition of the heterotopia. As an example, he describes the cemetery as "a place unlike ordinary cultural spaces. It is a space that is however connected with all the sites of the citystate or society or village, etc., since each individual, each family has relatives in the cemetery" (Foucault, "Of Other Spaces," 25).

23 At the Toronto panel on arts funding (November 1999) artists Lisa Steele (video artist and teacher) and Winsom (artist) articulated quite different concerns around public funding, intention, and audience. Steele pointed to current examples of artistic excellence (Michael Snow, Stan Douglas) whose work has achieved international recognition. Their careers, she argued, would have been impossible without government support. Differently, Winsom described an arts community which was local, impoverished, and operated without access to state largesse. In this case circulation of artworks went on "in our living rooms."

24 Alloway, 13.

25 Susan Buck-Morss, "The City as Dreamworld and Catastrophe," *October* 73 (Summer 1995), 6. Alloway, writing in 1968, observes that the architecture of the pavilions could be categorized into different styles, with "folk" as a prevalent one. For example, the Canadian pavilion that opened in 1957 under the auspices of the National Gallery of Canada was an "intricate wigwam of glass and wood around a tree" (18).

26 A partial inventory of conflict throughout the nineteenth century reveals a global confla-gration: the Second Burmese War (Britain and Lower Burma), 1852, Russo-Turkish War (Palestine), 1852, Crimean War (Britain, France, Turkey, Sardinia against Russia), 1854, Persia and Britain at war, 1856, Indian Mutiny, 1858, France and Sardinia at war with

2001 - Summit of the Americas held in Québec City, April 2001. Activists opposed to the proposed Free Trade Area of the Americas treaty (FTAA) attend and demonstrate while Summit is protected by a 3.8-kilometre fence and 6,000 police.

Austria, and Morocco with Spain, 1859, Denmark and France at war with the Prussian alliance, 1864, Austro-Prussian War, 1866, American and Indian wars, 1871, Battle of Little Big Horn, 1876, Russo-Turkish war, 1877–8.

27 Buck-Morss, "The City as Dreamworld and Catastrophe," 13.

28 Michel Foucault, "The Political Technologies of Individuals," *Technologies of the Self: A Seminar with Michel Foucault*, Luther H. Martin, Huck Gutman, Patrick H. Hutton, eds. (Amherst: University of Massachusetts Press, 1988), 151–2.

29 Roger Shattuck, *The Banquet Years: The Arts in France 1885–1918* (London: Faber and Faber, 1959), 14–15.

30 Buck-Morss, "The City as Dreamworld and Catastrophe," 5–6.

31 Shattuck, 13–14.

32 Ibid., 14.

33 Buck-Morss, "The City as Dreamworld and Catastrophe," 11.

34 Michel Foucault, "Questions of Method," *The Foucault Effect: Studies in Governmentality*, Graham Burchel, Colin Gordon, Peter Miller, eds. (Chicago: University of Chicago Press, 1991), 84.

35 Martha J. King, "The National Gallery of Canada at Arm's Length from the Government of Canada: A Precarious Balancing Act," MA thesis, Carleton University, 1996, introduction.

36 Miller and Rose, 84.

37 Gilles Deleuze, *Foucault*, Sean Hand, ed. and trans. (Minneapolis: University of Minnesota Press, 1988), 94.

38 Couze Venn, "Beyond Enlightenment? After the Subject of Foucault, Who Comes?" *Theory, Culture and Society* 14:3 (1997), 24.

39 Ibid., 19.

40 Buck-Morss, *The Dialectics of Seeing*, 290.

41 Michel Foucault, *The History of Sexuality: An Introduction*, Vol. I, Robert Hurley, trans. (New York: Vintage Books, 1990), 96.

42 Andrew James Paterson, "When Public Became Private," *FUSE* 22:3 (1999), 11–12.

43 Foucault, *The History of Sexuality*, 96.

44 Naomi Klein, "Rebels in Search of Rules," *New York Times* (Late Edition), December 2, 1999, A35.

45 Venn, 23.

46 Buck-Morss, *The Dialectics of Seeing*, 54.

47 Venn, 23. Venn attributes his use of the notion "working through" to Edward Said. He writes, "[Said] suggests a rewriting which instead performs a work similar to what happens in the process of 'working through' (*Durcharbeitung*) in the analytic experience"; and a little further on he elaborates, "the process of 'working through' is produced by those postcolonial artists and intellectuals who regard their work as a responsibility owed to those who have been forced into invisibility or silence ..." (3).